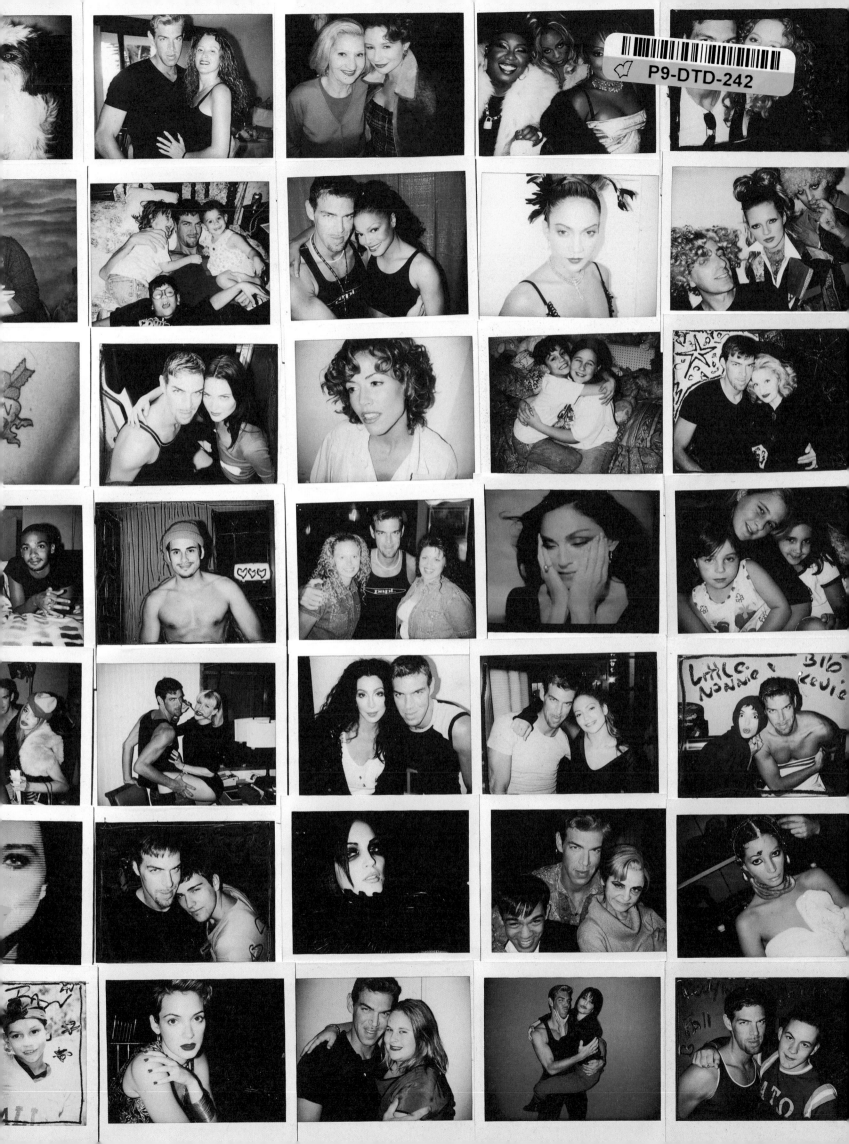

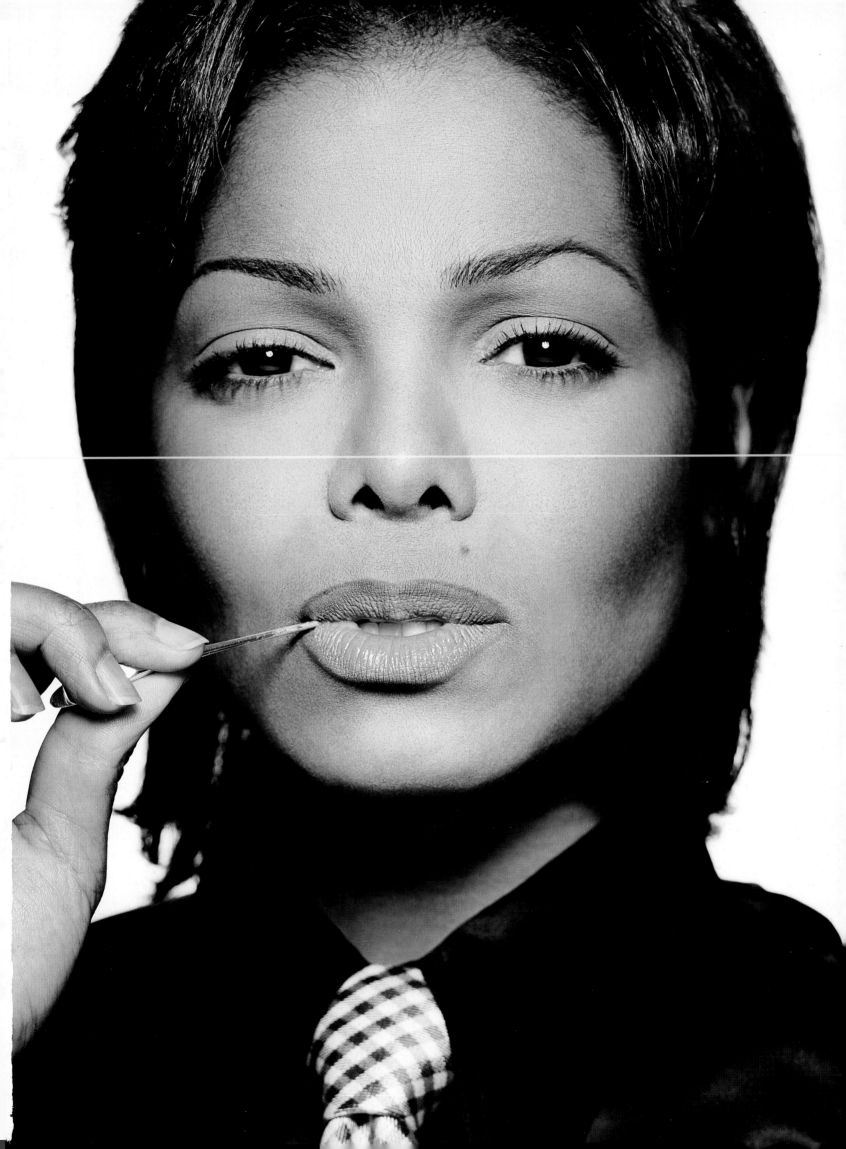

FACE *FORWARD*

Kevyn Aucoin

Little, Brown and Company
Boston • New York • London

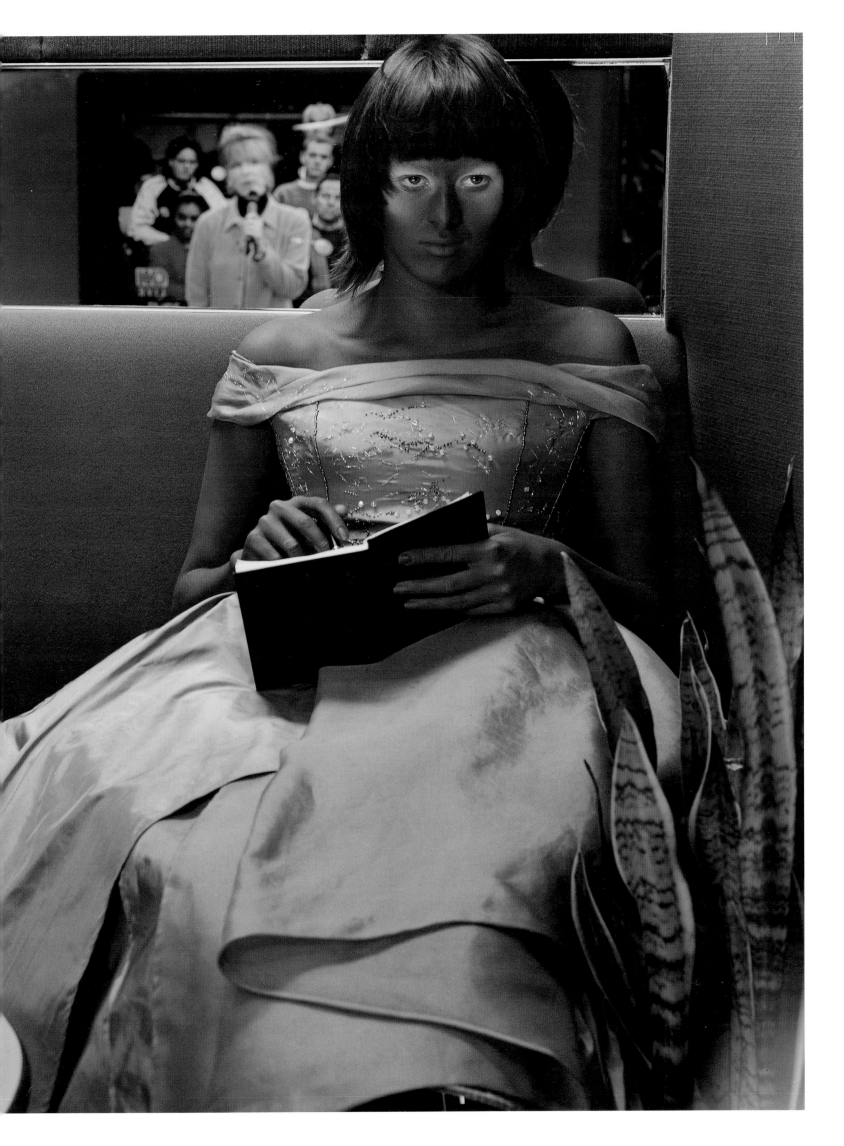

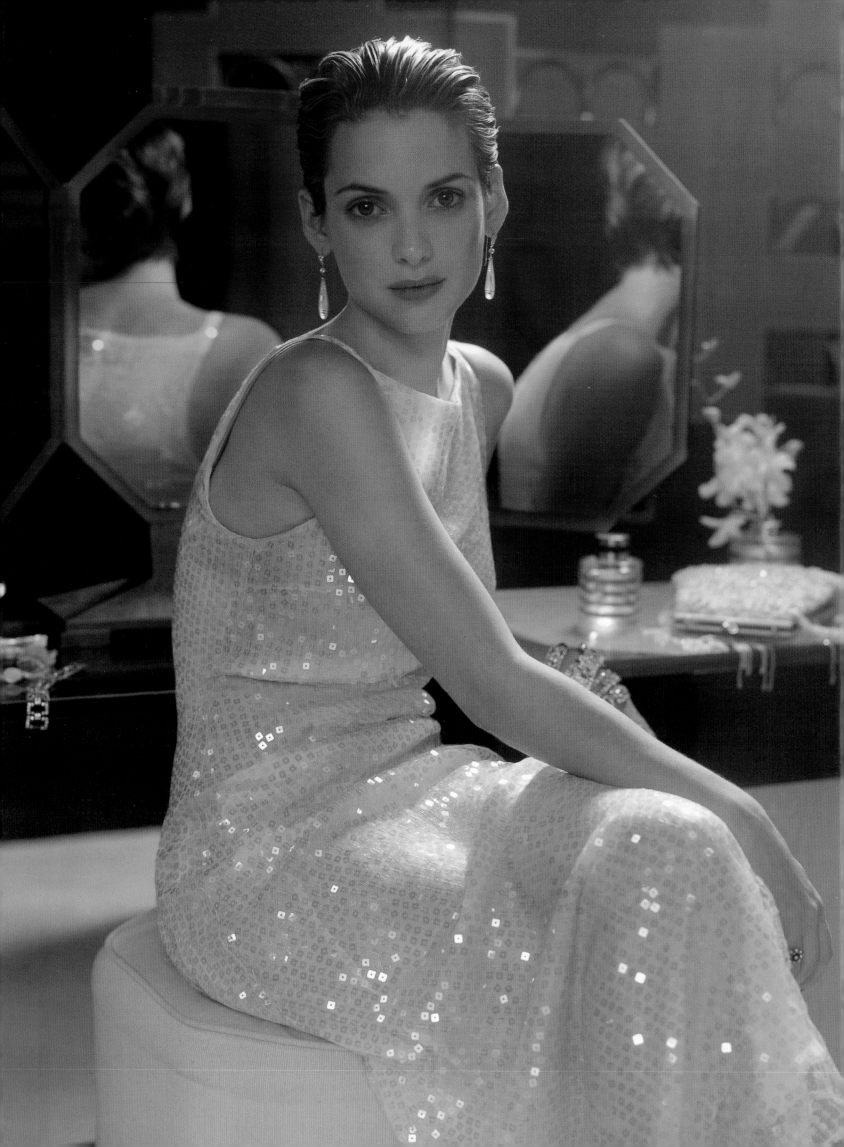

FACE*FORWARD*

written by
Kevyn Aucoin

creative direction and illustrations by
Donald F. Reuter

art direction and design by
Donald F. Reuter and Kevyn Aucoin

principal photography by
Kevyn Aucoin

featuring the photography of
Walter Chin, Patrick Demarchelier, Billy Jim,
Steven Klein, Dah Len, Steven Meisel, Herb Ritts,
Warwick Saint, Eric Sakas, Albert Watson,
and Firooz Zahedi

all makeup by
Kevyn Aucoin

This book is dedicated to

Steven Meisel, who basically saved my life, gave me my first job, and became not only a mentor, but a treasured friend

Irving Penn, for being the loving and supporting grandfather I never had, and for teaching me so much about loyalty and kindness

Steven Klein, who has believed in me through it all, and for sharing not only his talent, but his kind heart and brilliant mind with me

All the wonderful and amazingly talented photographers with whom I have worked over the years, including Herb Ritts, Patrick Demarchelier, Albert Watson, and Warwick Saint (all of whom contributed their work so generously for *Face Forward*), and countless others. Through your unerring eyes and camera lenses I have seen a more beautiful world. Thank you for continuing to enrich and inspire us all.

on the cover: supermodels and superfriends Kiara Kabakuri and Amber Valetta in a dual composite image that "suggests" the merging of the world's races. **endpaper, from left to right:** me and très fabu *Vogue* editor, Andre Leon Talley; hip-hop sensation Li'l Kim; captivating Calista Flockhart and me backstage at the "Concert of the Century"; my birth father and his wife, Jerry and Josie Burch; my favorite furry friends, Nicky and Alex; me and my LA pal Dee Ragano; my mom, Thelma, and singing sweetheart Tori Amos; a trio of the best singing talent on the planet, Missy Elliot, Li'l Kim, and Mary J. Blige; gorgeous Nicole Kidman and me mugging for the camera; my darling niece Katarina Adkisson; me and the "spirited" Sylvia Browne; the beautiful Sharon Stone and me; Tina Turner, what a lady!; on the set with Hilary Swank, aka "Raquel," and my right-hand man Eric Sakas; me and my nieces and nephew, Katrina, Ian, and Falon; me and Janet, the gorgeous Miss Jackson; Jennifer Lopez at a Steven Meisel shoot; creative genius Paul Cavaco, model extraordinaire Kate Moss, and hair whiz Danilo; huggin' on angelic Winona Ryder; supertalent Julianne Moore playing Dietrich; me and friends Gina Gershon and Thomas Efaw; Jeremy and me; Jeremy's tattoo; Shalom Harlow and me; sweet Sheryl Crow; nephew Ian and godniece Samantha; mom and me; luscious Liz Hurley on location; me and sparkling Jewel; Eric and me; a heavenly Celine Dion; hair genius Orlando Pita and his boyfriend, George Casson; my good buddy Thomas; my birth sisters Jeanne, Kristy, and me; magnificent Madonna; nieces Katarina, Samantha, and Tatijana; me and pal Lisa Marie Presley; Janet, solo; Ian, with a little fuzzy buddy; Samantha and the hilarious Caroline Rhea; Cheri Oteri and me, and a bevy of buxom beauties; being made up by Courtney Love; my sweetie Cheri and me; Jennifer Lopez and me on the set of the video "If You Had My Love"; Little Nonie and Big Kevie; Cher on the set of her video "Dove L'Amour"; me and best friend Todd Littleton; Winona, à la Audrey Hepburn; me and Julia Roberts; Tori, captured on video; me and dear friend Rubin Singer; Chandra North, looking like you've never seen her before; me with Amy Sedaris and Orlando, on the set of *Strangers with Candy*; glorious Christy Turlington; me, Falon, and Alex Peruzzi; Rubin, Eric, me, Gena Rowlands, and Robert Forrest; Samantha and Katarina and their mom and my sis' Carla; adorable Anne Heche; me and Ian; another look at Winona; Sam and me; Gina and me; and finally, me and my ex, Brian Erb (photo collage by Billy Jim). **opening page:** the ever-fabulous Janet Jackson in male drag (photo by Albert Watson). **title page spread:** model Karen Elson spray-painted with dark-orange body makeup and lilac eyes looks to the future of beauty (photo by Steven Klein). **opposite:** a pensive and moody portrait of Winona Ryder (photo by Steven Meisel).

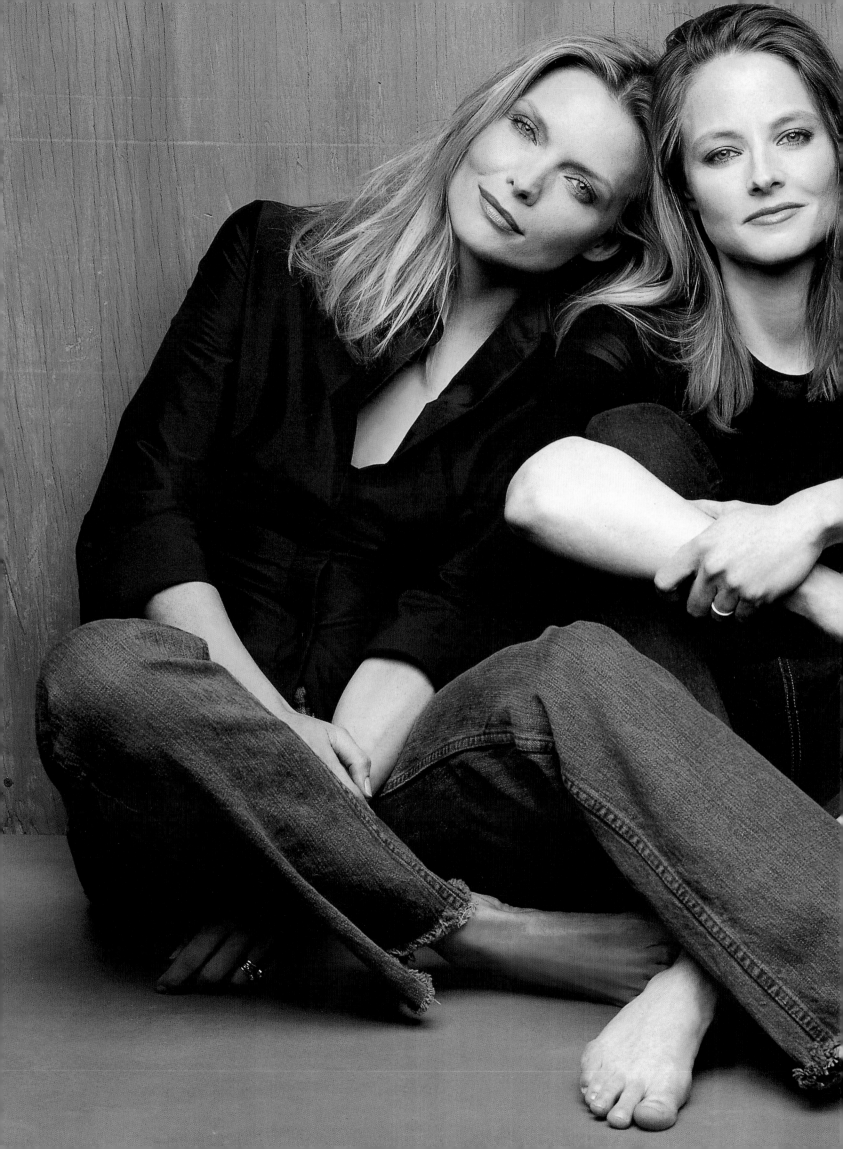

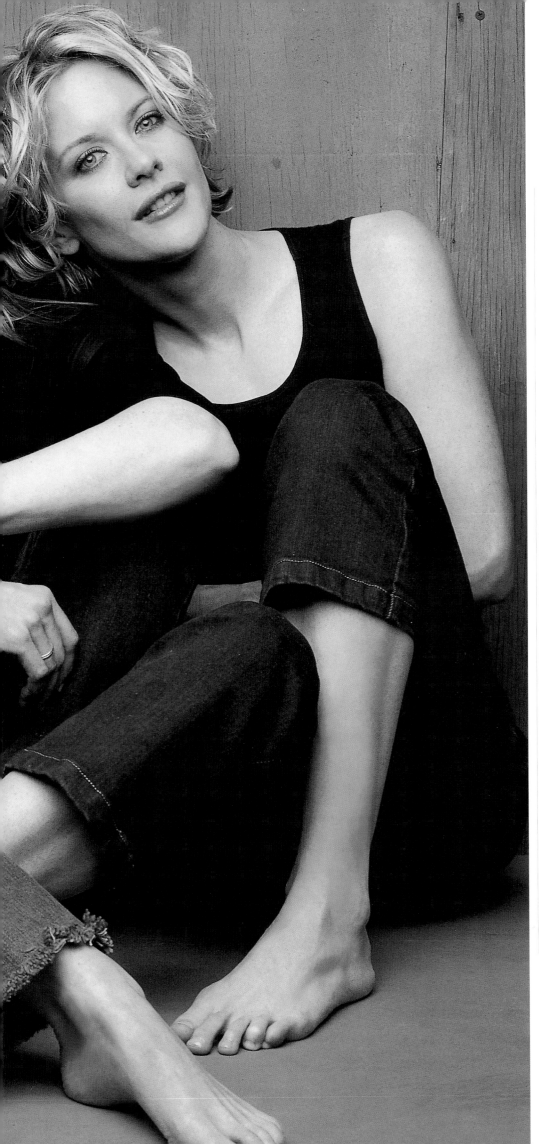

FACE*FORWARD*

Copyright © 2000 by Kevyn Aucoin

First Edition

ISBN 0-316-28644-3
LCCN 00-103729

10 9 8 7 6 5 4 3

PBI-IT

Printed in Italy

this spread: three of the most acclaimed and beautiful people with whom I have had the pleasure to work, Michelle Pfeiffer, Jodie Foster, and Meg Ryan. I chose to use the same makeup concept and colors on all three. This had an equalizing effect and yet still allowed their individuality to shine through. The occasion for this once-in-a-lifetime experience was for *Vanity Fair* magazine, and the photographer, the inimitable Herb Ritts.

contents

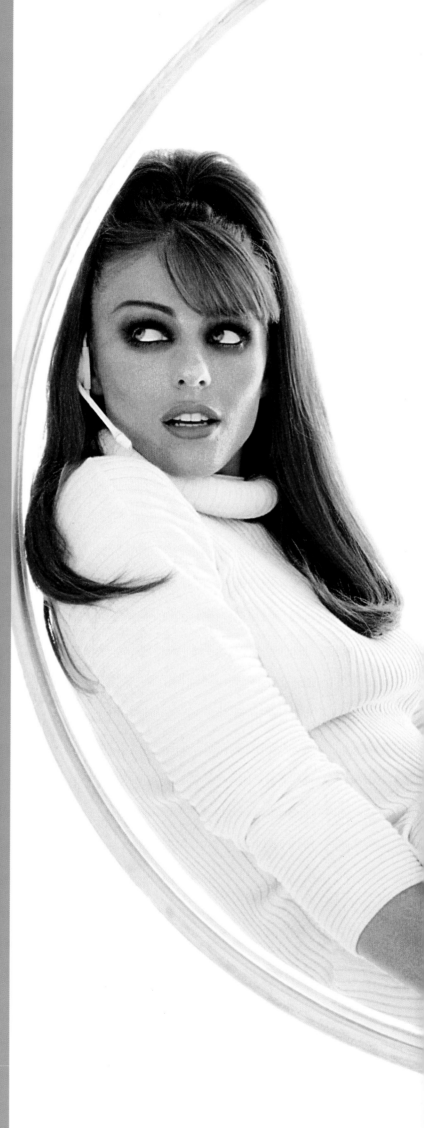

this spread: The divine Elizabeth Hurley in an homage to the future of fashion and beauty. Her makeup consists of intensely concentrated black shadow, blended onto the lid and crease, and pink-pink lips. Captured for posterity by the one and only Patrick Demarchelier. © 1999 Talk Magazine.

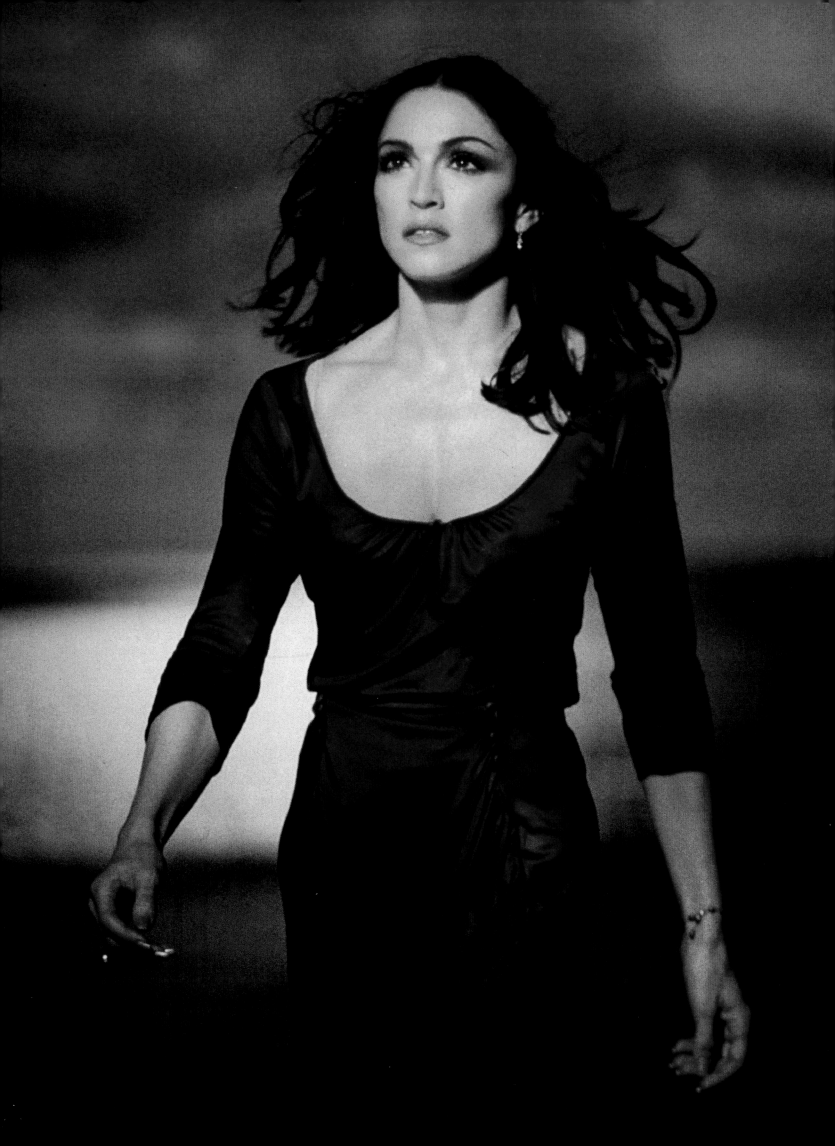

introduction

I have a confession to make: My entire mission in life is to help women take over the world. Not by force (the route so many men have taken since the beginning of time), but with compassion, perseverance, and love. Don't get me wrong, there are some men in power who regard emotion not as a weakness but as a strength, and who view prejudice in any form as unacceptable. Nor do I fault men alone for the generally unhealthy state of our society. Both sexes have contributed equally. However, I do believe women have a greater capacity for championing diversity, and an unlimited threshold for understanding the human condition.

When I first moved to New York City in the early 1980s, the popular political ideology at the time was based on a fifties fantasy world that conservative elitists often refer to as the "good old days." Remember, this period was a time when blacks had no civil rights, women were expected to be housewives or mistresses, and other racial and religious minorities—including lesbians and gays—were completely invisible. The eighties conservative movement echoed the McCarthyist ideal of "us against them." Even beauty "authorities" got into the game of upholding separatism in the name of unity. Regardless of the intention, terms like "ethnic," "Latino," or "global" beauty (which were in reality just ways to categorize someone as third world) still only amounted to mere labels. In the nineties, the first heroic attempt at true inclusion began, but we still had to deal with individuals obsessed with keeping the system in place. Desperate souls, afraid of sharing power, used gossip, innuendo, meddling, and dishonesty to create an atmosphere of negativity and fear. Fear is the most debilitating emotion in the world, and it can keep you from ever truly knowing yourself and others—its adverse effects can no longer be overlooked or underestimated. Fear breeds hatred, and hatred has the power to destroy everything in its path.

While traveling around the world, I've had the opportunity to work with every living beauty icon. I've learned to appreciate idiosyncrasy. The fact is, there is really no such thing as "normal"—everybody's different, and that is the essence of their beauty. To forgive yourself your differences and cherish them instead is incredibly liberating. Appreciating (even highlighting) individuality is one of the great things about makeup. However politically correct we've become, so much of our culture—whether it's the politicians, the media, or our

own ethnic group—either overtly or covertly perpetuates the idea that different is bad, and that otherness is something to be feared. That fear breeds alienation and self-loathing, which isn't good for anyone. So if you cannot embrace the inevitability and beauty of a unified world, you may have to live out the remainder of your life in a cave atop some remote mountain. Remember, conservative means withholding and liberal means generosity. It's pretty self-explanatory.

To me, beauty is beauty, no matter to whom you are referring. In *Face Forward*, while I do address specific (and general) issues relating to facial structure, skin color, and skin texture, you will not see any single group of people separated and placed together under one banner. There are no segregated sections on Asians, blacks, Latinos, whites, seniors, teens, straights, or gays. (For that matter, you won't see any exclusive chapters on right- or left-wing beauty either!) The point is for anyone, no matter who, to be able to use *every* page in this book as a source of information and inspiration. No more class systems, no more types, no more barriers.

In this book I wanted to explore the entire range of beauty, including its past, present, and future. Tori Amos examines her Cherokee heritage as well as her Scottish roots; Lucy Liu goes from earth to wind to fire; Amber Valetta reveals her feminine *and* masculine sides; and Mary J. Blige exposes her vulnerability first before taking off into outer space. The fun continues with Gwyneth Paltrow playing a glam gun moll *and* an unexpected fifties screen icon, while Julianne Moore's perfect facial symmetry melts seamlessly into an incarnation of sixties mod, then does a startling about-face that leads into the next horizon. From the cover, which represents the disintegration of racial lines, to its appreciation of all ages, races, sizes, and sexualities, to the concept that individuals have the right to alter their own bodies in any manner they see fit—whether in skin tone, facial features, or sexual identity—*Face Forward* is my idealized vision of a world of beauty that knows no boundaries and follows no rules.

They say that normally only 10 percent of the human brain is ever used. I believe this is often true of our hearts and spirits as well. Yet it is the free-spirited women and men whom we most admire and often envy—those individuals who dare to be themselves. As you read through this book get ready to hear a lot of praise. Everyone was chosen because of their hearts and souls, as well as their exteriors. These are people who are helping to change our social and emotional landscape. I believe that we are here on this planet to make the most of what we've got and who we are, and contribute to the world so it's a little bit better when we leave it. I'm not saying that putting on makeup will change the world or even your life, but it can be a first step in learning things about yourself you may never have discovered otherwise. At worst, you could make a big mess and have a good laugh. Well, as they say, nothing ventured, nothing gained, right? Take a chance, have some fun, and enjoy the rest of the book.

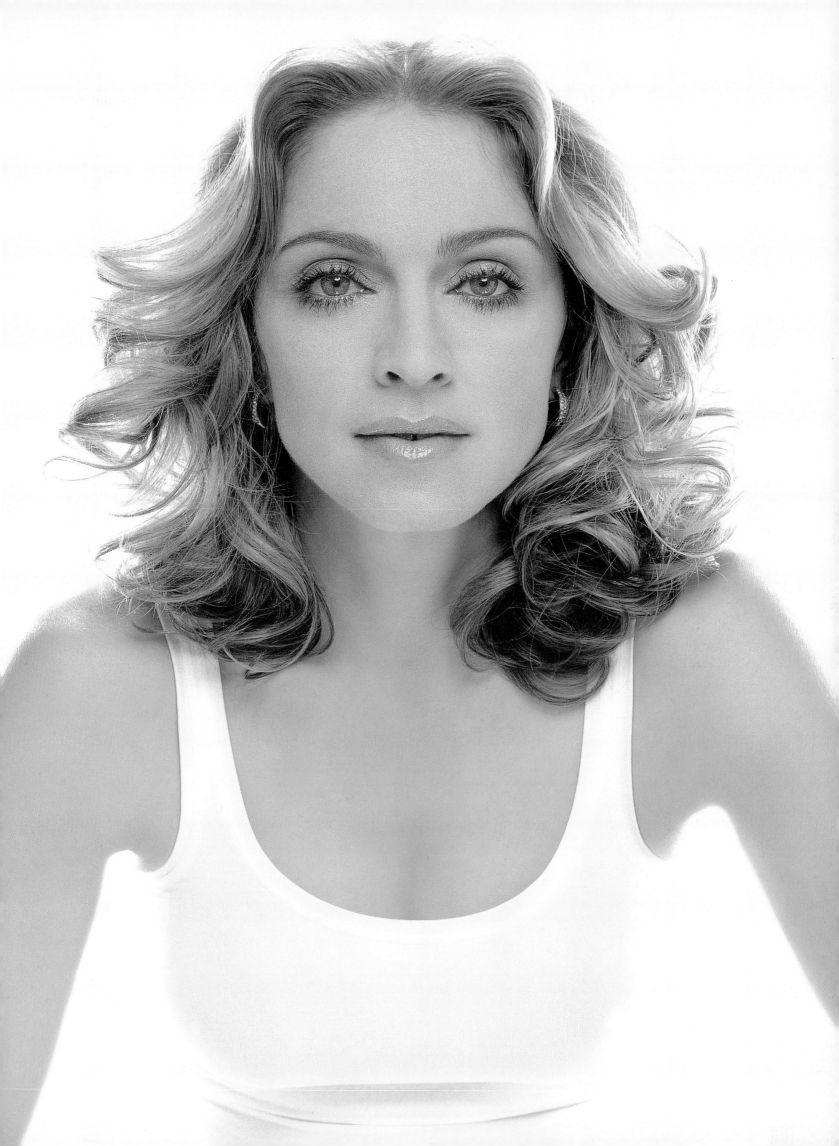

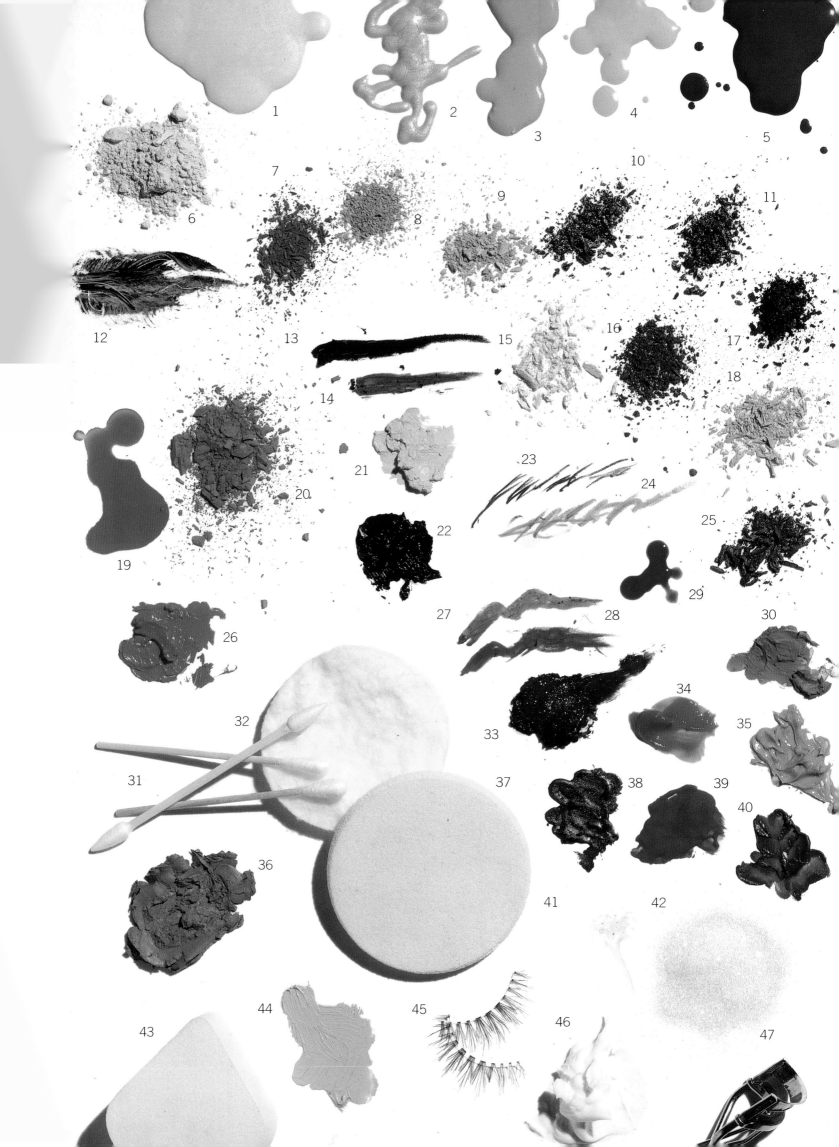

getting started

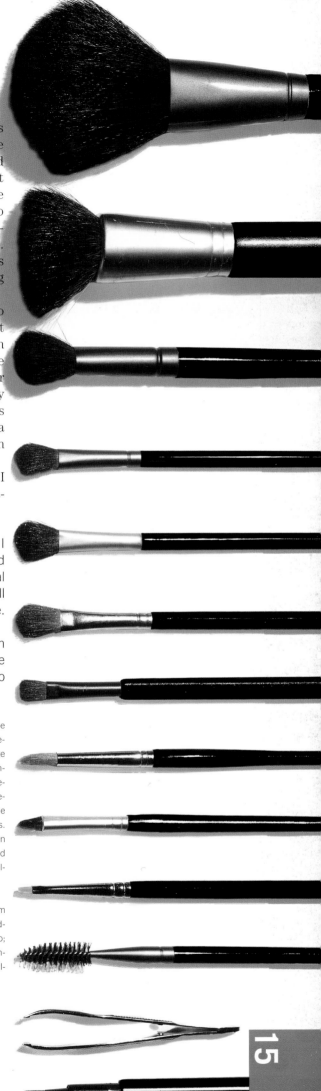

No matter how artistic a person is, without quality tools and products even a genius like Michelangelo would not have been able to paint the Sistine Chapel. This can be really important if you want to get the best results. But you don't need to go out and buy everything all at once—some things you might never need and some you might not like—so accumulate them over time. By the way, you already possess two of the best makeup *tools* on the market—your hands and fingertips. These allow you to forgo a lot of the others and "dig right in." I've found that skin on skin, not to mention the natural warmth of the fingertips, often works exceptionally well. Surprisingly enough, I believe the most important tool a person needs is *time*—this allows you to practice and perfect your technique. Remember, anything worth doing is worth doing right.

When buying products try to go for the best quality. This may mean you'll have to spend a little more than you like, but you will save money in the long run. I'm not saying you have to spend a fortune either, just be prepared to spend a bit more on certain things. For instance, while there are some great inexpensive products on the market, often lower-priced foundations do not blend as well, last as long, or offer enough colors to match skin tones. However, it is easier to find comparable quality lip colors and mascara in both price ranges. In the end, only you can decide what is best for you—and your pocketbook. The most important product may be *desire*—a willingness to attempt and explore the range of different looks made possible with makeup. Be generous and patient with yourself when it comes to this.

I was never taught how to do makeup, I taught myself. I made tons of mistakes, but I never gave up. I devoted a lot of time to it and, slowly but surely, got better and better, and I am still learning new things every day.

to the left: Here is a selection of my favorite makeup products and colors. Though I know it frustrates a lot of people, I do not name specific brands. My reason behind this is that three months from now they will be off the market—as many are seasonal products and colors. I also created most of the products you see here for myself. I will come out with my own products when I achieve the quality and uniqueness I desire. My integrity dictates that they must be innovative and special—or not do it at all. Repeatedly throughout this book, I have used the makeup products and colors shown here to different effect. Try to find compatible products in your favorite brands. The truth is, there is no "magic" makeup product. Though some products are superior to others, the "magic" is in the application.

1 sheer iridescent sparkle liquid foundation. **2** gold sparkle liquid foundation. **3** neutral beige liquid foundation. **4** pale flesh liquid foundation. **5** deep brown liquid foundation. **6** loose translucent face powder. **7** primary blue powder eyeshadow. **8** lime green powder eyeshadow. **9** golden honey powder eyeshadow. **10** pewter powder eyeshadow. **11** bronze powder eyeshadow. **12** basic black mascara. **13** basic black eye pencil. **14** basic brown eye pencil. **15** off-white shimmer powder eyeshadow. **16** basic brown powder eyeshadow. **17** dark blue powder eyeshadow. **18** peach powder eyeshadow. **19** rose liquid blush. **20** hot pink powder blush. **21** basic yellow creme eyeshadow. **22** basic black creme eyeshadow. **23** basic brown eyebrow pencil. **24** blond eye pencil. **25** warm brown powder eyeshadow. **26** basic red creme lip color. **27** light flesh lip pencil. **28** dark flesh lip pencil. **29** eyedrops. **30** natural rose creme lip color. **31** cotton swabs. **32** absorbent cotton pad. **33** iridescent indigo creme lip color. **34** sheer red lip gloss. **35** caramel lip gloss. **36** golden honey stick foundation. **37** flat, circular makeup sponge. **38** bronze lip gloss. **39** sheer tawny liquid lip color. **40** blood red liquid lip color. **41** clear lip gloss. **42** loose, iridescent all-over powder. **43** foundation sponge. **44** light flesh concealer. **45** false lashes. **46** creme moisturizer. **47** eyelash curler.

to the right: Here is a selection of my favorite tools, starting from the top: a large blush and powder brush; a medium blush and powder brush (also great for blending); a small contour brush, which can also be used for blending eyeshadow; the next three are medium-size rounded-tip eyeshadow brushes; a small eyeshadow brush with a soft, flat-edge tip; a small eyeshadow brush with a softly rounded tip; a small eyeshadow brush (also good for defining eyebrows); a concealer brush (with a tiny tip for exact placement); an eyebrow brush and a mascara wand; basic tweezers; and the all-important lip brush.

behind beauty

By now, thanks to dozens of magazines devoted to beauty, countless books dedicated to makeup application and technique, television segments focusing on the latest beauty trends, and an abundance of knowledgeable cosmeticians, salespeople, and salon staffs everywhere, most likely you are more savvy about doing your own makeup than you get credit for. There are hundreds of step-by-step instructions in this book, and every face is accompanied by a generous amount of information to help you recreate the look, but in *Face Forward* I depart from the expected to go *behind* beauty. More and more often, people ask me "why" instead of the "how" when I do makeup. Obviously, now that they themselves are capable of artfully applying their own makeup they want a better understanding of the creative process itself. A person can easily be shown where to apply black liquid liner, but they become skilled artisans when they learn the effect that black line can have. So instead of treating *Face Forward* as a basic paint-by-numbers beauty book, I also get into the theory, reason, and just a smidgen of the philosophy, history, and politics of beauty. I expect by the time you reach the end, you will have a better understanding of the *why* along with the *how*. Incidentally, the "numbers" are still here, but you get to decide if you want to use the paint, and what color it is. I want to call your attention to one other aspect of *Face Forward.* Every person featured in its pages is represented by at least two images. I did this so you could see the change a different makeup application can have on one individual. I still get excited at the power makeup has to help you discover yourself.

structure: face

The entire concept of cosmetic adornment originated as a way to define and enhance facial features and skin coloring. But like everything else in history, even the use of makeup has changed, carrying with it different meanings, liabilities, and benefits. Why we use cosmetics today differs from the past and from individual to individual. However, even though there are as many variations to the human face as there are people, the basic structure is something that we all share.

The face is made up of areas that protrude and recede: the apples and hollows of the cheeks, the tip of the chin, the slight indentation of the temples, and so on. Traditionally (*a word I absolutely hate*), these places are highlighted and contoured to accentuate the face's natural shape. Here on Vanessa Williams we have two spectacular examples of natural bone structure that has been enhanced with the use of makeup. By playing with foundation colors noticeably or subtly darker or lighter than your own natural skin tone you can create startling and dramatic results. A nose can be sharpened, a brow can be lifted, a cheek can be carved out, all by carefully placing and, most important, blending makeup products. When you approach your unmade-up face, allow yourself time to explore, experiment, and play. The foundation you lay creates the support base for the rest of the makeup application. (When I say foundation I do not necessarily mean product.) You can disregard that fact and go straight to the eyeshadow or smear on some lip color and run out the door. But if there is something about your face you want to play with or give more study to, the basic structure of the face is the best place to start. Understanding its curves and planes will allow you to create better and more pleasing effects with all cosmetics in general, and in specific areas of the face.

Vanessa Williams

I have met many people over the years who are beautiful, yet their beauty was hard to see because they had no light coming from within. However, in Vanessa Williams's case her inner beauty shines through like a beacon. Talent, kindness, humor, and compassion are just some of her many fine traits. She is not only a cherished friend, but an unforgettable human being as well.

Vanessa is blessed with extraordinary good looks, and her face is a stellar example of amazing bone structure—most especially her splendid cheekbones. In these two portraits, I also use the presence and absence of full color to make another point. In both photos, the dark areas recede in shadow and the light areas come forward in highlight. These are most often, though not always, the areas I tend to darken and highlight with makeup to accentuate and define.

structure: skin

With skin as our basic "canvas," its condition and appearance are paramount in achieving your "cosmetic ambitions." Be it oily, dry or normal, there are more and more makeup products geared specifically to skin type. The key to a long-lasting look can be as simple as a dab of powder all the way to the use of concealer, foundation, and pressed powder combined. For instance, a simple trick is to dab a touch of loose powder on your eyelid prior to the application of powder eyeshadow. This allows for a smoother, more even application. Without that light layer, the natural oil of the eyelid "grabs" color and often results in a blotchy look. The same goes for powder blush. Unless your skin is not too dry and not too oily, powder blush applied directly to skin can appear spotty and uneven.

It goes without saying (as my dear friend dermatologist Pat Wexler will tell you) that there is no substitute for beautiful skin. If you're a teen reading this you might be rolling your eyes into the back of your head like a slot machine. As hormones rage, often your skin does as well. Today's over-the-counter skincare products are as good as (or better than) prescription skin care twenty years ago. In the case of acne, adult or teen, several combinations of therapy, not the least of which is accutane, can completely rectify the problem. For serious skin issues try to consult a dermatologist, as expert advice can often save you money. Having someone who knows what they are doing tell you the one or two products that will work for you sure beats the often very expensive trial-and-error method.

Many of the looks created in *Face Forward* use little or no foundation. I've found that covering skin imperfections with concealer using a small brush creates a flawless yet natural finish. That said, just as many looks were achieved using foundations in all forms (stick, liquid, powder, etc.) and in all colors. As always, the choice is yours.

Prepping the skin with moisturizer, astringent, or oil-absorbing gel can be key to minimizing fine lines and making your skin soft and pliable. It is often a matter of trial and error to find just the right combination of skincare product, base product, and/or powder. I've found over the years, the less you use the better. The reason behind this is during the day as you smile, talk, or frown (hopefully not), foundation tends to migrate into creases and lines. Powder tends to intensify this effect, though it is useful in areas prone to shine, such as the nostrils, bridge of the nose, chin, and forehead. This is not to say shiny skin should be matted down—it may be the look you are going for. It all depends on the look you prefer.

structure: teeth

In my last book, *Making Faces*, I had the opportunity to address two non-makeup areas that have a profound effect on the way a person looks: cosmetic surgery and skincare. However, I was remiss; there was a third area that has an equal impact: your smile. A great smile can do a lot more for you than a whole makeup kit full of expensive cosmetics. Even the most dour circumstances have been enlivened with a smile—whether it is someone else's or your own. In the same context as last time, which utilized professional advice (geniuses Dr. Daniel Baker for cosmetic surgery and Dr. Pat Wexler for skincare) instead of my own personal conjecture, I went to Dr. Gregg Lituchy for his expert opinions. The duo of Lowenberg & Lituchy have been doing smile "makeovers" for more than fifteen years and are often referred to as the "dentists to the fashion world," with a client list that

Frances Vega

It was at Julia Roberts's twenty-seventh birthday party that I met Frances Vega. I was drawn to her kindhearted eyes. What I didn't know was that they concealed a wicked sense of humor. In the middle of working on this book, I found out Frances was going through a very difficult divorce. Julia and I decided that she needed something to lift her spirits, and a day of beauty was ordered. We both suggested that Frances begin with a visit to world-renowned dermatologist Pat Wexler. (By the way, Frances was the only person in *Face Forward* whose makeup application actually began with a dermatological procedure. Though I highly recommend proper skin care, this is not meant to imply that everyone needs additional measures in order to look better, nor am I suggesting that Frances's was a drastic case.)

At her appointment, Pat used Botox to soften Frances's forehead lines and hylaform to fill in where needed. Frances emerged from Pat's office with a glow that she had not shown for quite some time. I don't think it was just the fact that she looked amazing that gave her renewed self-confidence. I believe it was because she was finally doing something just for herself. The day of the shoot, Julia went first in order to let her friend relax. Nevertheless, feeling confident with her new fresh face and beautifully highlighted hair (courtesy of Paige Wu at Louis Licari salon), Frances was quite happy and enthusiastic. I continued creating her sexier new look. We were both excited that makeup products worked differently on her—and with decidedly more pleasing results—after her skin treatments.

structure:teeth

includes Christy Turlington, Amber Valetta, Shalom Harlow, and countless others.

The smile is the focal point of the face, but its enhancement has been neglected in favor of more popularized, though highly effective, procedures. While a new nose and a clear complexion can improve your appearance, they may also call attention to an imperfect smile. If you are uncomfortable with your smile it affects the way you carry yourself and how you behave with others. Raising your hand to hide chipped or yellowed teeth can make you guarded and insecure. Your embarrassment can be read as uptight and unfriendly behavior. If that's not who you are, something can be done about it. There is one particular procedure, for which Dr. Lituchy is highly regarded, called a porcelain laminate veneer (which sounds much more complicated than it is), that can work a smile miracle. Working hand in hand with his technician, Jason Kim (an oral design ceramic technician—how's that for a lengthy title?), Gregg consults with the individual to select a proper "shade" of white porcelain (which can range from soft translucent white to full-on bright white). This selection process takes into consideration face shape, lip shape, skin tone, and even your own personality. (Believe me, if you weren't the outgoing type before, a dazzling new smile will make you the center of attention!) The veneer is then applied to your teeth, giving them strength and a naturally brilliant appearance. You come out looking and feeling like a totally new person. Again, I cannot overemphasize the importance of a great smile. It can light up your whole face and illuminate a room. It's like creating your own energy source—one that can *em*power you and affect all those around you.

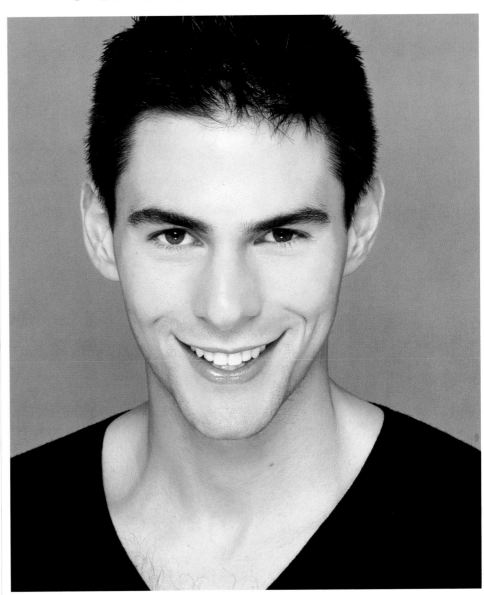

Jeremy Antunes

Above is a portrait of Jeremy Antunes, who had his smile reworked by Dr. Lituchy. Look for Jeremy twice more in the book and in different places in collages.

Kara Young

Working in this business you have many memorable days and some forgettable days. With Kara you laugh in the cab on the way to work, just anticipating her first hilarious remark. Needless to say, all my days spent with her leave fond memories. Kara and I met what seems like ages ago (it must be fifteen years now) and have worked together quite a bit over the years, including on a *Vogue* cover which was considered quite a milestone. (Since Kara is of a multiethnic background, for a major magazine to show her off that way was cause for an amazing amount of discussion and debate.)

The beautiful portrait of her on the left is technically an "after" shot. Kara underwent one of those porcelain veneer procedures I described, with Dr. Lituchy. With a smile that radiant I kept the balance of the makeup low-key. (Read more about balance in makeup on page 29.)

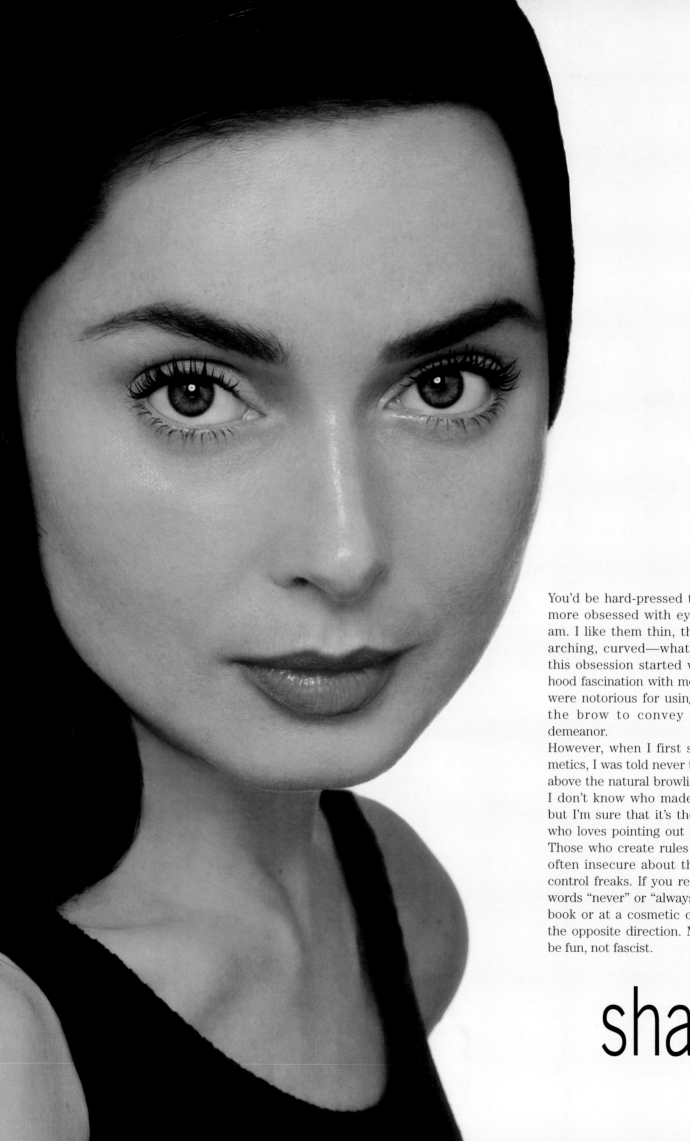

You'd be hard-pressed to find anyone more obsessed with eyebrows than I am. I like them thin, thick, groomed, arching, curved—whatever. I'm sure this obsession started with my childhood fascination with movie stars, who were notorious for using the shape of the brow to convey emotion and demeanor.

However, when I first started in cosmetics, I was told never to tweeze hairs above the natural browline, only below. I don't know who made up that rule, but I'm sure that it's the same person who loves pointing out your mistakes. Those who create rules for others are often insecure about themselves and control freaks. If you read or hear the words "never" or "always" in a makeup book or at a cosmetic counter, run in the opposite direction. Makeup should be fun, not fascist.

shape:

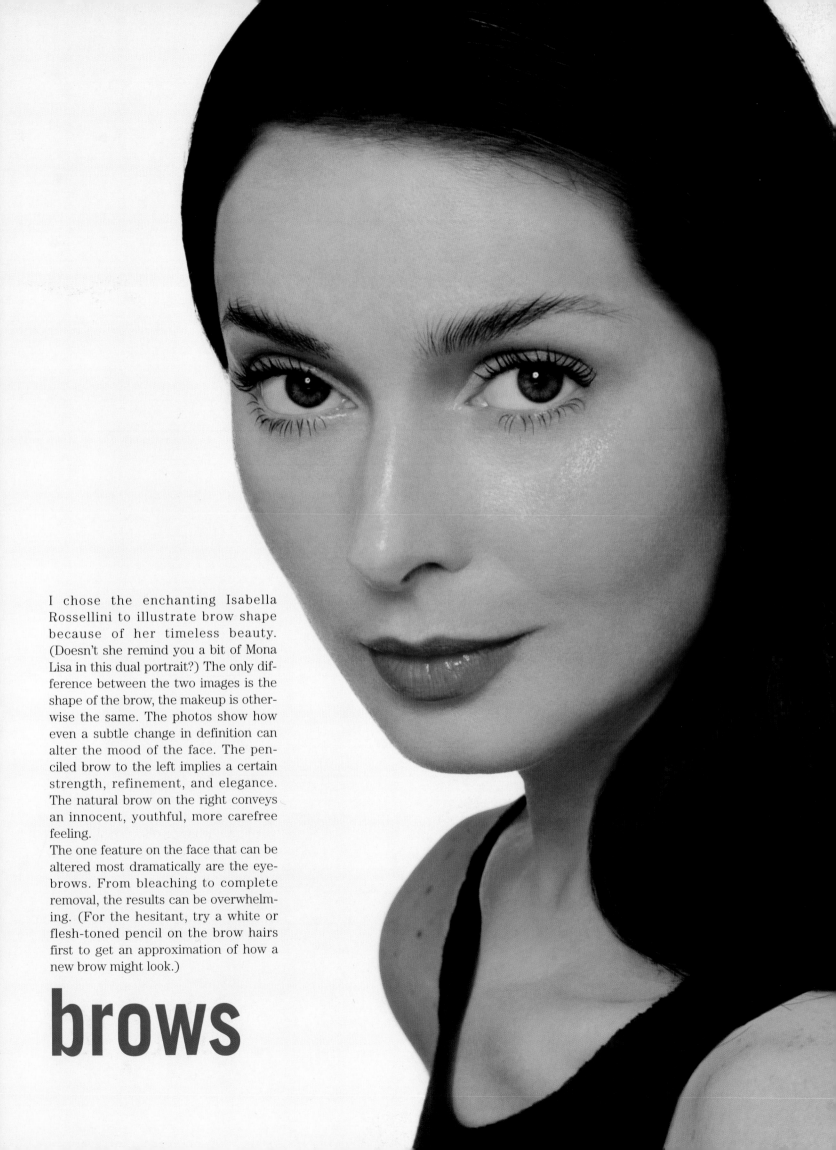

I chose the enchanting Isabella Rossellini to illustrate brow shape because of her timeless beauty. (Doesn't she remind you a bit of Mona Lisa in this dual portrait?) The only difference between the two images is the shape of the brow, the makeup is otherwise the same. The photos show how even a subtle change in definition can alter the mood of the face. The penciled brow to the left implies a certain strength, refinement, and elegance. The natural brow on the right conveys an innocent, youthful, more carefree feeling.

The one feature on the face that can be altered most dramatically are the eyebrows. From bleaching to complete removal, the results can be overwhelming. (For the hesitant, try a white or flesh-toned pencil on the brow hairs first to get an approximation of how a new brow might look.)

brows

shape:lips

Chandra North

When I first saw Chandra North, I was completely stunned. Her movie-star beauty momentarily concealed her down-to-earth, Southern warmth and charm. I told her that she reminded me of one of my favorite screen actresses, Linda Darnell, a 1940s film siren. (Coincidentally, they were both from Dallas, Texas.) Inspired by that brilliant yet largely forgotten legend, I set about creating two natural-looking, but quite different, lip shapes.

Here is how the makeup was done in both photos. (Note: It is the same make-up application, except for the lips.) **1** First the skin is prepped with **moisturizer**. **2** Then, using the fingertips or a small brush, **concealer** is dabbed on any red spots, blemishes, or discoloration, and blended well. (Note: a touch of concealer was used to bring forward the sides of the mouth.) **3** A touch of **dark foundation** (for contouring) is used to softly define the hollows of the cheekbones and sides of the nose, and blended well. **4** Using a *medium shadow brush*, a **light brown shimmer creme eyeshadow** is washed over the eyelid and browbone, and lightly under the outer two thirds of the eye. **5** The crease of the lids is defined using a *small shadow brush* and a **dark brown powder eyeshadow**. **6** One coat of **black mascara** is swept on the upper lashes, and one light coat of **brown mascara** swept on the lower lashes. (This dual coloration of mascara softens the look of the eye.) **7** Brows are defined using a **basic brown eyebrow pencil**. Both lip shapes are drawn and filled in using a **dark flesh lip pencil**. For the "full" lip to the left: the outer edges, both top and bottom, were slightly overdrawn to increase fullness. For the "cupid's bow" lip to the right: the peaks of the upper lip and the roundness of the lower lip were accentuated. Then both mouths are filled in, using a *lip brush*, with a **natural rose creme lip color**. **8** On both faces, the cheeks, chin, and temples are dusted with **soft pink powder blush** with a *large blush brush*.

Changing your lip shape with a lip brush and pencil can very subtly or dramatically alter the look of your lips and face. Following your natural lip shape is only one option.

In the 1930s, the "cupid's bow" mouth was *the* popular shape. This coquettish style, with its curvy bow drawn slightly on the inside of one's natural lip shape (seen above), created a very distinctive pursed look—as if one was about to be kissed. Amazing, isn't it, how one shape can imply both the duplicitous qualities of innocence and sensuality simultaneously? The large portrait on the left follows the evolution of nonbleed lip color. This development allowed the user the freedom to change the perimeters of the mouth. As time progressed, women felt freer to use lip color in a more provocative and ornate way, often by exaggerating the fullness of their lips. On Chandra, I enhanced the shape of her lips by lining them just on the outer edge of the natural lip line.

Remember, all of your facial features become malleable with makeup. However, it's up to you to decide when, where, how, and if you want to alter them.

shape:eyes

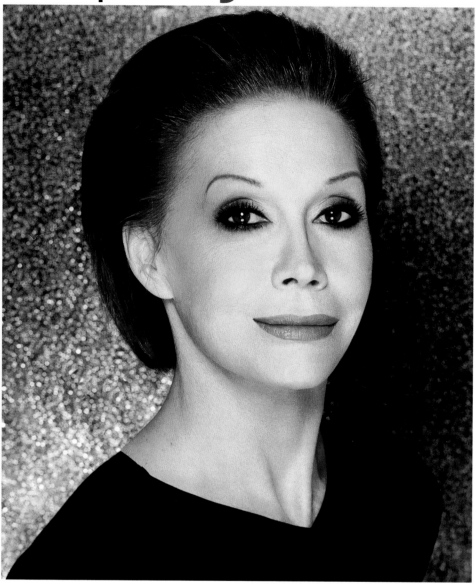

Mary Tyler Moore

If eyes are the windows to the soul, then is the mouth the garage door? Just wondering. Anyway, my friend Mary Tyler Moore will appreciate that comparison and probably have an even more interesting reply. For anyone who knows Mary's life story, admiration is much too weak a word to describe my feelings for her. Despite a daily battle with diabetes, Mary has maintained an optimistic approach to life, but as she has said, "I'm not a survivor, I'm a thriver." All you need to do is look into her soulful eyes to discover that truth. Her resilience and triumph in the face of seemingly insurmountable adversity makes her a hero to everyone who knows her, and I am at the top of the list of her admirers.

Throughout this book, eyes are made up over a hundred different ways. Try them all to find the ones you love (okay, maybe not all on the same day!). Remember, there's no magic to eye makeup, or makeup in general. But with perseverance, a commitment to fearlessness, and a sense of joy, you can create some very magical effects!

Speaking of magical effects, I chose an American icon, Mary Tyler Moore, to exemplify two different ways in which a basically similar use of eye makeup can change the shape *and* mood of one's face. Using a smoky eyeshadow only on the upper lid (right) created uplift to the eye and added warmth to the face—like an instant smile. Encircling the eyes with the same shadow (above) made the eyes look rounder and fuller—and added a touch more drama to the face. Either can be done to varying degrees, creating more or less intensity. Neither is more or less beautiful. It's up to each individual to decide how far to go. Take a tip from Mary, persevere with passion and never lose your ability to face life with a sense of humor and adventure.

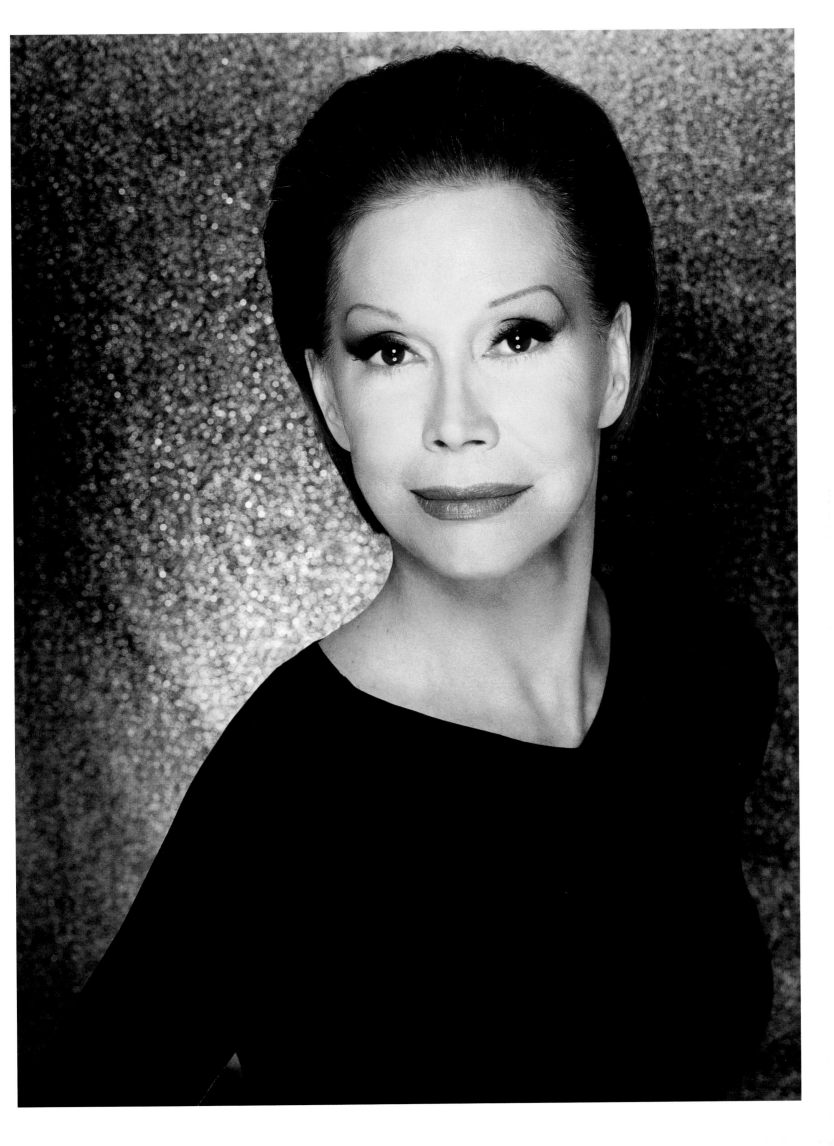

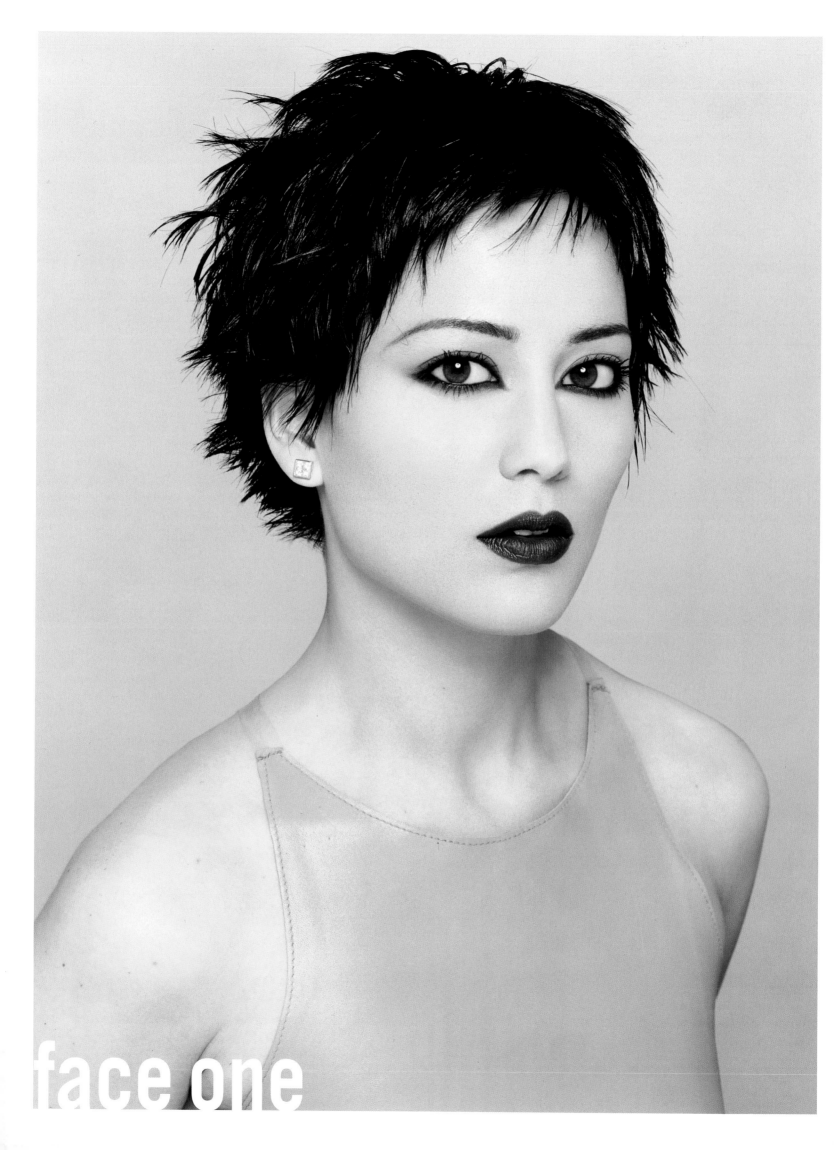

face one

in balance

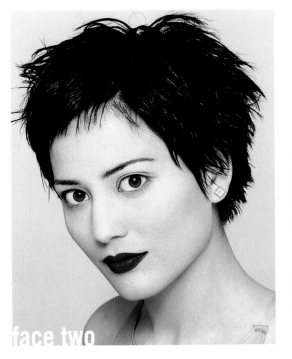

face two

Knowledge of basic face structure leads to an understanding of the concept of makeup *balance*. Though the variety of products we can use is infinite, the places to put them are not. We all begin with the same elements—two eyes, a nose, mouth, cheekbones, jaw, etc. Now work with me: Divide your face into two halves—a top and a bottom—then remember the importance of light and dark. We basically have four placement options to consider: a dark eye area balanced with a dark mouth; a light eye area balanced with a dark mouth; a dark eye area balanced with a light mouth; or a light eye area balanced with a light mouth. Keep in mind, the terms *light* and *dark* are relative—you can modify intensity and work somewhere in the middle. What these four fundamental balance combinations do is simply shift our attention up or down, or broaden it to take in the face as a whole. (Note: *halving* your face into right and left sides is a different type of balance, and usually requires simple things such as extending brow length or overdrawing one side of the mouth to match the other.)

face one

1 First **moisturizer**, then even out skin tone with a **light foundation**. **2** Dust the face with **loose translucent face powder**, with a touch more under the eyes to catch loose eyeshadow. **3** Using the natural arch as a guide, tweeze off stray brow hairs and brush the rest into place. **4** Then line the entire inner rim of each eye with a **basic black eye pencil** (with a softened tip) and use a *small shadow brush* to soften and blend the line into the lashes. **5** Using a *sponge-tip applicator*, encircle the eye in **matte black powder eyeshadow**, making sure to blend and soften the edges. (Note: the points were extended slightly at the inner and outer corners of the eye.) **6** Lashes are curled and topped off with a coat of **black mascara**. **7** The entire lip is lined and filled in with a **dark flesh lip pencil**, then, using a *lip brush*, covered with a **blood red liquid lip color**.

face two

All steps remain the same as in face one, but no shadow is used on the eyes, only curled lashes and mascara.

face three

All steps remain the same as in face one, except lips are lined with a **neutral flesh-tone lip pencil** and covered with a **pale flesh-tone creme lip color**.

face four

The same eye treatment as face two, with a return to the paler mouth in face three.

Louisa Lee

I had the great fortune to meet Ms. Louisa Lee while shopping for a Christmas present last year. I was struck first by her kind smile, next by her resemblance to Isabella Rossellini. Within five minutes, I found myself asking her if she would like to be in my new book. Of course, I always feel a bit awkward asking total strangers this question; it can be misconstrued as a pickup line. Yuck! So I find myself over-explaining the where, when, why, and how. Louisa was simply charming, and was genuinely surprised when I actually called to give her some dates.

Louisa had never modeled before and now she was being asked to work like a professional. Some would be intimidated or shy, but Louisa's spirit only flourished. At the end of the shoot, as with many of the people I have been fortunate to work with, she found herself in tears. Coming from a mixed-race background—half Mexican, half Chinese—Louisa grew up feeling like she never belonged to any one group. Now this uniqueness made her feel special. I believe it was the realization that she had allowed herself to believe fitting in was more important than celebrating her one-of-a-kind status that had her so emotional. They were tears of relief and self-acceptance.

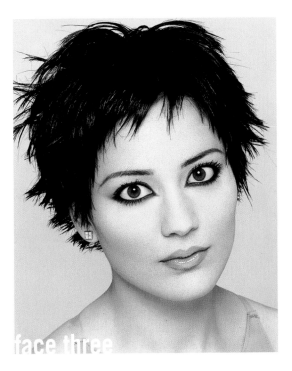

face three

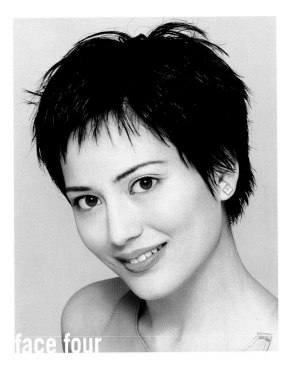

face four

color in makeup

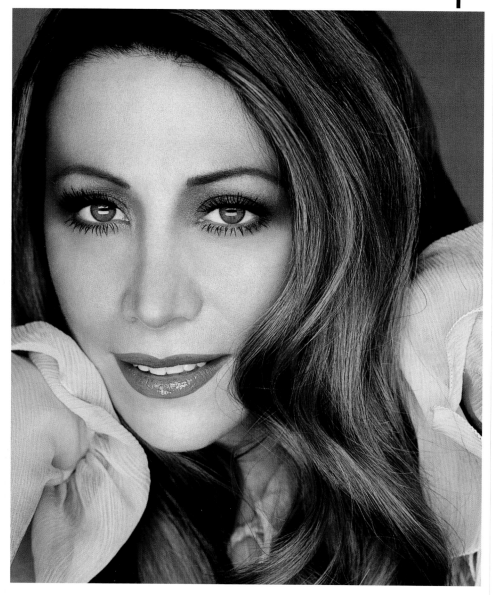

Cheri Oteri

The sidesplitting characters Cheri creates are often less than attractive, but always unique and uncannily believable. Coupled with her distinctive energy, they reveal a talent that is here to stay. I decided to take this comedic chameleon and show the beauty behind the funny face.

Using neutral and nougat, peach and plum, I found Cheri's classic facial features the perfect canvas for color comparison. So adept in the art of metamorphosis, she takes on a Jerry Hall circa 1978 look and exudes a deep sensuality that she is rarely allowed to exhibit onscreen.

As a makeup artist, I've had to teach myself the endless variations possible with color. I've also learned how differently color affects each face I approach. The more I learn about different skin tones, bone structures, and even personalities, the better my work becomes. Be more open-minded yourself when it comes to using color. Try making up a friend; you'll be surprised at how much you can learn about your own face by making up someone else's. Years ago, just for fun, I made up a friend using dark and extreme colors. We were having a good laugh, when I suddenly saw her face completely differently. The intense hues brought out not only her hair, skin, and eye coloring, but also her bone structure.

I've learned to be generous with color application on new faces; you can always wipe it off or tone down excess and learn something new in the process. It's hard to grow by playing it safe.

In the mid-eighties, I helped to create the first all neutral-colored makeup line, aptly named "The Nakeds." Its enormous success helped pave the way for many neutral-based cosmetic lines that followed. Thankfully, women of all colors are now able to choose among shades going all the way from invisible to eggplant. It is important that we see the shades of beauty not just in terms of white or black. The world is a very "colorful" place—to the inclusion of everyone.

On these two pages, Cheri Oteri shows two very wearable color palettes. Above, a neutral look; to the right, a colorful face of plums, burgundies, and pinks. For some reason, most people feel more comfortable wearing stronger colors at night and softer tones during the day. For those of you who feel trapped by this rule, use a lighter touch with colors deemed too extreme for daylight. When lightly applied, a deep berry lip color becomes a soft magenta; a bright pink biush used sparingly looks like a naturally flushed cheek; and a chocolate-brown eyeshadow fades gently into the crease of the eye, subtly enhancing the shape.

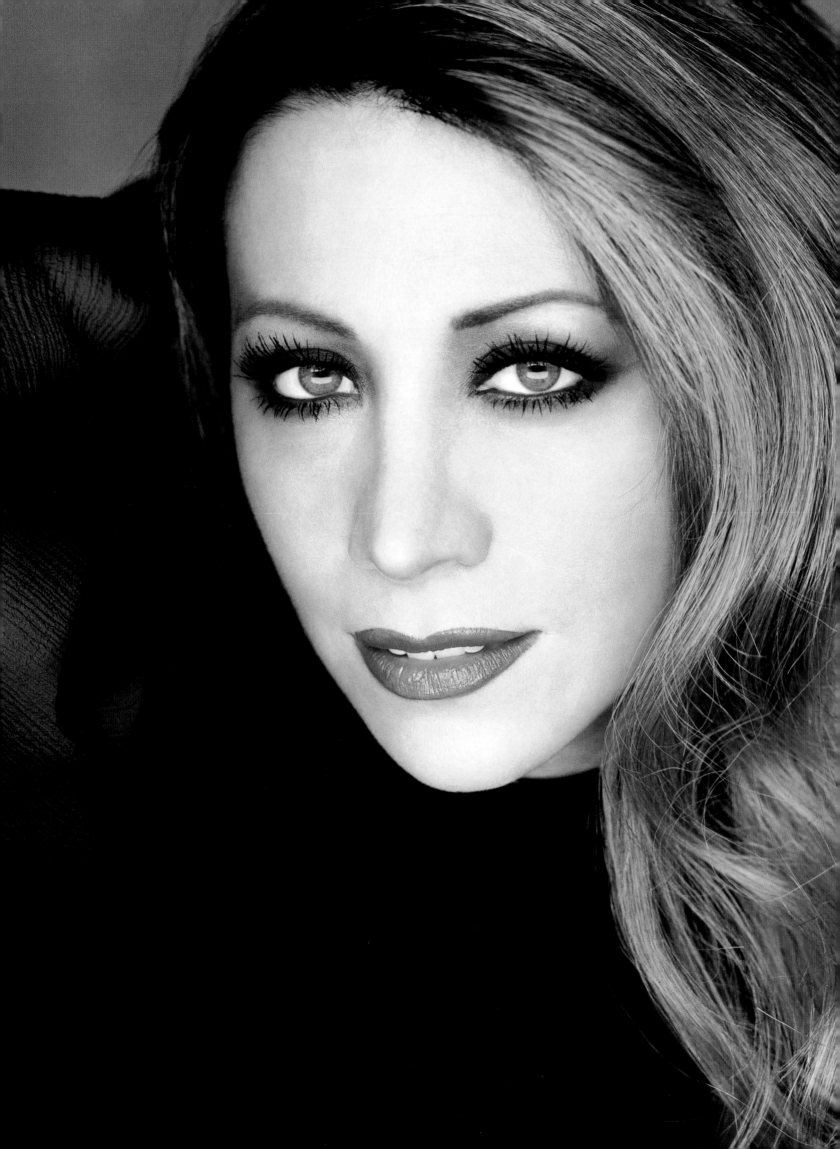

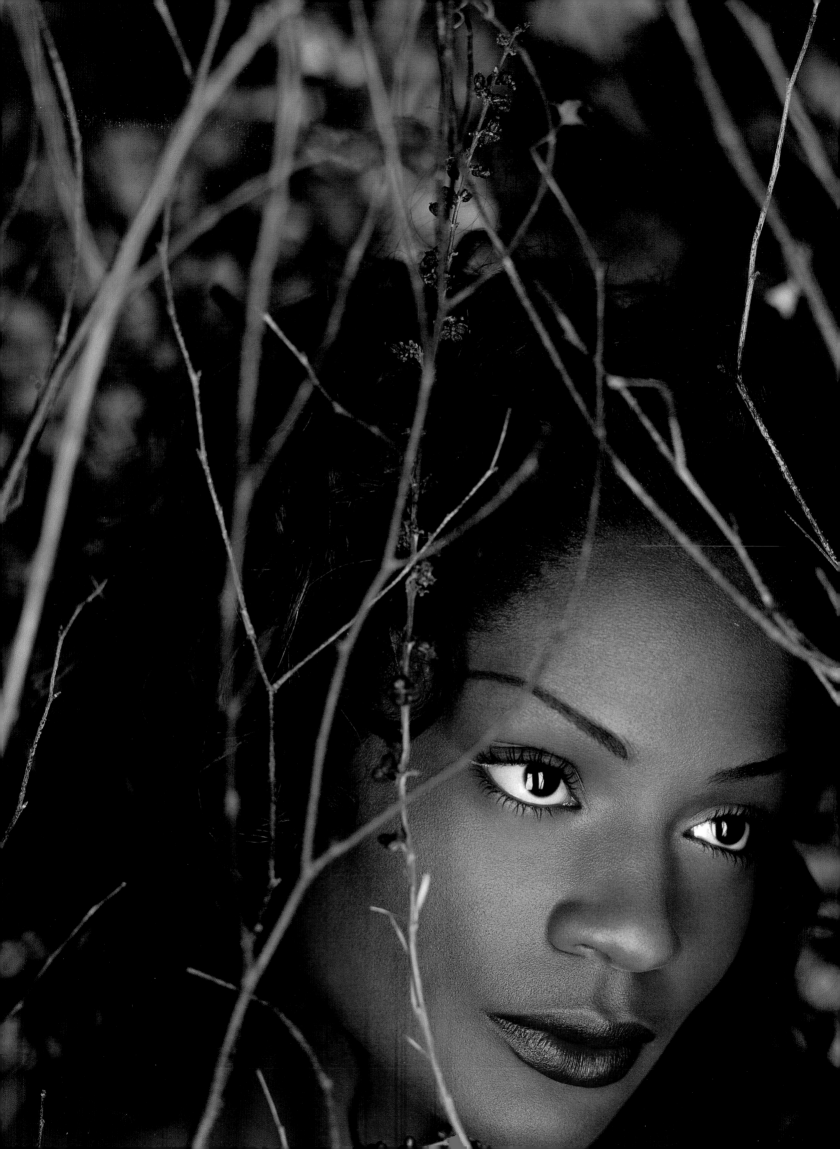

color in makeup

Victoire Charles

Victoire, along with my mother, Thelma Aucoin, became one of my main muses for this book. It helped that Victoire is an aspiring actress, because she was called upon to play a wide variety of roles. Fortunately, she also has an amazing amount of patience and generosity, which, believe me, were put to the test with this project. She serves as a great example of how one individual can embody many different makeup looks. Her incarnations reveal a complexity we all share, yet rarely take the opportunity to explore.

To get Victoire's beautiful "ripe fruit" colored face on the left: 1 Using the natural arch of the top of the brow as a guide, mark over bottom brow hairs with a **white eye pencil**, then tweeze. Afterward, clean the eye area with a mild **astringent**. 2 The face is then prepped with a light application of **moisturizer**. 3 Once dry, smooth on a light application of **foundation** (to match) with a *sponge*. Blend well. 4 The foundation is set using a *circular sponge* and **loose translucent face powder**. 5 Using a *medium shadow brush*, **basic brown powder eyeshadow** is swept into the crease of the eye and onto the eyelid. 6 Lashes are curled and lightly coated, top and bottom, with **black mascara**. 7 A **black brow pencil** defines the shape of the newly groomed brows. 8 The lips are lined and lightly filled in with a **dark flesh lip pencil**. 9 Using a *lip brush*, a **berry red creme lip color** finishes off the mouth. 10 Last, using a *large blush brush*, a **hot pink powder blush** is dusted high up on the apples of the cheeks.

Women with deeper skin tones often have problems finding foundations that match, but where other color products are concerned, you are only limited by your own imagination. Try burgundies, chartreuses, and turquoises on the eyes, lips, and cheeks.

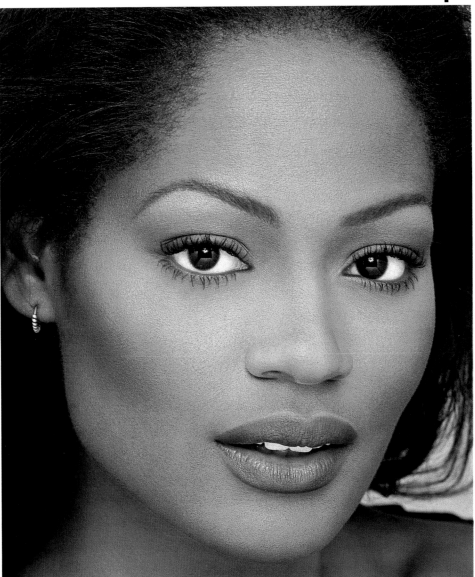

Over the years, working with such amazing (and legendary) talents as Jessye Norman, Tina Turner, Janet Jackson, Whitney Houston, Judith Jamison, Aretha Franklin, Halle Berry, TLC, Mary J. Blige, L'il Kim, Missy Elliot, Chaka Khan, Grace Jones, Naomi Campbell, Oprah Winfrey, and Diana Ross, I have learned a great deal and had a great time. It also helped me to realize that women with deeper skin tones have largely been ignored by cosmetic companies. (For the longest time, I was forced to go to theatrical supply houses to find makeup in shades that I would later mix together in order to achieve the colors I needed for work.) Finally, as corporations become aware of the immense buying power of these women (why is it always about money?), we are seeing an increase in overall product selection.

The biggest complaint among women with deeper skin tones is that it often ends up looking ashy. You know, that gray cast that comes from using a foundation that is often too pale or pink. I prefer foundations in warm golden tones, because they tend to "melt" seamlessly into the skin. By the way, if you ever have your makeup done in a cosmetics department or makeup store, take a mirror and go out into the daylight to see the truth. Often the lights in makeup boutiques are not neutral. Once you get home you may look completely different.

makeup:texture

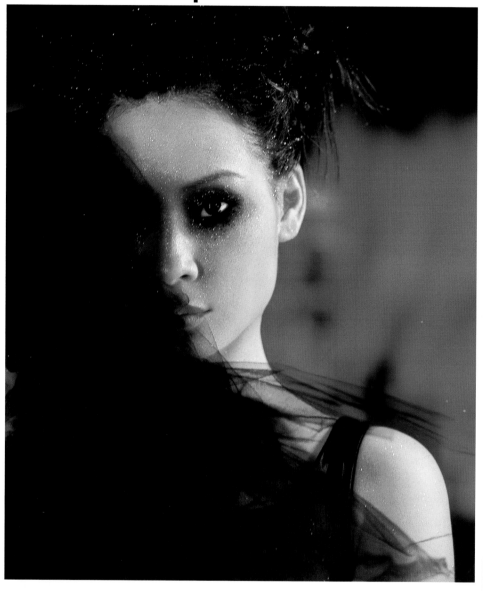

All the way from flat and matte to shimmer and glimmer, makeup texture plays a very important role in achieving a desired look. Texture, not unlike makeup hues, follows the principles of light and dark—light brings things forward, dark makes them recede. Therefore matte makeup—which absorbs light—makes skin texture and color recede. Shimmers, glosses, pearls, and other shiny cosmetics catch the light, bringing forward, emphasizing, and highlighting your skin's natural texture.

The concept of texture applies not only to the look, but to the feel of makeup too. Typically (though not always), matte makeup products contain little if no oil. So products of this type are well suited for those who tend toward oily skin. People with normal skin often favor water-based products with only a hint of added moisture. Those prone to excessive dryness lean toward oil-based cosmetics. But don't let the texture of your own skin keep you from experimenting with seemingly incompatible products. It may be a simple matter of placement. Use non-oily products in areas prone to shine and moisture-rich items in spots where the skin becomes dry, to give yourself the best overall results.

Lucy Liu

While I was surfing the tube one night, my eye caught a unique talent in the form of Lucy Liu. As Ling on the hit show *Ally McBeal*, Lucy conveys a distinct confidence and acerbic wit. Her caustic quips and devastating beauty immediately drew me in. She is also gifted with rare comedic timing—on and off screen.

Though we had never met, I was thrilled when Lucy agreed to indulge me by participating in this book. Between shooting a major motion picture and her obligation to her regular series, Lucy sacrificed what little personal time she had. Needless to say, she won my heart. With only three hours from start to finish we managed to get three great photographs (two of which are seen here; the third is on page 156). What a trouper!

To the left, Lucy is wearing liquid foundation that contains a touch of shimmer. I compounded the effect with a spray of glitter. The face on the right is lightly covered with a very sheer matte foundation. (For her third photo, the foundation is soft and dewy.)

The majority of the world's population of six billion people is nonwhite. Over a billion-and-a-quarter individuals are Chinese. Mandarin Chinese is the world's most-spoken language, and Buddhism one of the leading religions. I mention these statistics because the world's cultural demographics are different from what Western culture would have us believe; they are changing in this country as well. But no Asian model has graced the cover of a major American fashion or beauty magazine in the last decade. The excuse given is as obvious as it is insensitive. The widely held belief is, if you place any nonwhite person on the cover of one of these magazines, then that particular publication is perceived as being marketed to that specific race. Therefore, whites will not buy it. Admittedly, if you read the sales figures, this does happen—and that's a damn shame. But continually following that "rule" does not allow for the acceptance that comes from the greater visibility of all the races. I know this is business, but to continually suggest that America is blond, blue-eyed, and buxom is just not letting us see the whole picture.

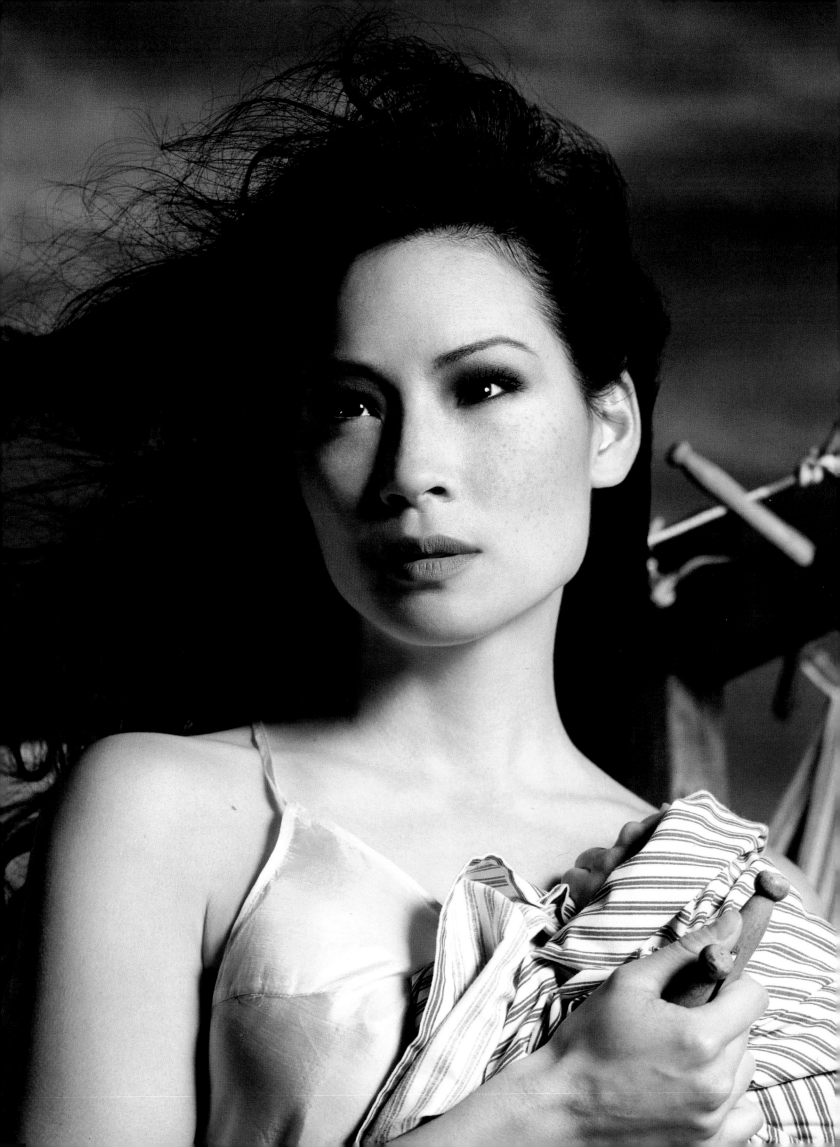

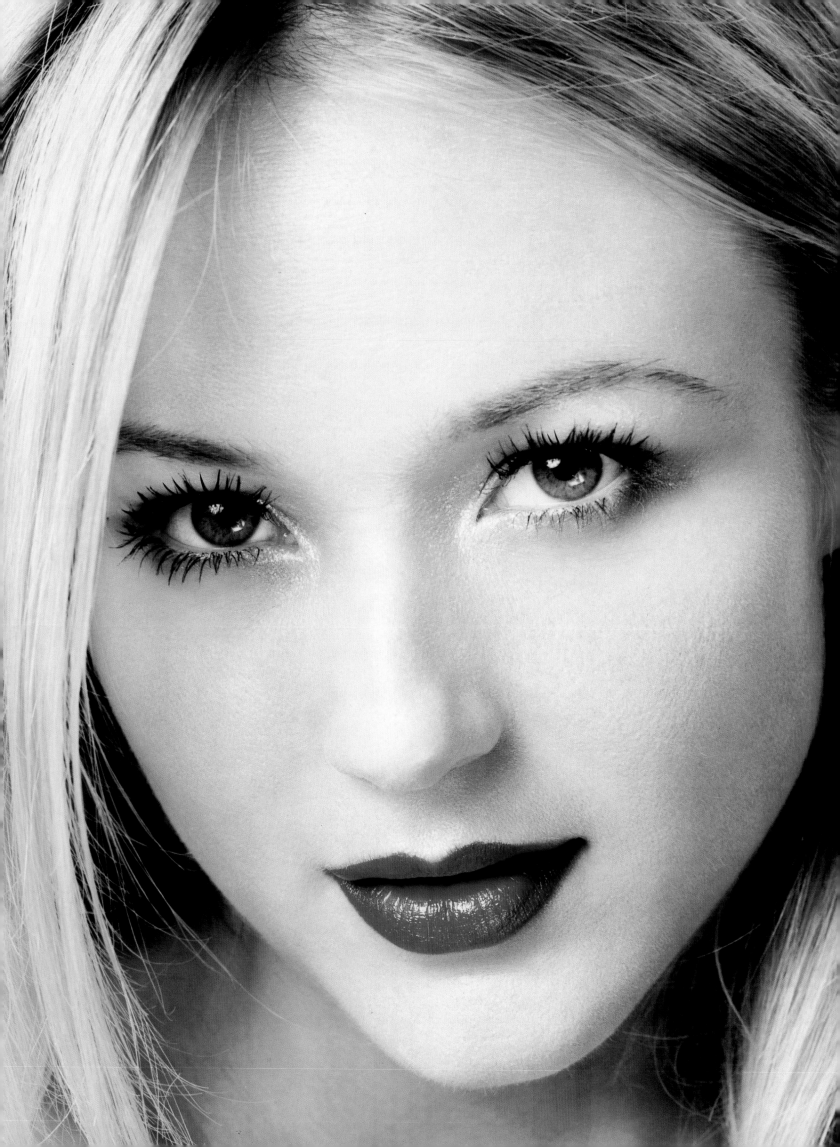

makeup:setting

Jewel

When I first listened to Jewel's *Pieces of You* CD, I called my friend Patti Conte at Atlantic Records to ask if she would introduce me to this wonderful new talent. Jewel's music and lyrics had a profound effect on me from the very start, and I wondered if there was anything I could do to get the word out about this prolific young folksinger. As a female- vocalist addict, I was worried that the music-buying public might ignore this extraordinarily gifted singer in favor of the bubble-gum pop of boy bands. Was I ever wrong. It seemed the door that was opened by songstress Tori Amos and her piano would be knocked off its hinges by this girl with a guitar. Fortunately, such phenomenal debut success did not spoil this gem. In the years since we met, not only has Jewel maintained the same level of integrity in her music that first drew me to her work, but our friendship has evolved and deepened as well. When no one else gets my twisted sense of humor, I can always count on her, and vice versa. We're often the only two people laughing in a room filled with puzzled expressions. It's nice to know I'm not alone in my insanity.

Makeup instructions for both of Jewel's faces: 1 First, skin is prepped with ***moisturizer***. 2 Then, using the fingertips or *small brush*, dab ***concealer*** on any red spots and blend well. (Note: light-colored concealer can also be used to highlight the browbone and eyelid.) 3 To the left, ***dark foundation*** is used to softly define the crease of the eyelid. To the right, ***basic brown powder eyeshadow*** is used to give dimension to the eye area. 4 Lashes are curled in both photos and swept with ***black mascara***, lighter on the lashes in the left photo, denser on the lashes to the right. 5 To the left, the lips are lined using a ***true red lip pencil*** and filled in; to the right, they are lined with a ***light flesh lip pencil***, also filled in. 6 Then to the left, ***basic red creme lip color*** is applied with a lip brush. To the right, ***caramel lip gloss*** is swept onto the mouth. 7 To finish, ***soft pink powder blush*** is dusted on the cheeks of both faces. (Photograph on left by Walter Chin. Video on right directed by Lawrence Caroll.)

In my line of work a makeup setting can take on many different locales, ranging from day to evening, indoor to outdoor—sometimes in one afternoon. After creating Jennifer Lopez's sophisticated signature look for her *On the 6* CD cover, I began to work on her videos. In one scene from the video "Waiting for Tonite" she is seen dancing with friends in a forest. Her makeup is soft and sexy. Suddenly, in the next scene, she isn't even human anymore. Jennifer has been transformed by lighting, editing, and makeup into a celestial being. It was necessary to darken her entire skin tone and hand apply hundreds of crystal rhinestones. This was not easy, but the overall effect was worth the effort. To convey different moods, sometimes the makeup drastically changes. Especially if the venue shifts from something ordinary to the extraordinary.

Lighting as well as camera angles are important considerations when conceptualizing the makeup. To the left is a close-up beauty portrait of Jewel. When the camera gets this close it is important that the skin be clean and clear, and that the placement of the makeup be precise and articulated. Above, in a video excerpt from "Down So Long," Jewel's mood is more thoughtful and the camera shows the actual setting. Though the light and camera depth are more forgiving, her makeup needed to appear moodier, which was accomplished with softer shadings and application.

makeup:setting

Robin Lituchy

After seeing pictures of Robin in her husband's office, I asked if he thought she'd like to be in my book. Gregg answered yes, but mentioned that his wife was very shy. Not surprisingly, when she arrived at the studio, she appeared very apprehensive. As I looked all around the set—with hairstylists, clothing and prop stylists, assistants, racks of clothes, bright lights, makeup tables, and equipment—I realized how intimidating this environment can appear. Yikes!

For many women, the thought of showing themselves anywhere without makeup is akin to being naked. Further, since Robin does not wear a lot of makeup in her everyday life she was also naturally reticent in the beginning about where this would be going. As we began the makeup, we discussed our ideas and desires. (A long time ago, photographer Steven Meisel taught me that respecting the feelings of your subject will have a positive effect on the end result.) Robin and I collaborated, and by the end of the shoot I showed her that with trust you can learn a lot about yourself. When she left, Robin was more self-assured, and her initial fear and trepidation went the way of her tweezed eyebrow hairs.

Robin's makeup in both portraits is quite simple. **1** They both start off with **moisturizer** to prep the skin, then a touch of **concealer** to any red spots, followed by light **foundation**. (Normally, for photographs, full foundation is preferred because the intense set lighting drains the skin of color. For everyday life, foundation is only necessary if you want or need to use it.) **2** To the right, the eyes are softly defined with a **basic brown powder shadow**, kept to the upper eye area; to the left, the application is intensified with a **dark brown powder shadow** encircling the eye. **3** Lashes are curled and coated in **black mascara** in both, but the application is greater on the left. **4** Further, on the left, the top lashline is enhanced with a line of **black liquid eyeliner**. **5** Cheeks are dusted with **powder blush**: right: soft pink, left: warm apricot. **6** Both sets of lips are lined with a **light flesh lip pencil**, but the **creme lip color** choice for each makes all the difference between the two.

I am frequently asked for my forecast for a new season's colors or what I think are the new looks for evening. Well, frankly, scarlet (and I do mean scarlet), I don't give a damn. If you really want my opinion, I don't care what kind or color makeup anyone wears—be it deep purple for spring or glittery silver for work—just as long as you feel good wearing it. Honestly, color predictions and hot makeup trends are just ways to get you to buy more product. But you knew that already, didn't you? Don't allow yourself to believe that a favorite shade of makeup is *in* or *out* just because some cosmetic "expert" told you so.

If there is any real justification for daytime makeup versus evening makeup, or fall colors versus spring colors, it is this: the lighting—natural or artificial—which changes how colors are perceived. During the day, natural sunlight and intense work light render colors more intensely—often to the point of glaring. However, at night, for obvious reasons, the same colors are more subdued. Therefore, we strengthen color and exaggerate shape in order for them to register. Sparkle and shimmer work the same: though the former may be too animated in the sun and more entrancing by candlelight, the latter is already a slight modification that can add subtle highlights in both daytime and an evening setting.

in perspective

Thelma Aucoin

This sixty-six-year-old beauty is my mother. You're going to be seeing a lot of her throughout this book. We had the best time creating her many incarnations. For a nonprofessional, she approached this project with great enthusiasm—and a desire to learn more about herself. I am often asked what my favorite look is for my mom. Honestly, I can say there is none. She's a sensation any way you look at it.

1 To the left: Begin by prepping the skin with a **light moisturizer**.

2 Then a **light creme foundation** (to match) is smoothed onto the face and blended outward with the fingers. (Note: any excess moisture or oil should be blotted using a tissue.)

3 A *sponge* is used to apply a **loose translucent face powder** to set the foundation.

4 Brows are lightly groomed and filled in by drawing short, feathery strokes with a **basic brown eyebrow pencil**, then brushed upward and into place.

5 With a *medium shadow brush*, **warm brown powder eyeshadow** is washed all over the entire eyelid, into the crease, and softly under the eye, then blended.

6 The browbone is softly highlighted, using the same *medium shadow brush*, with a **peach powder shadow**. Add a soft dot to the inside corner of each eye, too.

7 Lashes are curled, then swept with an ample coat of **black mascara**.

8 Using a *large blush brush*, **light pink powder blush** is dusted onto the apples of the cheeks, forehead, tip of the chin, and temples.

9 Finally, the lips are lined and filled in using a **light flesh lip pencil** and covered with a **cherry red creme lip color**. Use a *lip brush* for accuracy.

As a society, we find it easy to judge each other by how we look: she's too old for this, or she's too young for that; she wears too much makeup, or why doesn't she put on some lipstick? We've all done it, and I'm as guilty as everyone else. We allow ourselves to typecast people into roles, as a way of instantly editing information. Unfortunately, this process doesn't allow for much opportunity to see the diversity around us *and* within ourselves. You'd be amazed at the enjoyment you can experience with something new or what pleasurable time you can spend in the company of people you have allowed to be who they are, not what you want them to be.

The idea of wearing sexy and fun makeup is not the exclusive territory of the young, nor is wearing conservative *maquillage* something only the mature can appreciate. These two pictures of my mother, Thelma, show what I'm talking about. By allowing herself to be positively influenced by the world around her, she set out on a journey to explore life, in all its glory. (It didn't hurt that she had such a vocal son.) She never limits herself or her expectations, and I for one think she looks great doing it!

in perspective

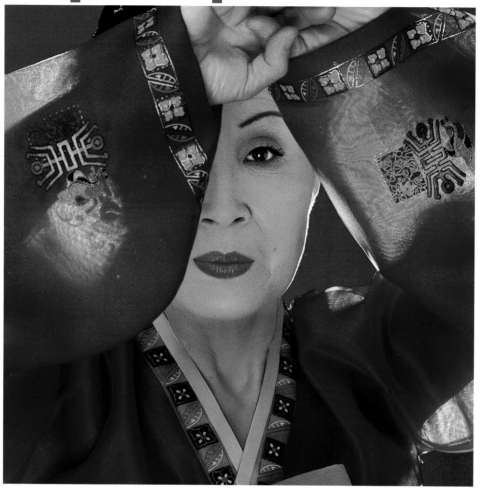

Don't kid yourself. In spite of what you may read about the "latest lip color" and "newest shade of eyeshadow," much of the beauty industry and the image makers are still stuck in the past. Time for a dose of reality. Women (and men) will wear what they like, when and where they want to. It is increasingly evident that the cultural demographics of our country (and the world) are changing, and people who represent different races, religions, sexes and sexualities, and ages are being seen and their presence is being felt.

To that end, I offer these two images of Bobbie Reuter, a woman who spent the first part of her life in Inchon, South Korea, and the second part, right smack-dab in the middle of America—Cincinnati, Ohio. In the photo above, Bobbie is wearing a spectacularly colored *chimachigura*, a traditional Korean gown. Nowadays, this garment is worn on only the most special of occasions. Of course, I considered this shoot as one of those occasions and took the opportunity to do a little beauty updating. Here, I complemented the vibrant hues of the silk fabric with a matching lip color, but set things off with a mix of light green and blue powder eyeshadows, which coordinated with the embroidered trim. This look was something Bobbie said she would not have thought to create on her own, but she admitted when we were done that she planned on copying it for her next evening out. In her second portrait, we went for full-tilt sexy, from the gentle swoop of her newly groomed brows to the matching sweep of her plunging neckline. Now tell me, does she look like your typical doting sixty-four-year-old Midwestern grandmother?

Learn to expect and try the unexpected—and not follow any rules put into place by others, unless you are sure they're right for you.

Bobbie Reuter

Bobbie was born in Korea over sixty-four years ago to a family of seven brothers and sisters. Early life was one of struggle and endurance, but her strength and courage rallied the entire family through two horrific wars. During the late fifties, Bobbie met an American serviceman, fell in love, and moved to the States. Today, she is the proud mother of three adult children, one of whom is my creative director (and very close friend), Donald, and a grandmother.

When Bobbie and I met more than eleven years ago, my Southern hugs and kisses were quite a shock to her; she was not used to anyone being so physical. However, over the years she came to expect my hugs whenever we met up after time apart. Slowly but surely, her initial rigidity changed to warm embraces and big smiles. Bobbie's tumultuous and trying youth had made her wary of strangers, and rightfully so. But it has been so wonderful to see her open up and let the beautiful light inside shine brightly outside.

to the right: 1 Bobbie's beautiful complexion needs only a touch of **concealer** and **foundation** (especially around the eyes to help hold shadow), which is set with **loose translucent face powder**.

2 Her brows are groomed and brushed into a soft arch and defined using a **basic brown eyebrow pencil**.

3 Using a *medium shadow brush*, **basic brown powder eyeshadow** is softly washed over the eyelid; **dark brown** is used to define the crease and outer corner of the eye; **light beige** is used to highlight the browbone.

4 **Black liquid eyeliner** lines the upper lashline—slightly thicker along the middle. Lashes are curled—especially important for women whose lashes grow straight out—and lightly swept with **black mascara**.

5 The lips are defined with a **light flesh lip pencil**, filled in, then covered with a **basic red creme lip color**, using a *lip brush*, blotted, and reapplied.

6 Finally, **soft pink powder blush** is dusted onto the apples of the cheeks, chin, and temples, using a *large blush brush*.

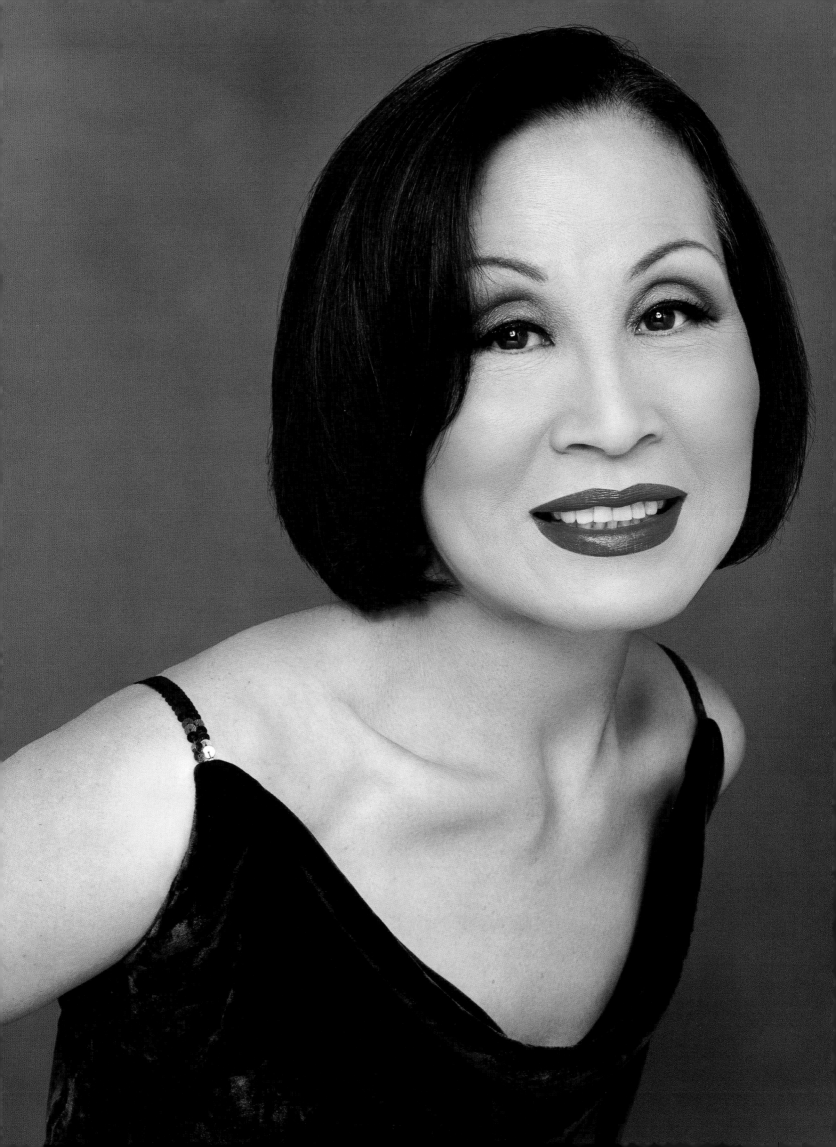

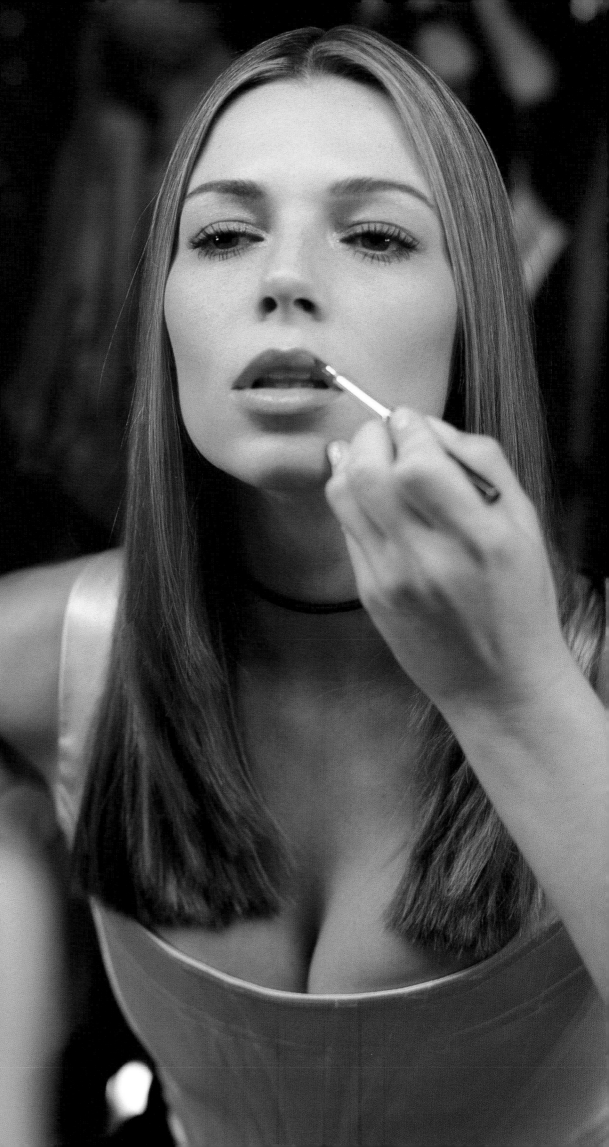

face to face

The next time you come "face to face" with yourself in the mirror, try to step back *mentally* and see the person, and her needs, reflected as a whole—not as separate parts. It helps to have an overall vision in order to decide where you're going with makeup application. If you concentrate too hard, or are consumed with microscopic details, instead of the essence of a look, you end up losing the big picture—you.

For the next thirty-two pages, I assembled a diverse group of people and collaborated with each on creating their look. As you will see, there is a broad representation not only of people, but of individualistic beauty. These people were selected solely for the sake of variety—and you may recognize a face or two—but no application was created specifically for any one type of person or need. If you can, while looking through this book, free your mind of thoughts that limit you. Regardless of who you are—race, age, size, or inclination—elements from any given look can be adapted and used on yourself. (Note: responding to requests regarding my last book, I chose to illustrate many of the step-by-step instructions in this section with actual photographs of the subjects. Showing how people look as makeup is applied allows for a clearer understanding of the process and how it affects each facial feature. In addition, the hair has been pulled back to show more of the face. This was done to help focus on the facial features.)

By the way, this is a light eyes and light mouth face, referring to the "in balance" text on page 29. From here on, notes like this are provided to help explain the finished portraits from both an aesthetic and a technical point of view.

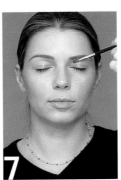
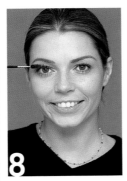
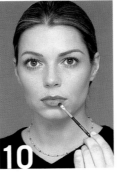

1 A light application of **moisturizer** is applied all over the face to soften the skin and allowed to dry. Blot excess with a *tissue*.

2 **Concealer** is used on red spots and blended well. Use a *small tip brush* to apply, but blend with your fingers or a *sponge*.

3 A very light application of **foundation** is used on the face and blended outward with the fingertips.

4 Using the fingertips, dot **bright red creme blush** onto the apples of the cheeks, temples, and tip of the chin and blend well. (Note: creme blush works best on non-oily skin types.)

5 Brows are groomed by lightly tweezing stray hairs. (Any long hairs can be clipped with a pair of brow *trimmers*.) Fill in spots with strokes of a **dark brown eyebrow pencil**. Brush hairs together, going upward and outward.

6 Using the fingertips, dab **shimmery white eyeshadow** to the inside corner of the eyes to highlight. (Use your fingertips only if you have short nails, otherwise use a *small shadow brush* or *sponge-tip applicator*.)

7 With a *medium shadow brush*, **basic brown powder eyeshadow** is applied to the outer corner of the eye, along the lashline, and into the crease. Blend and soften edges.

8 Lashes are curled and swept with **dark brown mascara** (Note: brown was used because Sibi is a blonde.)

9 The natural shape of the lips are defined and filled in using a **light flesh lip pencil**.

10 The lips are topped with a sweep of **sheer pearlescent lip gloss**.

sibi bale

Sibi has maintained an optimistic outlook on life despite her tumultuous childhood in Bosnia. But hers is really a Cinderella story. When Sibi moved to America, she quickly found a job as Winona Ryder's personal assistant. (Talk about good fortune!) In the fall of 1999, when Winona first introduced us,

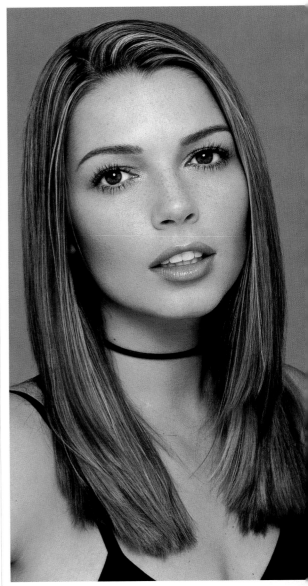

I noticed that Sibi had an incandescent natural beauty. But Sibi was unaware of her extraordinary good looks—part of what I think makes her so attractive. This also made her a perfect candidate for *Face Forward*. Recently, Sibi married actor Christian Bale (more good fortune!) and is taking time to explore her new life. I wish her even more good fortune.

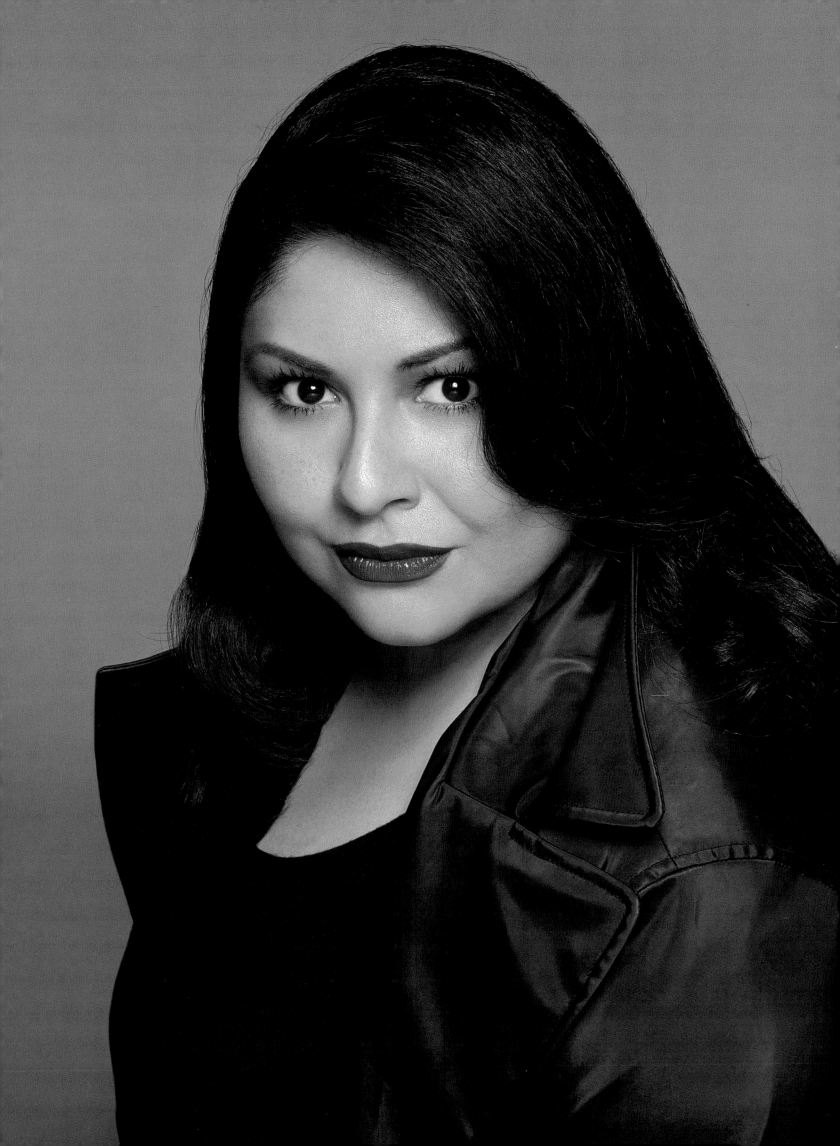

1 First, the skin is prepped with a light application of **moisturizer**.

2 Then, stray brow hairs are tweezed and the overall shape defined. Sparse areas of the brow are filled in using a **basic brown eyebrow pencil**. Brows are then brushed upward and into place (Note: to keep them there, lightly sweep with **clear mascara** or **brow gel**.)

maryliam crespi

As the Gal Friday to dermatological miracle worker Pat Wexler, I met "M" (as she likes to be called) on my first visit to the esteemed doctor's office. M immediately reminded me of my sister Kimberly. I don't know if it's just me, but when someone looks like someone I am close to I feel instantly comfortable with them. But it is M's uplifting and joyful personality that has been the basis for our ongoing friendship. Ever the professional, M manages to keep Pat's impossibly insane schedule on track. Amazingly, I have never seen M lose her temper or have an unkind word to say about anyone.

Besides her beautiful face and lustrous black hair, M exudes an unconscious sexiness that I feel I captured in her final portrait.

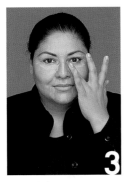

3 Using the fingertips, a light application of **foundation** (to match) is applied and blended well past the jawline. (Note: a few dots of lighter foundation were used as spot concealer.)

4 A **rose liquid blush** is used to give M's face a "come-from-within" glow. It is dotted on the apples of the cheeks, chin, and temples and blended well. (Note: liquid blush must be worked with quickly. If allowed to set too long in one place it can appear spotty.)

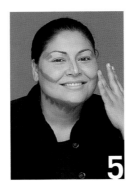

This is an "in balance" face consisting of dark eyes and a dark mouth. But remember what I said before about dark and light being relative terms? Even though this is a "dark and dark" look, the eyes are not deep and smoky, nor are the lips painted black. In addition, in relation to other elements of the face—including the hair style and color, and outfit—none of the individual parts overshadow any of the others.

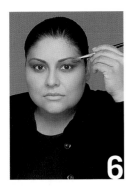

5 Strokes of **darker foundation** are used to contour the hollows of the cheeks, sides of the nose, and under the chin. Strokes of **lighter foundation** are used to highlight the cheekbones, under-eye area, browbone, and middle of the chin. In both instances, use a stick foundation and blend well.

6 A **dark-brown powder eyeshadow** is washed onto the entire lid and lightly under the eye, using a *medium shadow brush*. Blend well.

7 Curl lashes. Then apply **false lashes** to intensify the look of the eyes.

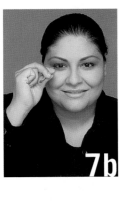

8 Starting at the base of the lashes and working outward, sweep a coat of **black mascara** to the top and bottom lashes (Note: shifting the mascara wand from side to side while moving forward deposits more mascara on the lashes.)

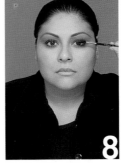

9 A **dark flesh lip pencil** is used to define and fill in the mouth.

10 The finishing touch is a **burgundy creme lip color** applied, for maximum control, with a *lip brush*. (Applying lip color directly from a tube does not allow for as much accuracy.)

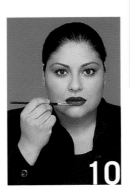

sharon stone

What do you get when you mix beauty and brains with strength and wit? The incredible Sharon Stone, of course. From her enigmatic screen presence to her extraordinary work with AmFar (The American Foundation for AIDS Research), Sharon has proven herself a complex yet compassionate and courageous human being. More than mere surface, the true essence of her beauty has been informed by her life's experiences. Imbued with a youthful spirit and sagelike wisdom, a conversation with Sharon has the amazing ability to transcend time and place—the world falls away, and you and she are all that exist.

Shown here with only a touch of lip stain, gloss, and mascara, Sharon's portrait is proof that one doesn't need artifice to be compelling.

This is Sharon's first of three portraits in *Face Forward*. Her unbridled enthusiasm to explore different parts of herself through the relatively simple process of makeup application owes a great deal to her being a gifted actress. Actresses in general understand that the ongoing process of embodying different roles broadens their knowledge of how people live, love, laugh, and cry. In the end, it makes them better actresses—and, consequently, better people. Isn't it interesting that the more you open yourself up to the world—and its people—the closer you get to being a better you?

This finished portrait refers back to two "behind beauty" topics. Can you guess what they are? The first is makeup texture, which in this case is obviously dewy. Second is balance: light eyes and light mouth. (Note: all the finished faces end up with a specific makeup texture and are often one of the four balance combinations. Therefore, I will only mention it if it was a prime objective with the makeup application.)

1 Prepare the skin with a light application of **moisturizer**. Blot excess with a *tissue*.

2 Lightly apply **concealer** if, and where, needed.

3 With your fingertips dab a touch of **rosy-pink creme blush** (or **rose liquid blush**) on the apples of the cheekbones, chin, temples, and forehead—anywhere you want the skin to have that "rosy" glow. (Note: because the finished look of the face is dewy and moist, the blush goes on first, underneath the foundation. If done the other way, the blush would just slide around on the surface of the skin.)

4 On cheeks, forehead, bridge of the nose, chin, and neck, use a **sheer iridescent sparkle liquid foundation** to give the skin a gleam. Smooth on with your fingers.

5 Groom brows, tweezing if necessary. Fill in sparse spots with strokes of a **basic brown eyebrow pencil**.

6 Curl lashes before lightly applying **black mascara**. (Waterproof mascara is preferable with this dewy look.)

7 Enhance and softly define the lips with **liquid blush,** or apply **blood red liquid lip color**, then blot until all that is left is a stain of color.

8 Finish lips with a sweep of **clear (or pink) lip gloss**.

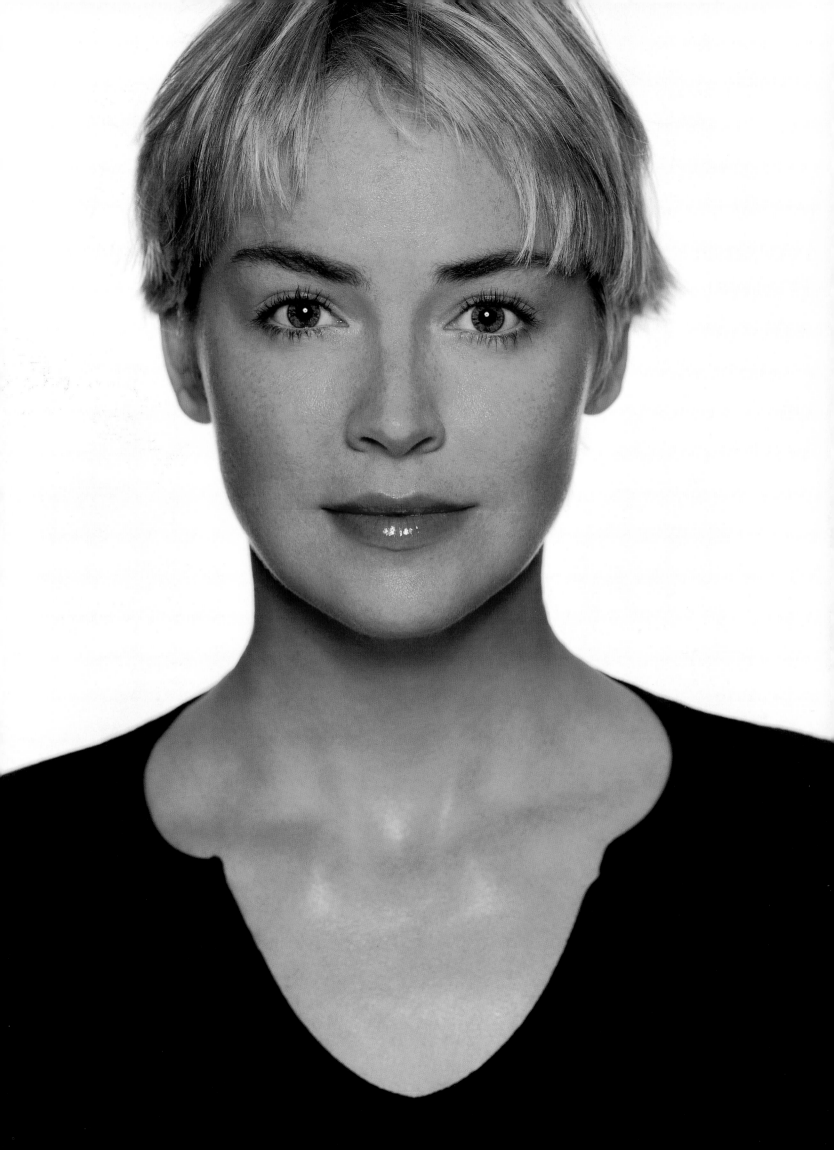

The contoured shape of the eye, which draws you into her hypnotic gaze, is what stands out in Sylvia's finished portrait.

1 Use **moisturizer** to prep the skin.

2 The brows are groomed with a light tweezing of stray hairs. Sparse areas are filled in using a **basic brown eyebrow pencil** and the shape defined, ending in a tapered point.

3 **Concealer** is used in spots around the face and blended well.

4 **Foundation** (to match) is smoothed all over the face, blending outward from the center. A touch of lighter foundation was smoothed under the eyes to bring that area forward.

5 The face was set with a dusting of **loose translucent face powder** using a *circular sponge*.

6 Using a *medium shadow brush*, a **basic brown powder eyeshadow** is used to softly define the eyelid into the crease, and lightly under.

7 Then, using the same shadow brush, **charcoal gray powder eyeshadow** is used to contour the eye—by sweeping an arc into the crease (just past halfway), along the top lashline, and very lightly under the eye. Blend well to soften edges.

8 Using a **black eye pencil**, line the top and bottom lashline. Emphasize the top lashline with a thicker line, especially as you work your way to the outer corner of the eye. Smudge into lashes with your fingers or a *sponge-tip applicator*.

9 Curl top lashes to form a base and apply **false lashes**. (Note: false lashes stay in place better when you run a line of extra *adhesive* along the strip. When you do this, let the extra adhesive set for a moment to get tacky, then apply. Start from the outside corner of the eye first, then work your way in along the lashline.)

10 When lashes are dry, curl again and sweep with a coat of **black mascara**, top and bottom.

11 Lips are lined using a **dark flesh lip pencil** and filled in. Then, using a *lip brush*, lips are covered with a **natural rose creme lip color**. Blot, and reapply.

12 With a *large blush brush*, dust **soft pink powder blush** onto the apples of the cheeks, temples, and chin.

sylvia browne

With her frequent television appearances and her bestselling books on New Age spirituality, Sylvia Browne has helped countless people. I love her so much because our views on existence, religion, and the afterlife match so well, or maybe it is her no-nonsense, practical, and humorous approach to life. Whatever it is, she has me hooked. What you see first when Sylvia walks into a room are her warm, luminous eyes. You cannot escape her gaze.

Shortly after meeting, Sylvia and I sat down to talk and she gave me some chilling insights about my life. She told me, "This is your last time here on earth, you came back as a teacher. Your mission is to teach about beauty of the soul." As she spoke, a sense of calm and security came over me. I asked if she would mind speaking with my mom and dad for a minute on the phone. As soon as my mother answered the phone, Sylvia told her to have the femoral arteries in her legs checked out because she felt there was some blockage there. A week later, my mom went to see her doctor for a stress test. He said she was in perfect health and her legs were fine. Not satisfied with the results, I pushed Mom to schedule another test as soon as possible. Less than two months later, a second test was administered. Still the doctor insisted all was well. My mom demanded a sonogram. Two days later, they confirmed 100 percent blockage in both legs. The lesson here is: trust your intuition, and always get a second opinion! Thank you, Sylvia, for saving my mom's life.

Here, I wanted to bring out Sylvia's innate sexy side, à la Italian star Gina Lollobrigida. Initially, I hadn't had Lollobrigida in mind for an inspiration, but once Sylvia put on the brunet wig, the sauce really got hot. That's part of the fun of makeup—taking things as they come and not forcing them into any one direction. Makeup can lead you down a road to new and exciting places. Just ask Sylvia, a person who can take you on a journey without even leaving the room.

julia roberts

With the face of an angel, the strength of a prizefighter, and the heart of a child, Julia never ceases to amaze and surprise me. During a particularly difficult time in my life, Julia dropped everything to spend an entire evening listening, encouraging, and coaching me through my ordeal. Her generosity of spirit is rare and her resilience is inspiring—from sixteen-hour-long press junkets to endless photo shoots, she maintains a sense of humor throughout. For this photo, we decided to pull back her trademark brunet mane and expose her delicate bone structure, which looks as if it were made out of porcelain. She is also blessed with skin so perfect that I rarely, if ever, use foundation. I used none here. (I know, sickening, isn't it?) This is a great example of a sensual look where you can see the skin, but the eyes and lips are still pronounced and striking. With the use of creme eyeshadow, blush, and a touch of concealer, anyone can create this dewy, touchable face—though I must admit, most of Julia's glow comes from within.

While Julia is a one-in-a-million beauty, she is also the type of woman whose looks feel accessible to the public. Nor does she have a standoffish personality. She is what millions of women want to look like *and* be like. This makeup look—as well as all those in this section—reflects that. Beauty 101 is unadulterated and simple— allowing for the essence of the person to shine through, while still enhancing the features.

An important aspect to this finished face is that it is balanced, with light eyes and a light mouth. Again, the term *light* is relative. Some may see this as a dark-and-dark balanced face. However, the makeup colors chosen actually just enhance, not contrast with, Julia's natural skin and lip coloring.

1 Prep skin with **moisturizer**, making sure to blot any excess with a *tissue*.

2 If necessary, tweeze and groom the brows. Fill in and define brow with a **basic brown eyebrow pencil** and brush upward with a *spooly brush*.

3 Using a **burgundy brown powder eyeshadow** and *small shadow brush*, wash the eyelid—into the crease—softly under the eye, and all along the lashline. Blend well, but keep the application concentrated and light.

4 Over the top of the eyeshadow, with a *medium shadow brush*, wash **white shimmer powder eyeshadow** and blend well. This gives the eye a dewy look. Also be sure to add a dab and blend a touch to the inside corner of the eyes.

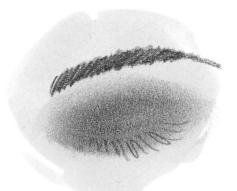

5 Curl the lashes and apply a generous coat of **black (or dark brown) mascara**.

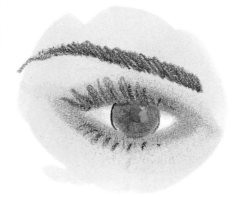

6 With the fingers, dab a touch of **soft pink creme blush** onto the cheeks, chin, temples, and forehead, and blend very well.

7 Line the lips with a **light flesh lip pencil** and fill in.

8 Cover pencil with a coat of **sheer red lip gloss**.

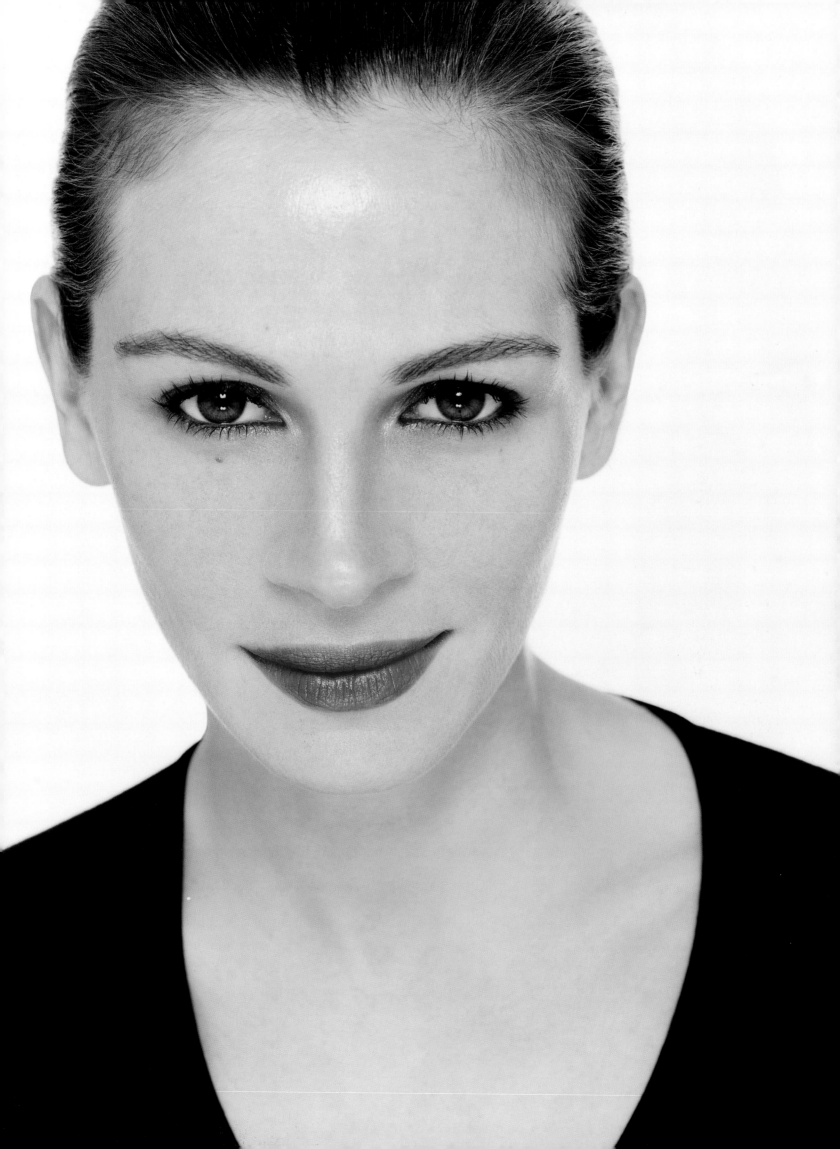

1 Prep skin with **moisturizer** and blot any excess with a *tissue*.

2 Shape brows with *tweezers*. If you haven't tweezed in a while, use *waxing strips* to remove larger areas of hair more quickly. (Note: strips usually come in small rectangular pieces. You may want to trim the edge into a soft curve. Also, be sure to pull off in the opposite direction in which the hairs grow.) Brush brows upward and into place. Fill in any obvious sparse spots with a **dark brown eyebrow pencil** and define the natural arch.

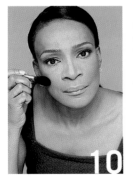

3 With the fingers, apply **liquid foundation** (to match) to even out skin tone. Blend outward with fingers or a *sponge*.

4 With a *circular sponge*, dust **loose translucent face powder** to set foundation. Add extra to the under-eye area, bridge and sides of the nose, and around the side of the mouth to softly highlight.

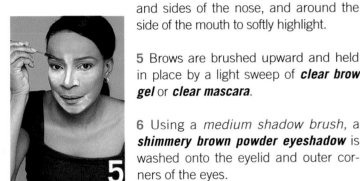

5 Brows are brushed upward and held in place by a light sweep of **clear brow gel** or **clear mascara**.

6 Using a *medium shadow brush*, a **shimmery brown powder eyeshadow** is washed onto the eyelid and outer corners of the eyes.

7 Then a **golden-honey powder eyeshadow** was stroked onto the browbone to highlight with a *medium shadow brush*. Blend well.

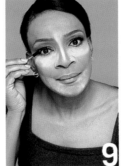

8 The brow shape was softened with a sweep of **medium-brown powder eyeshadow**.

9 Curl lashes and apply two coats of **black mascara**.

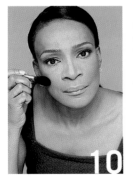

10 With a *medium blush brush*, dust **soft pink powder blush** onto the cheeks, then a touch of **hot pink powder blush** over the top, for a three-dimensional effect. (Note: because of the vivid colors of the blush, this is definitely a "color" face.)

11 Line the lips with a **dark berry lip pencil** and fill in. Cover with a **blood red liquid lip color**, using a *lip brush*. Blot and reapply.

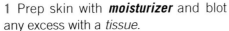
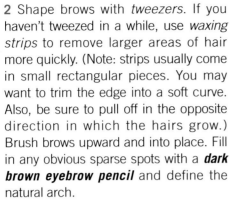
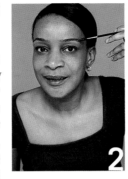
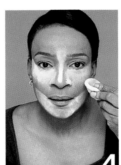

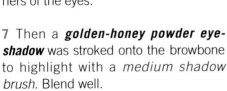
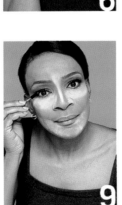
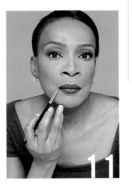

verna eggleston

The Hetrick-Martin Institute in New York City is one of the only places in the entire country dedicated to the care and welfare of gay, lesbian, and transgender youth. At the Institute since its inception, Verna has become the surrogate parent for thousands of children as young as thirteen, who were disowned simply for revealing their sexual identity. It is beyond my comprehension that anyone could toss a child out onto the street just for being honest about who they are. Fortunately, this is where Verna comes in. She is the rescuer of many who would have ended up becoming prostitutes, drug addicts, or, worse, suicide statistics.

While doing the makeup, Verna had a revelation: sitting in a robe with her hair pulled back, she was admiring her newly tweezed eyebrows. Suddenly, tears began to stream down her face, which she quickly covered with her hands. Worried that I had shaped her brows in a way that she disliked, I gently asked what was wrong. It was several minutes before she could say, "It's just that I've been trying to help these kids see the value and beauty they possess inside. They've been robbed of the ability to see how wonderful, important, and loved they are. I realize now that it's been years since I've seen that woman in the mirror. I've been so busy helping others that I've completely neglected myself."

As a makeup artist, I found this to be one of the most rewarding experiences I've ever had, and it was the reason I began doing makeup in the first place—to help others see their own beauty, inside and out. Some may say makeup is just a facade; cosmetics affect only the surface. For some that may be true, but I feel that any road that leads you to a better understanding of yourself is worth taking. For Verna, it wasn't her lip color or hairstyle that had her so emotional, it was rediscovering the forgotten butterfly buried deep inside, waiting so long for the chance to reemerge.

martha stewart

The sight of Martha Stewart walking into the photo studio with a birthday cake for *me* is something I will never forget. I mean, how could I? This was *the* Martha Stewart—the woman who has taught millions about proper party planning, the right decorations and decor, and glorious, mouth-watering cooking. Besides, with a schedule to rival that of world leaders, it was amazing that she even remembered it was my birthday. Within minutes of arriving, after taking the time to introduce herself to everyone, she had us all eating out of the palm of her hand (my cake, no doubt!). Martha's directness (a quality I live for) and her boundless humor energized the entire studio. I couldn't wait to get started.

As with all successful women, Martha has had to deal with a lot of unfair and often cruel criticism. My experience with her revealed a powerful, witty, and fair-minded human being. I realized that day, Martha's success did not only come from her own immense talent— she became a self-made billionairess because as a teacher and philanthropist she has given a sense of pride and accomplishment to other people's lives. Put another way, Martha does something relatively simple, yet it happens so rarely: she makes one feel appreciated and understood.

This is a light-eyes-and-light-mouth face, mainly because it uses a neutral-based color palette to softly enhance the features.

1 Prep skin with **_moisturizer_**, blotting any excess with a *tissue*.

2 Apply **_concealer_** in spots anywhere it is needed. Blend well with a *sponge*.

3 If you like, use a light application of **_foundation_** (to match) to even out the skin tone. Be sure to lightly dust with **_loose translucent face powder_** to set the foundation.

4 Groom the brows with a light tweezing. Fill in any sparse spots with a **_blond eyebrow pencil_** by drawing in short, sharp strokes to simulate real hairs.

5 With a *medium shadow brush*, lightly wash a **_basic brown powder eyeshadow_** along the lid and crease of the eye. Blend well.

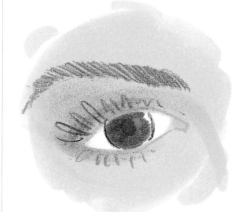

6 Curl lashes and apply a light coat of **_black mascara_** to top lashes and very softly on bottom lashes.

7 With the fingertips, dot **_soft pink creme blush_** on the cheeks and blend well. Smooth what little is left on your fingers onto the tip of the chin.

8 Line the lips with a **_light flesh lip pencil_** and fill in. With a *lip brush*, cover with a **_natural rose creme lip color_**, blot, and reapply.

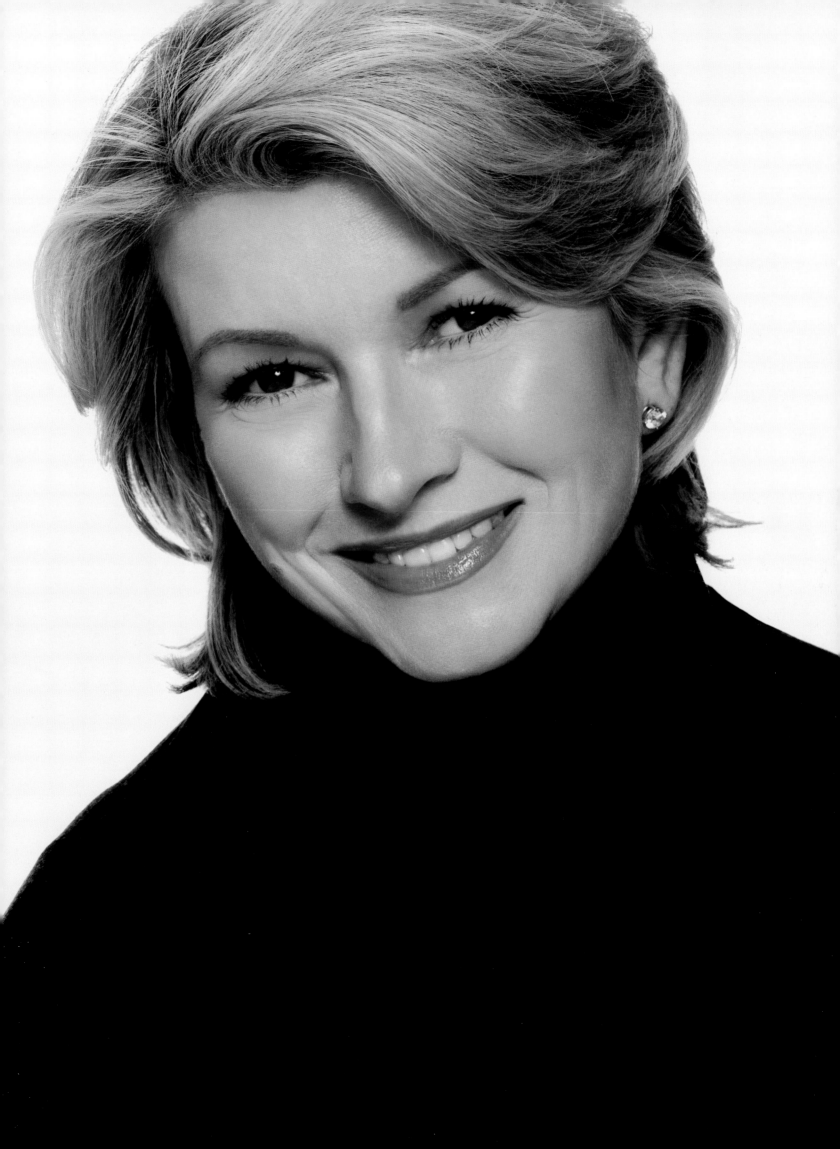

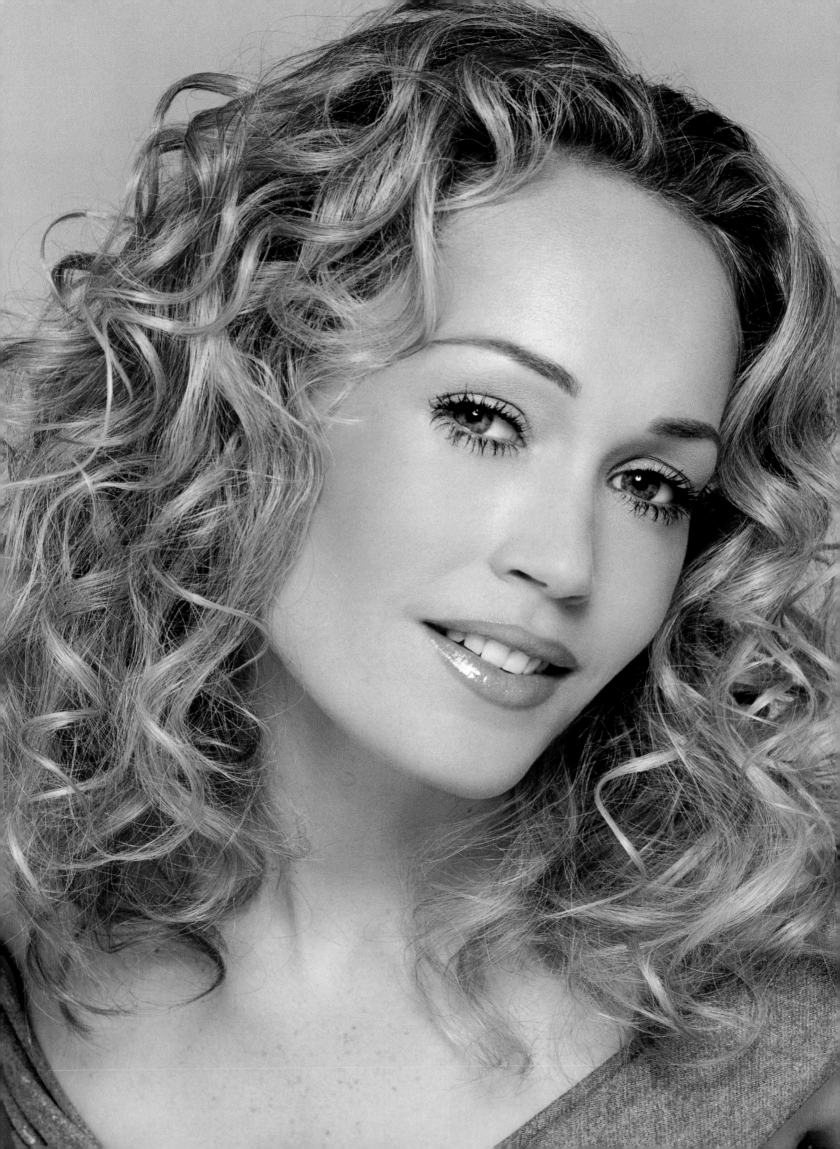

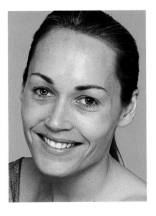

1 Prep skin with a light application of **moisturizer**. After smoothing into the face, allow to set for a moment to properly dry. Blot any remaining moisture with a *tissue*, which may interfere with the rest of the makeup application.

2 Tweeze and groom brows. Use a **basic brown eyebrow pencil** to fill in sparse areas. Create a shape with the pencil that follows and defines the natural arch of the brow.

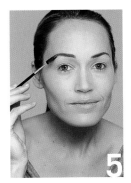

3 Use **foundation** (to match) and/or **concealer** where needed to even out skin tone, and blend well with fingertips or *sponge*.

4 Apply a light dusting of **loose translucent face powder** to set the foundation using a *circular sponge*.

5 Brush brows into place and keep them there using a light sweep of **clear mascara** or **clear brow gel**.

6 Dust **hot pink powder blush** onto the cheekbones with a *large blush brush*.

7 Curl lashes to create a base and apply a full set of **false lashes**. When dry, curl real and false together.

8 Lightly apply a **lime-green powder eyeshadow** to the eyelid and lightly under using a *medium shadow brush*. Smudge and blend outward and upward, past the crease. (Note: the secret to using vivid colors is to start out with a small amount, then blend and soften. Check the overall effect first before adding more product, which may quickly become too intense.)

9 Apply two coats of **black mascara** to top and bottom lashes. Keep an *eyelash comb* handy to comb out any mascara clumps. (Note: mascara clumps, which are created by partially dried product, can be avoided by regularly cleaning off the mascara wand with a tissue.)

10 Line the lips with a **light flesh lip pencil** and fill in. Then over that, apply **baby-pink creme lip color** with a **lip brush**, and a lick of **clear lip gloss**.

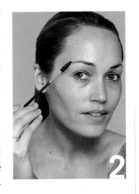

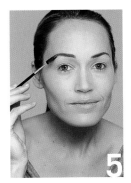

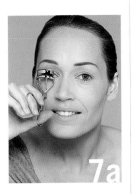

mary wigmore

Mary met her lifelong best friend at the tender age of three. Since then, their mutual love and support of each other is one of the major positive forces in our mutual friend Gwyneth Paltrow's life. Gwyneth introduced me to Mary several years ago. At the time, Mary had casually pulled her hair back and was sporting sweatpants and a T-shirt. Still, her beauty was so awe inspiring I was literally dumbstruck. Blessed with obvious good looks, Mary also possessed the same wit and charm that first drew me to Gwyneth. I vowed at that moment to put Mary in my next book.

During the day of the shoot, Mary had to run out for an acting audition with her head wrapped in a scarf and her hair still in pin curls. When she raced back to the studio after her tryout, looking like an out-of-breath Julie Christie (circa 1974), I inquired as to the nature of her character. Hoping that she was auditioning for the part of some glamour girl, Mary revealed that she was up for a rather Plain Jane role on a television drama. Unflustered, Mary patiently sat down to have her hair brushed out.

In every situation I have found myself with Mary, she consistently exhibits the same calm demeanor. When I revealed that I had a lime-green eyeshadow and baby-pink lip color in mind, she didn't bat an eye. It is that easy openness to new experiences and a zest for life that most impresses and inspires me about this budding star. Typically, Mary wears her hair straight and uses minimal, if any, makeup. My rebellious nature insisted that I create a sexy, colorful look. The result was a joy on every level.

This is definitely a "color in makeup" face, referring to the text in *behind beauty*, as well as a light-and-light balance look (see page 29).

m o n i c a

The first time I saw Monica was on MTV late one night. I was dozing off when this sultry beauty flashed across the screen. It wasn't just her striking looks or her infectious voice that caught my attention; I was simply enamored with her entire being.

About a year later, I was in Los Angeles mixing business with pleasure. Tori Amos's five-star *Venus* CD had just been released, and I was in town working with her for some television appearances. I had also promised my niece Falon and nephew Ian that I would take them to Disneyland the next time I had the chance, so they flew out from Louisiana with my mother to join me on the Coast. After a fantastic visit and a teary good-bye, I was returning to my room when I ran right into Monica. We just began talking as if we'd known each other forever. She asked what I was doing in town, and I told her I was working with Tori. When she told me how much she loved Tori's music and that I should say hello for her, it instantly sealed our friendship. (If you want to become an instant friend of mine, knowing and loving Tori's music is sort of a prerequisite.)

Monica flew in from Atlanta for an appointment the day before the shoot. When the meeting was canceled she didn't cancel me. Mind you, we had never worked with each other before so she certainly didn't owe me any favors; I was truly touched. However, it was experiencing her incredible open-mindedness, intelligence, and thought-provoking conversation at the shoot that impressed me the most. At only twenty years of age, she possesses a maturity not seen in most forty-year-olds. She is a woman of few words, but many insights. Her photos were taken on the very last, exhausting shoot day for the book. Her patience and enthusiasm during those final moments of this project not only enriched the entire experience of producing this book, it solidified our new friendship. I look forward to the years ahead with her.

1 Prep skin with *moisturizer*.

2 Apply a light touch of **concealer** under the eyes and anywhere else needed. Blend well. (It usually looks more natural to use concealer in spots—not as an all-over foundation product.)

3 Lightly dust the face with **loose translucent face powder** using a *circular sponge*.

4 Groom the brows and brush upward. Use a **basic brown eyebrow pencil** to fill in and define shape.

5 With a *medium shadow brush*, lightly apply a **basic brown powder eyeshadow** to the outer corner of the eyelid and softly stroke in toward the bridge of the nose. Blend very well.

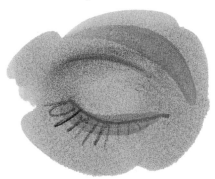

6 With a *medium shadow brush*, wash a **peach powder eyeshadow** all over upper eye area.

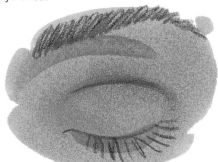

7 Curl the lashes and add a coat of **black mascara** to the upper lashes only. (This will further emphasize the eye area, but with a light touch.)

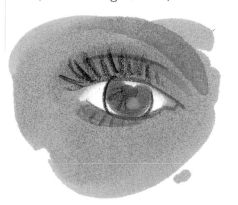

7 Using a *lip brush*, line and fill in lips with a **grayish-pink creme lip color**. (No pencil was used, which leaves the mouth with a softer edge.)

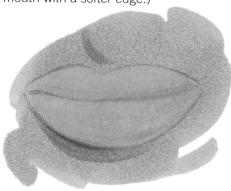

8 Finish the lips with a coat of **clear pink lip gloss**.

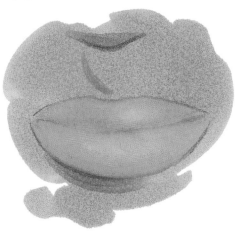

9 Blend well a touch of **soft pink creme blush** onto the cheeks. (Note: you can use a touch of the same creme lip color for blush instead, to bring together lips and cheeks.)

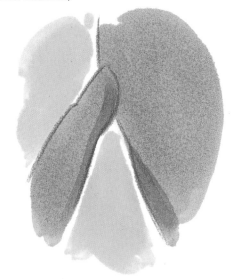

You guessed it, this is a light-eyes-and-light-mouth face. Again, the color palette used softly enhances the features.

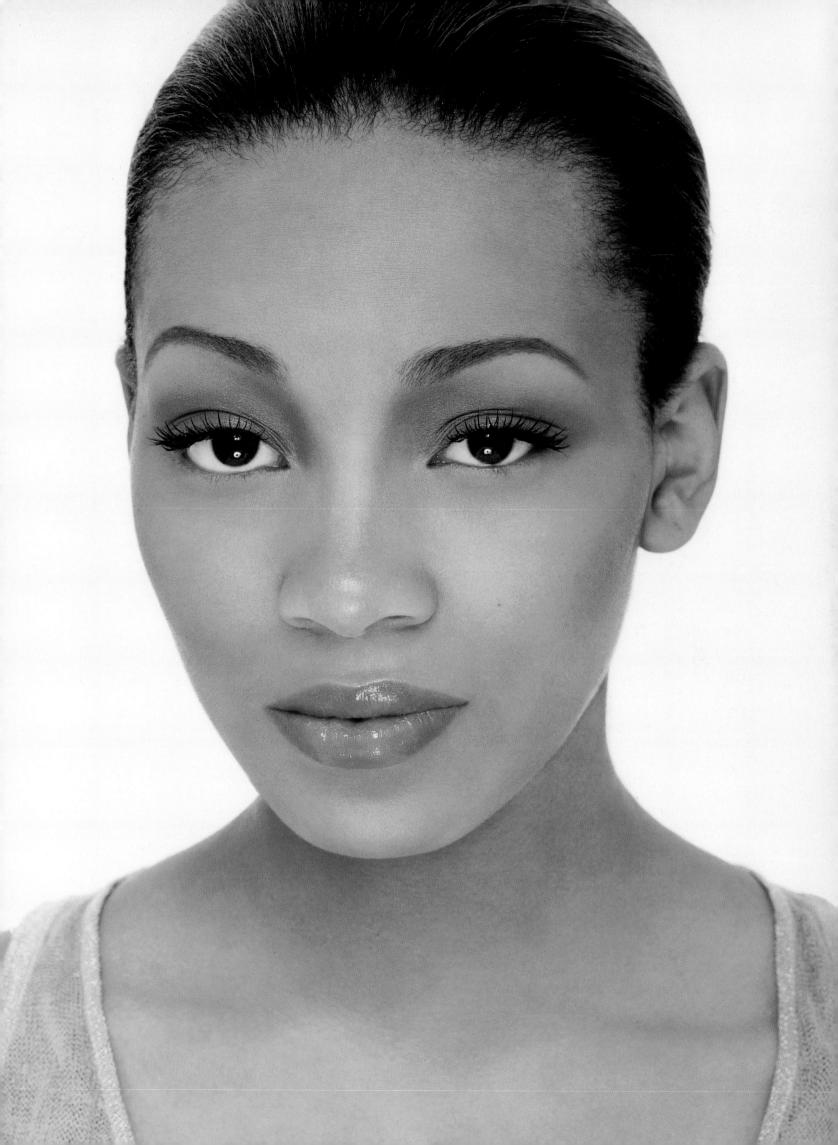

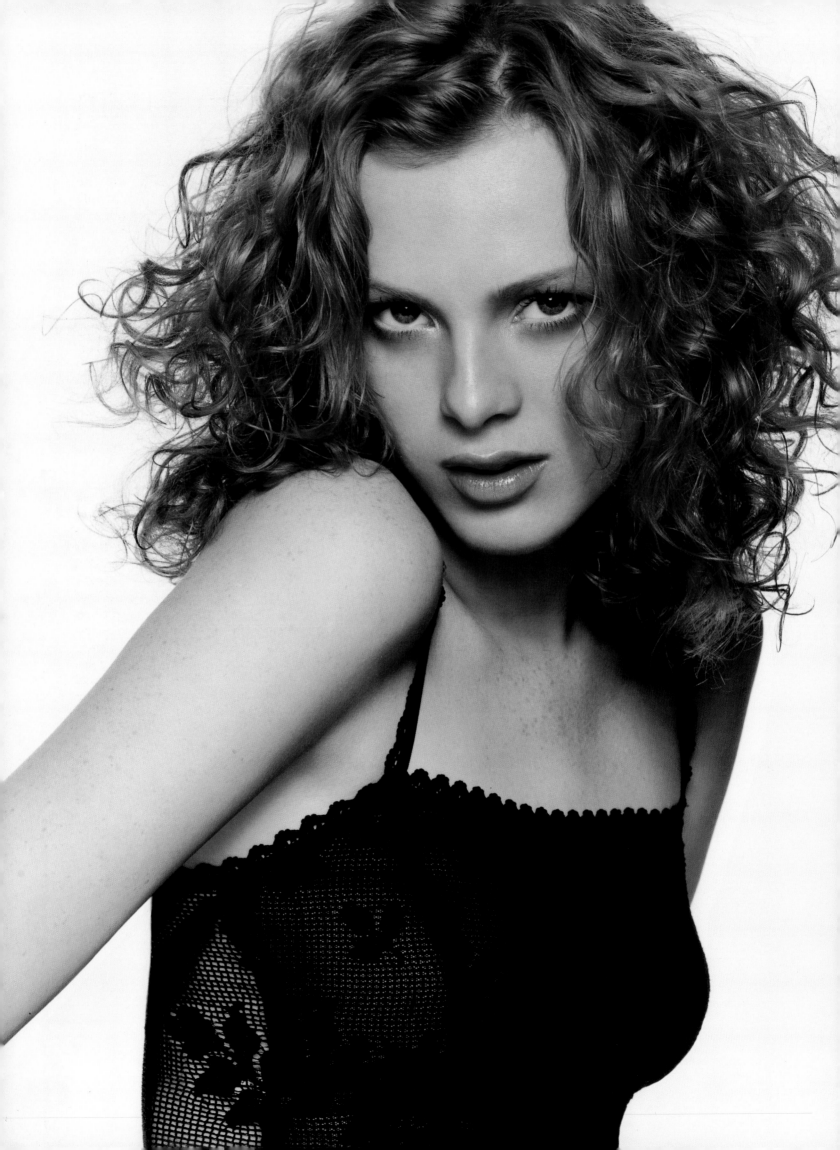

1 Prep skin with ***moisturizer***, including the face, neck, upper chest, shoulders, and arms (anywhere the skin is exposed). Blot any excess with a *tissue*.

2 Lightly define the brows by tweezing only stray hairs. Fill in any sparse spots with ***blond eyebrow pencil***.

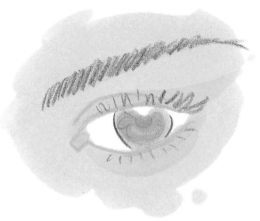

3 With a *medium shadow brush* or *sponge tip applicator*, softly line the eyes with a ***basic brown powder eyeshadow***. Be sure to soften the line under the eye, and blend the line onto the lid and into the crease above the eye.

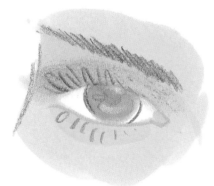

4 With a *small shadow brush*, dab **white shimmery liquid eyeshadow** onto the inner corner of the eyes. Soften and blend the line with your fingertip.

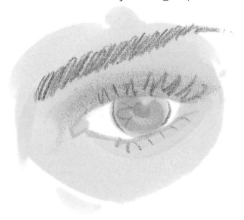

5 Curl the upper lashes and apply a light coat of ***burgundy mascara***, top and bottom. Burgundy is a great alternative to black or brown mascara. It softens the eye and gives the area just a hint of color.

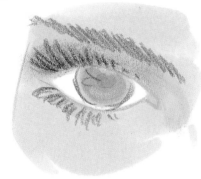

6 With the fingertips, blend a touch of ***soft pink creme blush*** onto the cheeks for a healthy glow.

7 Line the lips and fill in with a ***light flesh lip pencil***. Cover that with a coat of ***clear lip gloss***.

karen elson

Karen Elson hails from Merry Olde England—which would be quite obvious if you could hear her delightful accent. She is one of those people everyone loves. Karen's upbeat, wickedly funny, open-minded, and generous of spirit. It is unusual for someone caught up in the somewhat self-absorbed world of modeling to be so grounded and considerate of others. She is a breath of fresh air in a business that considers criticism and negativity "cool." All of this, and Karen has a face that looks like it was created by a Renaissance artist. Her natural flaming red hair, peaches-and-cream complexion, and blue-gray eyes are unique—and breathtaking. All of which came in very handy for this book, as you will soon see.

There are two ways we can go through life: one is to never make waves, never take chances, and never push the envelope. The other is to treat every day as if it were your last. Nothing fatalistic, just having a sense of anxious discovery when you turn every corner and the excitement of thinking that every new person you meet might be a new friend. Karen is the type (like so many of my closest friends) who, even if she wasn't a kid in a candy store, would treat every place like it was a day in a chocolate factory.

This is a light-eyes-and-light-mouth look that has an even softer effect because the color palette complemented Karen's already very light features.

angela barrett

While shopping at Bergdorf Goodman's one day, my right hand, Eric Sakas, received a call from yours truly. I was wondering if he knew of any fortyish women of color who would drop everything they were doing and come right down to the photo studio to shoot a picture for my book (a bit audacious of me, wouldn't you say?). Surprisingly, Eric replied, "Yes, and she's standing right in front of me." It turned out that Angela, a sales associate at Bergdorf's, was in the right place at the right time (at least for me). An hour later, she arrived at the studio, exuberant if not a bit shell-shocked. Her quiet, trusting nature elicited from me a very nurturing response—I wanted to make her feel safe and happy, in thanks for her affording me this opportunity.

Tweezing her brows was the first step I used to bring out Angela's radiant beauty. Her skin tone was uneven (a problem for many people) and took the focus away from her pretty eyes, so I went to work on that next. Once the foundation was applied, I began defining her bone structure. With every brush stroke, powder puff, and eyelash curl, Angela's mood brightened. As the process went on, I discerned a childlike twinkle in Angela's eyes. It seemed we were both enjoying this transformation.

The colors I used, all very bright and intense but softly applied, complemented Angela's skin tone. I often use extreme hues in an effort to create a "fresh" look, but I work with them lightly. By doing this I am able to create warmth while at the same time maintain sheerness. Frequently, with vivid color, you need to use only a hint of product to get amazing effects. Obviously, this is a "color" face, as well as a dark-eyes-and-dark-mouth look. But again, the word *dark* is only a signifier. The eyes are softly enhanced with black shadow and the lips are dark only in relation to their natural coloring. This is a mouth shape photo, too.

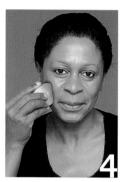

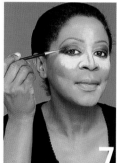

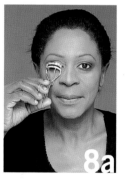

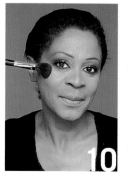

1 Prep the skin with a light application of moisturizer. Blot any excess with a tissue.

2 Angela's brows need defining. To see the shape in advance, the hairs to be removed were marked with **white eye pencil**.

3 Brow hairs are tweezed and the shape is defined using a **basic brown eyebrow pencil**.

4 **Foundation** to match is smoothed on using a *triangular sponge* and blended well.

5 The foundation is set with **loose translucent face powder**, with extra dabbed under the eyes and along the bridge of the nose and the sides of the mouth to act as a subtle highlight.

6 Using a *medium shadow brush*, a **basic brown powder eyeshadow** is used to softly define the entire eye area, top and bottom.

7 Using a *small shadow brush*, **black powder eyeshadow** is used to contour the eye area, along the top and bottom lashline, and into the crease—but only two thirds of the way toward the inner eye.

8 A **light beige powder eyeshadow** is used to bring forward the browbone and inner third of the eyelid, using a *small shadow brush*.

9 Lashes are curled and enhanced with a set of **full false lashes**. When dry, the lashes are curled together and coated with **black mascara**.

10 **Hot pink powder blush** is dusted onto the cheekbones using a *large blush brush* (Note: with color this vivid, use sparingly at first, then add until desired effect is achieved.)

11 The lips are lined and filled in with a **dark flesh lip pencil**. Then the mouth is covered with a **cherry red creme lip color** with a *lip brush*.

12 As a final step, the lips were coated with a **clear lip gloss**.

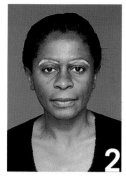

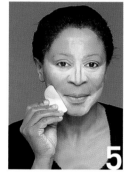

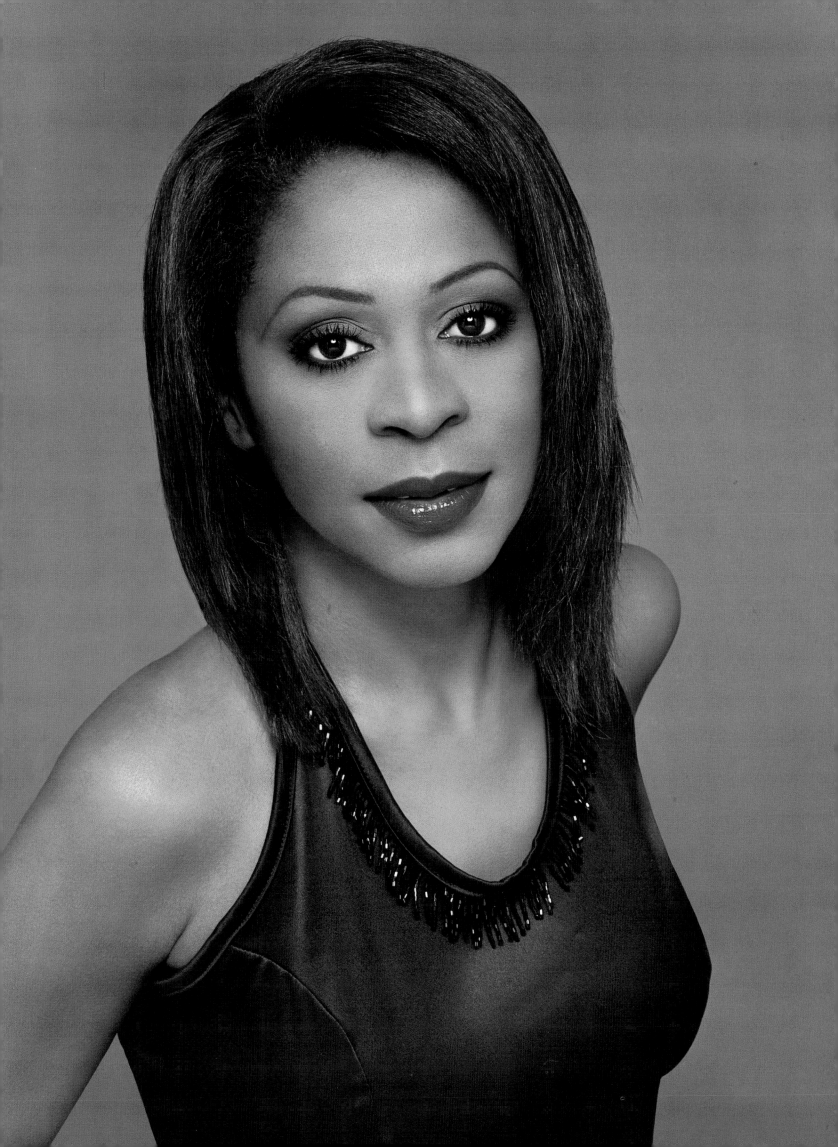

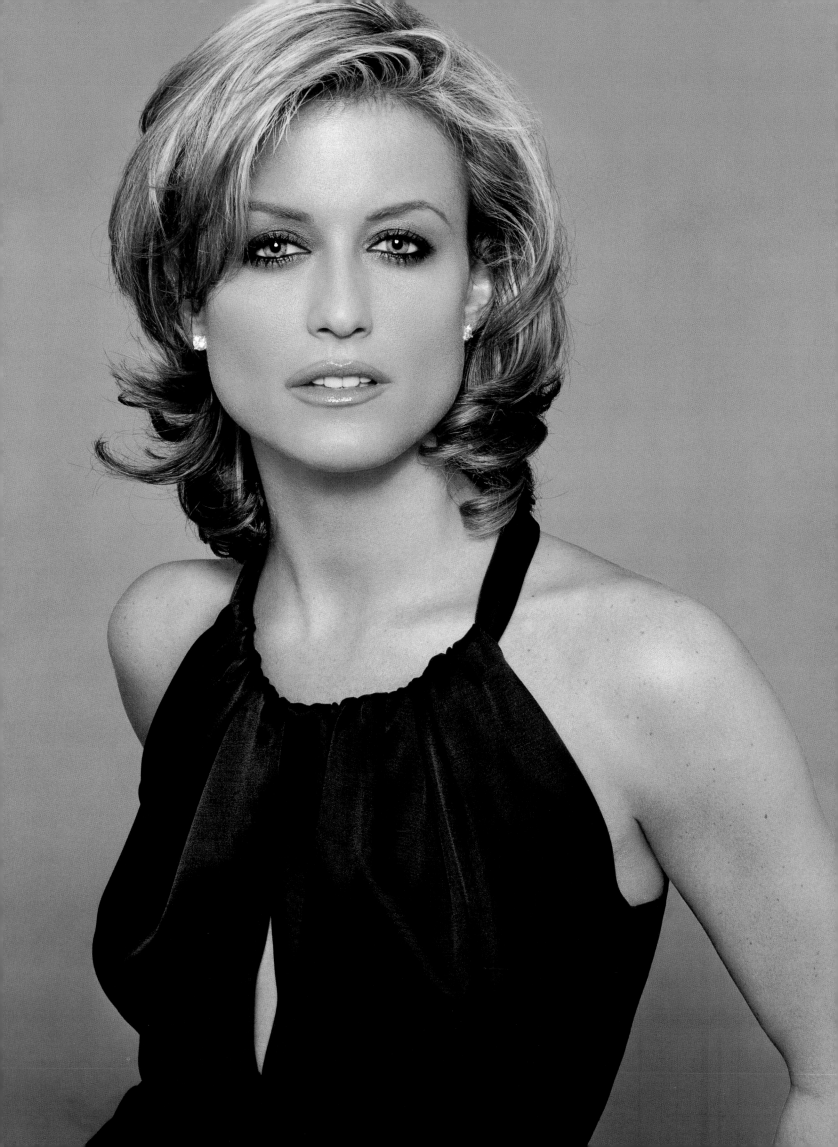

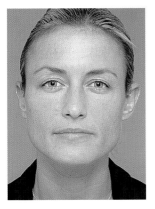

1 Prep the skin with a light application of **moisturizer**. Blot any excess with a *tissue*.

2 Next, the brows are groomed. Marleen's were already in very good shape, so only hairs from underneath were removed. Nevertheless, the shape was marked with a **white eye pencil** to show what the finished brow would look like.

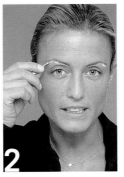

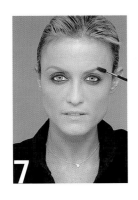

3 First **concealer** in spots, then **foundation** (to match skin tone) is smoothed onto the face and blended outward. Pay special attention to the under-eye area if you have circles or discoloration.

4 **Rose liquid blush** is dabbed onto the face—cheekbones, temples, and chin—and blended with the fingertips.

5 Line the inner rims of the eyes with **basic black eye pencil** and smudge into the lashline using a *small shadow brush* or *sponge-tip applicator*.

6 A soft, **dark brown powder eyeshadow** is used to further "smoke up" the eyelid, using a *medium shadow brush*. Make sure to also apply lightly under the eye and blend away any noticeable edges.

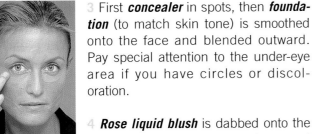

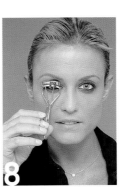

7 The brow is softened and defined with a **basic brown eyebrow pencil**. Then the hairs are brushed up and into place.

8 Lashes are curled with an eyelash curler.

9 **Black mascara** is used to coat top and bottom lashes.

10 The lips are lined with a **light flesh lip pencil** and filled in.

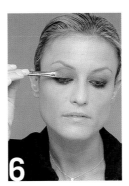

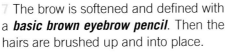

11 Then, using a *lip brush*, the mouth is covered with a **grayish-pink creme lip color**. On top, a sweep of **clear lip gloss**.

12 Finally, the finishing touch of a light dusting of **soft pink powder blush** over the top of the liquid blush with a *large blush brush* adds the illusion of depth.

marleen everett

Marleen and I forged our friendship through an addiction known as shopping. I was buying presents for my family at Gucci when I happened upon this amazing woman. Right from the start, she was honest, funny, and forthright. Not your typical salesperson—and thank goodness! Since then Marleen has become not only my friend, but a friend to my entire family. Marleen especially adores my mother and her Southern charm, which of course has endeared her to me even more.

Marleen is always busy making sure everyone else looks good, so I decided to turn the tables on her. Though not used to being the center of attention, Marleen slowly but surely got into the mood. In the end, she displayed a great deal of vulnerable sexiness.

Why not look at stepping outside of yourself as something we should all do at least once in a while? Maybe your work week doesn't allow you much freedom to have fun and your boss and company are conservative (there's that horrible word again). But isn't this what the evenings and weekends are made for? (There's no reason to consider this as an all-or-nothing proposition.) This is your own time to do as you please and not have to answer to anyone. Take these opportunities, when they come, to do a bit of self-exploration. Like Marleen, forget the person you have to present to your customers (or boss) and let your hair down. Maybe it's time you went for something vampy or something pyschedelic. Any way you choose, it's your choice—and your face. And while we're on the subject, who's to say you can't stretch some of those limits at the office? You never know what positive things can happen to you and others around you.

This is a version of the dark-eyes-and-light-mouth look. How does this work? Your attention is brought to the eyes, which are soft and smoky, while the mouth is neutral, because it is lightly colored.

davida williams

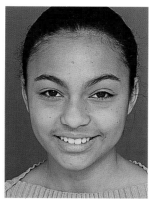

At fourteen years old, Davida is the youngest participant in this project. Her eagerness and excitement that day were reassuring; I've always had concerns about working with people under the age of eighteen. Don't get me wrong. I've made up my nieces (and nephew) for home movies, and I've certainly worked with teenage models early on in my career. It's just that I've seen too many young people pushed to grow up and begin working before they are ready. By the way, the worlds of modeling and acting are problematic, but largely because they are among the most visible and easy to attack. This problem surfaces anytime a child is raised by another child—be they fifteen or fifty.

Luckily this is not the case with Davida. After a lengthy conversation with her mother, I could see where this bright, articulate teen gets her strength and guidance. Two days later, I received a thank-you note that confirmed my hopes that the shoot had been a fun and valuable experience for her. It seems we were *both* honored to have worked together, and to have in some small way affected each other's lives for the better. Thank you, Davida.

Two things: This is a texture face, because of the overall shimmery look. And it is an "in perspective" face, because it lightly deals with the issue of makeup and age.

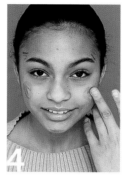

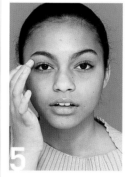

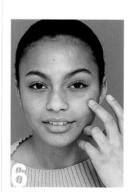

1 Good habits start as early as possible. To keep your skin looking healthy, moisturizing is a good place to begin. (Also, try to avoid smoking and *smokers*, and late nights!) So begin this light make-up application—any application—with **moisturizer**. Smooth on and work into the skin with your fingertips. Blot any excess with a *tissue*. (Do this every day and every time before applying makeup. Years from now you'll thank me.)

2 Groom brows. If only a light grooming is needed, use a pair of *tweezers* and gently remove stray hairs that distort the brow's natural shape. (If this is the first time you have tended to your brows, you might want to use a *waxing strip*, which is helpful in removing a larger number of hairs. However, use them with caution—they tend to smart a little and can remove more hairs than you expect. A mom, sister, or friend might be helpful.) Fill in any noticeably sparse spots with a matching brow pencil and draw in short, hairlike strokes.

3 After grooming, brush brow hairs upward and keep in place with a light sweep of **clear mascara** or **brow gel**.

4 Dot a small amount of **rose liquid blush** onto the apples of the cheeks and blend well. (If you like, add a touch to the temples, too.)

5 If necessary, use a touch of **concealer** on red spots and blemishes, and blend well.

6 Using a **sheer iridescent sparkle liquid foundation**—mainly just for fun—smooth very lightly all over the face. This will highlight the highest features on your face—the tip of the nose, cheekbones, and chin.

7 Using a **light blue metallic creme eyeshadow**, smooth onto eyelid up to eyebrow with your fingertips. Blend well to soften edges.

8 The lips are enhanced with the sweep of a **pink lip gloss**.

1 Use *moisturizer* to prep the skin.

2 Lightly tweeze the brows to clean up any stray hairs. Fill in any sparse spots with a ***basic brown eyebrow pencil***.

3 ***Concealer*** is lightly applied under the eyes, sides of the mouth and nose, and chin to conceal any redness.

4 ***Soft pink powder blush*** is lightly dusted upon the apples of the cheeks, temples, forehead, and chin with a *large blush brush*.

5 ***Dusky brown creme eyeshadow*** is applied with fingers to the upper eyelid only.

6 ***Cocoa brown eye pencil*** is used to line the inner rim of the eyes.

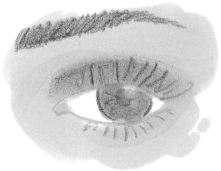

7 ***Burgundy mascara*** lightly coats the upper and lower lashes.

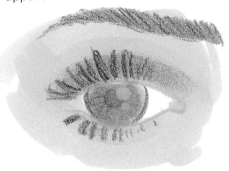

8 ***Champagne-colored metallic creme eyeshadow*** is lightly blended onto the browbone, cheekbones, and chin with the fingertips or *medium shadow brush*.

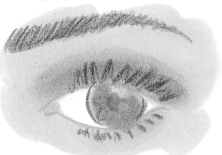

9 Dab a tiny bit of ***pearly-white liquid eyeshadow*** or ***white shimmery powder eyeshadow*** at the inside corners of the eyes with the fingertips or a *small shadow brush* and blend well.

10 ***Sheer red liquid lip color*** is dabbed onto the lips, then removed, and reapplied, until lips are stained.

christina ricci

Though I had never met Christina Ricci, I was desperate to work with this amazing young talent. When *Face Forward* was being planned, I hoped to use it as an opportunity to get my wish—and I succeeded.

In person, Christina is quite enigmatic. She is shy, yet astute—and very kind. Christina is also quite open and trusting, something I sensed from the very first moment she arrived.

It is rare for an actress so young to display such enormous range, but as her growing list of credits attests—beginning with *Mermaids* (where she starred with Winona Ryder and Cher), *The Opposite of Sex* (one of my favorite Ricci films), to *Sleepy Hollow* (with gorgeous Johnny Depp)—we have a lot to look forward to with Christina's career. For her three pictures in *Face Forward*, she also changed characters effortlessly. With great aplomb, she went from this "natural" portrait right into my interpretation of a child of the "future." Then she did an about-face, went back in time, and after a taxing day, astonished us all as the reincarnation of the soulful singer Edith Piaf.

This is a light-eyes-and-light-mouth face. It is also a color look, because of the soft, subtle use of color in unexpected ways.

jeremy antunes

It was serendipity—plain and simple. When our eyes first met a distinct feeling of déjà vu consumed us both. Jeremy is an aspiring playwright. Coming from similar backgrounds and choosing hope and humor to combat despair sealed our bond. You can love someone passionately, but if you do not respect their intelligence, chances are there's little hope of it working out. Such is not the case with Jeremy and me. Reading his work inspires and invigorates me. On our first date I was so nervous that I asked my friend Gina Gershon to come along. Gina's laid-back demeanor helped ease my painful shyness. What a friend! I guess it worked because that was almost two years ago. Many eyebrows were raised at our twelve-year age difference. But while they're getting more forehead lines, we're having the time of our lives. C'est la vie!

What follows is a simple lesson in male grooming. I know the words *makeup* and *male* mix about as well as Charlton Heston and common sense. So we will just use the word *grooming* so we don't scare all those big, strong, butch men with a silly little word like *makeup*.

Based on my previous comments, this is an "in perspective" face. But take a look at Jeremy's portrait on page 139, which is a "texture" look: men look great in all degrees of makeup.

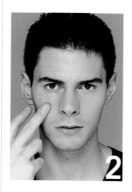

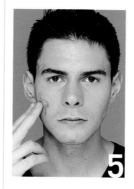

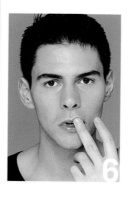

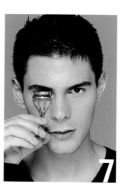

1 Prep skin with a light application of **moisturizer**. Blot any excess with a *tissue*.

2 Use **concealer** where needed. Using your fingertips (or a *thin shadow brush* for more accuracy), apply lightly to red spots, blemishes, and darkness under the eyes. Let the concealer set for a moment, then blend with fingers or a *sponge*.

3 Groom the brows, tweezing as you see fit. (Many men prefer to remove their "uni-brow"—the hairs that grow between the brows. However, I happen to think that most men's brows look best unplucked.) (Note: if you choose to do it, it is a little easier to pluck out brows in the direction they grow.)

4 After tweezing, brush the brows into place and, if you like, keep them there by using a sweep of **brow gel** or **clear mascara**.

5 With the fingertips, dab a few dots of **rose liquid blush** onto the cheeks and blend well. If there is any excess, smooth onto the temples and chin.

6 A coat of **lip balm** is applied to the mouth and smoothed with the fingertip.

7 Curl eyelashes. Don't be afraid to do this; it can be a pleasantly eye-opening experience. Carefully position the *eyelash curler* as close to the base of the lashes as possible, and squeeze once, twice, three times. Slowly walk the curler out along the lashes, squeezing as you go along.

8 Finally, **anti-oil gel** is used to cut any sheen on the skin. Use a *circular sponge* or just your fingers and try to keep the application light.

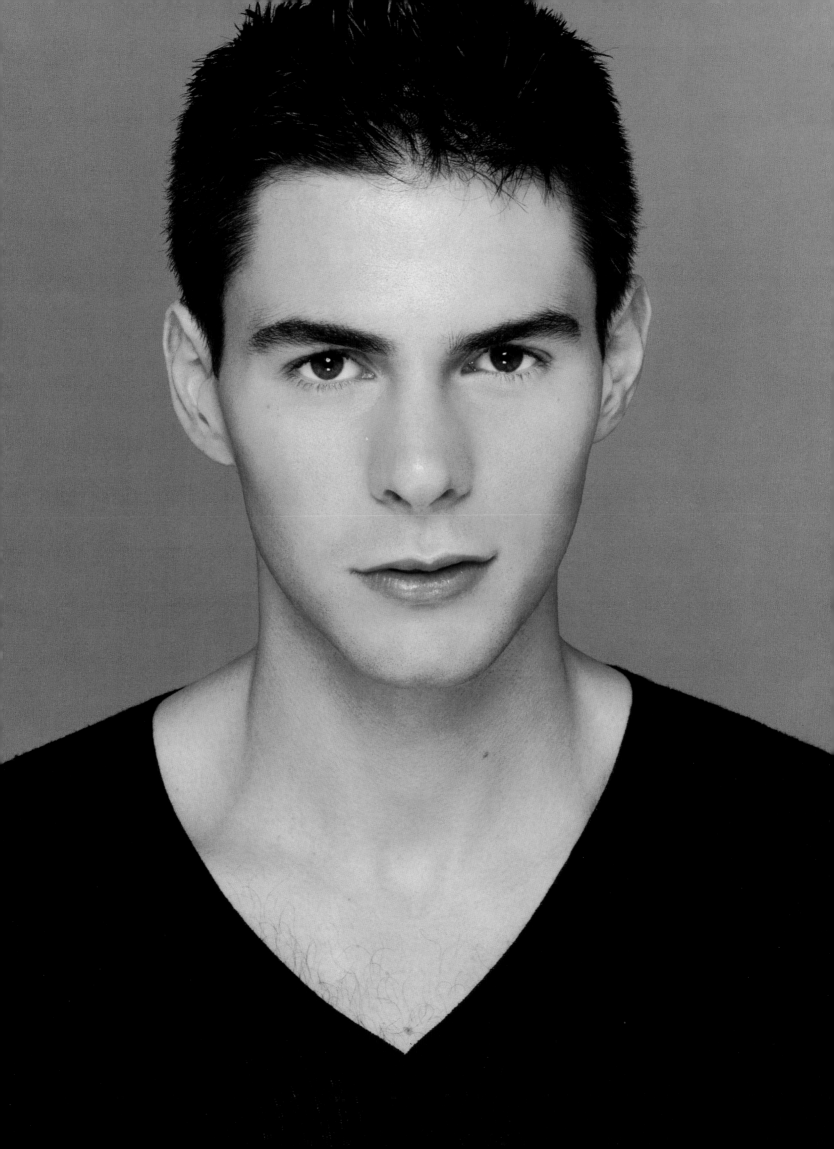

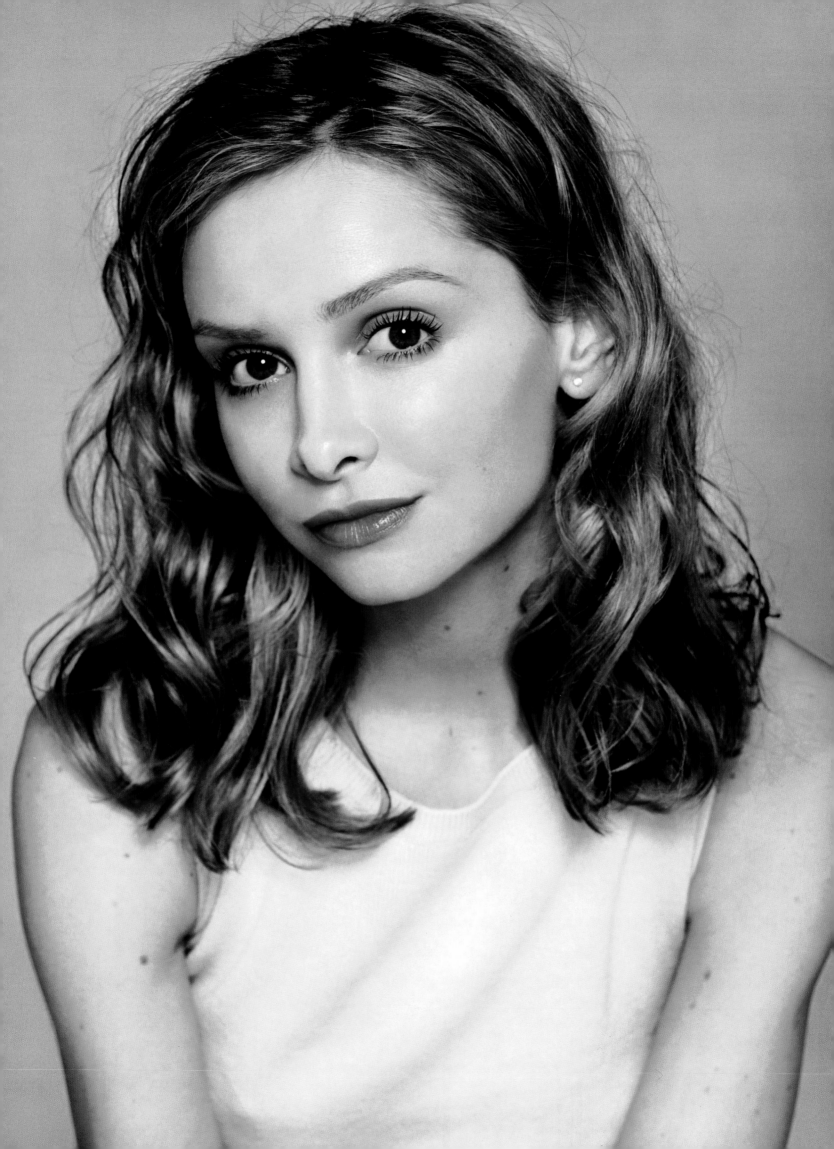

1 Prep skin with *moisturizer*.

2 *Concealer* and *foundation* are used where needed. Lightly set with *loose face powder*.

3 Using the fingertips, *warm brown creme eyeshadow* is applied to the lids, into the crease and blended under the browbone, and lightly blended along the outer corner of the lower lashline.

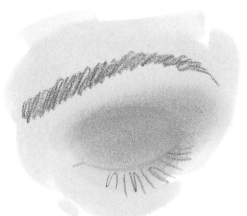

4 The brow is lightly defined using a *basic brown eyebrow pencil*.

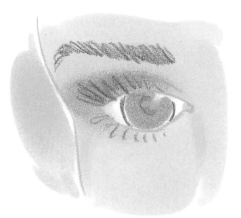

5 Lashes are curled, and *black mascara* is applied to upper and lower lashes.

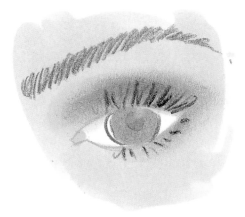

6 Using a *natural rose creme lip color* and a *lip brush*, give the mouth a softly defined shape.

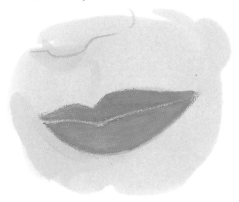

7 *Clear golden-yellow lip gloss* is smoothed onto the lips.

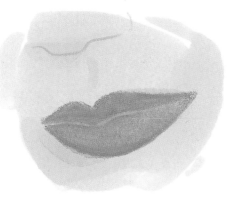

8 *Soft pink powder blush* is very lightly dusted on the apples of the cheeks, temples, and chin with a *large blush brush*.

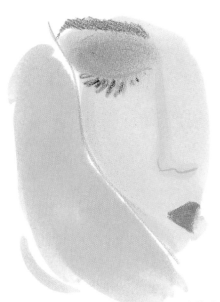

This is a classic light-eyes-and-light-mouth face that could easily become another one of the four balance combinations. Why? Because just the slightest increase in intensity to the eyes or lips would change the focus and balance.

calista flockhart

It was through my amazing friend Casey Patterson that I met Calista Flockhart. Casey orchestrated all of the talent for the epic "Concert of the Century" in Washington, D.C. She somehow convinced me that in two hours I could make up Gwyneth Paltrow, Sheryl Crow, Keri Russell, Sarah Jessica Parker, and Calista Flockhart. How do you spell stress attack?! Surprisingly, everything went smoothly. Calista was last, and I was nervous, as I am with everyone I work with for the first time. When Calista walked in we were watching an episode of Comedy Central's *Strangers with Candy*. This little-known cable show is one of my absolute favorites. Calista got its ironic humor and we bonded. After meeting the amazing President Clinton and the extraordinary First Lady, Hillary Rodham Clinton, it was time for touch-ups. Our dressing room had been taken over, so Calista and I searched in vain for another place. Even though we had just met, Calista was as calm and reassuring as an old friend. Three months later, on my way to photograph her for this book, I found myself half an hour late. We'd only worked together once, and I pride myself on always being on time. As I walked in, Calista and a friend were having tea, and her dog ran up to greet me. Her heartfelt and forgiving smile was the beginning of a magical day.

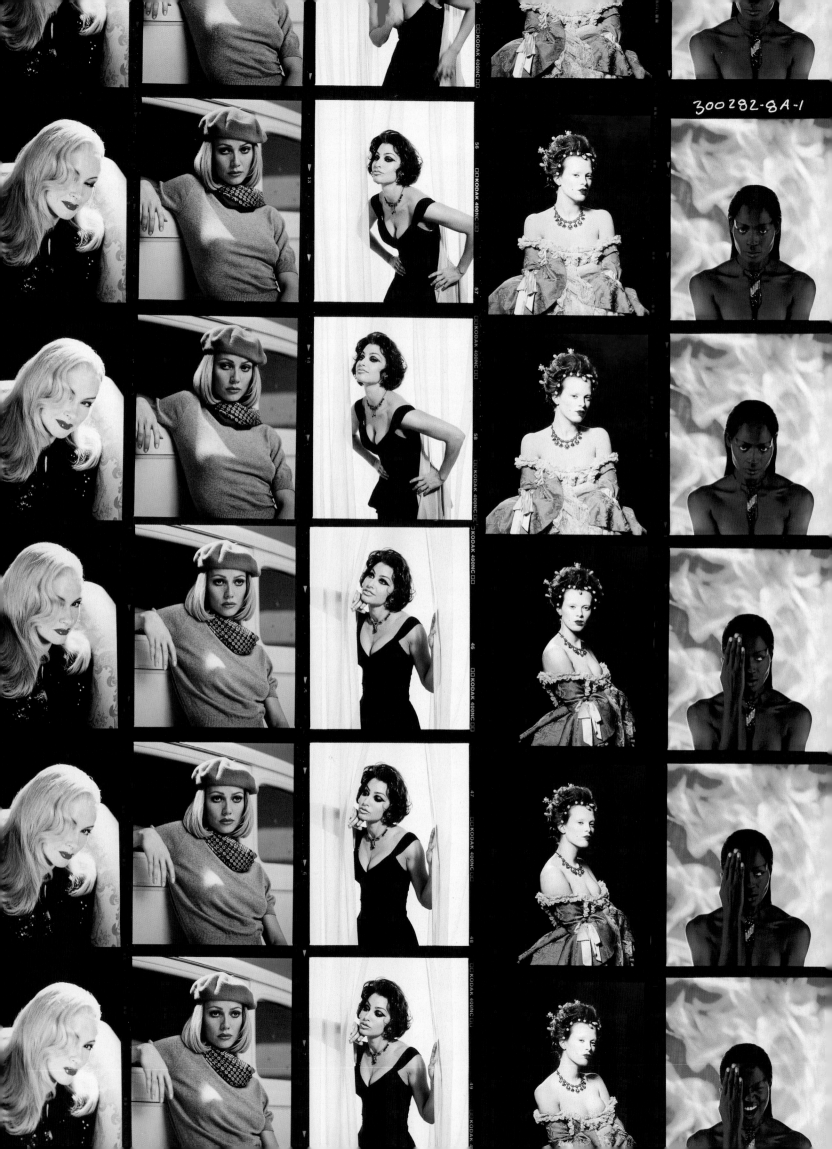

300282-8A-1

dimensions

This section of the book is called Dimensions. I chose the word because we are all complex and unique individuals. Sadly, however, most people neglect variety in favor of self-imposed control and sameness. Looking sexy one day, conservative the next, and casual the following day does not make you indecisive or crazy. In my book (and in life) it just means you're open-minded and self-expressive.

Here, a closer look is taken at beauty's past. Our concepts of beauty do not exist in a vacuum. How we choose to look today—though it may differ greatly from how we looked years or just months before—is directly linked to the past, present, and future. Makeup application is a creative undertaking, and as such, our inspirations are limitless and ever-evolving.

In Dimensions, there are many classic personifications of beauty—and many that are unique. There is a great deal of truth in the statement "beauty is in the eye of the beholder." It would be impossible to get everyone to agree on the absolute definition of the word. Beauty has no boundaries, no limitations. In this section, I chose to include many iconic images from the past, following them with modern looks as well as visions of tomorrow. Every image in this book was chosen or created because I felt it represented an important aspect of beauty.

Guardian Angel

Our journey back in time begins with someone who transcends time completely—the Guardian Angel. If the way we wear makeup is inextricably linked with the past, then certainly this icon has proved it, and has served as a fount of limitless inspiration throughout the ages. From her rosy cheeks and nude lips, to her softly plaited hair, our winged figure (inspired by a painting) at rest is beauty at its most timeless.

Sharon Stone is beautiful, talented, vivacious, sexy, intelligent, and altruistic, but the quality I most admire about her is that she is fair. Sharon has the uncanny ability to see both sides of any issue. She is also very in touch with her humanity. Therefore, I asked Sharon to be my Guardian Angel to make this point: no one person is all saint or sinner; we are all a perfectly imperfect mix of both. I believe it is paramount to allow ourselves, and others, the freedom to choose for ourselves and be who we truly are. Remember, the point of a democracy is not rule by the majority, but protection of the minority.

As with the previous section, I will be including short notes referring back to our basic "behind beauty" theories. Going forward, obviously all of the portraits in Dimensions have one thing in common: setting. Therefore, I will only mention this if it is of particular relevance to the finished photograph.
This is a light-eyes-and-light-mouth face, as well as a texture look because of the soft gleam created with the iridescent foundation.

Sharon Stone as the Guardian Angel

1 Use **moisturizer** on all exposed areas of the body, including neck, upper chest, shoulders, arms, and hands. Blot any excess with a *tissue*.

2 Use **concealer** in spots where needed and blend well.

3 Lightly groom brows, but keep them softly defined and natural-looking. Fill in sparse spots with **basic brown eyebrow pencil**.

4 Smooth on a light application of **sheer iridescent sparkle liquid foundation**. (This type of foundation will naturally highlight high spots on the face—cheekbones, chin, bridge of the nose, etc.)

5 With the fingertips, softly wash the eyelids and crease with a **grayish-brown creme eyeshadow**.

6 To curled lashes, apply a light coat of **burgundy mascara**, top and bottom. (The color burgundy softens the eye.)

7 **Rose liquid blush** is dotted and smoothed onto the apples of the cheeks and blended well. (Note: if you tend to have oily skin it's probably best to use a powder blush rather than a liquid or cream.)

8 The lips are softly defined using a **light flesh lip pencil**, defining the shape and filled in.

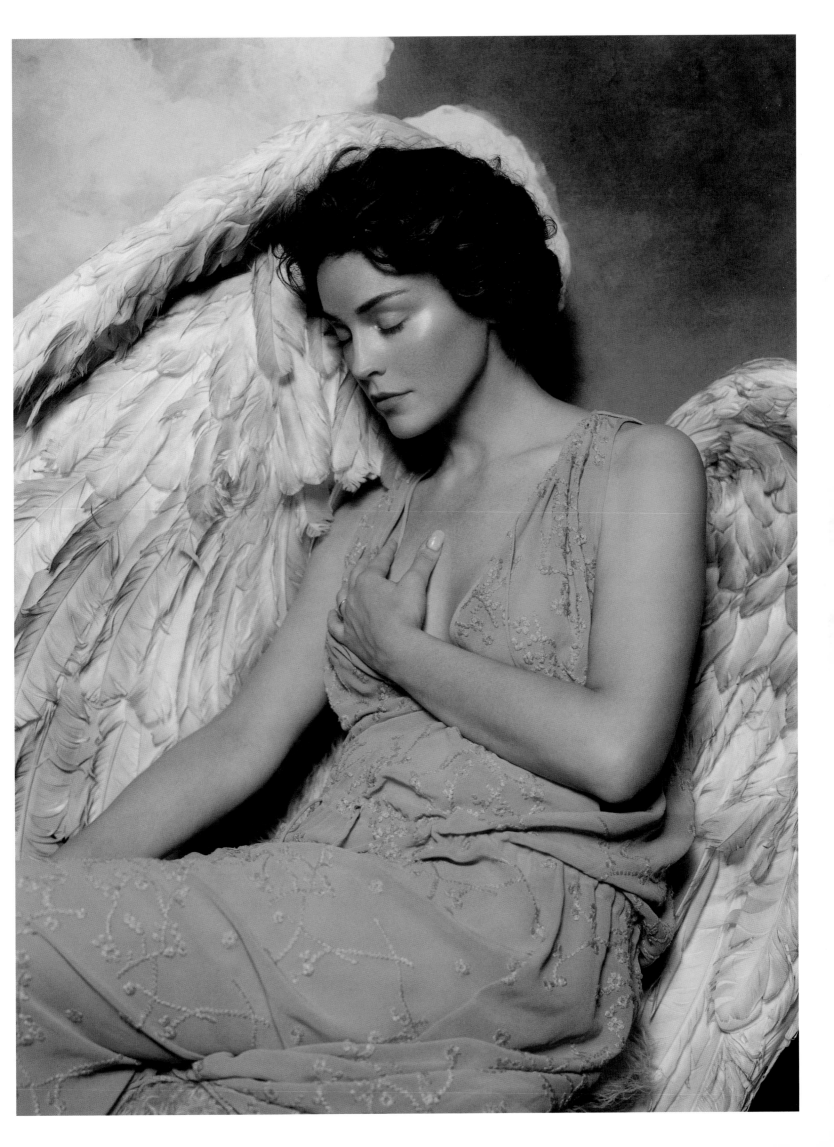

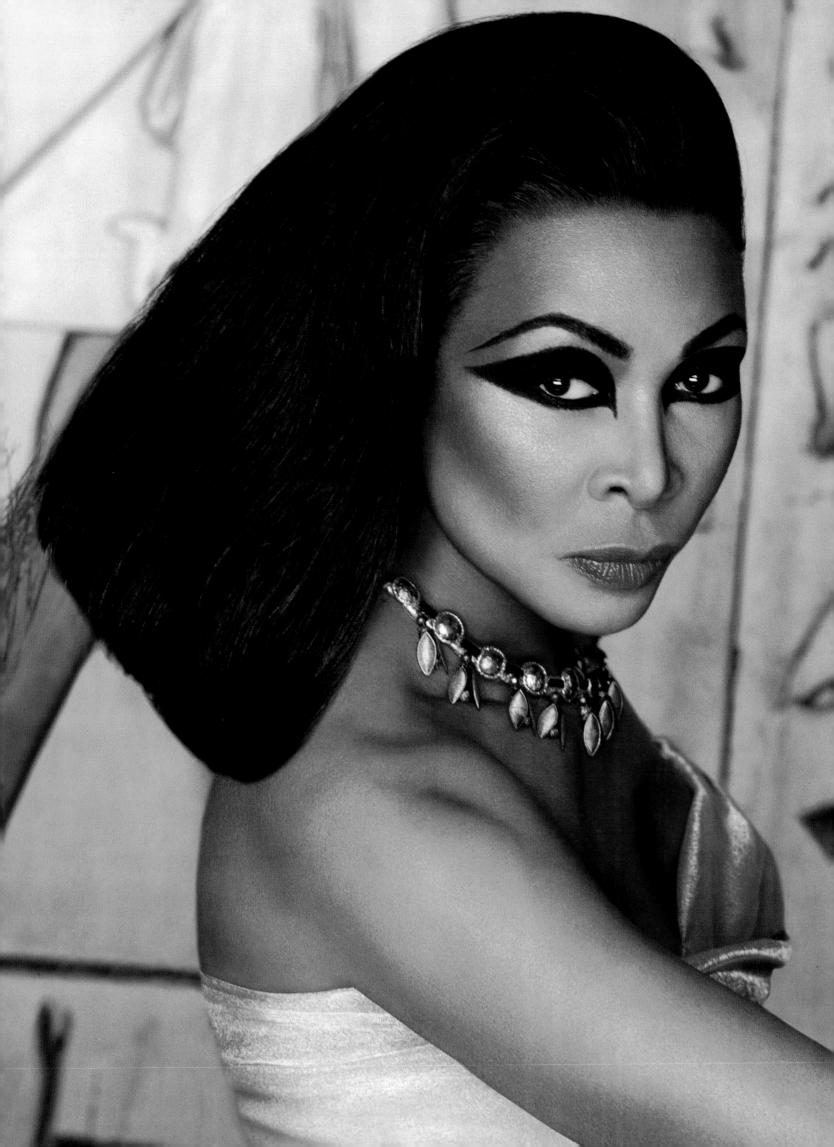

cleopatra, queen of egypt

Tina Turner as Cleopatra

1 Prep skin with *moisturizer*, blot excess with *tissue*.

2 Apply *concealer* to any red spots or discoloration and blend well with a *sponge*.

3 Smooth on a small amount of *gold sparkle liquid foundation* and blend outward from center of face.

4 Using a *basic black eyebrow pencil* or *liquid eyeliner*, draw in defined arched brow. (Note: for this look, it is not necessary to draw in individual brow hairs—a solid filled-in shape is more true to the original Cleopatra look.)

5 For the Cleopatra eye: First, rim the inner lashline, top and bottom, with a smooth-tipped *basic black eye pencil*. Be sure to get into the lashes.

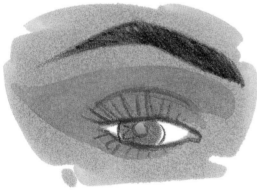

6 Then, taking the same black eye pencil, lightly sketch in the basic shape outline, which is drawn from the inside corner of the eye, above the crease, and extended outward, past the end of the brow. (Note that the inside corner is also extended downward.)

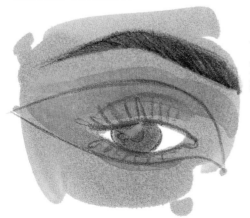

7 Fill in the outline with *basic black powder eyeshadow* or, if you feel confident, *black liquid eyeliner*. Be sure to cover over the entire eyelid, crease and above, and directly under the bottom lashline. (Note: this is a very defined shape with edges that are not blended or softened.)

8 Finally, sweep heavy coats of *black mascara* on top and bottom lashes (which should be curled, though that is not absolutely necessary).

9 Taking a *small shadow brush,* apply *golden honey powder eyeshadow* to highlight the exposed browbone.

10 With a *medium blush brush*, stroke *golden brown contour powder* along the hollows of the cheeks and temples.

11 With a *large blush brush*, dust on *apricot powder blush* to the apples of the cheeks, temples, and chin.

12 Line lips with a *light flesh lip pencil* and fill in.

13 With a *lip brush*, cover with a *dark coral red creme lip color*.

14 Top off with a coat of *clear gold lip gloss*.

This is a texture look, because of the use of shimmery golds, and an eye and brow shape face, too. (As if that isn't obvious!)

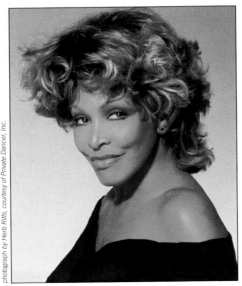

photograph by Herb Ritts, courtesy of Private Dancer, Inc.

Cleopatra may be the most famed female ruler of all time, but her reign over fertile Nile-quenched valleys and desert landscapes was far from idyllic. From her initial ascent to power at age eighteen to her dramatic death (by self-induced snakebite), Cleopatra's twenty-year rule was rife with conflict and tragedy.

This Nubian royal held potent sway over her subjects—she was said to be highly intelligent and charismatic, spoke several languages, and was considered quite the fashion plate. The attraction was not lost on two of the most important men of the day, Julius Caesar and Marc Anthony, with whom she had scandalous long-term affairs.

Today, if there is a woman who has that same power over people, it is Tina Turner. Photographer Steven Meisel first introduced me to the "Queen of Rock 'n' Roll" in 1983, when he was shooting the now famous *Rolling Stone* cover of her jumping in the air. It was the beginning of Tina's comeback—and an education in life for me. She has become like a second mother—never criticizing, always supportive, and full of endless humor, strength, and love.

I was traveling with her on a ten-day-long publicity tour recently, when this shoot was planned. Tina graciously managed to spare me an hour in her hectic schedule. She arrived at the hotel, and despite the pressure, was enthusiastic and calm. Working quickly, I created the brows, lips, and signature Cleopatra eyes. Once the makeup was finished, Tina donned her strapless gown and jewels, and we went into the next room to shoot two rolls of film, before she was off to her next appointment. When the contact sheets came back from the lab, my assistants were amazed. They had been so mesmerized by "Cleopatra" that they forgot it was really Tina underneath. But, having worked with this wonderful woman for so many years, I was used to her performing miracles.

madame BUTTERFLY

In the classic Puccini opera *Madame Butterfly*, tragic heroine Cio-Cio-San marries American naval officer B. F. Pinkerton, who basically deserts her and returns to the States before the end of the first act. Then we discover in the second act that Pinkerton left behind something rather important—his son. By act three, doormat Cio-Cio, still waiting for her man to return, discovers that Pinkerton has remarried. So what does our little heartbroken waif do when she hears the news? Offs herself with a knife, of course!

Enter legendary actress Gena Rowlands. Her long marriage to actor/director John Cassavetes has been noted for its amazing collaborative achievements. He was the director and she was the star of many of the most important independent productions placed before the camera. When I met Gena, through good friend Liza Minnelli, I was almost speechless (which, you can imagine, is rare). For so many years I had wanted to meet her, having fallen in love with her heartfelt, poignant portrayals of gutsy heroines (*Gloria* is an all-time favorite film). When I had the opportunity to say something profound, all I could muster were the typical pleasantries. Fortunately, I have had lots of opportunities since then to tell her of my love and admiration for her and for her work. Today, she and companion Robert Forrest are like family to me.

Gena Rowlands as Madame Butterfly

1 Prep the skin with **moisturizer**. (Note: moisturizing is especially important because of the amount of all-over foundation used for this look.)

2 Cover over the brows using *brow wax*, *spirit gum*, and *sealer*.

3 **Soft white creme foundation** is applied all over the face, neck, hands, and arms, and smoothed with *sponges* and fingertips. (Note: white foundation easily shows inconsistencies. Apply enough to obtain even coloration.)

4 Set foundation with a generous dusting of **iridescent white loose face powder**, using a *large blush brush* or *sponge*.

5 Using **dark charcoal-gray powder eyeshadow** and a *small shadow brush* (or *sponge-tip applicator*), encircle the eye close to the lashline, top and bottom. Extend the shadow line at the inner and outer corner of the eye.

photograph by Eric Sakas

6 **Hot pink powder blush** is dusted high on the cheekbones and up past the temple area. In addition, a generous amount of **apricot-orange powder blush** is applied *on top* of the hot pink, just below the eye and extended past the temple. In both instances a *large blush brush* is used. (Note: when using such vivid colors it is important to use sparingly at first and increase application for desired effect.)

7 Brow is drawn in, first using a **black brow pencil**, then covered over with **black liquid eyeliner**. (Note: this brow is drawn with no arch, and dramatically high above natural brow area.)

8 The sweetheart mouth is drawn inside the natural lip line using a *lip brush* and **dark red creme lip color**. No pencil was used.

9 Using the tip of the finger, a dot of **orange creme lip color** was dabbed onto the center of the bottom lip.

This is a texture face (white foundation and shimmery powder), a color face (lips and blush, especially), a brow, eye, and lip shape face, a dark eyes and dark mouth face, as well as a setting look (because the time and place are inextricably linked with the character).

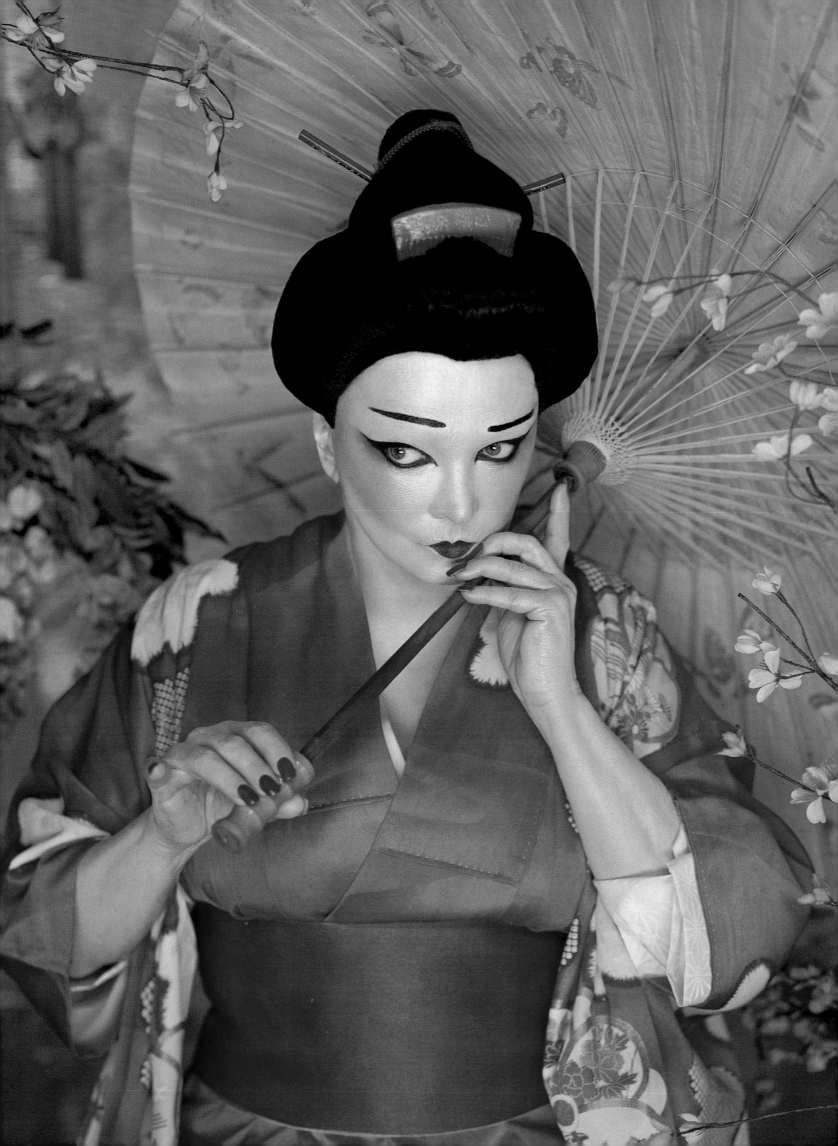

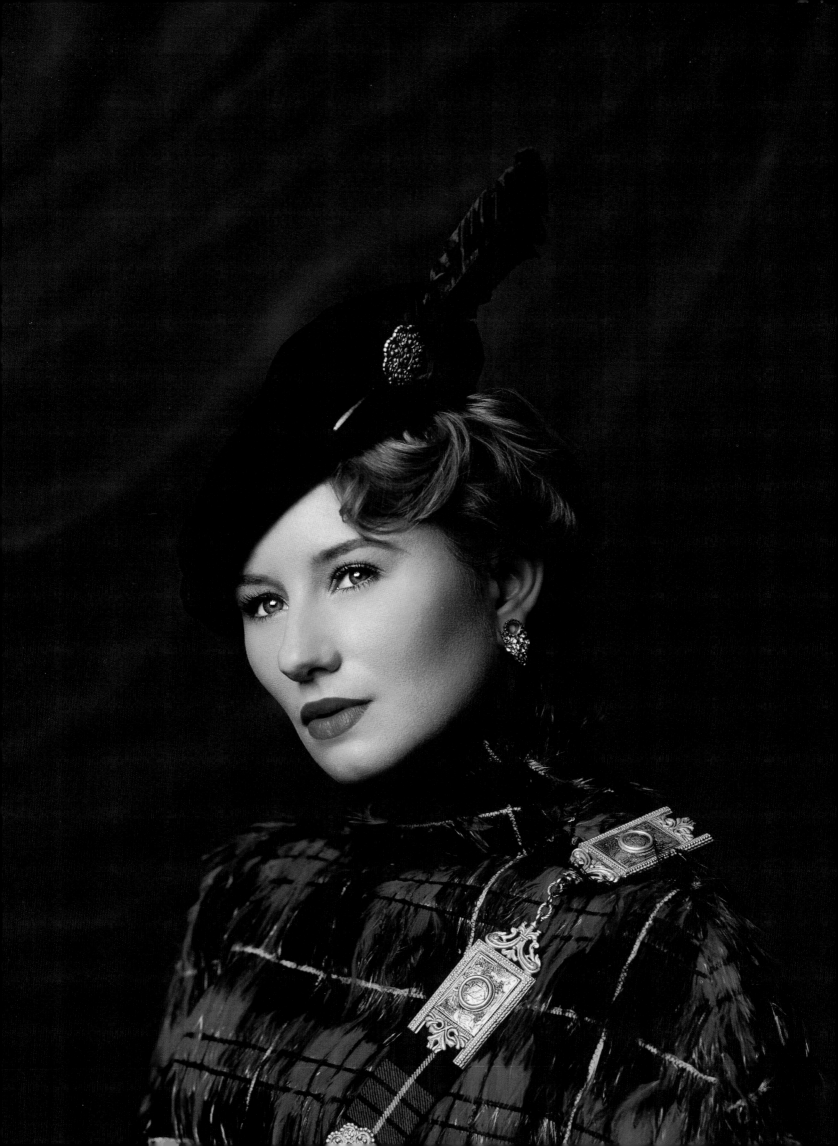

Tori Amos as Mary, Queen of Scots

1 Prep skin with *moisturizer*, and blot any excess product with a *tissue*.

2 *Light foundation* (to match) is applied all over the face, blending outward from the center with *sponge* or fingertips. (Note: Tori used no concealer—you should use only if needed.) *Loose face powder* is dusted all over the face to set foundation, with a touch more under the eyes and eyelids.

3 Brows are groomed and lightly filled in using a *basic brown eyebrow pencil*. Brush and keep in place using a *clear mascara* or *brow gel*. (Note: Mary, though alive at the same time, was not known to have affected the same drastic brow look as her cousin to the south, Elizabeth I.)

4 Using a *medium shadow brush*, *basic brown powder eyeshadow* is washed softly all over entire eyelid, with a touch more concentration on the inner eye to give it added depth.

5 Lightly curl lashes, then coat with *black mascara*.

6 No lip pencil was used. Simply fill in mouth with a *basic red creme lip color* using a *lip brush*. (No pencil was used because the mouth needed the look of softer lines.)

7 *Hot pink powder blush* is lightly dusted on the apples of the cheeks and temples using a *large blush brush*.

Even though the setting is the sixteenth century, this light eyes and dark mouth face is a classic and can be worn anytime and anywhere.

Mary Stuart became queen of Scotland just six days after her own birth, with the death of her father, King James V. One could take this as a sign that Mary's life would be marked by political intrigue and untimely deaths—and it was. Her first marriage ended in the sudden death of her husband, King Francis II, just a year after he ascended the French throne. Upon her return (still as queen) to Scotland, Mary wedded Lord Darnley, a Catholic as well, which unfortunately raised the ire of the Protestant popular government. Needless to say, this union also ended in tragedy, with Darnley's murder. Mary's third marriage—by now you'd think she would have known better—was to the earl of Bothwell, a man tried but acquitted in the death of her previous husband. This final union resulted in her abdicating the throne to her son, James VI. Meanwhile, Mary had been locked for many years in a rivalry with her cousin to the south, Queen Elizabeth I. Elizabeth at one point offered her rambunctious relation safe harbor from the religious fanatics who wanted her dead, but our scandalous Scot bit the hand that fed her. Though Mary was renowned for her beauty and charm—the cause of much consternation for her less than comely cousin—no amount of eloquence could save her in the end. Found guilty of conspiracy to overthrow Elizabeth and ascend the English throne, Mary was beheaded in 1587.

This reference to the Scots side of her ancestry is the first of two visual explorations into Tori Amos's diverse cultural past. As is the case for many of us, Tori's ancestry is a mix of races and religions, philosophies and professions, fortunes and foibles. What to some may seem like a family tree grown wild and untamed is actually a mighty oak that has weathered life's many storms and can still put out a rare and beautiful blossom like Tori. (See another side of Tori on page 88.)

ELIZABETH I

Though her ascent to the throne of England was hardly easy, Elizabeth I proved to be the island empire's most powerful and effective sovereign—female or male—until Queen Victoria, nearly three hundred years later. In order to reach such a lofty position, Elizabeth had to circumvent the notion that women did not have the physical, spiritual, or intellectual capacity to govern a nation. She also had to deal with the widely accepted sentiment, expressed by *both* sexes, that powerful women should be regarded with caution. Nevertheless, Elizabeth forged ahead, and during her reign steered England to a course of world dominance, introduced the notion of compromise in governmental policy, and raised the station of women to a place of long overdue respect and admiration.

Elizabeth I was hardly a conventional beauty. However, her affinity for dress, style, and culture (she did, after all, favor William Shakespeare) set the standard for much of the "civilized" world. Elegant women of the day were expected to wear unforgiving undergarments and heavy ornate gowns, shave their foreheads, and powder their skin ghostly white with a concoction mixed with poisonous lead. Needless to say, many ladies even back then thought current style something "to die for" and became the first true fashion victims.

The part of Elizabeth I fit Karen like a whale-boned corset. It was a marvel to see her traipse around the set in her custom-made Vivienne Westwood jacquard fabric and lace-edged gown and tennis shoes. Just like in olden days! This is one of the things I like most about makeup: you can visit many different places and times, but you don't have to venture beyond the makeup table if you don't want to.

Karen Elson as Elizabeth I

1 Prep skin—including face, neck, shoulders, arms, and chest—with **moisturizer**. Blot excess with a *tissue*. (Note: it is especially important to moisturize your skin when you are wearing this much all-over foundation.)

2 Cover the brows using *spirit gum*, *brow wax*, and *sealer*. When dry, cover with **true white creme foundation** and set with **true white loose face powder** and a *circular sponge*.

3 Using your fingers or a *large sponge*, apply a **true white creme foundation** all over face (including the eye area), neck, arms, and all exposed parts of the body. (Note: it is very important to blend and smooth foundation well, so that the skin has one consistent coloration.)

4 Set foundation with a liberal dusting of **true white loose face powder**, using a *large sponge* or *large blush brush*.

5 Using a **dark flesh lip pencil**, draw in mouth shape. (Note: the Elizabethan mouth was drawn very small and curvaceous within the natural lip line.)

6 Using a *lip brush*, fill in the mouth with a **basic red creme lip color**.

7 Using a *large blush brush*, dust **hot pink powder blush** onto the apples of the cheeks. (Be careful not to go too heavy with the blush, as it can easily appear too pronounced on such a light foundation.)

8 Add a beauty mark using **black liquid eyeliner** or **pencil**. (The beauty mark can be placed anywhere on the face—or body—and was used as a way of calling attention to that body part. Atop one of the exposed bosoms was a particularly popular spot.)

This is a texture face, a *very* light-eyes-and-dark-mouth face, and a mouth-shape face, too. It is also a setting look, because rare is the occasion when you would dress like this—unless you were going to a costume party (or a photo shoot!).

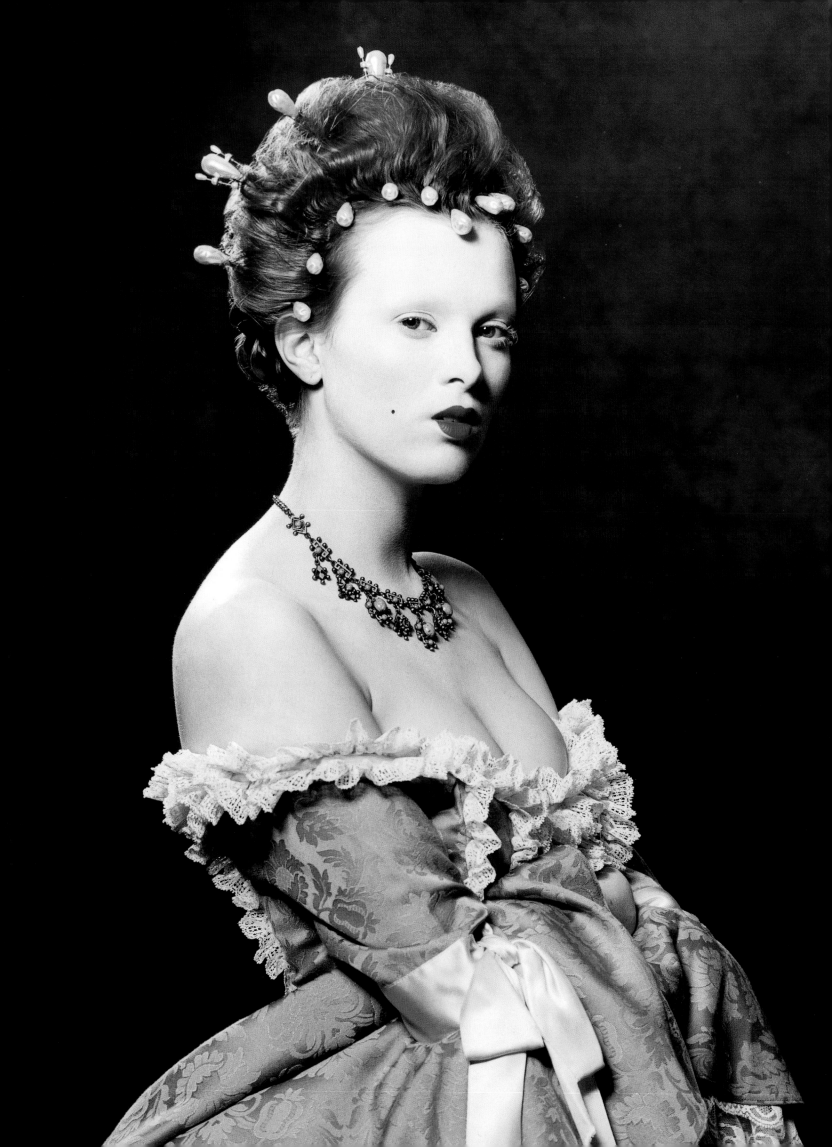

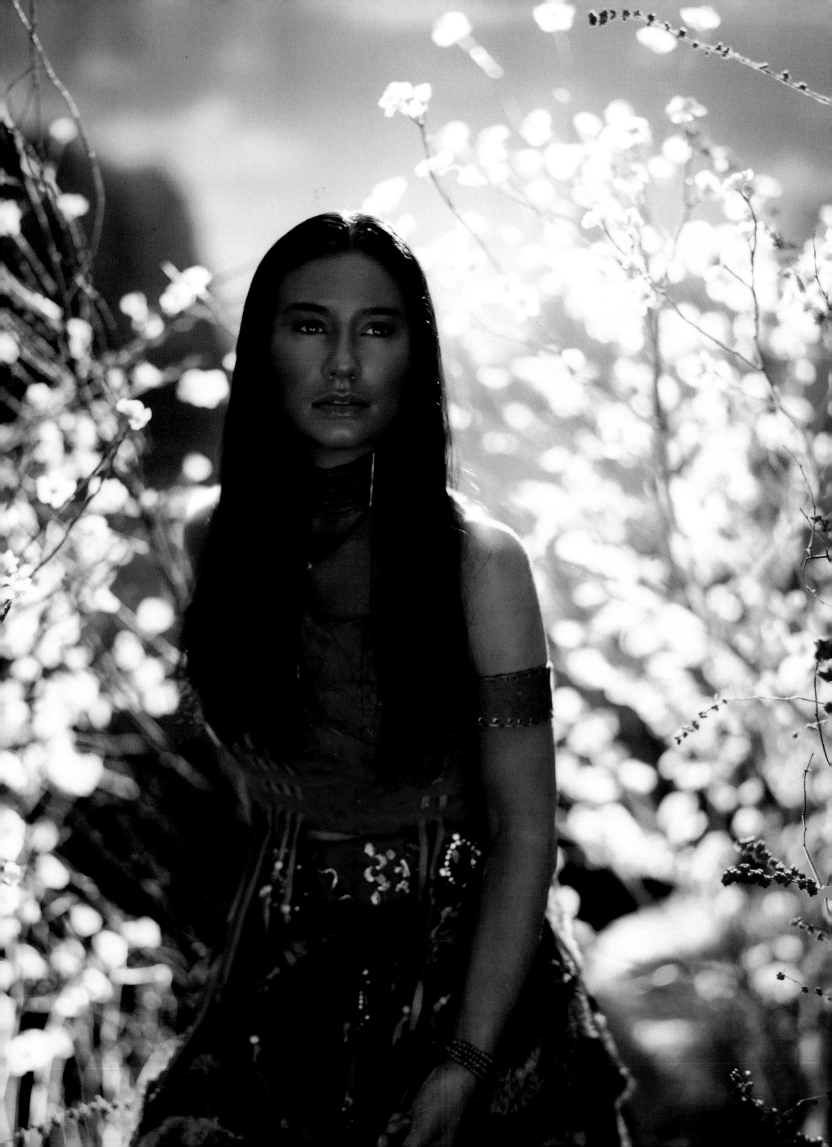

Tori Amos as Ton'ingina

1 Prep skin with **moisturizer**.

2 Groom and define brows with a **clear brow gel**. If you wish to darken them, try using a **dark brown mascara** or **dark brown eyebrow pencil**.

3 Apply a very **sheer translucent foundation** in a golden-brown color. (If you want to make foundation sheerer, add a touch of moisturizer.) This skin tone can also be achieved with a tinted moisturizer, bronzing powder, or even a self-tanning lotion. Typically, I like self-tanners because they don't mask your skin, but give it a healthy glow.

4 With a *medium shadow brush* and a **medium brown powder eyeshadow**, lightly encircle the entire eye area.

5 Using a **dark brown eye pencil** (with a softened tip), line the inner rim of the eyes, top and bottom. Smudge into the lashline.

6 Lightly curl lashes and apply a light coat of **basic brown mascara**.

7 Using a **rose liquid blush**, lightly smooth onto cheeks, temples, chin, *and* lips.

The finished makeup look in this portrait truly had to consider its setting—a quiet, somber, and reflective tribute to Tori's proud heritage.

As I mentioned in my introduction, *Face Forward* gave me the opportunity to explore a wide range of looks not possible in the expected book on makeup. It also gave my collaborators the chance to explore a bit of themselves. When Tori Amos and I first spoke of this project, we immediately decided that her two portraits would focus attention on her multi-ethnic background. The first, which you saw just a couple pages earlier, shed a spotlight on her Scottish ancestry. This second photo is an homage to her Cherokee Indian lineage.

The Cherokee are a proud people with a proud past, and though they shared their abundance and culture with white settlers, this was not held sacred by the white man. Surprise. In one act of unfathomable cruelty, many thousands of Cherokee were driven from their homes in the Southeast to reservations a thousand miles to the west. This exodus was called the Trail of Tears because many of those forced to undertake the journey never finished it. Many starved along the way, many grieved for the loss of the land of their ancestors and their loved ones. Brokenhearted, many chose to end their suffering rather than allow themselves to endure the degradation and the rape of their way of life.

Many generations later we find Tori Amos. There is an education to be found in any one line of Tori's music. Her lyrics read like lessons in life. But her gifts range far beyond vocal and songwriting skills. As one of the most compassionate people I have ever known, she has a magical, near-mystic presence that deeply affects everyone she touches. Tori's mother's paternal and maternal ancestors are registered on the eastern Cherokee tribal rolls and fled into the Smoky Mountains to rebel against the Trail of Tears. With Tori, it's not hard to see the bloodlines. I've renamed Tori Ton'ingina (from the Omaha Tribe, Inshta'çunda clan), which translates into "new moon coming." Tori, in you the new moon comes—and the warm sun rises.

queen isabella

Beautiful Queen Isabella of Spain is best remembered for her sponsorship of the voyage of Christopher Columbus, which led to the creation of Spain's immense overseas empire—and the discovery of the New World. However, Isabella is also known for her instigation of the notorious Spanish Inquisition. Needless to say, some of the loveliest people are responsible for some of the most unlovely things.

When you do makeup—on yourself or others—try to free yourself of any restrictions or rules. I'm talking about the expectations and limitations you set on makeup and on what it can and cannot accomplish. Don't let me or anyone else goad or manipulate you into thinking that to attain any level of "beauty" requires anything, with the exception of open-mindedness—*beauty simply is*. The same goes for inspiration; there are no set rules or prerequisites. When Cher and I worked together on her video "Dové L'Amore," her inspirations were the famed Spanish maidens of yester-year—cloaked in black lace mantillas, passion, and mystery. I took the idea one step further, and was thinking specifically of the famed Spanish royal. With Cher's help Isabella is now cavorting in the twenty-first century, some five hundred years after her own spirit floated into the heavens. Having the freedom to create and recreate ideas and personalities with makeup should be cause for rejoicing at the vanity table. At the very, very least, it allowed me to use rhinestones and multicolored eyeshadows when evoking the Iberian queen.

Have you ever met someone and felt like you've known them forever? That's what happened when Cher and I first met. Within minutes, we were talking as if we were picking up a conversation we had the day before. We've never questioned the fact that souls gravitate toward each other. In other words, we all find the people we are supposed to be with—good or bad—in this lifetime. Cher has had a truly cathartic effect on me. To say she has changed my life is an understatement. We spend hours laughing at "Deep Thoughts" by Jack Handy. One of our favorites goes like this: "If you're a circus clown and you have a dog that you use in your act, I don't think it's a good idea to also dress the dog up like a clown, because people see that and they think, 'Forgive me, but that's just too much.'" Right now you're either rolling around on the floor or wondering what the hell is wrong with us—or both! Anyway, when I think of Cher I smile, not only because she holds a sacred space for everyone who feels "different," but also because she makes me feel very loved.

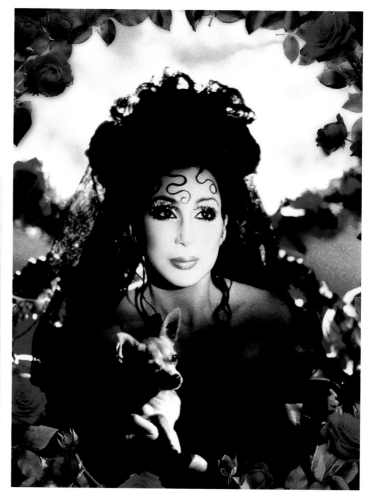

Cher as Queen Isabella

1 Prep skin with **moisturizer**. 2 Blend **pale foundation** into the skin, followed by **concealer**, if needed. 3 Fill in the brows with a **dark brown eyebrow pencil**. 4 Line eyes, inside and out, with a **basic black eye pencil**, then lightly smudge into the lashline. 5 Using a **dark brown powder eyeshadow**, define the crease of the eye and blend well. 6 Very carefully, using small **diamanté stones** and **eyelash glue**, begin applying clear stones on inner corner of the eye. Gradate outward using **iridescent stones, then pink, red, burgundy, and black**. (Hint: use the color of each stone as you would a dark eyeshadow to create depth.)

7 Apply individual **false lashes** all along the top and bottom lashline and follow with a coat of **black mascara**. 8 Using a *large blush brush*, lightly dust **soft pink powder blush** to the cheeks, temples, and chin. 9 Line and fill in the lips with a **light flesh lip pencil** and finish off with a coat of **opalescent lip gloss**.

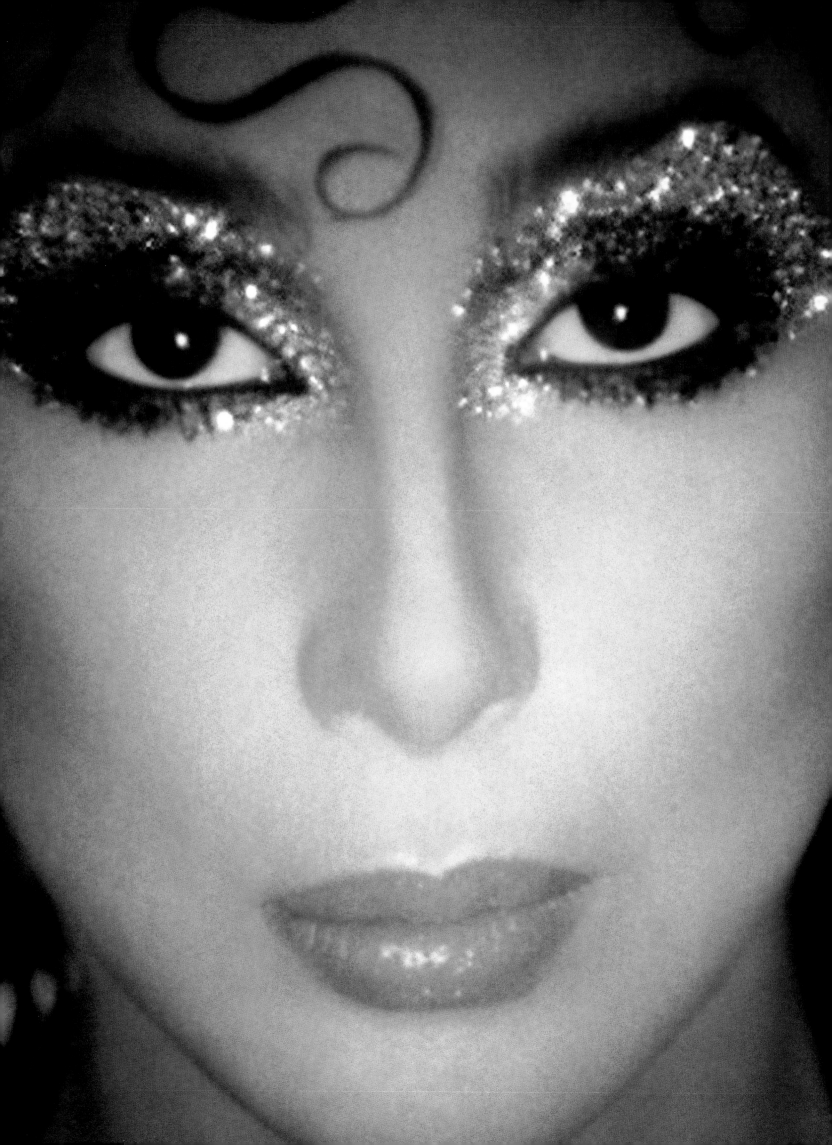

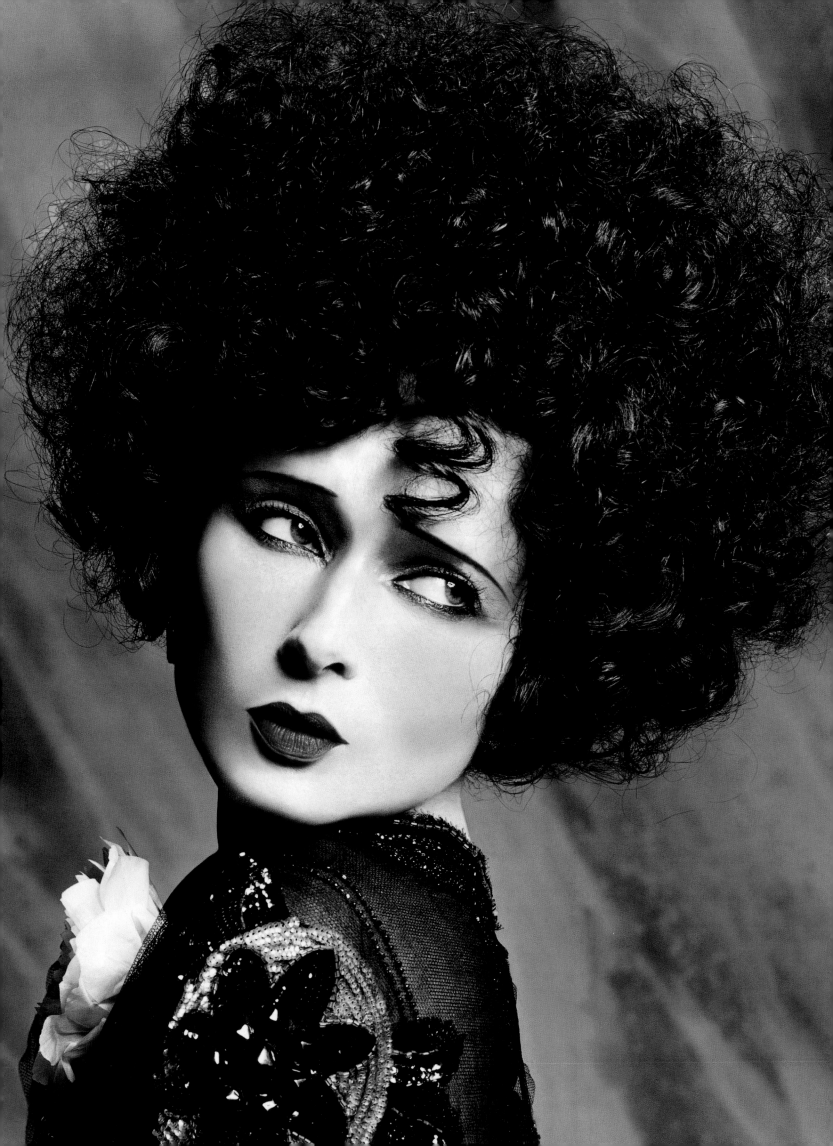

Isabella Rossellini as Alla Nazimova

1 Prep skin with light *moisturizer*.

2 First, conceal brows as instructed on page 86. (However, this brow shape is drawn close to the natural line of the brow, not above, so it may not be necessary.)

3 Using your fingertips or a *sponge*, apply a **light-colored foundation** (for a whitish pallor) all over the face, neck, and exposed areas of skin. Set with **loose translucent face powder**.

4 Using a *medium shadow brush,* apply **soft blue powder eyeshadow** to the entire eyelid, lightly under and into the crease. Blend.

5 Using a **basic black eye pencil** with a smooth softened tip, fully line the inner rim of the eye, both top and bottom, and smudge into lashline.

6 Using a *sponge-tip applicator,* smudge black liner on outer lower corner of the eye. (This shaping helps to increase the somber quality of the face.)

7 Since we are going for authenticity here, the shape of the mouth should be drawn on the *inside* of the natural lip line and corners of the mouth using a **dark flesh lip pencil**, then filled in.

8 Using a *lip brush*, fill over the lips with **dark cherry red creme lip color**, blot, and reapply.

9 With a **basic brown (or black) eyebrow pencil**, the shape of the brow is drawn horizontally across, then down at the ends and filled in. Often the inner brow can actually start a touch higher—as in the picture—then continue downward at the ends for even greater exaggeration.

10 Against the pale, pale skin, dust **soft pink powder blush**, using a *large blush brush*, on the cheekbones and temples.

This finished portrait of Nazimova shows how important brow and lip shape can be. Horizontal and downturned at the end, the brow conveys a somber mood. The lip is done in the style of the day, which was underdrawn because lip products bled into the corners of the mouth, and the shape implied a sense of innocence. Since this was also during the time of black-and-white photography, the colors used—powder blue and cherry red—come directly from the covers of movie magazines of the day, which were hand-colored.

Once lovingly referred to as "Jazzy Nazzy" because of her funloving personality, Alla Nazimova was at one time silent-era Hollywood's most powerful and highest-paid star. I'm sure many of you are saying, Alla who? I would have been among you if I hadn't happened across the amazing story of her life.

Here was a strikingly beautiful Russian émigré who trained under famed acting teacher Stanislavsky, became the toast of European and American theater, took Hollywood by storm, was partially credited with discovering Rudolph Valentino, then with the coming of sound pictures, fell from favor and was largely forgotten by the public. With all that seemed to be going for her, what hastened her disapppearance from the silver screen? In the early 1920s, filmdom's male hierarchy was loath to acquiesce to the needs of any actress, regardless of her talents and contributions—and Nazimova was notoriously demanding and proud. She was also so resolute in her professional convictions—she produced many of her own films—that she would rather have starved than compromise her artistic integrity and allow herself to be a player in an unjust and sexist system. But the biggest mark against her was her bisexuality (and a blatant disregard for the rule of the day—or should I say century?: to keep it in the closet). For all her determination and individuality, she was, as is often still the case today, simply pushed aside in favor of more pliable actresses.

A project like this gives me the opportunity to pay tribute to women of the past by intermingling them with an homage to women of the present—and hopefully, shed light on the positive attributes of both. Isabella Rossellini, whom I have known for years (and am lucky to call a friend), was eerily perfect for assuming the "role" of Nazimova. Maybe it was her own first-hand knowledge of the treachery of a male-dominated business. Regardless of the reason(s), her "silent" portrait speaks volumes.

BETTE DAVIS

Bette Davis, arguably the greatest movie star of all time, starred in well over one hundred films during her luminous career. At the start, Davis had to contend with those who told her she was not only unattractive but untalented as well. But Bette would not take no as an answer. From *Jezebel* to *All About Eve*, *Dark Victory* to *Whatever Happened to Baby Jane?*, Bette's performances were simply perfect. Most would agree that she was and remains a role model for all actors and actresses.

This portrait is a moment taken from one of Davis's early films, *Of Human Bondage*, which brought her to national attention. Eventually she would receive eleven Academy Award nominations and two statuettes. How's that for a lesson in tenacity and perseverance, and a dedication and love of one's work?

Of today's major screen actors—female or male—Susan Sarandon stands out not only for her remarkable dexterity at playing characters, but for a talent most would agree is unsurpassable. Instead of telling you what you already know, let me tell you what I have grown to love most about Susan. It is her devotion to the betterment of the world, and all its creatures—great and small. Some say politics and acting do not (or should not) mix. Fortunately, Susan has dismissed that idea and used her celebrity to advance human, animal, and environmental rights. And she won't stop until her business is complete. She is one of the people I aspire to be more like, and is simply one of the most amazing human beings I have ever met.

Susan Sarandon as Bette Davis

1 Prep skin with a light application of **moisturizer**.

2 With your fingertip, smooth a touch of **concealer** to lighten under the eye area.

3 Smooth **creme foundation** onto the center of the face and blend outward using a *sponge*.

4 Using a **basic brown brow pencil**, create a strong, horizontal brow shape with a slight curve. (Susan's brow hairs were purposely combed down at the start and at the end, to create a moody "downturned" look, while the middle part is brushed straight across.)

5 Using a **dark grayish-brown powder eyeshadow** and a *small shadow brush*, define the crease of the eyelid.

6 Then with the same shadow and brush, encircle the *outer* corner of the eye, emphasizing the lower half—to further compound the "downturned" look. Soften by blending well. (Note: this is a similar shadow shape to the one done on Mary Tyler Moore on page 26.)

7 Curl the lashes (or, if you like, add a pair of false lashes) and sweep on many coats of **black mascara**.

8 The bowed-lip shape is best created by first using a touch of **concealer** (or foundation) to cover over the natural lipline, blended and powdered. Then with a **light flesh lip pencil** the new shape can be created. The top of the mouth has soft arcing peaks . . .

9 . . . while the bottom lip is slightly overdrawn at the sides for a more pouty look. Finish the mouth by filling in with pencil, for a beautiful soft look, and lightly coat with **caramel lip gloss**.

10 A **soft pink powder blush** is lightly dusted onto the cheeks, temples, chin, even the Adam's apple and bosom with a *large blush brush*.

This portrait uses brow, eye, and lip shape to complement the setting—a re-creation of a 1930s film scene.

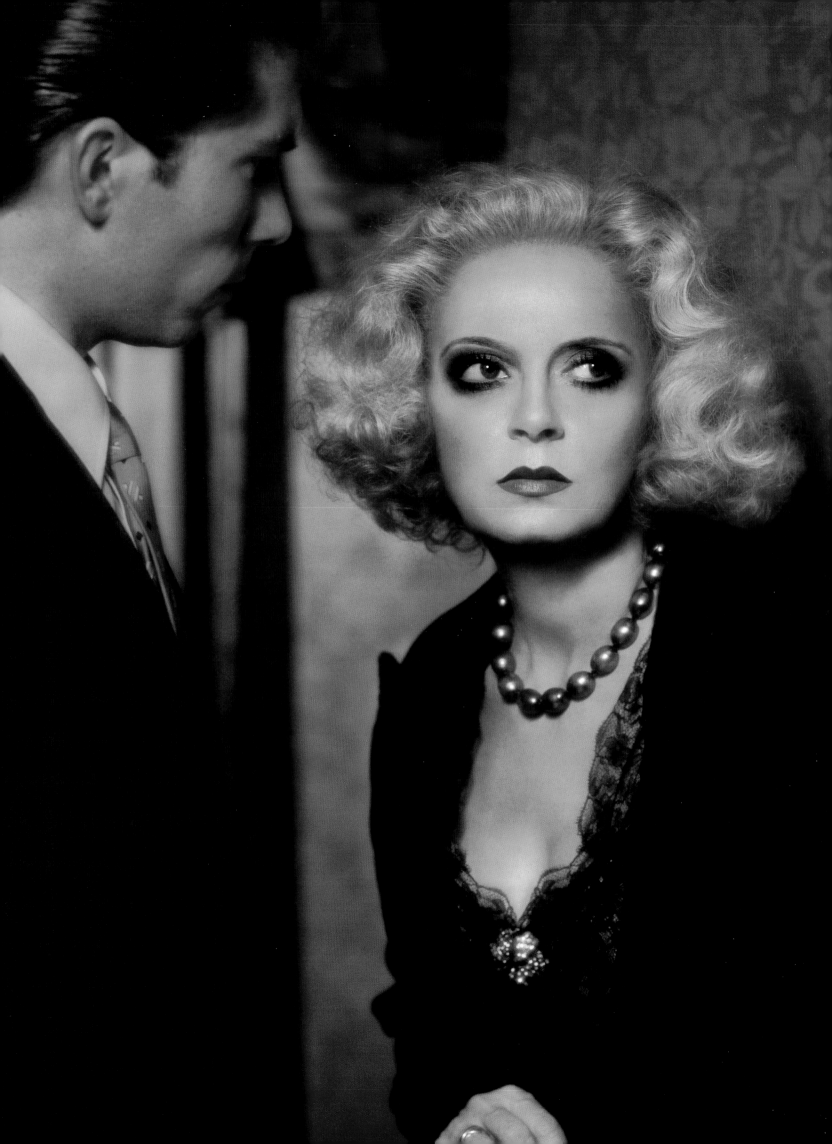

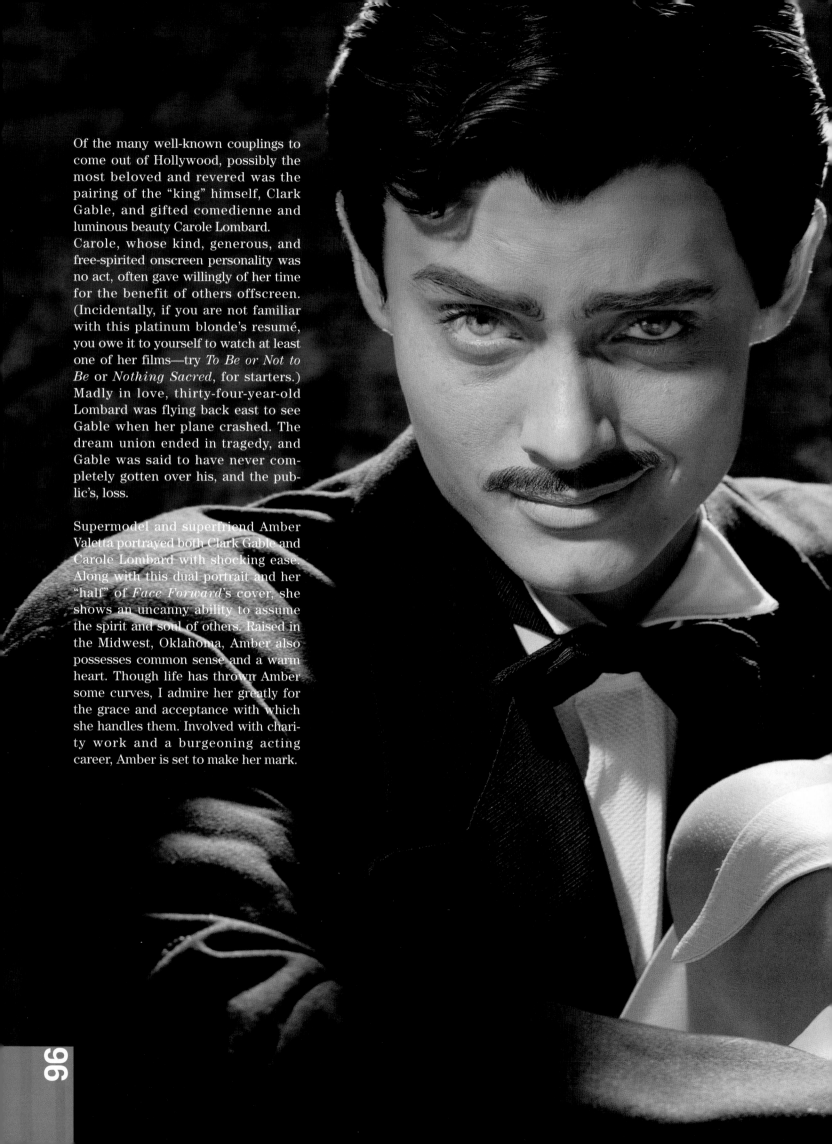

Of the many well-known couplings to come out of Hollywood, possibly the most beloved and revered was the pairing of the "king" himself, Clark Gable, and gifted comedienne and luminous beauty Carole Lombard. Carole, whose kind, generous, and free-spirited onscreen personality was no act, often gave willingly of her time for the benefit of others offscreen. (Incidentally, if you are not familiar with this platinum blonde's resumé, you owe it to yourself to watch at least one of her films—try *To Be or Not to Be* or *Nothing Sacred*, for starters.) Madly in love, thirty-four-year-old Lombard was flying back east to see Gable when her plane crashed. The dream union ended in tragedy, and Gable was said to have never completely gotten over his, and the public's, loss.

Supermodel and superfriend Amber Valetta portrayed both Clark Gable and Carole Lombard with shocking ease. Along with this dual portrait and her "half" of *Face Forward*'s cover, she shows an uncanny ability to assume the spirit and soul of others. Raised in the Midwest, Oklahoma, Amber also possesses common sense and a warm heart. Though life has thrown Amber some curves, I admire her greatly for the grace and acceptance with which she handles them. Involved with charity work and a burgeoning acting career, Amber is set to make her mark.

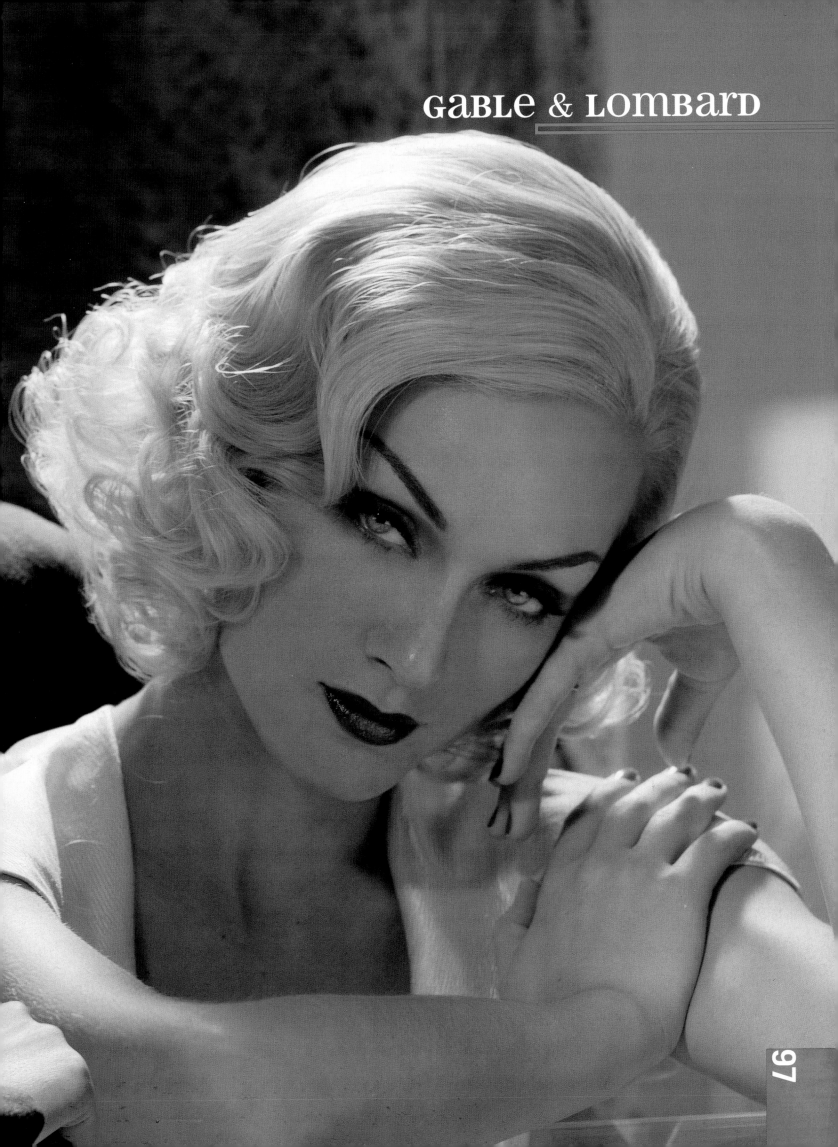

BiLLie HOLiDay

Because music is auditory—its edges invisible and boundless—it has the power to transcend boundaries. But because we like to attach a face to a voice, this form of nonjudgment and nondiscrimination often proves short-lived. Consider the life of the inimitable Billie Holiday—a woman who was so unquestionably beautiful in face, spirit, *and* voice, yet who was treated so poorly in her lifetime because of her color that it seems by today's standards nearly impossible to fathom. Nevertheless, Holiday was not alone. Even by the mid-sixties, top black female singers were not allowed to stay in the same hotel where they were performing (and, in some instances, not allowed to use the same entrance as white patrons); there were no well-paid, top black female actresses; and no top black female model had yet appeared on the cover of a major fashion magazine. If "Lady Day" had been born to a later generation, not succumbed to drug addiction (which I would argue was a result of her abuse), and been loved for, not in spite of, her color, the world would be an even more harmonious place today.

I wanted my friend Victoire Charles to incarnate Billie Holiday—and the transformation was startlingly easy. Like all memorable icons, Holiday, beyond her distinctive vocals, was also known for a signature look that set her apart from other entertainers. The look consisted of a simple sheath gown, dark berry lips, light powdery-blue eyeshadow, and, of course, her most famous accessory, a delicate, fragrant cluster of white gardenias. It looks like Victoire is developing some of her own visual signatures, too. Her beautifully shaped mouth and high-sculpted cheekbones are unavoidably distinctive in all her photos, including those on pages 32 and 33, here, and on page 173.

Victoire Charles as Billie Holiday

1 First, soften and restore the skin with *moisturizer*. Blot any excess with a *tissue*.

2 Dot **concealer** on any red spots or blemishes, and blend with *sponge* or fingertips.

3 Use just a touch of **foundation**, if necessary, and smooth outward from the center of the face. Be sure to include the eyelids.

4 Brows are groomed and filled in using light strokes of a **dark brown brow pencil**. (Note: Victoire's brows were drawn in slightly thicker toward the inside of the eye to mimic Holiday's own.)

5 A **shimmery blue powder eyeshadow** is washed over the entire upper eyelid, using a *medium shadow brush*, up to the browbone, inner corner of the eye, and out toward the top of the cheekbone. (Note: when working with a shadow in high color contrast to your skin tone, it is best to work in increments: start with less and increase the amount until desired effect is achieved.)

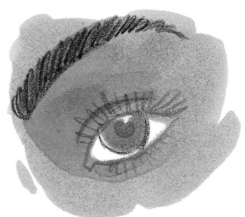

6 Using a **dark flesh lip pencil** the mouth is lined and filled in.

7 The mouth is then covered with a **deep purple creme lip color** with a bronzy cast, using a *lip brush* for accuracy. Blot and reapply.

8 **Hot pink powder blush** is lightly dusted onto the apples of the cheeks, temples, and chin with a *large blush brush*.

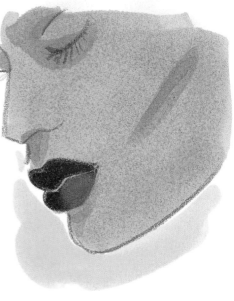

Christina Ricci as Edith Piaf

1 Prep the skin with **moisturizer**.

2 Cover the brows using *spirit gum*, *brow wax*, and *sealer*. Then conceal with **foundation** and set with **loose translucent face powder**.

3 **Concealer** is applied with a *small brush* and **foundation** with a *sponge* lightly all over the face to even out skin tone.

4 **Peach powder eyeshadow** is washed all over the eyelid with a *medium shadow brush*.

5 A **basic brown powder eyeshadow** is used to define under the browbone and lightly on the outer corner of the lower lashline using a *medium shadow brush*.

6 A **light flesh lip pencil** is used to draw and fill in the lip shape, which was slightly overdrawn on the sides of the upper half.

7 Then a **blood red liquid lip color** is used to fill in all over the mouth, blotted, and reapplied.

8 With a *large blush brush*, very lightly dust **hot pink powder blush** on the cheekbones.

What singer Judy Garland was to forties and fifties America, Edith Piaf was to France. Born to an impoverished acrobat father, Piaf performed with his troupe until the age of fifteen, then set out on her own to sing in Parisian cafés and sidewalks. She was not an overnight sensation, but when attention finally came her way, "Little Bird" soared high above the rest. Her simple presentation, almost peasant-like, was a marvelous contradiction to her powerful, expressive voice. Her songs became anthems of a country torn apart by years of war and conflict.

When I discussed playing Piaf with Christina Ricci, she was not familiar with the soulful singer. But when I told her more about Piaf's fascinating life she quickly welcomed the opportunity to "act" the part of the famed *chanteuse*.

In order to truly mimic Piaf, Ricci had to shed some of the expected trappings of a beauty portrait—there would be no elegant gown, no sparkling jewels to animate the face, and no smoldering eyeshadows to deepen the eyes. (In fact, when it came to the eyes, I knew Ricci's own soft brown irises had exactly the same soulful depth and passion as Piaf's.) Instead, what she got was a plain navy dress, no jewelry, and very little makeup (save the covering of the brows). Working with the spareness of her attire and set, Ricci was able to evoke the pure, unadulterated essence of Piaf's enormous passion.

Of course, the shape of the brows and lips are indicative of the great Piaf, but Ricci's stance adds to the poignancy of the moment. Also note that the look is light eyes and dark (or *strong* might be a better word) mouth.

veronica Lake

Perhaps there are several still well known beauties who became popular during the forties. Among them were Betty Grable, Lena Horne, Hedy Lamarr, Lauren Bacall, Lana Turner, Jennifer Jones, Gene Tierney, Linda Darnell, Rita Hayworth, and one of my all-time favorites, Veronica Lake. When Lake hit the silver screen, audiences were transfixed by her sultry voice and bewitching one-eyed gaze—from behind her trademark notorious "peek-a-boo" hairstyle. It is almost shocking, even to me, the power something as simple as a hairstyle can have over the public's interest. But even more amazing, this signature look was rumored to have come about purely by accident. It seems our young starlet was constantly having to contend with her hair falling over one side of her face during an audition. So beguiled were studio employees that she was signed on, tresses and all. However, her famed curtain of hair proved so popular that the government actually stepped in to request that Lake have it restyled; it was feared that female factory workers, mimicking their idol's look, would be prone to more accidents because of obscured vision. Beware! the unknown power of the moving picture image.

I was amazed at the striking physical resemblance between Martha Stewart and Veronica Lake (I also saw great similarities between Stewart and Lauren Bacall). Martha Stewart has, for years, been the unofficial hostess supreme for countless millions of Americans (and beyond). We love to put people in neat little boxes, don't we? That way we don't have to deal with them as three-dimensional beings. After all, viewing people as one-dimensional stereotypes means you don't have to allow them their humanity or individuality. It seems to me that the public wants Martha to look and behave a certain way. They expect her to dress casually, be well groomed, but not expose her sexier side. This photo reveals just another aspect of Martha that has been there all along.

Martha Stewart as Veronica Lake

1 Begin by prepping skin with **moisturizer**. Blot any excess with a *tissue*.

2 Apply **concealer** to under-eye area, or anywhere needed.

3 Next, a light dusting of **loose translucent face powder**, with a *sponge*, to set the concealer and give the face a matte surface.

4 Groom the brow, tweezing where needed to define the natural arch. (Note: a 1940s brow was thin and defined, but not as exaggerated as a 1930s brow.) Fill in brow where needed with a **basic brown eyebrow pencil**.

5 With a *medium shadow brush*, stroke a **basic brown powder eyeshadow** along the crease of the eyelid. Run lightly along top lashline. Blend well for a smoky effect.

6 Using a **white eyeliner pencil**, line the inner rim of the bottom lid. (This line gives the eye a dewy, sensuous quality.)

7 Curl lashes and coat with **black mascara**, top and bottom.

8 Using a **light flesh lip pencil**, draw in the mouth shape and fill in. (Note: the 1940s mouth was called a "smear," which was often greatly overdrawn—top and bottom—over the natural lipline. The intention was to create a dramatic mood with the shape of the mouth.)

9 With a *lip brush*, fill over the mouth with a **basic red creme lip color**, blot, and reapply. For added shine, coat with a **clear lip gloss**.

10 With a *large blush brush*, dust the cheeks, temples, and chin with **soft pink powder blush**.

This is a classic light-eyes-and-(not too) dark-mouth look that women have loved for years. Therefore, it transcends its 1940s setting completely. The mouth shape is also an important focal point, now as it was back during the years of World War II.

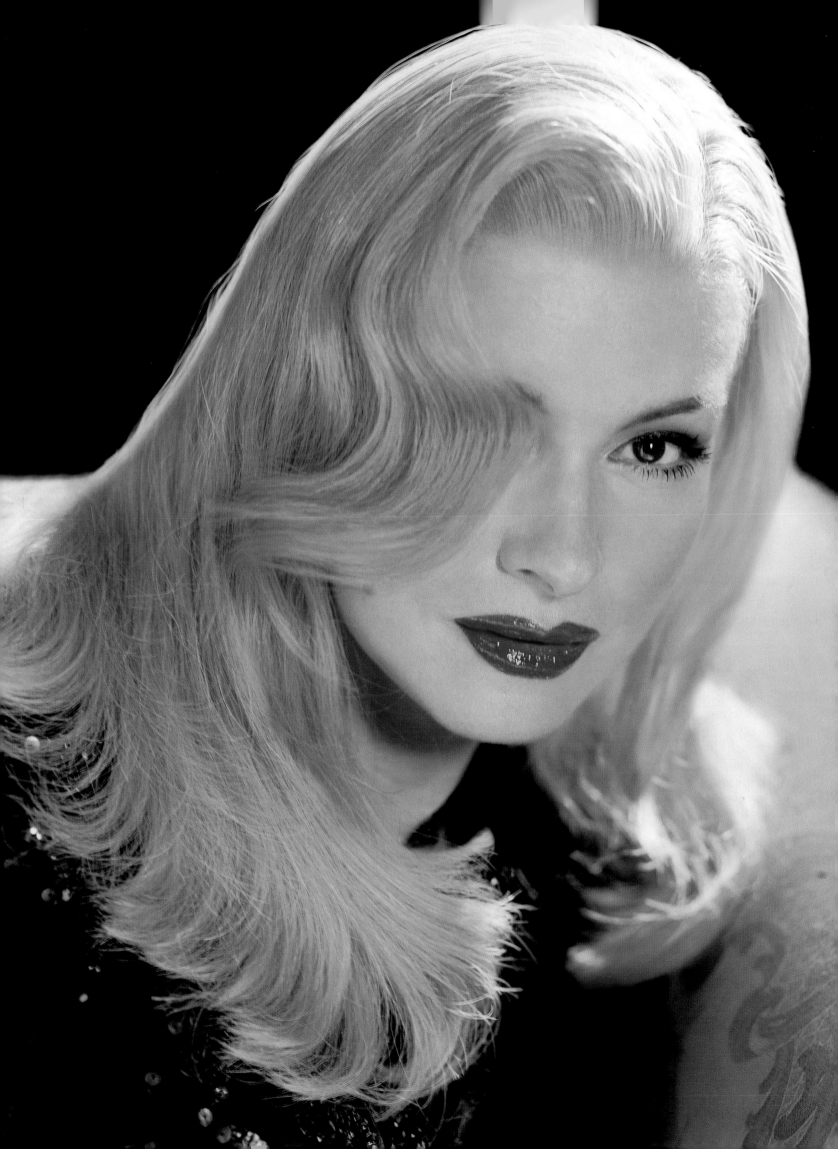

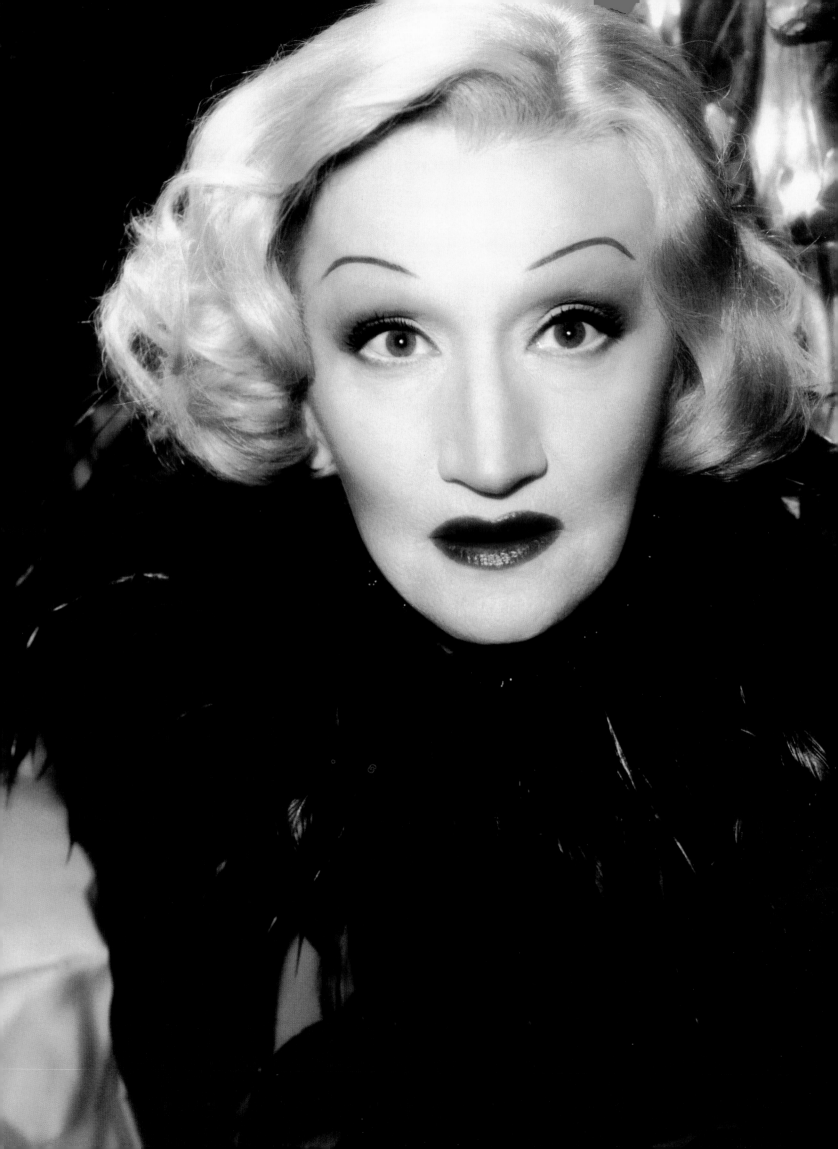

marlene dietrich

Thelma Aucoin as Marlene Dietrich

1 Prep skin with ***moisturizer***, blotting excess with a *tissue*.

2 Dot **concealer** on any red spots or blemishes, and blend with *sponge* or fingertips.

3 This look requires a full face of **foundation** to recreate the flawless matte "canvas" inspired by the black-and-white studio portraits of Hollywood's golden age. However, that does not mean you have to use foundation to excess. Just a light touch all over is all that's necessary. Be sure to blend well.

4 A dusting of **loose translucent face powder** will set the foundation and make the face even more matte.

5 Using a *small shadow brush*, a line of **black powder eyeshadow** is drawn thinly across the top lashline, concentrating on the outer two thirds of the lid. Just a touch of the same shadow is used on the outer third of the bottom lashline.

6 Using a *medium shadow brush*, a soft **brown powder eyeshadow** creates subtle contouring to the eyelid (keep to the outer half of the lid, and blend softly upward and over the browbone).

7 Apply **false lashes**. Let dry and curl with real lashes. (Note: you can lightly curl your own lashes first to create a support base before applying false lashes.) Once lashes have dried, apply a generous coat of **black mascara** to the top lashes only.

8 Line the lips with a **dark red lip pencil** and fill in. (Dietrich's mouth was always drawn in the trademark "smear" shape popular at the time. The upper lip is largely overdrawn to effect a melodramatic quality.)

9 Using a *lip brush*, fill over mouth with a **basic red creme lip color**. (Note: it may be necessary to use a darker shade of red lip color that will "appear" as red on black-and-white film.)

10 The hollows of the cheeks were contoured (again, à la Dietrich) using a stroke of **dark foundation**. Be sure to blend well. (Note: this step can be done at the beginning when entire foundation is being applied.)

11 No blush was used in this picture because it would have appeared the same as the contours to the cheeks because of the black-and-white film.

12 Finally, the brows were drawn in using a **basic brown eyebrow pencil**. (Note: my mother's brows were already quite thin, thanks to yours truly, so no alteration was needed. However, to properly recreate Dietrich's signature high, thin, arching brows, it may be necessary for you to cover yours over.)

I think of this as an "in perspective" look, because the photograph recreates Dietrich, in her fifties, with my mother, who is in her sixties.

The great Dietrich is perhaps my favorite screen beauty—and remember that list is quite long. Dietrich knew what she was doing when it came to attracting the public. Everything about her presentation was controlled—from the angle of a camera to the position of a light. All of us who work in beauty owe her a great debt. Perhaps what I loved most about her—even more than her looks—was the type of person I believe she was. (Of course, we never met.) Her early screen roles were decidedly sensual—in an age when even the hint of sex could have your film immediately yanked from release. For the health of my libido, I am forever thankful. The fact that she openly courted men and women—on and off-screen—made her a scandalous rebel without pause. She also played a major part in leading fashion out of the dark ages—she was as sexy in pants as she was out of them. (Pardon the pun.) Even when she became a grandmother, the public deemed her "The World's Sexiest." And speaking of settling down in your mature years—was that what we were talking about?—Dietrich took that tired notion and literally trampled all over it in her late fifties, when she stepped onto a nightclub stage and was an unbridled triumph. She would continue with sellout appearances well into her seventies, making monkeys out of those who felt seniors should be retired to a home. Her presence is missed by all of us who appreciate her contributions—we're not likely to happen upon another like her anytime soon.

Even I was stunned at how much my mother looked like Marlene Dietrich. But I don't know why I was so surprised; I've seen her in possibly every conceivable combination of makeup—and they're all my favorites. Take a look at her "coquettish" turn on pages 40 and 41, her "modern" woman on 152, and as "Coco" Chanel on 174, and all throughout the collages for examples of this "woman of a thousand faces."

ava Gardner

Wanna talk about stunningly beautiful Hollywood stars? Well, any conversation about lovely leading ladies would not be complete without a word or two (or more) about Ava Gardner. There are moments, when she is onscreen, where she completely eclipses all other female beauties from your consciousness. But don't take my word for it, rent *One Touch of Venus*, *Mogambo*, or *The Barefoot Contessa* and decide for yourself. While you're at it, try reading a little bit about this Spanish beauty's life, long career, and infamous marriages (to bandleader Artie Shaw, Frank Sinatra, and Mickey Rooney). If she could be married to those three gents and live to tell about it, imagine what the rest of her story must be like.

Often people ask me what it is that I see in one person that reminds me of another. Sometimes what I "see" is emotional or spiritual, but more often it is a physical similarity. Gena Rowlands and Ava Gardner have the same cheekbones, forehead, and jawline (for the famous Gardner cleft I used makeup). Together, combined with Gena's uncanny ability to embody the "part," the rest was easy. Basically, that's what it takes—a willingness to explore, experiment, and, most of all, have fun with makeup. One of the greatest blond beauties in history has now become one of the greatest brunettes.

This is mainly a setting picture, because the colors used and their application needed to coordinate with the clothes, lighting, mood—even the nails. This portrait is also an homage to one of the great portrait photographers of the twentieth century, Hoyningen-Huené.

Gena Rowlands as Ava Gardner

1 Prep the skin with **moisturizer**.

2 A touch of **concealer**, where needed. Then apply **light foundation**. (Note: To recreate Ava Gardner's signature cleft in her chin, a deep neutral foundation (in stick form) was used. The same foundation was blended into the hollows of the cheeks, along the sides of the nose, on the temples, and along the jawline. These "shadow" areas were thereby deepened and the entire look made more dramatic.)

3 The entire face is set with **loose translucent face powder**, using a *circular sponge*.

4 The brows are groomed and solidly defined using a **basic brown eyebrow pencil** and softened with **dark brown powder eyeshadow** and a *sponge-tip applicator*.

5 Using a *small shadow brush*, use **basic brown powder eyeshadow** to lightly define the lower lashline.

6 Using a *medium shadow brush*, a **bronze powder shadow** is washed over the entire eye area and well blended up over the brow bone so there are no harsh edges. **Dark brown powder eyeshadow** was used to define the crease.

7 A **peach powder eyeshadow** was used to softly highlight the inner corner of the eye and browbone, using a *medium shadow brush*.

8 **Basic brown eyepencil** is used to softly define the upper lashline.

9 **Basic black eyepencil** is used to rim the upper inner lashline; **white eyepencil** is used to rim the bottom inner lashline.

10 A touch of **dark face powder** is used to softly contour the temples and hollows of the cheeks, using a *medium-size blush brush*.

11 Curl lashes and coat with **black mascara** on top and lightly on bottom.

12 **Neutral flesh-tone lip pencil** is used to draw in the lip shape, which is slightly overdrawn at the peaks and bottom lip. Fill in with pencil.

13 Using a *lip brush*, the lips are filled over with a **natural rose creme lip color**, blotted and reapplied. Then topped off with a lick of **caramel lip gloss**.

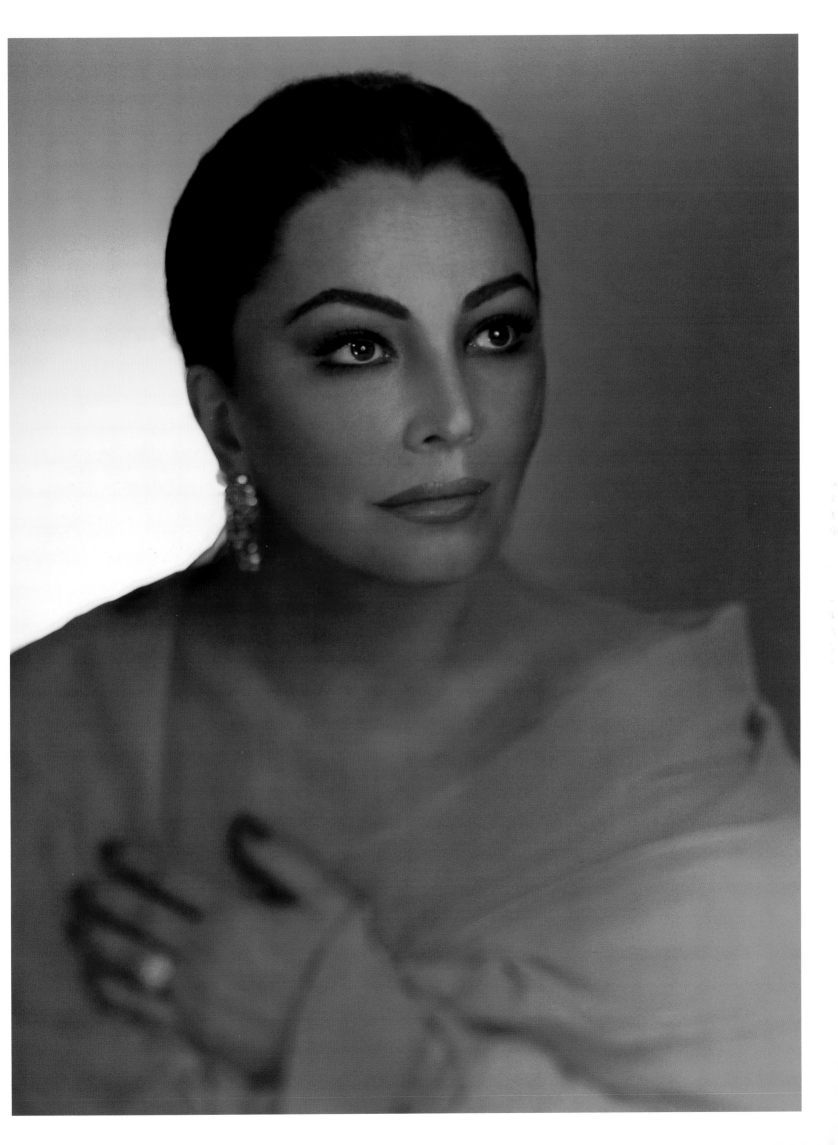

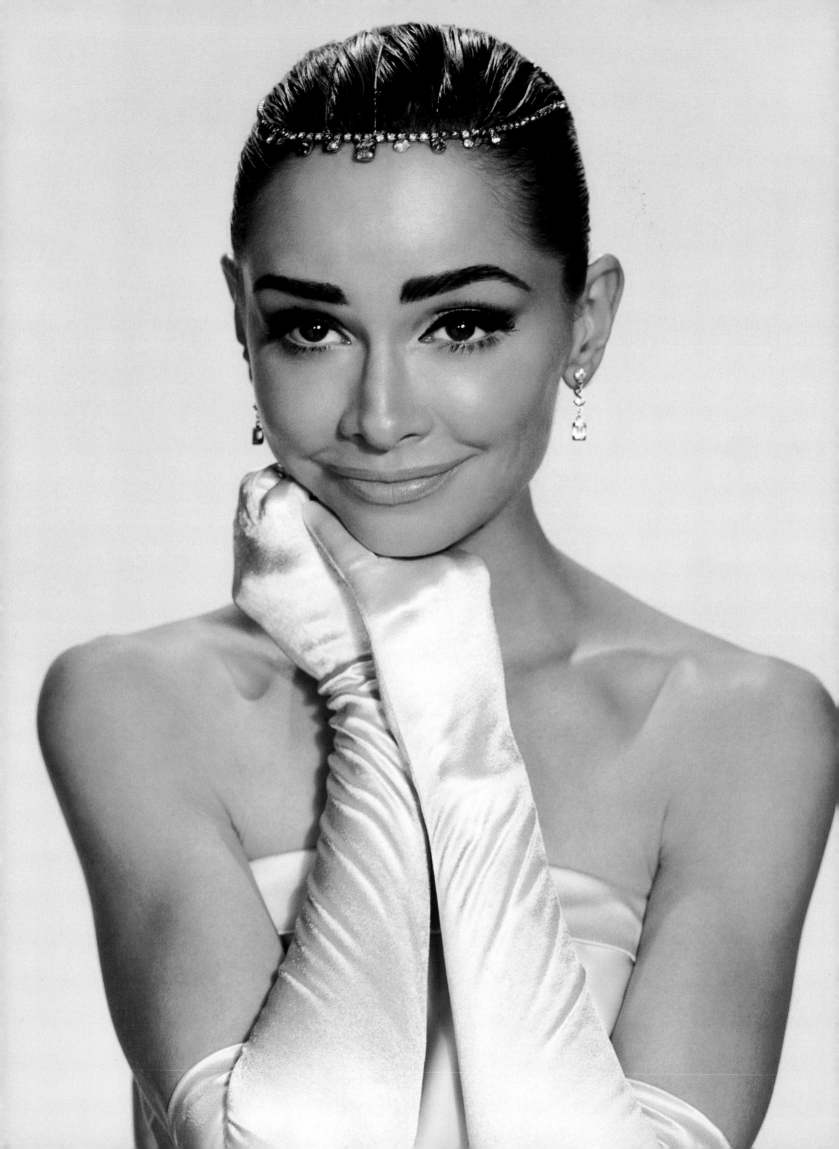

Calista Flockhart as Audrey Hepburn

1 Prep skin with *light moisturizer*.

2 *Creme foundation* is lightly applied all over the face, neck, shoulders, upper arms, and chest, blended in, and set with *loose translucent face powder* and a *sponge*.

3 *Black liquid eyeliner* is applied along the upper lashline, extending slightly out and upward at the outside corner of the eye. (Note: the line is drawn thicker along the middle of the lid.)

4 *Basic black eye pencil* is used to fill in spaces along the upper lashline.

5 *Full false lashes* are applied to upper lashline. (Note: black liquid eyeliner can be used to cover over any spots of glue.)

6 The crease of the lid from the outer corner inward is defined with *dark brown powder eyeshadow* using a *small eyeshadow brush*.

7 A heavy coat of *black mascara* is swept onto the upper lashes and lightly along bottom lashes.

8 Brows are overdrawn in the prevalent style of the day. Using a *basic brown eyebrow pencil*, the shape is made square at the center, thickly through the middle, and tapering to a fine point at the outer end.

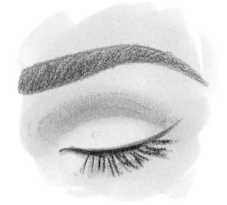

9 *Dark flesh lip pencil* is used to define and fill in the shape of the mouth, which was very slightly overdrawn on the upper and lower lips.

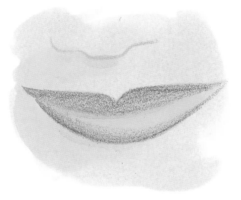

10 With a *lip brush*, *dark peach creme lip color* filled in the mouth.

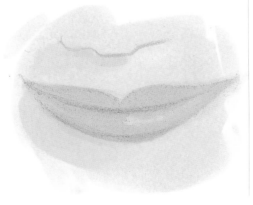

11 A very light dusting of *soft pink powder blush* is dusted onto the cheekbones with a *large powder brush*.

Though some actresses may be highly praised for their acting prowess and some others for their great beauty, Audrey Hepburn was probably the most beloved star of all—and for just being who she was. I had the supreme good fortune to have worked with her numerous times. When I was in her presence the reality of her great beauty—physical and spiritual—was obvious. To say she is missed is a vast understatement. But memories of her fill my heart with love and admiration.

How does one pick a seminal Audrey Hepburn image—when paying tribute—when there are so many from which to choose? Do I go for a moment from *Roman Holiday*? *Breakfast at Tiffany's*? *Sabrina*? I knew the best thing to do in this instance was leave things to fate. When Calista Flockhart stepped into the makeup room, I knew instantly we would go for something instantly recognizable: the classic chic of *Funny Face*.

At times, when Calista was being made up, I thought I was going to pass out. I was shocked at how much she truly resembled Audrey Hepburn. Once under the lights and against the soft pink background, Calista took on every nuance, every gesture and physicality of the iconic Hepburn. Everyone on set was speechless. Most stayed that way for the rest of the shoot. Between the camera lens and a handheld video camera I keep with me for moments such as these, there was no telling the two apart.

This is a dark-eyes-and-light-mouth face, as well as a brow-shape face, too. In fact, during the fifties, this type of brow shape was favorite look on many women. In fact, there were two brow styles prevalent during the period. This one, which was considered elegant while at the same time dramatic, and the curvaceous Monroe-Taylor–style brow, which was thought to be the more sensual-looking.

James Dean

James Dean's few but unforgettable screen appearances took place during a troubled real life. But still, his brooding demeanor matched with delicate, almost feminine features won the hearts of women and men alike and sealed his immortality. Few film legends, save Marilyn Monroe, have enjoyed such enduring idolatry from the moviegoing public. Gwyneth Paltrow, beloved daughter of actress Blythe Danner and director Bruce Paltrow, seemed destined for success. Her ascent has been meteoric, due to her brilliant talent and undeniable allure. Gwyneth's wicked sense of humor mixed with astounding beauty take a backseat to her kind and generous nature. Dean, by contrast, was abandoned by his father as a youth shortly after his mother's death, and never recovered from those wounds. For both stars, stardom was an unwanted by-product of being great actors. Fortunately, there is a powerful difference between them: Dean's self-destructive nature is nowhere to be found in Gwyneth. Yet inconceivable as it may seem, it was extraordinary how these two beauty icons—worlds apart in time, disposition, not to mention gender—somehow managed to melt into one.

For this look (Gwyneth's second after her incarnation as Faye Dunaway's Bonnie Parker, on page 122), I had only fifteen minutes to make her up and take the picture. Already late for an engagement, Gwyneth threw on her custom-made Bob Kelly wig and brows and ran on set. A few breathless moments later, with just enough time for me to emasculate her with a little blush and lip gloss, she was out the door, her channeling of the "rebel without a cause" sent back somewhere into the cosmos.

Gwyneth as James Dean is an "in perspective" portrait. Its most important aspect is in allowing yourself to see a beautiful woman as a beautiful man.

Gwyneth Paltrow as James Dean

1 To start this look, let go of everything negative you have ever felt about the opposite sex and embrace the idea of playing a guy.

2 For this portrait, "James Dean" brows were actually made and easily glued into place. However, you can simulate a masculine brow by taking a **basic brown brow pencil** and draw in the desired shape. Often, men's brows grow thicker and more uneven than women's brows. Also, there tends to be less space between the brow and eye. Hairs also tend to grow farther outward and inward. Keep this in mind, and experiment.

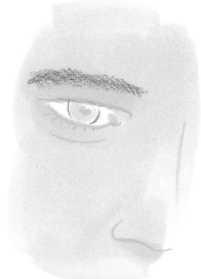

3 After drawing in brow hairs, use a **dark brown mascara** to brush through your natural hairs, making them fuller.

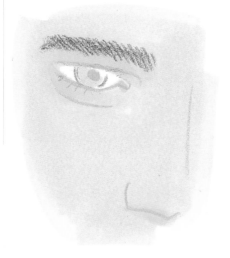

4 Using a **basic brown powder eyeshadow** and a *large shadow brush*, create natural-looking shadows under the eye and wash over the lids. Be sure to blend well.

5 Using the same basic brown shadow (or **bronzing powder**) and a *large blush brush*, sweep onto areas of the lower face where men normally have hair growth—the hollows of the cheeks, the chin, the upper lip—to create a "five o'clock shadow."

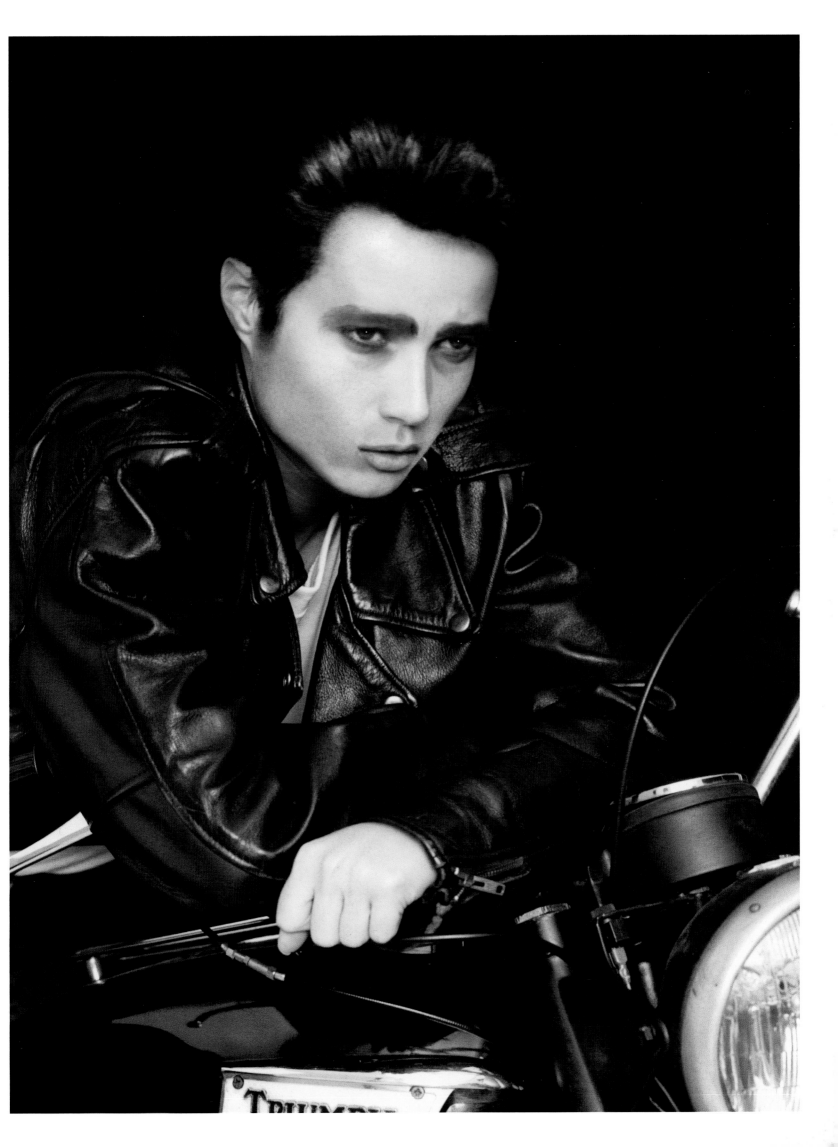

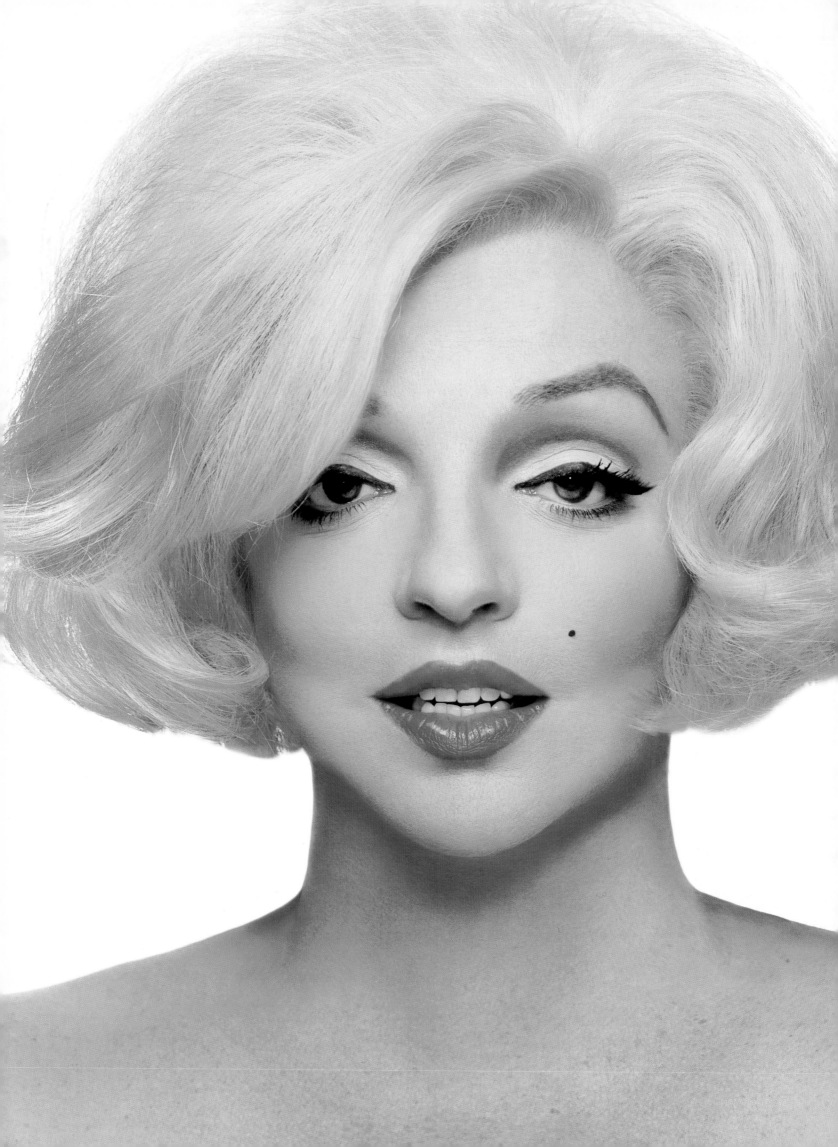

Liza Minnelli as Marilyn Monroe

1 Prep skin with **moisturizer**.

2 Groom the brows and fill in with a **golden-brown brow pencil**. Brush into place and set with a **clear brow gel**. (Note: the 1950s-style brow was thicker than the 1940s-style, and had a dramatically defined, often bent, arch.)

3 Apply **concealer** to the undereye area and smooth **liquid foundation** all over the face, blending outward with a *sponge*.

4 With a *circular sponge*, dab **loose translucent face powder** evenly all over the face. Apply extra powder under the eye, down the center of the nose, and on the chin, to act as a soft highlight.

5 With a *medium shadow brush*, apply **basic brown powder eyeshadow** to the crease of the eyelid—blending well to enhance the contouring effect—and lightly under.

6 With an **off-white shimmer powder eyeshadow** and a *medium shadow brush*, wash the eyelid, making sure to get into the inside corner of the eye. Blend well. Use the same shadow on the browbone to highlight.

7 Using a **black liquid eyeliner**, line the upper lashline, getting as close in to the lashes as possible. Toward the inside of the eye the line is thin and becomes thicker in the middle, thinning out again at the outside corner and slightly winging outward and upward.

8 Apply a *half* set of **false lashes** to the outer corner of the eye for a fluttery-eyed look. (Note: you can take one full lash and cut in half.)

9 When lashes are in place and glue is dry, curl lashes. Sweep lashes with a heavy coat of **black mascara** on top, less on bottom.

10 Line lips with a **light flesh lip pencil** and fill in. Cover with a **coral red creme lip color**, using a *lip brush*. Top off with a dab of **clear lip gloss**, smoothed onto the bottom lip. (Note: the 1950s mouth was overdrawn, but with more *sensuous* curves then the 1940s version.)

11 As a final touch, use **black liquid eyeliner** or **basic black pencil** to create a beauty mark. (Note: beauty marks can be placed anywhere on the face or body and are meant to call attention to a specific feature. In this instance it was the "Marilyn" mouth.)

This is a brow, eye, and lip-shape picture. It was important to take the shape and color of these features and enhance the similarities.

Born Norma Jean Mortenson (in 1926), Marilyn Monroe is the undisputed queen of twentieth-century sex symbols. But that dubious honor is for what Marilyn enjoyed least about her celebrity—being thought of solely in terms of the body. Marilyn was not just a plaything in a tight Travilla dress. She was more talented and intelligent then we will ever know, but had the misfortune to become popular during a time—the fifties—when women were not expected to think and act for themselves. If anything, they were expected to be trophies for men. Her untimely demise should serve as a stark reminder of our own insensitivity for the feelings of others—and our inability to allow people to be who they really are.

Of all the great women I have met over the years, few occupy a more special place in my heart than Liza Minnelli. When we first worked together in the late eighties, the two of us hit it off, as they say, "like a house on fire," and in spite of my neophyte status and her celebrity stature, we quickly became close friends. From the very start, Liza treated me with respect. To her, I wasn't the hired help, I was someone whose opinion and talent mattered. Liza has been a consistent and loyal friend—and someone I trust with my life.

Famed hair stylist Sydney Guilaroff (whose clients included Liza's mother, Judy Garland, as well as Marilyn) accidentally discovered the remarkable physical similarity between Liza and Miss Monroe while trying wigs on Liza for a movie. I thought the same thing when Liza and I first met, and have wanted to do her as Marilyn for years. However, once I viewed the finished portrait—which was inspired by the unforgettable images of Monroe by genius photographer Bert Stern—it was hard to ignore the spiritual similarity, too. Part of what makes Liza attractive is her vulnerability; the same is also an undeniable part of the allure of Monroe. That the two of them share these qualities only adds to the photo's emotional realism.

Winona Ryder as Elizabeth Taylor

1 Prep skin with **moisturizer**.

2 Just a touch of **concealer**, where needed, and lightly set with **translucent face powder** and a *circular sponge*.

3 Using a *medium shadow brush*, **dark brown metallic creme eyeshadow** is applied in an oval shape over the entire lid and toward the inner corner, and lightly under the eye.

4 **Black liquid eyeliner** is applied in a thick line along the top lashes and lightly along the bottom lashline.

5 To curled top lashes, glue a set of **full false lashes**.

6 **Black mascara** is swept in two coats on the upper and lower lashes.

7 **Dark flesh lip pencil** is used to draw and fill in Taylor's lip shape (which was curvy and full).

8 With a *lip brush*, the lips are filled over with a **basic red creme lip color**, blotted and reapplied.

9 The brows are lightly tweezed and the signature Taylor brow is made using a **dark brown brow pencil**. The shape of the brow is very feminine and curvaceous, drawn thicker and thinner before tapering to a point.

10 Just the tiniest hint of **soft pink powder blush** is dusted onto the cheeks with a *large blush brush*.

11 The beauty mark is made using the fine brush point of a **black liquid eye pencil**.

12 To maximize the "Liz" look, wear a pair of violet-blue contact lenses.

I have had the great luck to work with many of the screen's most famous and beautiful women. But of all the legendary film actresses whom I have had the privilege to work with over the years, few have the same palpable aura of genuine star presence as Elizabeth Taylor, often referred to as "the most beautiful woman of all time." When it came time to plan out this book, I couldn't wait to pay her homage.

Among Taylor's many memorable screen characterizations, Maggie from 1958's *Cat on a Hot Tin Roof* is one that stands out. Her Oscar-nominated portrayal of a woman fighting to regain the affections of a man who no longer wants her seethes with raw sensuality—you can almost hear her heart beat and see her blood racing. The publicity images of Taylor, in a barely concealing slip, grasping at the frame of the couple's unmade bed, were also some of the most provocative visuals of the day.

From the first moment I met Winona Ryder, I saw a part of her that reminded me physically of Elizabeth Taylor. So when the opportunity to transform her presented itself, I knew exactly what I was going to do. What I wasn't prepared for was the very short amount of time I would have to get her ready for the picture. When Winona arrived at the studio, we did as we always do—talked. She's like my little sister and I feel like her big brother. When we're together, the laughter never stops. Once we realized the hour, she had about thirty minutes left before needing to leave for a Golden Globe awards show rehearsal. Fortunately, this makeup is not nearly as complicated as you might think—really just red lips, eyeliner, and eyebrows. No one on the set could believe how much Winona and Elizabeth merged to become one.

Like the Marilyn portrait, the main objective was to take Elizabeth Taylor's signature brow, eye, and lip shapes and merge them with Winona's features.

maria callas

There is often great beauty to be found among the ruins of great tragedy. This is part of the fantasy and the reality of the world of opera. Maria Callas's abusive and deprecating mother forced her daughter to believe that she was either completely worthless, or exactly the opposite. If you have read or heard anything about this great tragedienne's life, you already know which course this ill-fated beauty's life took. From superstardom that seemed never to satisfy her to destructive love affairs, Callas never once felt the same enjoyment she gave to so many others with her mesmerizing voice. A doomed diva in every sense.

Though no stranger to the same poverty that surrounded Callas's childhood, singing sensation Celine Dion had the good fortune to grow up with the love and support of a mother who believed in who she really was. And though Callas and Dion both fell in love with men much older than themselves, Celine enjoys one of the most loving relationships I have ever seen, while Callas died alone of a broken heart. And though these women have two of the most powerful and distinctive voices in all of musical history, Callas's legacy is—amidst the triumphs—shadowed with pain, while Dion is recording for herself a much brighter lifetime filled with joy and contentment.

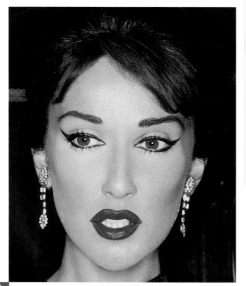

Celine Dion as Maria Callas

1 First, skin is prepped using a **light moisturizer**.

2 Spot **concealer** and a **matte foundation** is used all over the face and blended outward.

3 A continuous line of **black liquid eyeliner** is drawn along the top and bottom lashes, joined at the outer corner, thickened, and extended outward and upward.

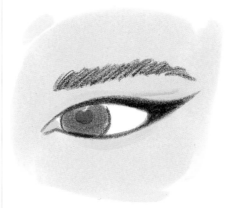

4 Eyebrows are dramatically groomed and defined to emphasize the arch with a sharpened **basic brown eyebrow pencil** and **black liquid eyeliner**.

5 **Black mascara** is swept onto curled lashes.

6 Using a **light flesh lip pencil**, the mouth was drawn in, exaggerating the shape by overdrawing, then filled in. On top, a **blood red liquid lip color** was "smeared" on, blotted, and reapplied.

7 Just a tiny touch of **soft pink powder blush** was dusted onto the cheeks.

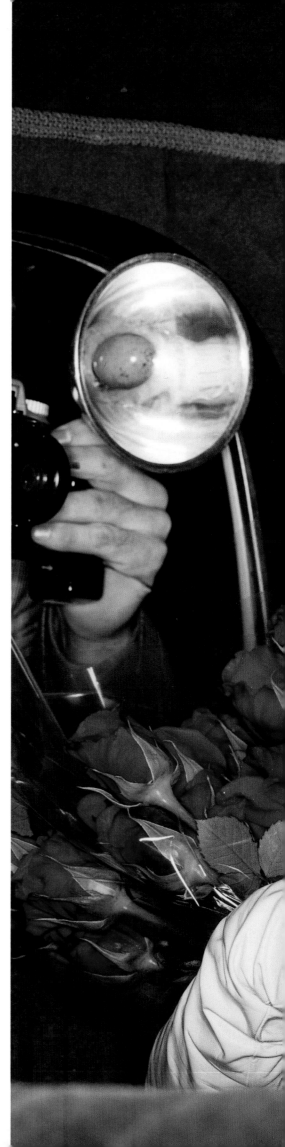

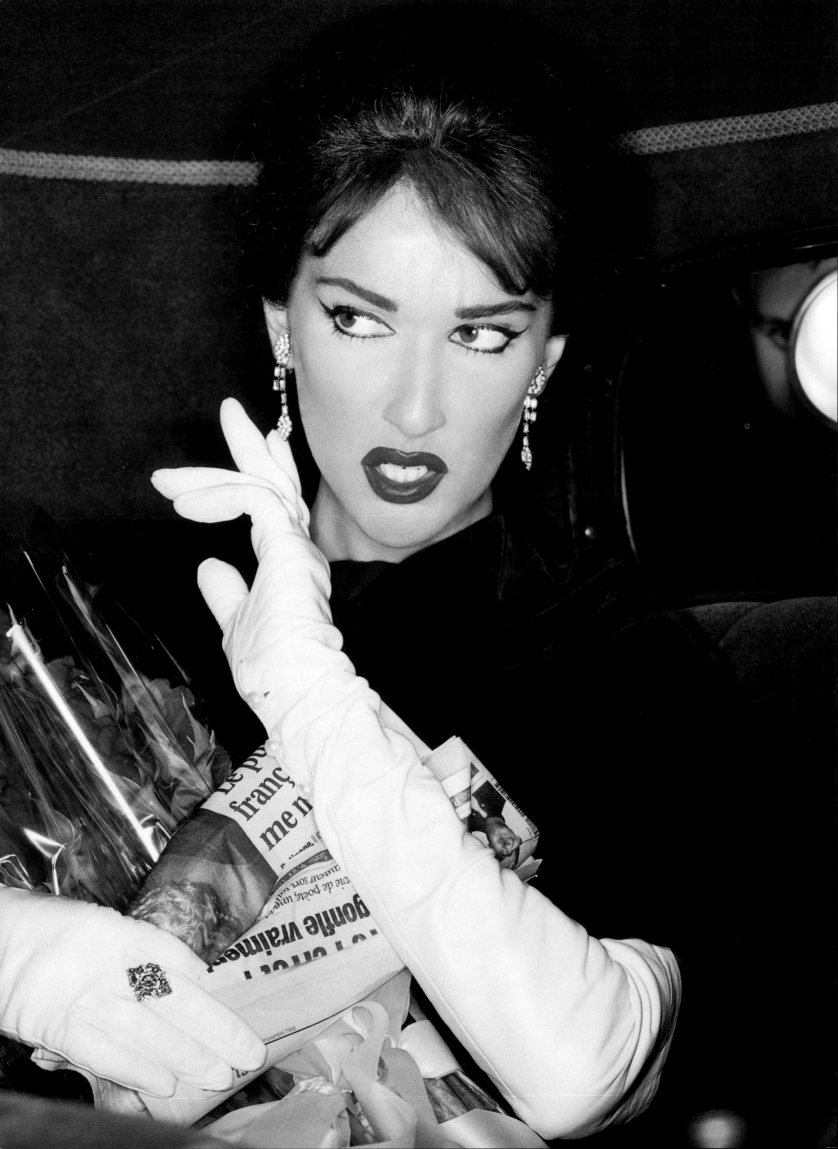

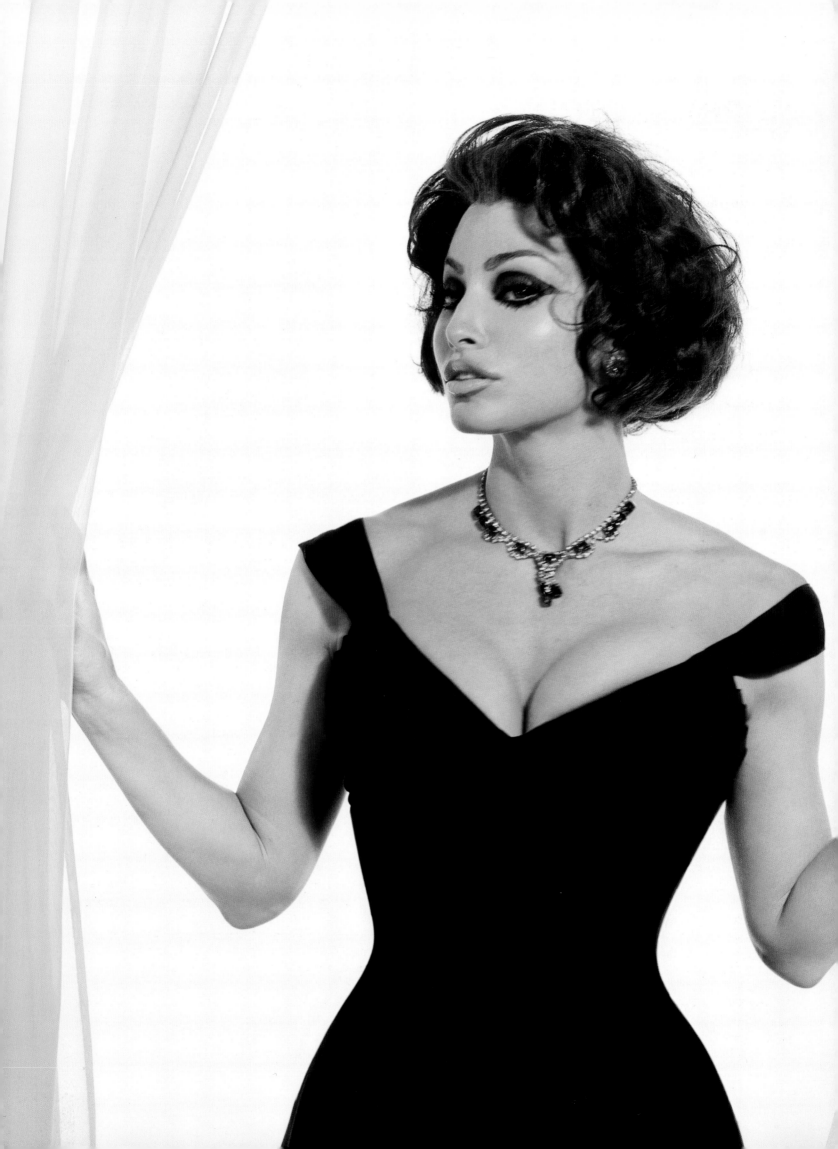

sophia loren

Any summary of Sophia Loren's life would not do her justice—she is larger than life—and certainly the cramped confines of a single paragraph in this book couldn't come close to capturing and coveying her true essence. But that wasn't going to stop me from paying tribute—not me—in whatever way I could.

Born in poverty and illegitimacy, Loren went on to become one of the most beloved sex symbols of all time (where she remains). But Loren has always been far more than just a body full of curves—her real popularity comes from passionate acting and an obvious zest for living. Her gusto is contagious, even to this day, and proof that true beauty, is not just what you see, but what you feel. It has no limits—in age, ethnicity, or temperament. Viva, La Loren!

Gina Gershon as Sophia Loren

1 Prep with *moisturizer*. 2 *Foundation* and *concealer* were used in spots where needed. 3 The brows are tweezed to expose a gentle curve, which is dramatically defined, using a *basic brown eyebrow pencil*, to a long tapered point. 4 A *charcoal-gray powder eyeshadow* is applied, using a *medium shadow brush*, to the lid of the eye from the crease to the lashline.

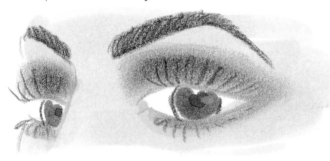

5 Using *black liquid eyeliner*, the crease of the eye is intensified, arched toward the inner corner of the eye, and extended slightly downward at the outer corner. Soften the line with charcoal-gray shadow.

6 *Basic black eye pencil* is used to rim both the upper and lower inner lashline. 7 *Full false lashes* are applied to *both* top and bottom lashes and swept with *black mascara*. 8 Using a *dark flesh lip pencil*, the mouth is shaped and filled in. 9 Using a *lip brush*, the mouth is filled in with a *medium flesh-toned creme lip color*, blotted and reapplied. 10 Just the tiniest hint of *soft pink powder blush* is dusted with a *large blush brush* high on the cheekbones, temples, forehead, chin, and bosom.

gina gershon

Several years ago at an AIDS benefit in Los Angeles, I saw Gina Gershon across the room. I had just seen the film *Bound* (one of my favorites movies) and wanted to share my enthusiasm with her. One of the great bonuses of my work is that I get to tell people whom I admire and love how their work has affected my life. In this way, I am able to complete the circle. Gina was so approachable and warm, she felt immediately like an old friend.

When it came time to match personalities to personalities in "Dimensions," right away I thought of Gina for my take on Sophia Loren. Of course, Gina's unabashed sexiness made her an obvious choice, but what I wasn't prepared for was how much she would end up looking like and emulating the much-adored Loren. There were times on set when Gina, bursting through the gauze curtains, actually made it look and feel like we were on the soundstages of Cinecitta in Rome.

Gina as herself, above: 1 *Moisturizer* preps the skin. 2 Groom brows and fill in with *basic brown eyebrow pencil*. 3 *Concealer* in spots. 4 Lightly powder. 5 *Bright red creme blush* is smoothed lightly to the apples of the cheeks, chin, temples, and forehead. 6 A *dark brown creme eyeshadow* using a *medium shadow brush* is washed on the lids and lightly under the eyes. 7 Then a *peach powder eyeshadow* is used to highlight the browbone. 8 *Black mascara* coats the lashes. 9 Lips are softly defined with a *blood red liquid lip color*, blotted, then lightly coated with *clear apricot lip gloss*. 10 With a *large blush brush*, lightly dust *hot pink powder blush* on the apples of the cheeks. (Layering blush products gives the cheekbones added dimension.)

julie christie

The character of Lara from Boris Pasternak's novel *Doctor Zhivago* is one of the most beloved and tragic figures in modern literature. The story was brilliantly brought to life by acclaimed director David Lean, who understood the grand scope of the visual canvas painted by Pasternak's words, as well as the intense intimacy he evoked with his ill-fated lovers in revolutionary Russia.

As amazing as the entire production is (which begs to be seen in all its full-screen glory), the pièce de résistance was the casting of sensational new star Julie Christie in the coveted female lead. Christie's nearly hypnotic presence was a combination of skillful acting and luminous beauty (which one player in the film rightfully remarked as seeming "far away"). Though I was too young to have seen it upon its initial release in 1965, by the time I finally viewed *Doctor Zhivago* on the small screen years later, the popularity of the film and Christie's beautiful performance were already legendary.

When I asked Julia Roberts if she was willing to be transformed into Julie Christie from *Doctor Zhivago*, I was pleased but not surprised to learn that the film (and Christie's role) were among her favorites, too. Something told me that with Julia's understanding of the character she was to portray, there would be no problem capturing the essence of Julie Christie as Lara. The resulting image is my tribute to the haunting original.

This is a dark-eyes-and-light-mouth face. However again, the eyes are dark only in relation to the mouth, which is colored almost to blend in with the skin tone of the face. Also note how eyeliner and the soft use of shadow on the outer edge of the eye widens the face ever so slightly.

Julia Roberts as Julie Christie in *Doctor Zhivago*

1 Prep skin with ***moisturizer***.

2 Groom and tweeze the brows. Fill in and shape using a ***basic brown eyebrow pencil***. Then brush brows upward with a *spooly brush*.

3 Apply ***light foundation*** with fingertips or *sponge*, blending outward from the center of the face. Using ***loose translucent face powder*** and a *sponge*, set foundation (which will also give the face a matte look).

4 Using a *medium shadow brush*, apply ***whitish-beige powder eyeshadow*** to the eyelid, crease, and browbone.

5 Apply a set of ***full false lashes***. When dry, curl together with real lashes.

6 Using a ***black liquid eyeliner***, define the upper lashline. Be sure to get to the base of the lashes and leave no empty spots.

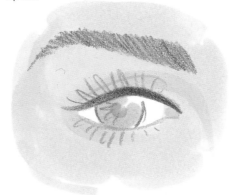

7 Using a ***basic brown powder eyeshadow*** and a *medium shadow brush*, lightly define the outer corners of the eye and blend well to soften and create a smoky effect.

8 Along the top lashes, sweep ***black mascara***. Along the bottom lashes use ***burgundy mascara*** (this color will make light-colored eyes stand out more).

9 Using a ***light flesh lip pencil***, line and fill in the entire lip area. Using a *lip brush*, over the pencil apply a ***pale gray-pink creme lip color***, then blot. Over that, dust ***loose translucent face powder*** all over the mouth to set the lips. Then reapply the lip color one more time, and blot.

10 Using a *large blush brush*, bring the whole face together with a dusting of ***soft pink powder blush*** on the cheeks, temples, chin, and forehead.

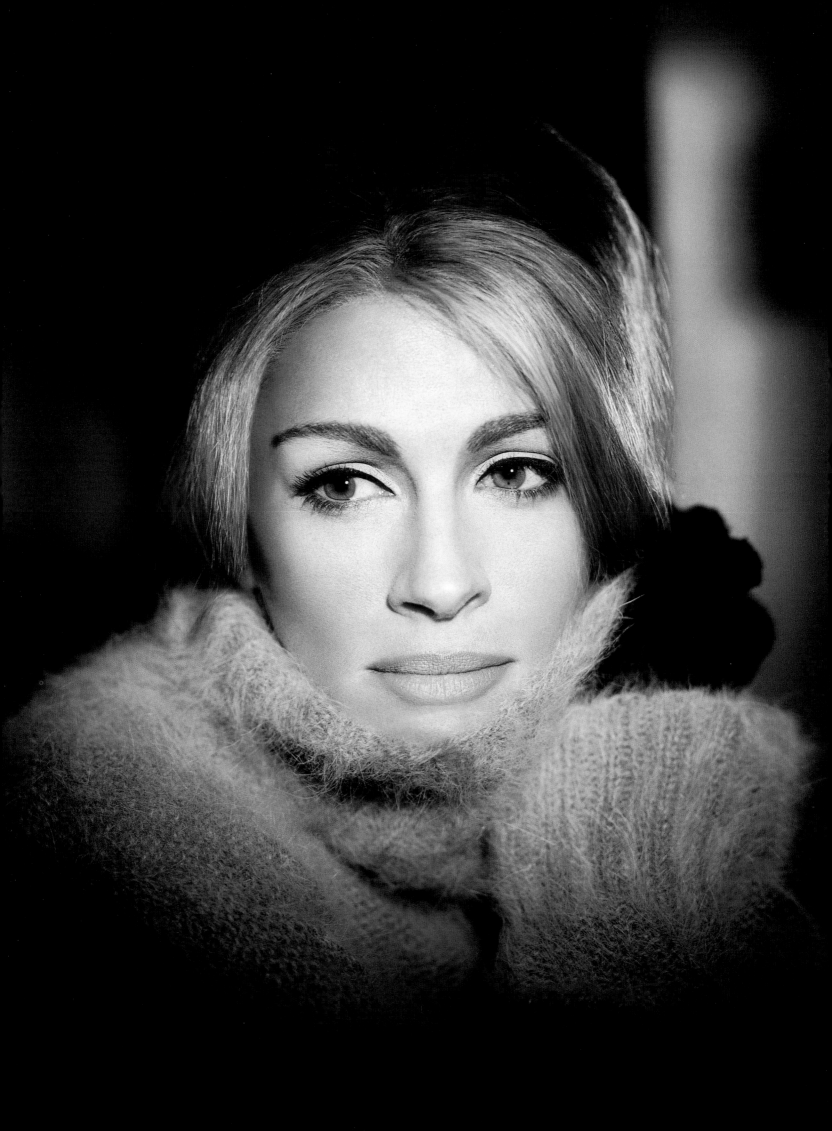

Faye Dunaway

Bad girl Bonnie Parker (with bad boy Clyde Barrow) left this world in a hail of gunfire just a few miles from where I was born, in Shreveport, Louisiana. In the evocative 1967 Arthur Penn (brother of Irving) film, *Bonnie and Clyde*, Parker was played by the brilliant and stunningly beautiful Faye Dunaway (herein portrayed by equally brilliant and stunningly beautiful Gwyneth Paltrow). From her blunt-cut blond bob to her Mary Janes, Faye's Bonnie Parker will go down in film and fashion history as one of the chicest gun molls ever recorded on celluloid.

For those who might think I'm glamorizing violence and crime (the same criticism that was leveled at the film itself) with this picture, I'd like to go on record as stating that I am totally in favor of gun control. Needless to say, I'm very opposed to shooting people and robbing banks. But with that said, bad girls always have their appeal. We often find ourselves drawn to those females who can hold their own in a man's world—and frequently these forerunners of feminism ran on the other side of the law.

When it comes to creating a beauty look, I have lots of fun when I "layer" my inspirations. In the last two photographs, you see not only the model playing the role of a star, the star she is "playing" is also assuming a role. Still with me? This is one way to show the true dimensional quality of beauty—it is not flat. The best type of beauty image illicits many responses beyond the appreciation of pretty lips, a sculpted nose, and contoured eyes. It involves what you see, what you don't see, and what you feel. It's also a key into the way my mind works when creating these looks; sometimes I like to mix things up. As if you hadn't already noticed.

The setting takes precedence here. Without the thirties-style clothes and car, Gwyneth's light-eyes-and-light-mouth makeup would look great in any decade.

Gwyneth Paltrow as Faye Dunaway in *Bonnie and Clyde*

1 Apply *moisturizer* to prep the skin.

2 Groom the brow area using *tweezers* and a *brow brush*. Fill in and accentuate the brow shape using a ***basic brown eyebrow pencil***. Brush upward and apply a sweep of ***clear brow gel*** to keep in place.

3 Apply spot ***concealer*** where needed to even out skin tone and areas that may have slight discoloration, particularly under the eye.

4 Using a *medium shadow brush*, lightly wash ***basic brown powder eyeshadow*** to the upper eye area and softly under. Blend well.

5 Softly stroke ***pale beige powder eyeshadow*** along the browbone to highlight, using a *medium shadow brush*. Blend well. (Remember that the key to soft-looking makeup is application—specifically, blending.)

6 Curls lashes and apply a few coats of ***black*** (or, if you prefer, dark brown) ***mascara*** to upper lashes only.

7 Line lips with a ***light flesh lip pencil*** and fill in. Then with a *lip brush*, cover with a ***natural rose creme lip color***, blot, and reapply.

8 Top off the lips with a light coat of ***caramel lip gloss***.

9 With your fingertips, smooth a light application of ***soft rose creme blush*** onto cheeks, temples, and chin.

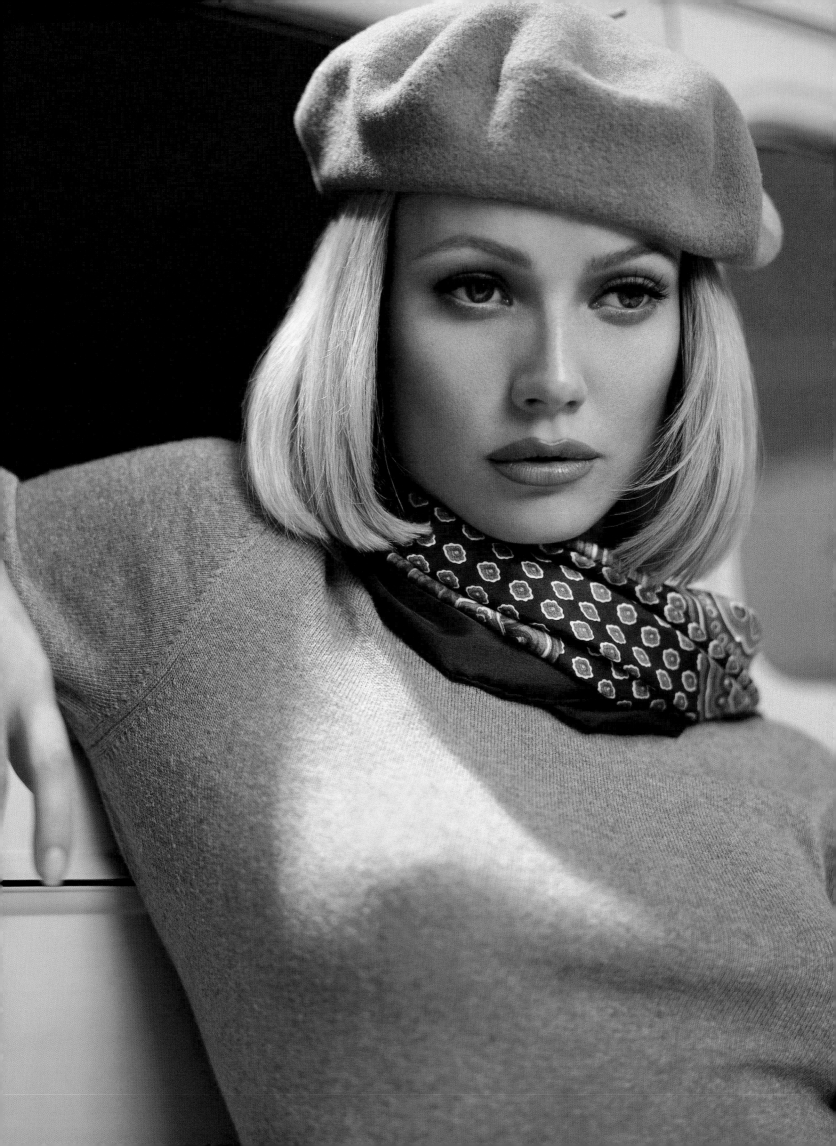

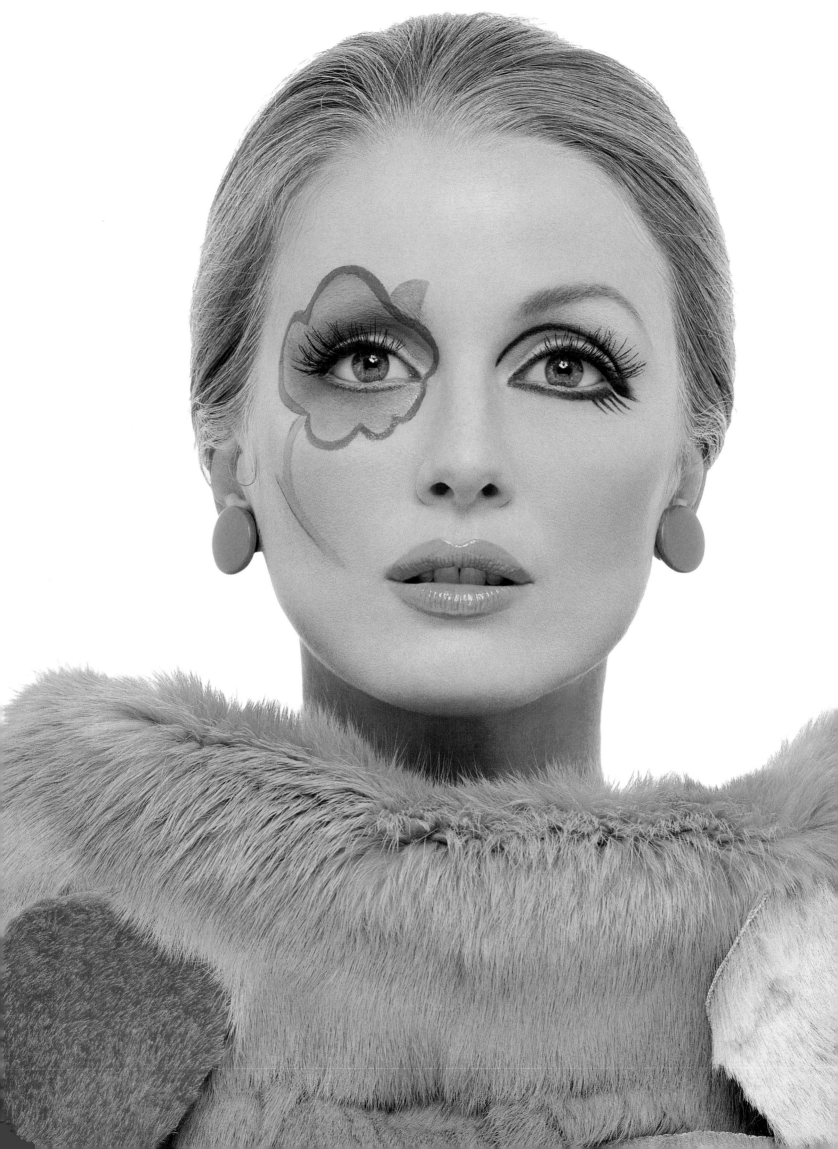

Julianne Moore as Twiggy

1 Prep the skin first with **light moisturizer**, then apply **concealer** to spots where needed and blend. If desired, use a light application of **foundation**, especially around the eyes, where most of the makeup is concentrated.

2 The left eyebrow is covered using *brow wax*, *sealer*, and *spirit gum*. Once dry, it is covered with foundation (as above) and set with **loose translucent face powder**, along with the rest of the face.

3 Only the inner *upper* lashline of both eyes is rimmed with **basic black eye pencil**. The line is smudged into the lashline with a *sponge-tip applicator* or *cotton swab*.

4 Using a *small shadow brush*, **basic black powder eyeshadow** is used to define the crease of the *left* eye. (Note: the line does not follow the arc of the natural crease.)

5 **Black liquid eyeliner** is used to emphasize the shadow line, then used to encircle the entire *left* eye, along the upper and lower lashline. (Note that the line does *not* meet at the outer corner.)

6 With the same liquid liner, draw in false lashes along the bottom outer edge of the lashline.

7 On the *right* eye, **sky blue creme eyeshadow** is used to make a handdrawn flower (using a *medium shadow brush*), then outlined using a **bright red creme eyeshadow** (using a *small shadow brush*). The stem and leaf are drawn using **chartreuse creme eyeshadow** and a *small shadow brush*, edged in light strokes of a **basic brown eyebrow pencil**.

8 Using a *small shadow brush*, a touch of **dark blue powder eyeshadow** was used to softly define the crease and under eye—matching the same arc as the left eye.

9 Lashes were curled and a pair of **thick false lashes** were applied, then coated with **black mascara**, just on the top lashes.

10 With a *small shadow brush*, a touch of **off-white shimmer powder eyeshadow** was used on both eyelids and on the browbone of the *left* eye.

11 Lips were lined using a **light flesh lip pencil**, then filled in and covered with a **sheer red lip gloss**.

With the world recovering from the repressive, McCarthy-era, questionable family values of the 1950s, the youth culture of the sixties exploded with an idealism that forever altered the course of modern history. Young people coming of age felt, and rightfully so, that the conservative status quo put in place by the "establishment" disenfranchised much of the nation.

Few people are as closely identified with the sensibility of that revolutionary decade as Twiggy. Considered androgynous because of her boyish physique, She was in reality far from masculine. But the concept of blurred sexuality itself was shattering enough to make Twiggy the poster girl-boy of a new generation of young and forward thinkers.

When it came time for some flower power, I turned to my friend Julianne Moore to help me capture the spirit of that innocent age. Julianne's natural beauty combines the knowledge of a worldly woman and the innocence of a child—the perfect combination for this Pop Art image.

This image is also an homage to master photographer Richard Avedon, whose work has inspired me, and countless others, over the years. I have had the opportunity to work with Mr. Avedon many times and the experience has been overwhelming. His talent is immense and inescapable. This photo is a loving tribute.

There are a few things to consider with this fanciful look. The first is that in relation to balance it really pushes the envelope; one might see it as a light-and-light combination or as dark-and-light. It is also very much a shape look, to the point where the flower can be drawn to any degree the artist (yourself) wants. It is also interesting to see how eyeliner and eyelashes (handdrawn on and/or glued), exaggerate and enlarge the size of the eye—quite a bit. Last, it is also a color face, which uses shades limited only by one's imagination.

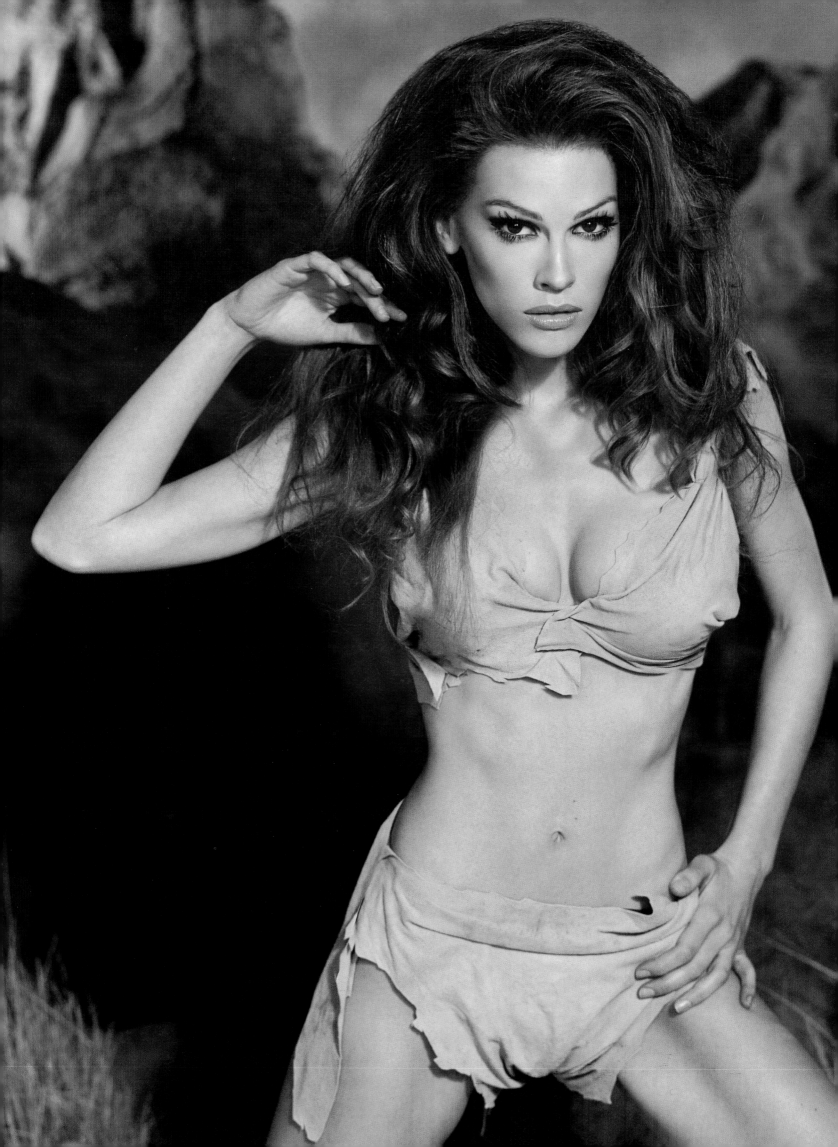

raquel WELCH

I had the chance to work with Raquel Welch a few years back, and let me tell you she is as beautiful in person as you would hope—outside and inside. I also learned a thing or two about makeup from her. Not only has she pretty much done her own for years—she's a true artist—she's very funny and we had a great time together.

Hilary Swank as Raquel Welch

1 Apply light *concealer*, if, and where, needed. **2** Shape the brows into a low, angular arch and fill in with *basic brown eyebrow pencil* to define. **3** Using a *medium eyeshadow brush*, wash over the entire eye area, from lightly under to just above the browbone, with a *basic brown powder shadow*. **4** Using the same medium shadow brush, use a *dark brown powder eyeshadow* to define the crease, going all the way from the outer to the inner corner of the eye, and along the lashline, top and bottom, emphasizing the outer two thirds of the eye. **5** Using a smooth-tipped *white eye pencil*, carefully draw along the lower inner eye rim. Extend the line just slightly at the outer corner of the eye. (This eye-opening technique was wildly popular during the go-go sixties. If done well, this gives the illusion of a wider eye.)

6 Using a *small shadow brush* or your fingertips, dab and blend a small amount of *white pearlescent creme eyeshadow* to the inner corner of the eyes along the bridge of the nose. (This technique is used to heighten the wide-eyed look.) **7** A full set of dense *false lashes* is applied to curled upper lashes, then both the upper and lower lashes are brushed with two coats of *black mascara*. **8** Using a *dark flesh lip pencil*, draw in the lip shape—slightly exaggerating to heighten fullness, if desired—and fill in with *natural rose creme lip color* using a *lip brush*. **9** Using a *large blush brush*, lightly dust the apples of the cheeks, chin, and temples with *hot pink powder blush*. (Note: in a getup like this, you may need to heighten your cleavage using contour and highlight. Just be sure to add sparingly and blend well.)

Compare Hilary's two pictures and you can see that while her homage to Raquel is a setting and balance picture, the makeup focus is definitely on the shape of the eye.

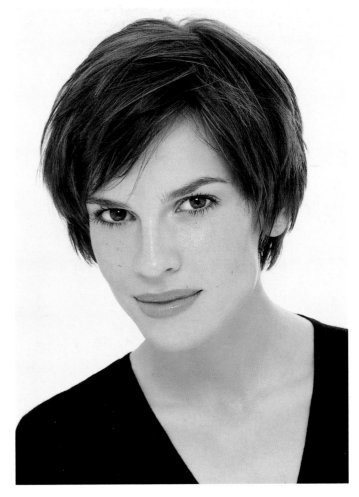

Hilary swank

Last year, the Hetrick-Martin Institute gave their twentieth-anniversary Emery Awards to Attorney General Janet Reno, Cher and Chastity Bono, Connie Chung and *20/20*, and me. The awards honored all of us for our work with gay youth. For that one evening, Hilary Swank flew from Los Angeles in the middle of her hectic schedule to emcee the event. At the time, her performance in the film *Boys Don't Cry* was winning high praise from critics and audiences alike. The character she played, Brandon Teena, struggled to be loved for who he was—a struggle he tragically lost. Hilary's performance was so authentic and disturbing that I had to walk out of the film the first time I went to see it because its hatred hit too close to home. The second time, I forced myself to watch in horror at the level of cruelty and indifference humans are capable of. Not only has Hilary gone on to win every award, including the Oscar, for her role, she herself was so moved by Teena's story that she has helped to educate millions through her appearances, speeches, and interviews. Hosting that night's event was just one of those instances; I greatly admire and adore her.

From playing a boy trapped in a woman's body to a woman trapped in prehistoric times: Hilary's unbelievably sexy figure and sensual features called to mind Raquel Welch in the film *One Million Years B.C.* It seemed delightfully ironic that Hilary, now so well known for her ability to look convincingly like a boy, could so effortlessly appear as one of the most womanly of sex symbols.

marissa Berenson

When I was growing up in the seventies, one of my favorite personalities was the beauty Marissa Berenson. Although she appeared in few films, I consoled myself with her frequent appearances in all the popular fashion magazines—at the time she was all the rage and everywhere to be seen on the printed page. Her lithe figure was well suited to the day's popular clothing styles of Halston and Von Furstenberg, and her slightly ethnic features perfectly mirrored the coming together of races, sexualities, and cultures. But the innocent expectations of the beginning of the "me decade" became dim hopes by its close. In the eighties, the nation no longer heralded the innocent promise of songs like "Love Train" and "Good Times," and we entered into a new era of conservativism and separatism. Marissa, along with others who represented uniqueness and diversity, was overshadowed by a political climate that desired Barbie dolls and rejected individuality.

I was the lucky makeup artist to be the first to work with Christy Turlington. I met this future superstar on a beauty shoot in the early 1980s. It's hard to believe that at the time Christy's dual ethnicity made it more difficult for her to get advertising campaigns and magazine covers. Luckily, as the nineties rolled around, such blatant racial prejudice—even though the New York fashionistas think they have no bias—began to dissipate. (Thank you, Mr. Clinton.) Today, it almost seems inconceivable that such ignorance existed—and sadly still does to a great degree. Christy has become a role model for those born of different races. She has shown that the "face" of beauty is not just one color, but many. And as she continues to model, Christy just gets more beautiful—inside and out.

I consider this a light-eyes-and-light-mouth look, but what are your thoughts? Shapewise, the thin, high brow and spiky lashes really open up the eye area. And let's not forget color.

Christy Turlington as Marissa Berenson

1 Prep skin with *moisturizer*.

2 Cover the brows, using *spirit gum*, *moustache wax*, and *sealer*. When dry, use a sponge to cover with a ***tan foundation***.

3 Apply same tan foundation all over face, neck, and exposed areas of the skin, and set with ***loose translucent face powder***.

4 Using an ***aqua blue creme eyeshadow*** and a *medium shadow brush* or your fingertips, wash shadow over entire lid and over covered brow. Be sure to stroke a small amount of shadow along the bottom lashline. Blend well to soften edges.

5 Along the outer edges of the browbone smooth on a ***sheer white creme eyeshadow*** to highlight. Again, blend well.

6 Curl lashes and apply a full set of ***spiky false lashes***. When glue is dry, run ***black liquid eyeliner*** along top lashline and coat lashes with ***black mascara***. (Note: bottom lash look can be created with mascara or the application of individual lashes.)

7 No lip pencil or color was used, however, the shape was enhanced using a ***light pink creme lip color***, applied with a *lip brush*.

8 With a ***basic brown eyebrow pencil***, softly draw in the thin line of the brow. (Note: during this period in the seventies, the style was mimicking that of the Art Deco 1930s and women's "signature" high, thin, and arched brow.)

9 High up on the cheekbones, dust on ***soft pink powder blush*** using a *large blush brush*.

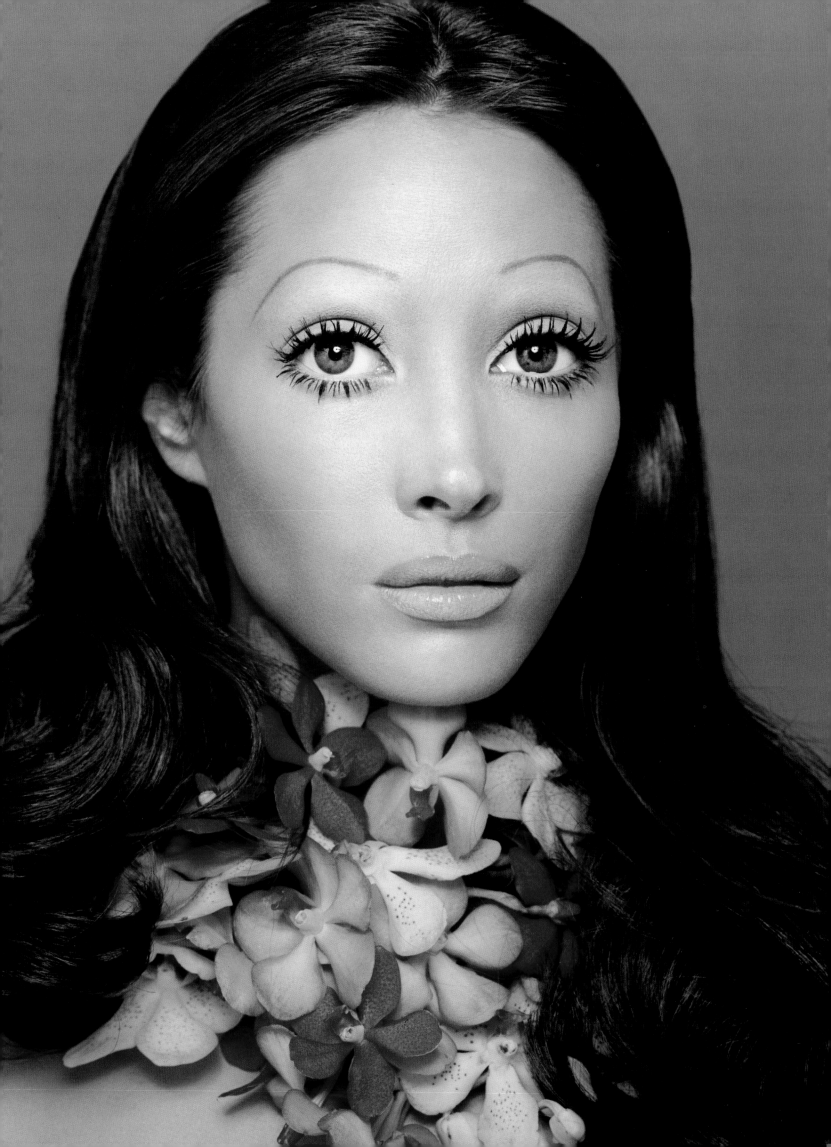

BaRBRa STReiSanD

I have tried to remain somewhat consistent with my three books. While it was not possible for me to use the same group of people every time, I have tried to keep a unifying thread among the three. One of those connections that has been included in all three works is the presence, in either body or spirit, of my longtime hero Barbra Streisand.

From the beginning, when she was for me, like so many millions of others, an enchanting vision up on the screen and a lyrical voice coming from my radio, to actually working with her, she has been a creative muse and a life's savior.

Like all enlightened and responsible souls, Barbra has used her celebrity to support and help others. From gun control to gay rights (the constitution says all men are created equal. What part of *all* don't people understand?)— Barbra has put her integrity before her bank account. There are few people I admire more.

This time around I solicited the help of the vivacious beauty Gina Gershon to help me pay homage. My inspiration was the character Esther Hoffman from one of my favorite films ever, *A Star Is Born*. (After viewing it twenty-one times I stopped counting.) You know the look I mean—where Barbra went in for a perm, and came out funky, foxy, and unforgettable. Watch closely now!

In terms of "balance" this portrait is similar to the one of "Marissa Berenson." With the shaping of the features, the eye area is also exaggerated using spiky lashes and high, thin brows. However, where "Marissa's" face placed color mainly in the eye area, "Barbra" places hers mainly on the cheekbones. Also, because the blush is dusted high up on the cheekbones and onto the temples, the bone structure of the face in that area seems to have shifted slightly upward too.

Gina Gershon as Barbra Streisand

1 First, the brows are made "invisible" with a combination of *sealer*, *spirit gum*, and *moustache wax*. When dry, they are covered with foundation . . .

2 . . . then, the entire face, neck, shoulders, arms, and upper chest are covered with the same **dark flesh-tone foundation**, using a *sponge* and blending well.

3 Then the entire exposed skin area is set with a **medium brown loose face powder**, using a *sponge*.

4 **Hot pink powder blush** is dusted high on the apples of the cheeks and temples with a *large blush brush*.

5 **Soft pink powder blush** is dusted high onto the cheekbones, temples, chin, and collarbones with a *large blush brush*.

6 A **peach powder eyeshadow** is washed over the entire eye area, up to the browbone, and lightly under it using a *medium shadow brush*.

7 A full set of **false lashes** is applied to both the upper *and* lower lashes, then densely coated with **black mascara**.

8 Define this beautiful mouth with **light flesh lip pencil**, and enhance it with a **caramel lip gloss** using the fingertips.

9 Finally, the brows were drawn in thin, high, and arching using a **basic brown eyebrow pencil**.

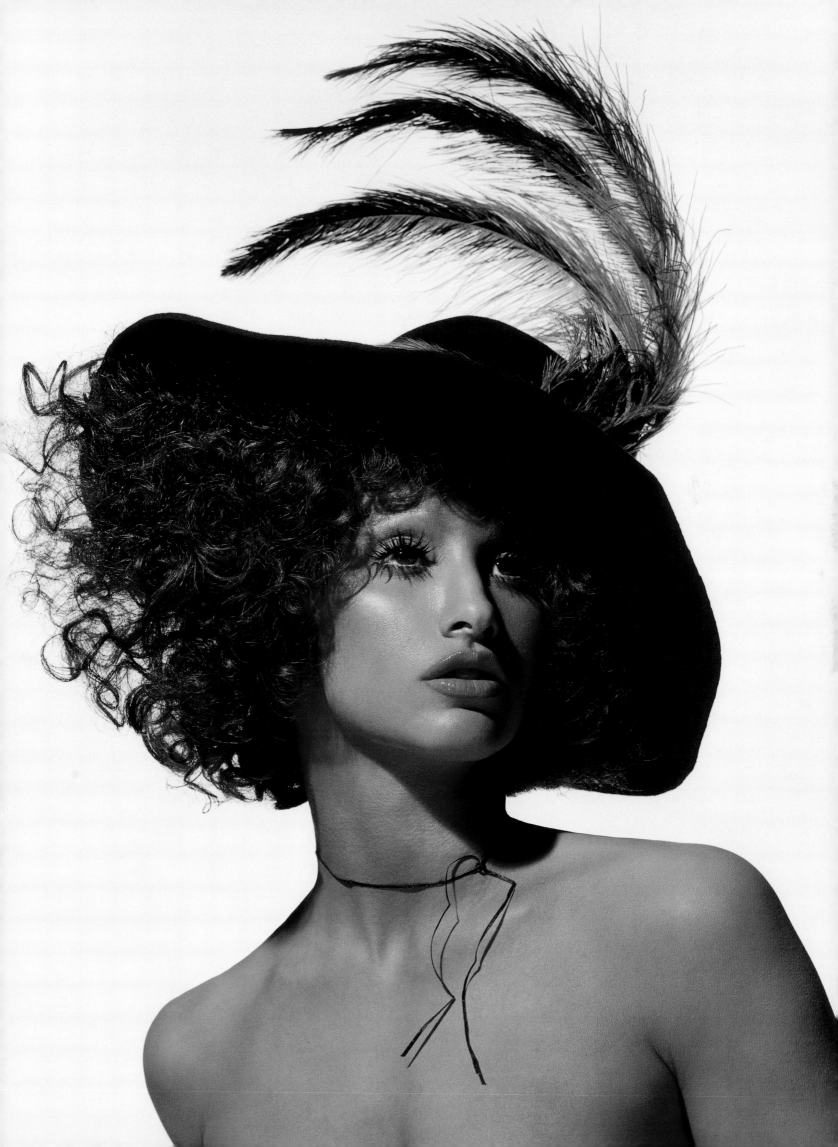

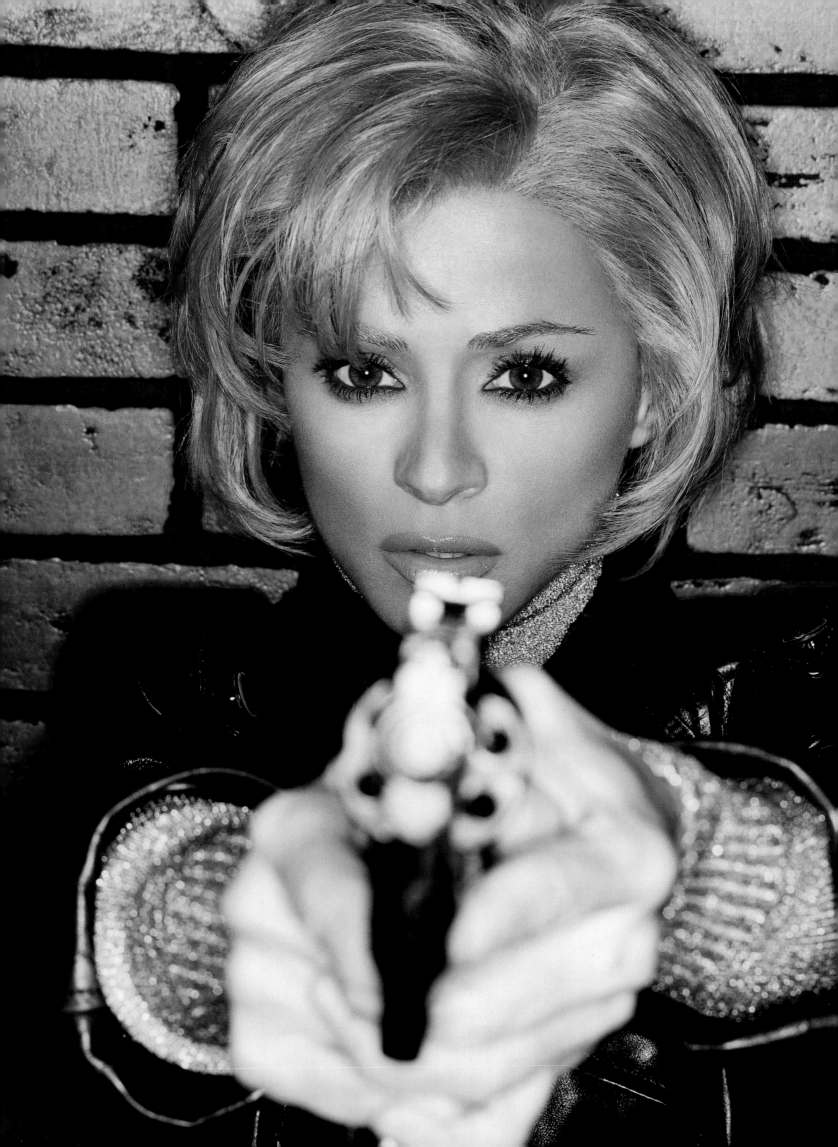

ANGIE DICKINSON

I do not agree with those who consider television a wasteland. Sure, there is too much banality, but on more than one occasion the tube has been a welcome source of inspiration and enlightenment. At the very least, it has shed light on some issues that may have otherwise been left in the shadows. Certainly the topics of racism, feminism, and sexuality are more visible today because of the medium. Enough already.

As a youngster growing up in the seventies, I was lucky enough to have been treated to a wonderfully eclectic mix of television fare. From the fascinating social commentary of "All in the Family" to the welcome independent spirit of "The Mary Tyler Moore Show" and the clever antics of Carol Burnett, the "me" decade certainly had its share of memorable moments. Along for the ride came what are now disparingingly referred to as "T and A" shows. (I hope you know what that stands for, because I ain't gonna tell you.) The most famous of these early babe-athons were, of course, "Charlie's Angels" and "Police Woman." Despite what has happened to the genre over the ensuing decades, the initial premise was more thoughtful than tittillating. Especially "Police Woman," with its effervescent star Angie Dickinson, was more than a repository for high fashion and hairspray. Our weekly heroine, Sgt. Pepper, was not only beautiful, she had brains and a position of authority. That in itself was a major step forward.

Amy Sedaris as Angie Dickinson (and herself)

1 First, use **light moisturizer**, blotting any excess moisture with a *tissue*. 2 Using the fingertips and a *triangular sponge*, stroke on **light foundation** to the face (and because it showed in Amy's own portrait, along her neck, shoulders, arms, chest) and blended well. (Note: a touch of **concealer** was used just on red spots.) 3 Using a *circular sponge*, set the foundation with a light dusting of **loose translucent face powder** (with a bit extra under the eyes to catch falling eyeshadow). 4 Groom brows lightly. (For the portrait of Angie Dickinson, the brows were swept with a **light blonde mascara**.) 5 Using a *medium shadow brush*, **light beige powder eyeshadow** was washed allover the entire eye area—including the lids, crease, and softly under the eye—and blended well so that there were no definite edges. 6 A second **basic brown powder eyeshadow** was used to define the crease and the outer corner of the upper and lower lashline. 7 The top lashes were curled and **black mascara** was swept onto both the upper and lower lashes. 8 The lips were shaped and filled in using a **light flesh lip pencil**, then filled over with a **caramel lip gloss**. 9 A touch of **soft pink powder blush** was dusted onto the cheeks for Amy's own portrait with slightly more added for her take-off of gun-toting Sgt. Pepper.

This is a classic (not too) dark-eyes-and-light-mouth look. The light wash of shadow all around the eyes enlarges them too.

AMY SEDARIS

The first time I saw Comedy Central's "Strangers with Candy," I made it my mission to meet its star, Amy Sedaris. "I think I know you from a past life" were my first words to this comic genius. We met for coffee and hit it off instantly. Her show is a rare, hilarious, *underpublicized* gem. Watch it, or else! Amy asked me to be on the show, playing a mortician named Sharpei. How could I say no? I had the time of my life, especially watching her makeup artist transform her into character. Amy plays Jerri Blank, a forty-six-year-old high school freshman. I kid you not. You can only imagine the trapped-in-the-seventies, trying-to-fit-in garish makeup she wears. I love it! From Tori Amos to Cher to Tina Turner and Winona Ryder, Amy has a celebrity-filled cult following. All I have to say is "fandango."

Female comedians like Amy Sedaris and Cheri Oteri (from earlier in the book) occupy a very special place in my heart. Beyond their unerring ability to make me laugh—often quite loud and long—lies the true essence of humor and of the human experience. Don't get me wrong, I appreciate a good belly laugh and barroom jokes as much as the next guy, but I must say that I do appreciate a little heart with my humor. Through their characters, these women—including Caroline Rhea, Catherine O'Hara, Andrea Martin, Roseanne, Janeane Garofalo, Margaret Cho, Molly Shannon, Laura Kightlinger, Paula Poundstone, Judy Gold, and Ellen DeGeneres—use pratfalls, pranks, and pancake makeup to disguise the real pathos of everyday life. These women help to make life's sometimes awful medicine taste a little sweeter.

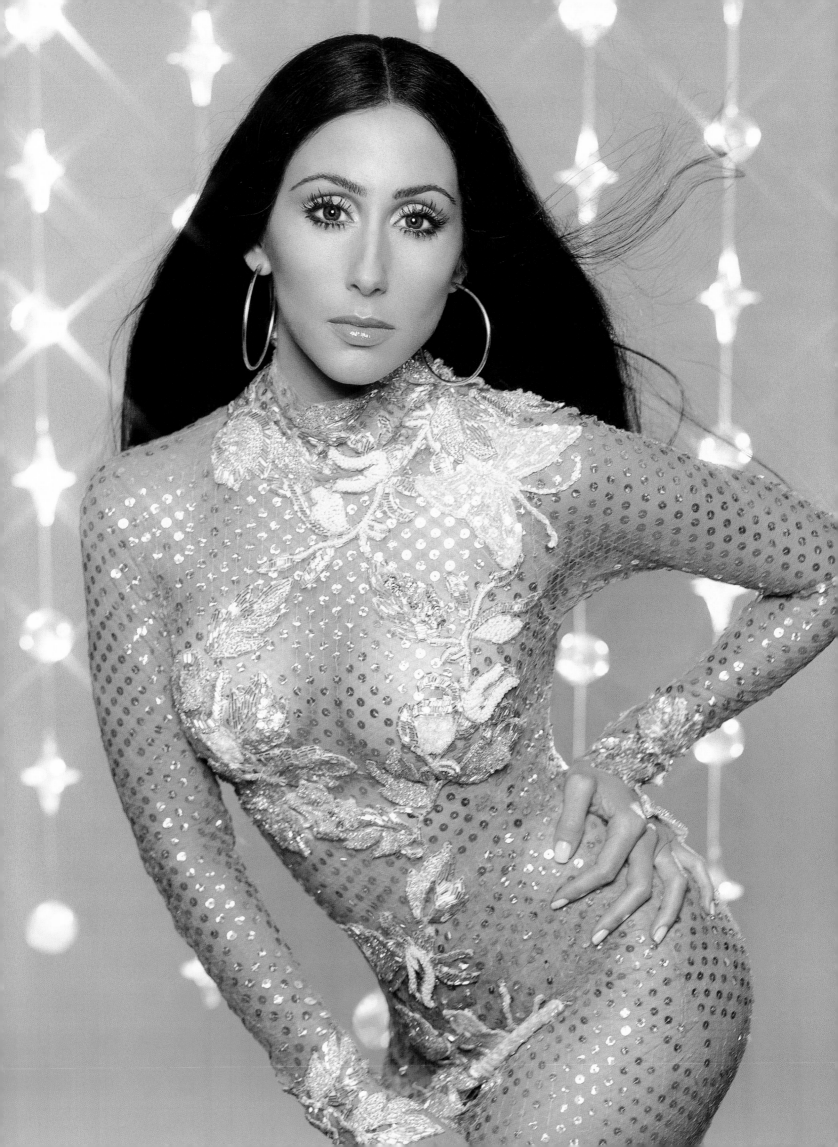

cher

How could anyone not be entranced by the sight of someone as breathtakingly beautiful as Cher—with her long mane of jet black hair, almond-shaped eyes, perfectly oval face, and body that will not quit? I, like so many others, first fell in love with this sexy sylph when she and then-hubby Sonny stormed the airwaves in the early seventies. She was mesmerizing in her barely there Mackie gowns (by the way, this number on Alexandra happens to be one of those original gowns) and equally riveting with her velvet-smooth voice and unadulterated sense of humor. What a package! But what I liked most of all was how these parts of her personality and physicality added up to a person of singular uniqueness. No one looked, sounded, or acted like her before (or since). She had a sharp, brazen, independent spirit with soft edges. In the age of "I Am Woman" she was the real deal.

Alexandra Von Furstenberg as Cher

1 First, skin is prepped with **moisturizer**. 2 Groom and tweeze the brows into a shape that has a very defined bend. Fill in any sparse areas with a **basic brown eyebrow pencil**. Using a **clear brow gel**, brush brows upward and into place. 3 Apply **concealer** (or **foundation**) under the eye and anywhere needed to even out skin tone. 4 With a *sponge*, dab **loose translucent face powder** all over face to set concealer (or foundation). Be especially sure to dab powder on eyelids and eye area. 5 Using a *small shadow brush* and **grayish-brown cream eyeshadow**, the crease of the eye was isolated and defined. Also, a touch was used under the eye.

6 Then, a **pale beige powder eyeshadow** was used to highlight the lid and browbone, blended, and softened. 7 Next, a dot of **white liquid eyeshadow** was placed right at the inside corner of each eye and blended well. This gives the eye a slightly dewy, moist look. 8 A soft **black eye pencil** was then used to line the outer half of the eye, at the lashline, and blended with a *cotton swab* for a smoky effect. Be sure to keep this black pencil on the outer half of the eye, which makes the eye look wider. 9 Apply a full set of spidery **false lashes**. When dry, curl with real lashes and sweep with **black mascara**. (Have an *eyelash comb* handy to comb out any clumps possible with extralong lashes.) 10 Line the lips using a **bubble-gum pink lipliner**, and fill in. Finish the lip with a coat of **extra-shiny lip gloss**. 11 Cheeks are dusted with **soft pink powder blush** using a *large blush brush*.

alexandra von furstenberg

One night, I was attending a very chi-chi dinner party. These are functions that I do not normally attend. I'm more comfortable sitting at home with friends watching videos and eating pizza. But on this particular occasion I was somewhat socially obligated to attend—as people often are in that instance. At the table, I found myself seated next to Alexandra Von Furstenberg. (Yes, of *the* Von Furstenbergs.) Hearing a name that long and aristocratic, I actually became intimidated. (Prejudiced thoughts, it seems, know no bounds and at that moment had claimed my typical open-mindedness as one of their own.) I was glad to be completely wrong. Alexandra turned out to be a down-to-earth, charming woman, as well as a mother, wife, and successful businessperson. (I've learned that the person hurt most by a preconceived, judgmental attitude is the one carrying it.) As we talked, I suddenly realized I was looking at a blond version of Cher. At that time, the book was in its planning stages, so I told her what had just crossed my mind. She seemed rather excited at the prospect of the transformation. We exchanged numbers and shortly thereafter took these pictures. During the shoot, Alexandra had to endure my outbursts and double-takes, allowing me to relish in the moment of incarnating one of my favorite people on a newfound friend. Upon seeing the finished portrait, Alexandra was speechless. When the real Cher saw it, her few words said more than enough: "She looks more like me than me!" It was the greatest compliment I could get.

diana ross

"I'm coming out, I want the world to know . . . I've got to let it show!" What else is there to say? No more hiding, no more lies—the truth, plain and simple. Why are we so afraid of the truth? Because we've been taught to fear what other people think of us. Well, if someone doesn't like you for who you are, to hell with them. That has been the "boss" Diana Ross's message from the start. Challenging prejudice all the way, Diana has learned what love and acceptance are all about. Not in a harsh or abrasive way, but in a "reach out and touch somebody's hand" way. Gentle and effective, that's the lady's style. Our work together has always been incredibly enlightening and rewarding. Diana always has the kindest words to say and energy to die for.

After we finished shooting Kiara's half of the cover, she and I started on her transformation into the one and only Miss Ross. As we were shooting the picture, guess who happened to be visiting the adjoining studio? You guessed it—Diana herself. My fear that she would not be so thrilled with our photos was quelled when she saw the Polaroids. She was as happy as I was. Afterward, I questioned why I was so leery of showing her the pictures; she's always been so kind, loving, and supportive of me. She's known as a diva, which I guess stands for Diana Is Vastly Amazing. I just love this woman. And if there's a cure for this, I don't want it!

I see this as an eye and mouth shape face. The eyes, because the shadow truly exaggerates the shape that is already there. And the lips, because at a glance they are the first thing my attention is drawn to. (In that regard, color also plays an important part in shifting your focus from one place to another.)

Kiara Kabakuri as Diana Ross

1 Groom the brow area, using *tweezers* and *scissors* if necessary to reshape brows or trim unruly hairs. Fill in brows using a **basic brown eyebrow pencil**, accentuating and bringing out the natural arch as far as possible.

2 Using a **golden-brown** (or lighter than your natural skin tone) **stick foundation**, apply in strokes to the center of the face, under the eyes, on the eyelids, bridge of the nose, forehead, high on the cheekbones, and around the sides of the mouth. Blend well with a *sponge*. This color will bring these areas forward.

3 With a **stick foundation** darker than your natural skin tone, stroke along the hollows of the cheeks, temples, sides of the nose, under the chin, down the neck, and in the crease of the eye (also include the hollows above and below the collarbone). Blend well with a *sponge*. These darkened areas will recede, creating shadows and contours.

4 Using a *circular sponge*, set foundation with a very light dusting of **loose translucent face powder**.

5 Next, apply a **dark brown-black creme eyeshadow** to the crease of the eye using a *small shadow brush*. From the outer corner of the eye, arc inward high along the crease of the eye toward the nose. Blend and soften edges, but leave the arc defined.

6 On the outer corner of the eye add a bit more of the same shadow (to about a third of the way onto the lid) and extend the corner slightly and wing upward. Blend and soften.

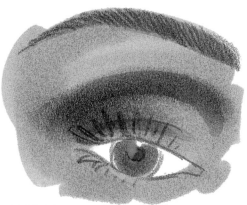

7 Finish with a shadow line along the bottom lashline. Blend and soften.

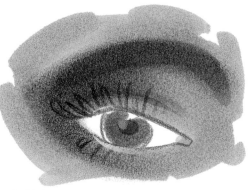

8 Using a *medium shadow brush*, smooth **golden-brown creme eyeshadow** along the inside of the eye, eyelid, and browbone. Highlighting these areas not only brings them forward, but will also heighten the illusion of distance between the eye and brow.

9 Curl the lashes and add a double coat of **black mascara**, top and bottom.

10 Using a **basic red lip pencil** and **basic red creme lip color**, line and fill in the mouth. Blot and reapply. (If you like, you can add extra shine with a coat of clear lip gloss.)

11 With a *large blush brush*, dust **hot pink powder blush** onto the cheeks, chin, and temples.

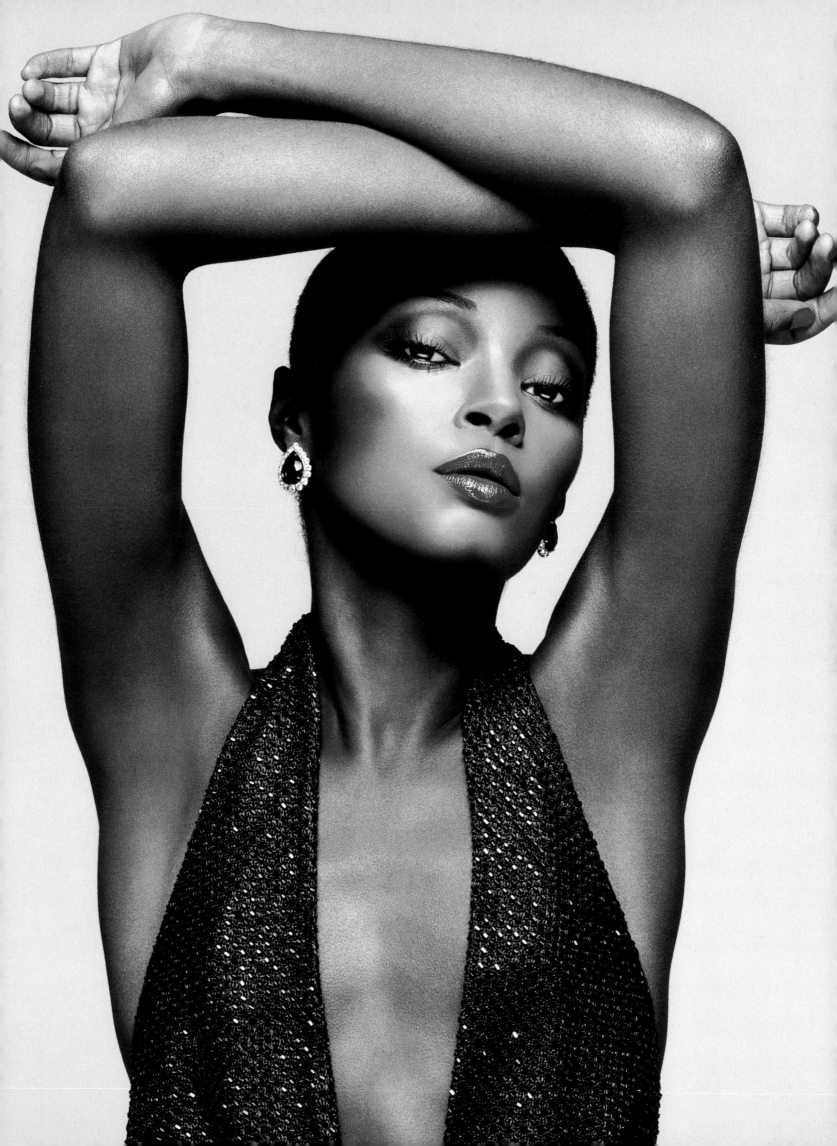

new york doll

During the late sixties, the world went through an amazing amount of cultural change. It was a time when blacks and other minorities, women, gays and lesbians first gained visibility. The "majority" no longer had absolute control; it was time to relinquish some of the pie. But below the surface of these unified new communities lurked a number of "underground" movements which were thought by many to be subversive. Therefore, less palatable to the ruling class. Of these was a compelling group of sexually androgynous men. However, these guys were not easily identifiable as straight *or* gay, and they differed from the definition of "drag queen" because they dressed only half the part. But that ambiguity was the whole idea. These "boys" were looking to erase the line between feminine and masculine physical traits—and, in turn, attempting to appeal to both sexes (which they did). This band of merry men included such famous fops as David Bowie (in the unforgettable guise of Ziggy Stardust), Mick Jagger, and Freddy Mercury.

As the seventies crossed over into the eighties the look mutated, incorporating aspects of new wave, disco, rock, and punk. The coolest glam-rock band of the time was, without a doubt, Buster Poindexter's New York Dolls. Here, Jeremy Antunes captures the man-child-doll look that was so much a part of early eighties "downtown" culture. Centered in the part of New York's East Village known as St. Mark's Place, these "straight" boys, in eyeliner and glitter, stole the hearts of punk girls and boys wherever they went. They acted pouty and vulnerable, emoting a wounded quality that made you want to take them in and heal their pain. But pity would be wasted on these rebels; they lived for themselves and their vanity. All that was required of you was your endless admiration and praise. After all, dolls just want to be played with.

Jeremy Antunes as New York Doll

1 Prepare the face and lips with an application of *light moisturizer*. Blot any excess with a *tissue*.

2 Using the fingertips or a *small-tip brush*, apply **concealer** to any red spots or blemishes and blend well.

3 Groom the brows, if necessary, to remove any stray hairs.

4 Using a *medium shadow brush* (or your fingertips), layer **bronze** and **gold metallic powder eyeshadow** all around the eyes, washing over the entire lid up to the brow, and under the eye.

5 With a *medium shadow brush*, apply a **basic brown powder eyeshadow** to the eyelid, up to the crease, and along the top lashline and lightly under. Soften any hard edges by blending.

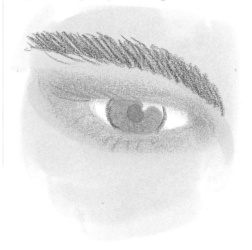

6 Sweep **black mascara** on the lashes. (If you wish, lashes can be curled first.)

7 Mixing a combination of moisturizer and **sheer iridescent sparkle liquid foundation**, smooth onto arms with hands.

8 Then, the entire face, neck, and arms are dusted with a **loose iridescent all-over powder**.

9 Lightly spray **metallic glitter** all over face, hair, neck, and arms. (Be aware that this metallic glitter will stick to your clothes—make sure you wear something washable.)

This is a texture and "in perspective" face. The texture part is undeniable. In perspective, many of us are still quite uncomfortable with the idea of men wearing makeup even though many have throughout history, including soldiers and royalty.

DEBBIE HARRY

We often recall with great fondness our early loves—be they person, place, or thing. As a sixteen-year-old gay boy trying to survive in southern Louisiana, I frequently sought solace and escape in music (a habit I still carry with me). I *loved* punk and new wave music; it represented noncomformist attitudes toward life, which were like my own and my friends'. At the front of this anarchistic army was one woman in particular, who blended the rawness of percussive primal beats with the smoothness of sophisticated dance rhythms. She was, of course, Debbie Harry. With her group Blondie, her music carried me through many a day (and night) as I ceaselessly made plans for the future. From "Heart of Glass" to "The Tide Is High," "Call Me" to "Rapture," each one a music milestone and treasured personal inspiration.

Eveline Lange as Debbie Harry

1 First, prep skin with *moisturizer*. **2** Apply *concealer*, where needed, and a light application of *foundation*. Set with *loose translucent face powder*. (Note: the foundation was much lighter than Eveline's natural skin tone to contrast with the dark eyes.) **3** A touch of *dark flesh-tone foundation* was used to contour the hollows of the cheekbones. Stroke on in place, and blend well. **4** Using a *medium shadow brush*, smooth on *black creme eyeshadow* into eye area, including the lid, crease, and under eye. Shadow should cover about two thirds of the eye area. Use shadow sparingly and add in increments to get desired shape. Be sure to blend and soften edges.

5 *Basic black powder eyeshadow* can be used to further soften edges. **6** *Light beige powder eyeshadow* is used to lighten inner eyelid and browbone. **7** Apply a full set of *false lashes*. When dry, curl with real lashes and add *black mascara*. Then apply *black liquid liner* to conceal adhesive and further define lashline. **8** Dust cheeks with a *large blush brush* and *soft pink powder blush*. **9** Line lips and fill in with a *light flesh lip pencil*, then lightly coat with a *caramel lip gloss*.

Eveline Lange's portrait of Debbie Harry is definitely an eye shape and dark-eyes-and-light-mouth look. (You couldn't miss seeing those eyes from a hundred yards back!) However, in her own portrait, the focus is shifted to the mouth, which appears much fuller by virtue of the color.

EVELINE LANGE

Why is it that being yourself is reason for others to judge, criticize, and attack? When I was young and gay (still am), just *trying* to be oneself was cause for abuse at the hands of others. I guess it didn't make matters any easier that my best friends were butch lesbians and transsexuals. Instead of fitting in, we stood out—in punk clothing and makeup—choosing to live our lives as truthfully as we could, forgoing an existence based on lies. That philosophical path led me to where I am today, and to the divine Eveline Lange.

Like any person living with a physical anomaly that requires correction, Eveline, too, had a physical challenge—she was born into the wrong body. Transgendered people are probably the most misunderstood on this planet. How can any of us know how it feels to be living inside a shell, not of our own making, that we are desperate to break free of? They say "don't judge another person until you've walked a mile in their shoes." Let me tell you, I couldn't walk a block in Eveline's stilettos. Don't get me wrong, I love her dearly, but I don't think I could handle the hurt and pain she has had to endure—herself, and so many others faced with the same issues.

Despite all of this, Eveline is a joy to be around, and our friendship is one that I deeply cherish. Her laugh-a-minute personality and lust for life are like a cactus bloom in the heat of the desert sun. How some of us flourish through adversity leaves me awestruck. I asked Eveline to be my "Debbie Harry" for reasons other than physical similarities. Both she and Harry stand for unconventionality, originality, and spiritedness. My kind of women!

siouxsie sioux

Walking alongside the new softer and more sensitive men ushered in by dandies Jagger, Bowie, and Poindexter, was a band of wild women who bypassed the sugar and headed straight for the spice. They took the definition of feminine and scrawled all over it with thick black lines, then used the remainder as makeup. This renegade troop was led by the already-praised Debbie Harry, Lene Lovich, Patti Smith, Joan Jett, Cindy Lauper, and the provocative beauty and brilliant lyricist Siouxsie Sioux. I was a fan right from the start, and Siouxsie's startling make-up and enigmatic imagery captured my imagination and won my heart.

My only encounter (if you can call it that) with Ms. Sioux was in Paris in 1998. I was there doing fashion shows and found myself out one night at Le Bain Douche with friends. As I parted a curtain to make my way to the back of the club, Siouxie herself emerged. We were face-to-face. I swear she looked twenty years old—I mean flawless. She had on her signature black eye make-up, spiked hair, and skin to cry for. I was so stunned that no words came and the moment was lost. So here is my tribute to an underappreciated god-dess.

Though Winona Ryder and I share a passion for obscure eighties bands like Karen Lawrence and the Pins and Holly and the Italians, it was Siouxsie Sioux and her "Slow Dive" that were the inspiration for this image. With a nod to punk founder and dear friend Vivienne Westwood.

This is a dark-eyes-and-light-mouth face and a color look, too. Also, keep in mind that the makeup application should have a random quality to it. What these women were going for was not the refined, exact placement of a fifties brow or lip—not at all.

Winona Ryder as Siouxsie Sioux

1 Prep skin with **moisturizer**. Blot any excess with a *tissue*.

2 Smooth on a **sheer iridescent sparkle liquid foundation**, blending outward. (If needed, use spot concealer on redness and blemishes, and blend well.)

3 *Under*emphasize the arch of the brow by exaggerating the horizontal shape. Fill in with a **basic brown eyebrow pencil** and soften with a *sponge-tip applicator* and a **dark brown powder eyeshadow**.

4 Line the inner rims of the eyes with **basic black eye pencil** (make sure the tip is not too sharp) and smudge into the lashes.

5 With a *sponge-tip applicator* or *small shadow brush*, wash the eyelid with a **frosty bluish-white powder eyeshadow**. Extend the shadow into the inner corner of the eye, the crease, along the brow-bone, and wing outward.

6 Along the bottom outside corner of the eyes and along the lashline, run a line of **eggplant powder eyeshadow**, using a *sponge-tip applicator* or *small shadow brush*, and blend well.

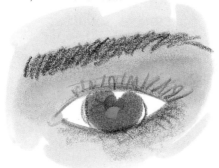

7 With the *sponge-tip applicator*, run **basic black powder eyeshadow** along the outside half of the eye, along the top and bottom lashline.

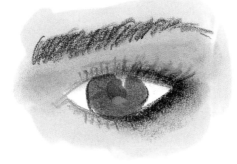

8 Curl lashes and apply a heavy coat (or two) of **black mascara**, top and bottom. (Have an *eyelash comb* handy to remove any mascara clumps.)

9 With a *large powder brush*, dust **soft pink powder blush** on the cheeks, extending upward toward the bottom of the eyes. Add a touch to the chin as well.

10 With a **light flesh lip pencil**, line the lips and fill in.

11 Cover the lips with a **light metallic pink creme lip color**. Blot and reapply.

Photograph by Warwick Saint

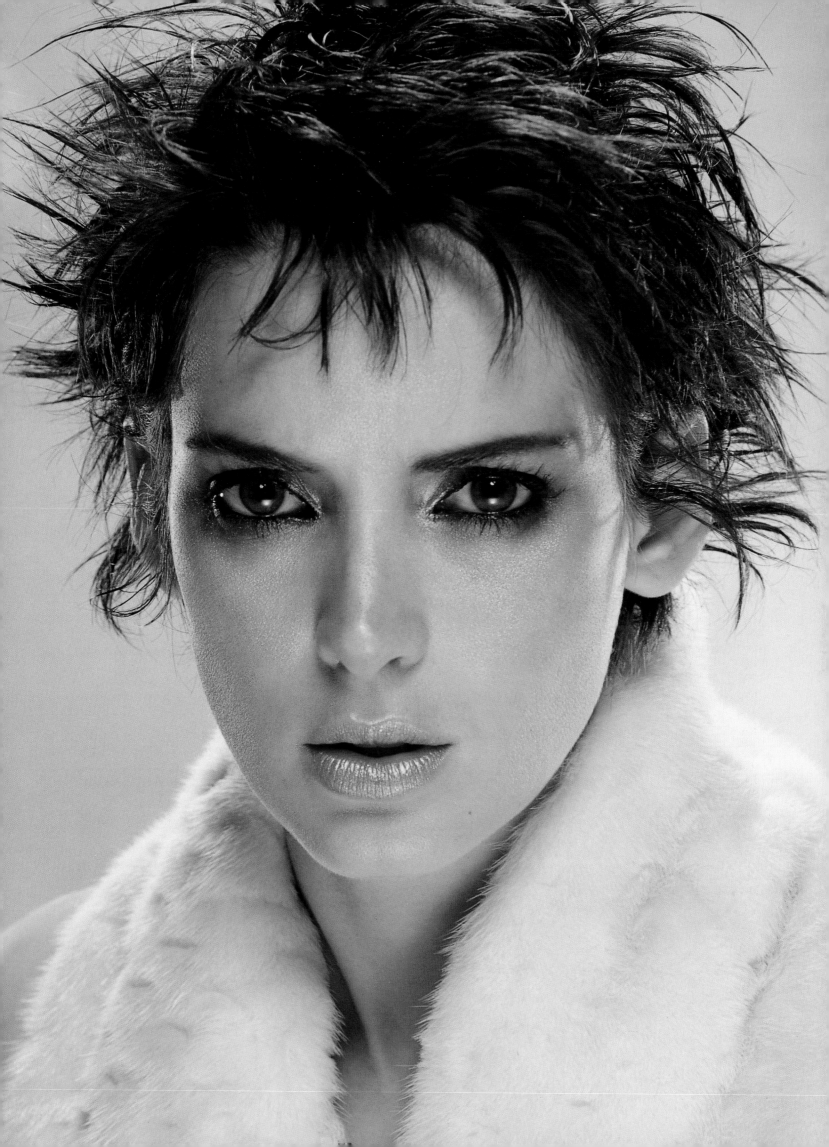

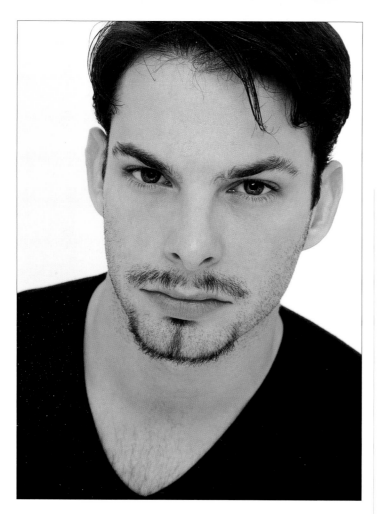

alex peruzzi

Alex Peruzzi was born on St. Patrick's Day, I was born on Valentine's Day, and the two of us met on the 4th of July. Instant fireworks. During our brief, but passionate, romance (just over a year) we weathered many storms. Today, Alex is one of my best friends and confidants. When we first met, I remarked about how much he looked like Linda Evangelista. (I wondered how many times he had heard that one before?) Now, over three years later, I found my opportunity to transform Alex into a dear friend and one of the greatest legends of the fashion world. Viva la Evangelista!

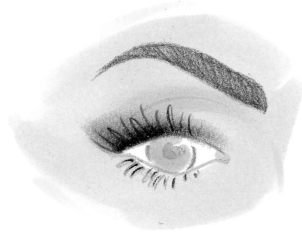

Definitely an eye shape look and a (relatively) dark-eyes-and-light-mouth one, too. Also, notice how highlighting the brow-bone and keeping the shadow to the outer half of the eye widens and extends the shape.

linda evangelista

To many, myself included, Linda Evangelista was (still is and always will remain) a revelation in the fickle worlds of fashion and modeling. But with her rare beauty, style, intelligence, professionalism, and humanity, Linda won our hearts. Everyone wanted to either know or look like Ms. Evangelista—and who wouldn't?

I first worked with Linda in the early eighties and have yet to meet another model who was more involved in every aspect of her work. Her specialties were knowing what was best for her hair, makeup, styling, and lighting—and Linda was always right. It was mind-boggling. Many of the unforgettable images of this haunting beauty were, in great degree, due to her involvement. This portrait is a humble homage to one of my own very favorite images of Linda taken by master photographer Steven Meisel. It was done during the early nineties and one of the first covers of *Allure* magazine that Steven, Linda, Garren, and I collaborated on. A reprint of the original can be found in my first book, *The Art of Makeup*. Genius.

1 Moisturize. 2 If you like, use *face tapes* to raise the eyes slightly, as we did here. 3 Cover the brows using *spirit gum*, *brow wax*, and *sealer*. When dry, cover with **foundation**. 4 Using the same foundation, cover entire face, neck, shoulders, and exposed areas with your fingertips or a *sponge*. Since it is not necessary to match skin tone, just be sure that all areas of the skin match in coloration. Here, we used a slightly darker flesh tone to give the skin a tanned appearance. Blend well and set with **translucent loose face powder**. (Because it is likely that you are not wearing this look to work, a slightly heavier application of foundation may be necessary to cover over beard hairs and ruddiness in skin tone.) 5 Run a thick line of **black liquid eyeliner** along the top lashes. Be sure to get in between the lashes, too. 6 For this darkly contoured eye, sweep **black powder eyeshadow** along the upper lashes, concentrating on the outer corner and into the crease—but only halfway—using a *small shadow brush* or *sponge-tip applicator*. 7 Using a *medium shadow brush*, **light beige powder eyeshadow** is washed onto the eyelid to give it soft definition. Blend well. 8 For highlighting, a touch of **champagne metallic shadow** is applied to the browbone. 9 Curl the lashes—to form a base—and apply a full set of **false lashes**. 10 Sweep top and bottom lashes with two coats of **black mascara**. 11 In the early nineties, models were keeping their brows in a very groomed, high arch. Taking a **basic brown eyebrow pencil**, draw in the brow shape with the arch slightly mimicking the shape of the eye. End with a thin but definite tapered point. 12 **Soft pink powder blush** is dusted onto the cheekbones and temples, and lightly on the chin, using a *large blush brush*. 13 To capture Linda's lip shape, use a **dark flesh lip pencil** to define the shape, but do not fill in. (On Alex, the top and bottom lips were slightly overdrawn at the sides to add fullness.) 14 Using a *lip brush*, fill in the mouth with a **light flesh creme lip color**. 15 Using your fingertips or lip brush, add the illusion of more fullness by smoothing on a touch of **bubble-gum pink creme lip color** just to the center of the mouth.

Starting with the Clinton administration, our country really began to see a change in the way the ethnic demographics of our country were perceived. This in turn led to a real broadening of our concept of the range of beauty. Slowly but surely, cosmetic companies, fashion and beauty magazines, and their advertisers began making attempts at inclusion, rather than indifference.

We still have a long way to go, but at least this movement is going in the right direction (though much too slow for me). What we have seen for the last few years is a glorious mixing of cultures, classes, and ideologies. Let's hope it doesn't stop until we reach the other side—true unity.

This new view of the world has proved a boon to the creative energies behind fashion and beauty. Talent is no longer expected to do the expected. The door is wide open to mix decades, races, ages, sexes—you name it, it's fair game. On the other side of this rainbow are those who find only insecurity in the unknown and hold on to the past, and its power, like sentinels. While I embrace and choose to learn from the past, I am not bound by it. Take life as it comes, and revel in its bounty.

We met Alexandra Von Furstenberg just a few pages earlier, as the uncanny recreation of Cher. However, as my "moving forward: face one" subject, she seems to have no connection to the past. But is that ever true? Look closer. Once you have it in your mind how beautiful someone looks one way, it's hard to see them completely separate from that vision. It is unlikely that anyone who meets Alexandra after viewing her earlier portrait as Cher will not try to find the resemblance between the two. There's nothing wrong with that; what is is being trapped by the past and allowing it to limit you in any way.

I look at this finished portrait and see a dark-eyes-and-dark-mouth look even though the eyes are made up with a currant colored shadow. Do you agree?

Alexandra Von Furstenberg: face one

1 Skin is first prepped with a **light moisturizer**.

2 A touch of **foundation** (and **concealer**, if needed) is blended outward with a *sponge* or fingertips. Set with a light dusting of **loose translucent face powder**.

3 Using a **rose liquid blush**, dot the cheeks, temples, and chin. Blend well with fingertips.

4 Rim the inner lashline using a softened **black eye pencil**. Smudge into lashline with pencil and *sponge-tip applicator*. Use the same pencil to softly line the lashline, upper and lower.

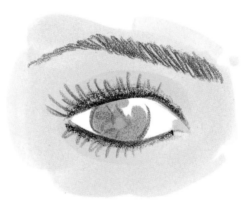

5 Using a **currant-colored creme eyeshadow** and a *medium shadow brush*, define the eyelid, crease, and softly under the eye. Concentrate shadow on the outer half of the eye. (When using vivid colors, always start out with small amounts and add in increments until you achieve the desired effect. I also think it's a good idea to blend the area with your fingertips to soften edges as you go along.)

6 Lightly coat curled upper lashes using a **black mascara** and a **burgundy mascara** on bottom lashes. (This will lighten the bottom half of the eye.)

7 No pencil was used to define the mouth. Instead, using a *lip brush* for accuracy, the mouth was filled in using a **warm red creme lip color** . . .

8. . . blotted, then covered over with a **blood red liquid lip color**. Blot and reapply. (Forgoing a lip pencil gives the mouth a subtly softer edge; using two lip colors gives the mouth subtle dimension.)

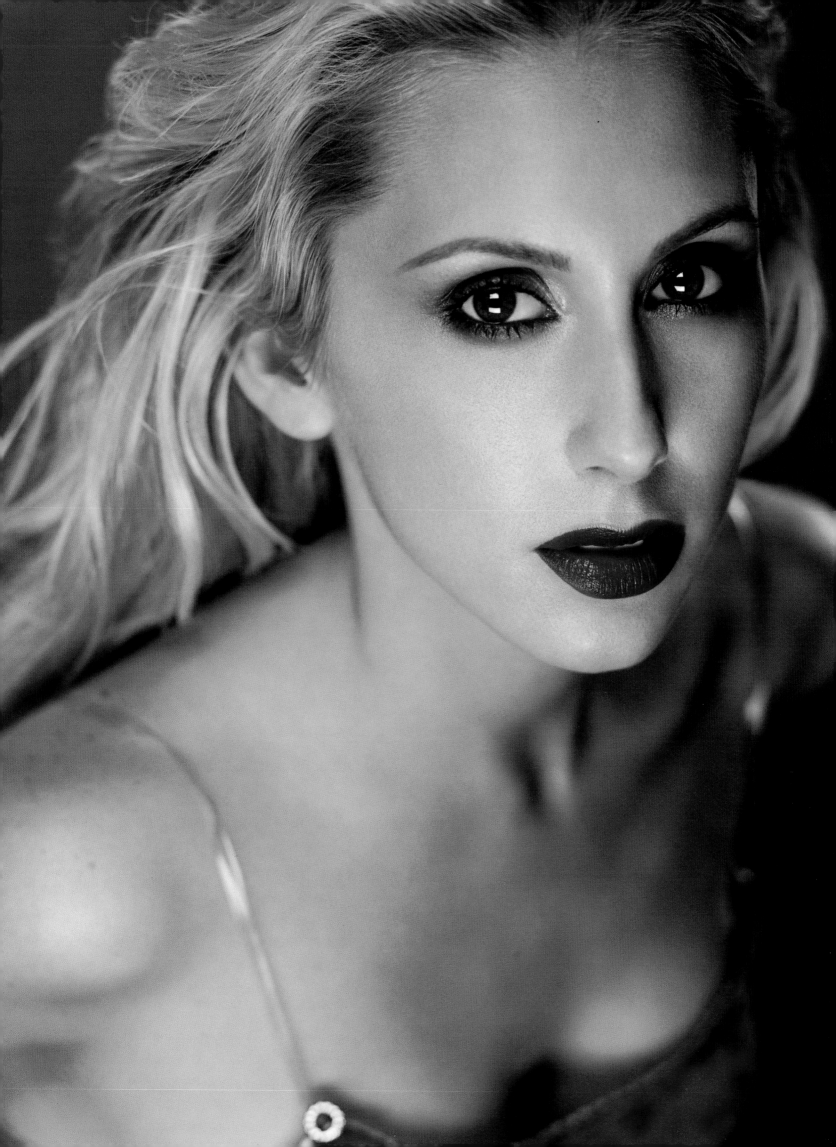

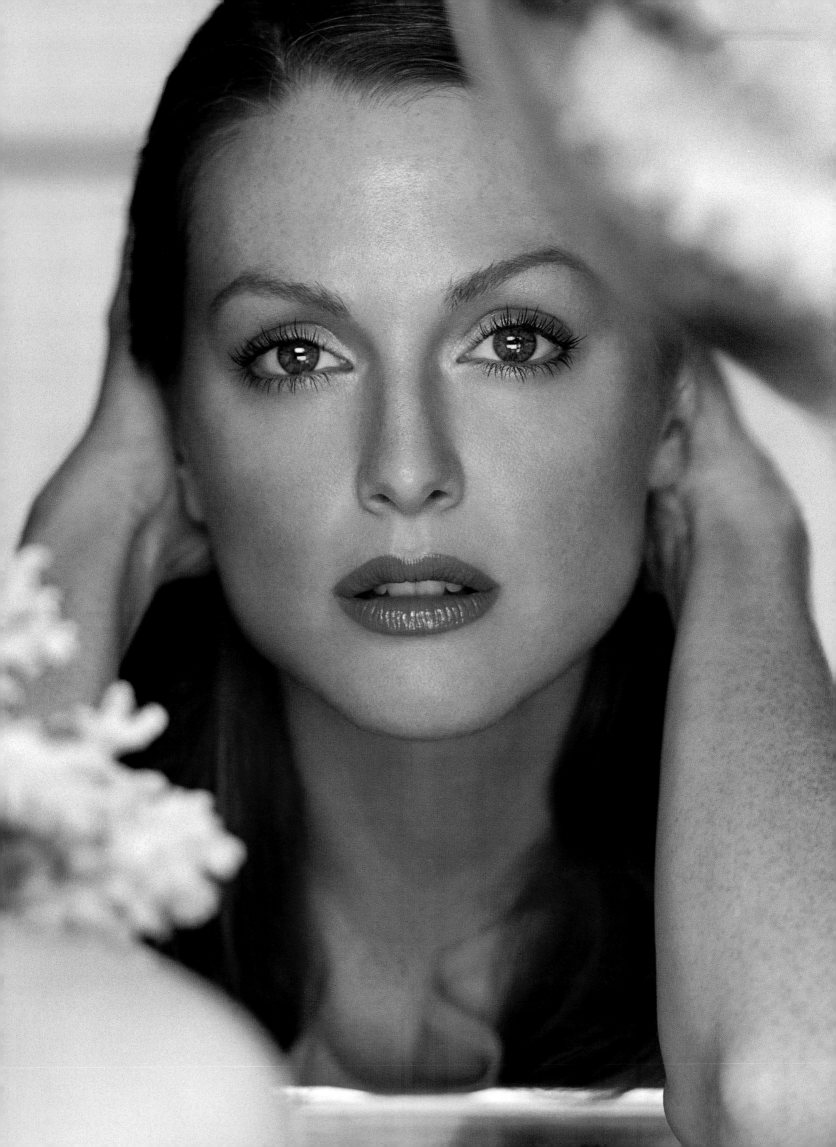

Julianne Moore: face two

1 Use **light moisturizer** to prep the face. Blot any excess with *tissue*.

2 Use the tiniest touch of **concealer**, if needed.

3 Brows are lightly groomed. Fill in any sparse spaces using **basic brown eyebrow pencil**. Sweep into place with a *spooly brush*.

4 Smooth on a light application of **gold sparkle liquid foundation**. Blend outward from the center of the face.

5 Using a *small shadow brush*, **grayish-brown cream eyeshadow** is used to softly define the outer half of the eyelid, crease, and softly under the eyes.

6 **Liquid silver eyeshadow** is smoothed onto the inner half of the eyelid to the inner corner of the eye and browbone, using a *small shadow brush*. Be careful to use sparingly at first, smoothing and blending as you go along, and add in increments if necessary. (Silver shadow brings these areas forward.)

7 Curl lashes and add a touch of **black mascara** to top and bottom lashes.

8 Using a **rose liquid blush**, dot the cheeks, chin, and temple, and blend with fingertips.

9 For this softly defined mouth, line the lips with a light flesh lip pencil and cover with a light coat of caramel lip gloss.

Inner beauty has rarely shown itself as brightly as in the face of Julianne Moore. The phrase "to know her is to love her" was made for this wildly talented woman. From her caramel freckles to her fragile yet powerful bone structure, Julianne is the embodiment of the modern woman.

Surrounded by watery blue crystal and beige coral, her natural red hair and pale skin tone take on an even more radiant warmth. A simple yet sophisticated color palette of grayish-brown creme eyeshadow, golden-pink pearl face shimmer, black-patent-leather mascara, and cool taupe lip color was used to focus the attention on Julianne's magnificent eyes.

Today's modern looks can mean anything from a full face of "war paint," to this look, which was created in less than ten minutes. But time is not always the most important consideration when deciding what look to go for. Often the most important consideration is the effect wearing any makeup (or no makeup at all) will have on the way you feel. Analyze the reasons you do (or do not) wear makeup. Some women, even with only moments to spare, won't even think about stepping outside without mascara and lip color. Is this because they fear the expectations unfairly imposed on women to look "pretty"? Or if you don't bother to make the effort—no matter how slight—somehow your feminity is in question? The point I'm making is very simple—from your mother to the girl behind the cosmetics counter to me— only you can decide how much or how little makeup you do or do not want to wear. In this regard, Julianne is an exceptional role model. Always ready and open to explore the immense variations of the human psyche, she revels in life's many facets and options. This is what makes her not only an actress's actress, but a valuable and unique friend.

A timeless light-eyes-and-light-mouth balance combination.

Mary J. Blige reminds me of my mother. They are certainly not twins, but every time I look at Mary J. I see a resemblance of my mother in her youth.

From humble beginnings to critical acclaim, Mary's unbelievably resilient spirit has remained grounded and she is an incredible inspiration to her countless fans, of whom I am certainly one. The first time I worked with her—(she has possibly the best skin on the planet)—was for a fashion magazine in a group shot along with L'il Kim and Missy Elliot. Though none of us had ever met, we got along like family. It didn't hurt that the creative director—of more fashion magazines that I can possibly name—Paul Cavaco, was there cheering us on. (Look for him in the collage with Kate Moss and Danilo.) You can also find a Polaroid of Mary J., L'il Kim, and Missy Elliot in the same collage.

Arriving the morning of the book shoot on a red-eye flight from Los Angeles, Mary J. was seated next to Cheri Oteri, who, coincidentally, I was also photographing that day. The two had never met before, so I'm sure there is some deeper reason why they crossed paths other then en route for this project. Regardless, I love the idea of everyone I know coming together to make our collective culture stronger and everexpanding. Anyone who feels that isolation is the way to true happiness and enlightenment is living in a house with the windows and the door locked. Open up and let some fresh air in. As Mary says, "That's all that I can say."

This is also a light-eyes-and-light-mouth balance combination, although it would also be accurate to say your attention might be drawn to the beautiful lip shape and coloring.

Mary J. Blige: face three

1 Prep skin with *moisturizer*.

2 Apply *concealer* where needed and blend well.

3 Gently shape and brush the brows upward. Keep them in place with a stroke of *clear brow gel* (or mascara).

4 With a *medium shadow brush*, lightly wash *basic brown powder eyeshadow* all around, including under, the eye. Softly blend, especially up past the crease and onto the browbone.

5 With a *small shadow brush* (or fingertip) , dab and smooth fine *white shimmer powder eyeshadow* across the lid and be sure to extend and blend into the inside corner of the eye.

6 Curl lashes and sweep on *black mascara*, top and bottom.

7 Smooth a *hot pink creme blush*, smooth onto the cheekbones. Then, on top, dust *soft pink powder blush* with a *large blush brush*. (Layering products gives the skin the look of dimension.)

8 Line the lips with a *dark flesh lip pencil*. Smudge the line in toward the center, but do not fill in entire mouth.

9 Next, using a *lip brush*, cover entire mouth with a *sheer tawny liquid lip color*—just to the edge of the pencil, then blot.

10 To finish, dab a touch of *caramel lip gloss* to the center of the mouth (Steps 8-10 give the mouth dimension.)

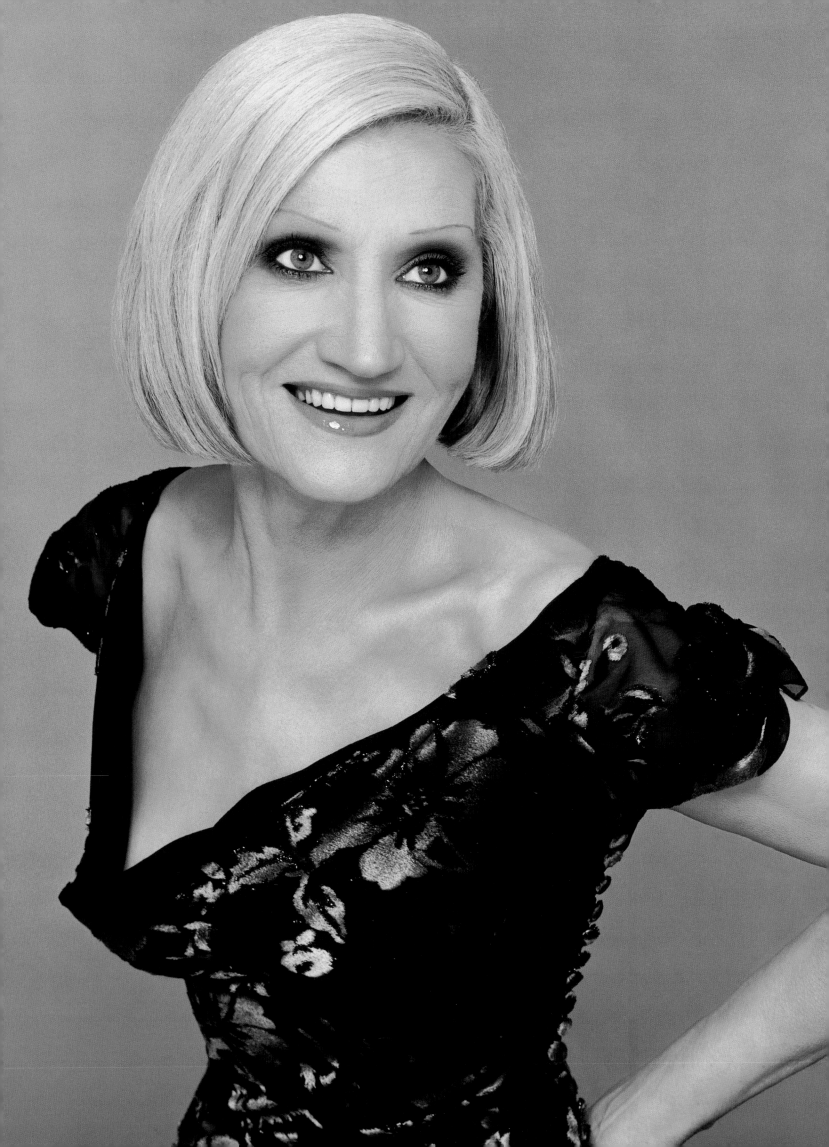

With all due respect to Sean Connery, Jack Nicholson, Michael Douglas, et al., it's time to end this ridiculous misogynistic propaganda about women of a certain age. Give me Gena Rowlands, Vanessa Redgrave, Susan Sarandon, or Catherine Deneuve over these male playboys any day. But is anyone in Hollywood listening?

I'm sorry, but few men have true strength. Women, on the other hand, don't have to show off the way men do; they just live it. Smoking cigars, playing the field, screwing people over (in business and pleasure), and playing sports does not a person of character make. I'd like to see men give birth, run a family, and still manage to be supportive and loving. For men, too often compassion and feelings equal weakness. Red alert. It takes a lot more strength to face your demons, your past, your sadness, and your grief, than it does to run from it in the guise of a stiff upper lip. That's called cowardice. Thank God things are changing, and more men are learning it is okay to be three-dimensional.

I hope this photo helps to break down the oppressive barriers set up regarding the image of more "mature" women. Two of my mother's role models, Cher and Tina Turner, have helped to redefine what it is to be a woman, young or old. So move over, guys, the sisters are doing it for themselves.

Of course, my mom has worn every conceivable makeup "balance" combination. Her four in this book, alone, are all slightly different variations on that concept. This one is an updated version of the classic (smoky) dark-eyes-and-light-mouth look.

Thelma Aucoin: face four

1 Prep skin with a **light moisturizer**.

2 A **creme foundation** slightly darker than my mother's actual skin tone was used, but a shade lighter was used under the eyes to counteract darkness.

3 Wash **basic brown powder eyeshadow** across the entire eyelid with a *medium shadow brush*, making sure to blend well and leaving no distinct lines.

4 **Black eye pencil** was used to line the inner rim of the eyes, top and bottom, and smudged into the lashline using a *sponge-tip applicator*.

5 Using the *sponge-tip applicator*, **basic black powder eyeshadow** was used to softly define the crease of the eye and top and bottom lashline.

6 Lashes were curled and **black mascara** was swept onto top and bottom lashes.

7 Lips were defined and filled in using a **light flesh lip pencil**, then covered with a **natural rose creme lip color**, using a *lip brush*. On top, a coat of **caramel lip gloss**.

8 My mother's thinly tweezed brows were defined with a **dark brown brow pencil**.

9 **Soft pink powder blush** was dusted high on the cheekbones, using a *large blush brush*.

Thelma Aucoin—my muse, my eternal inspiration, my teacher, and my best friend. Words alone cannot describe the incredible journey I have traveled with this resilient, tenacious soul. From her extreme childhood poverty, to quitting school so that she could support her ten brothers and sisters, my mother has lived a difficult life, but never complained. Following her marriage to my father, she discovered she could not have children of her own. Undaunted, they chose to adopt. Soon after the four of us entered the Aucoin household, my mother went through a very serious illness. Just one year later, as we gathered at my mother's parents' house for Sunday dinner, my grandfather—her idol—put a gun to his head and took his own life. He left no note, no reason. Back then, Valium was the "solution" doctors prescribed for women's problems, and therapy was for "crazy" people. Consoling herself with pills and drink, my mother began her long struggle with addiction, caused by the guilt and confusion of an inexplicable death.

When I left home at age fifteen, I made it my mission to lead my mother to sobriety and enlightenment. My "coming out" could have been the final straw for a woman so beset with strife and trauma. Instead, both my mother and father took it as an opportunity to reexamine their own long-held, yet never questioned, belief system. From the ingrained racism and homophobia of the South, to the duplicitous messages of love and acceptance mixed with judgment and damnation of religion, Mom and Dad had a lot of independent thinking to do. I learned that my parents' generation was taught never to question anything or anyone in authority. But once the two of them began, they couldn't stop.

At sixty-six, my mother is the true definition of a "modern" woman. Deeply spiritual, she has found that convention and compliance with rules made by others hundreds of years ago were the source of her lost sense of self, pain, and confusion. Today, the lessons in life we both experience are shared for the betterment of each other. Though I am adopted, Thelma Aucoin will always be my "real" mother. I love her deeply.

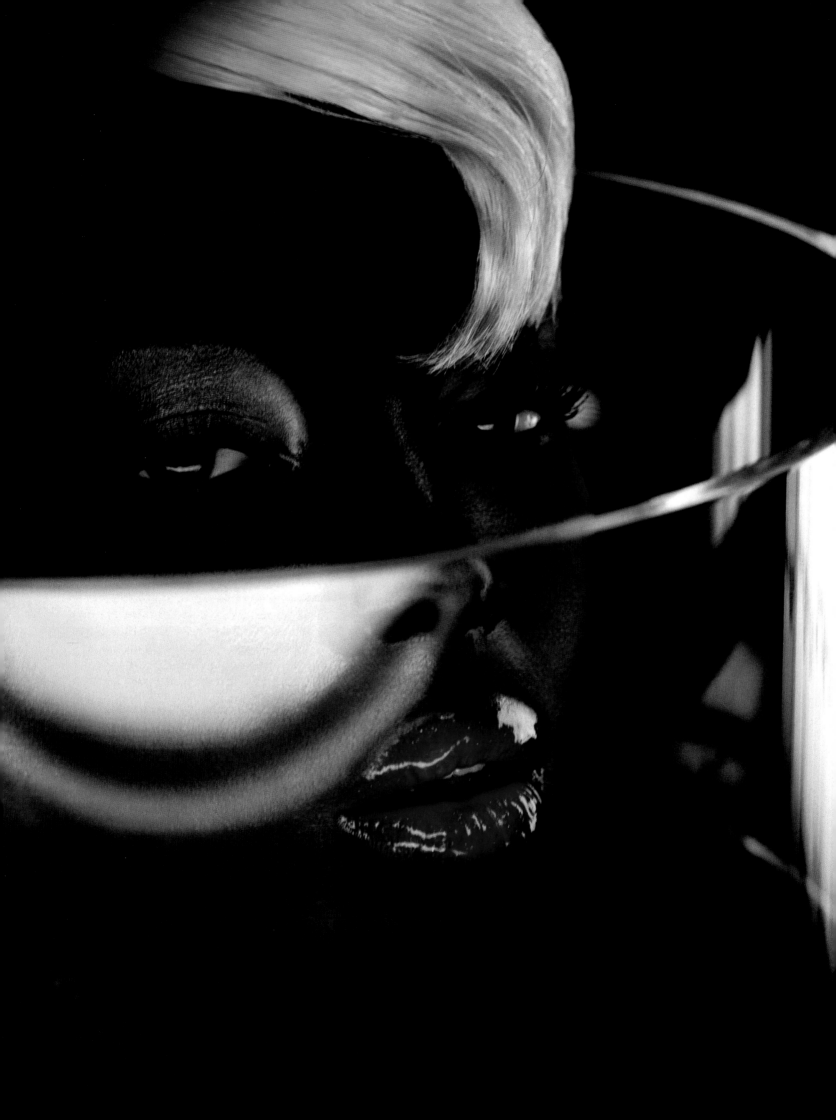

looking forward

Mary J. Blige as Explorer

1 Prep skin with *moisturizer*.

2 With a *sponge*, stroke **eggplant black body makeup** onto the face, neck, and shoulders and blend well. It is important that the application be evenly distributed so as not to look spotty. Set makeup with a very light dusting of **translucent black face powder**.

3 The inner rims of the eye are lined with **black eye pencil** (be sure that the point is smooth, not pointed) and smudge into lashline.

4 **Yellow**, **green**, and **blue metallic powder eyeshadows** are swept in broad strokes onto the eyelids, past the crease, and up to the brow, with a *medium shadow brush*. (Note: brows are completely covered with eggplant foundation.)

5 With a *small shadow brush*, stroke a line of **yellow metallic shadow** down the center of the nose.

6 Apply several coats of **black mascara** to curled lashes.

7 With a *large blush brush*, dust **hot pink powder blush** high on the cheekbones to just underneath the eyes.

8 Line the lips with a **deep red lip pencil** and fill in. Then, with a *lip brush*, cover with **basic red creme lip color**.

9 As a finishing touch, cover red lips with a generous coating of **clear metallic-glitter lip gloss**.

Though I am constantly asked my thoughts on the future of beauty, my guess is as good as anyone else's. I'm just a makeup artist, not a clairvoyant. Nevertheless, for the next twenty pages I wanted to take the title *Face Forward* literally and present a gallery of looks for the future. In it you will see a wild range of beauty concepts. As always, my philosophy is: take what you like and leave the rest.

Years ago, on a photo shoot with the incomparable Irving Penn, an interesting quandary occurred. Two of the models were American and two were African. Mr. Penn and I decided to take things to the extreme—the white girls would be made up Kabuki white and the African girls deep eggplant. As I applied the deep blue-black foundation (à la Grace Jones) on the second of the two African models, she burst into tears and stormed out of the makeup room. Upon returning she protested, "Why are you making me darker?" "Because they have never had women with distinctive African features and skin tones in this magazine. I want to do something subversive here, so please help me," I explained. It seemed her own internalized racism led her to believe that it was better to have a lighter skin tone than a darker one. Needless to say, her fears overcome, the shoot was a success on many levels.

Mary J. immediately understood not only the look I was trying to create, but collaborated to make this one of my favorite pictures. In "Looking Forward," Mary's explorer is a true visionary—resplendent in all the colors of the universe.

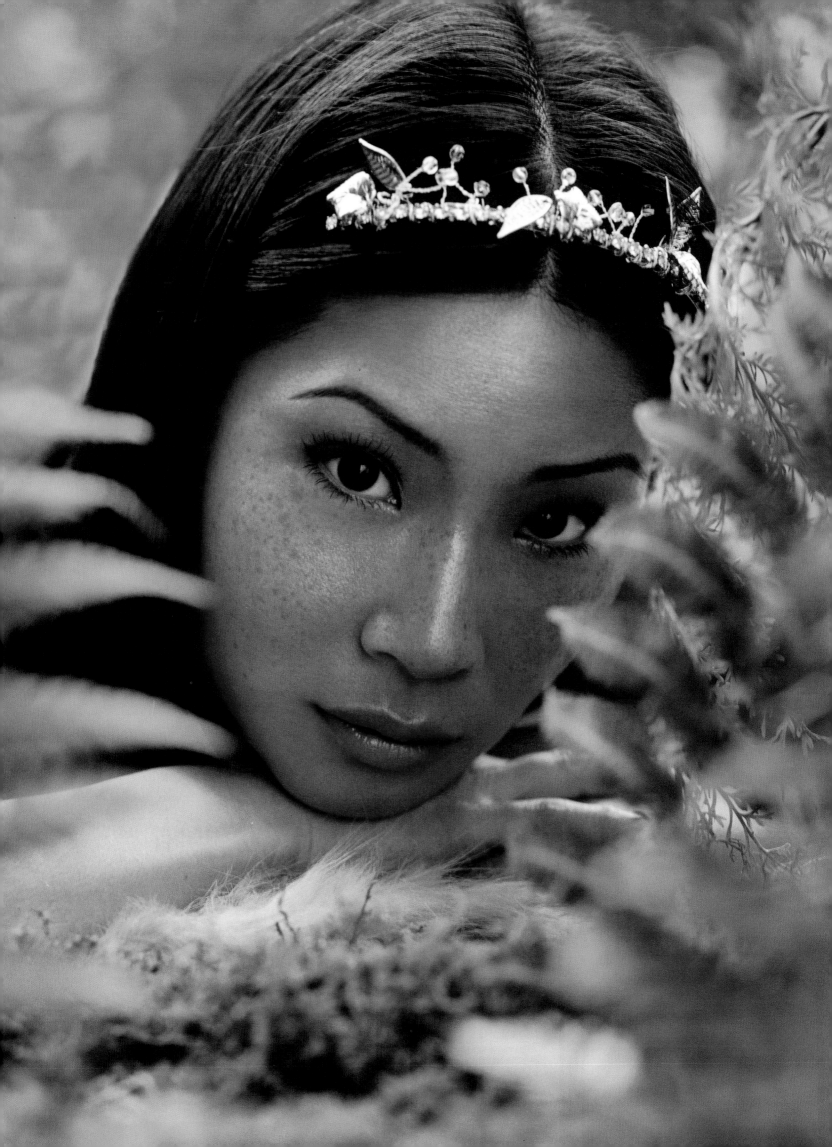

Lucy Liu as Floralia

1 Prep skin with a light application of *moisturizer*. Blot any excess with a *tissue*.

2 Lightly groom the brows. Tweeze hairs to enhance the natural shape and arch. Lightly fill in any sparse spots with the light feathery strokes of a **basic brown eyebrow pencil**.

3 Use **concealer** in spots and blend well.

4 No foundation is necessary for this look, but a light application of **sheer liquid foundation** will enhance the natural glow and sheen of the face.

5 With the fingertips, smooth a very sheer **soft brown creme eyeshadow** onto the lid and crease of the eye. Blend well, upward and outward.

6 Using a **basic brown eye pencil**, line the upper lashline and lightly along the bottom. Using a *cotton swab*, smudge into lashes to soften the line.

7 Curl the lashes and apply a light coat of **black** or **dark brown mascara**, top and bottom.

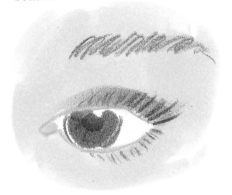

8 With the fingertips, smooth a dab of **soft pink creme blush** onto the cheeks and blend well. Smooth any excess on the chin, forehead, and temples.

9 Cover the lips with a generous coat of **transparent berry-red lip gloss**.

On our first stop through the future, we make a visit to a small planet—our own—and settle down in the cool streambed of a primordial rain forest. Here we find the splendid green flora and lovely fauna still thriving unhindered and unimpeded. Can't you just feel the cool, moist breezes? But for how long can this idyllic tableau continue? We could all do more to help protect the environment. But in my own defense, I am an anti-fur advocate and a crusader for animal rights (by the way, only fake fur was used in this book). I've also fought for years to make cosmetic companies stop animal testing, develop products that do not spoil or waste our resources, and recycle materials whenever and wherever possible. However, we must all make an effort to protect and share the resources on this planet. They are not infinite. Even I wish there was another way to print a book that didn't involve a tree. (Do me a big favor—if you ever throw this book away, recycle it.)

Lucy Liu has a type of beauty that I can only describe as pure, and she is one of those rare women who look just as beautiful with as without any makeup. That made her perfect for this portrait. I also just loved that her face mixes those almond-shaped eyes with Doris Day freckles. (I'll let you in on a little behind-the-scenes secret: our forest floor was actually created with ferns, shrubs, and moss on the parking lot of 5th & Sunset Studios in Los Angeles! When I asked Lucy to lie down on the cold pavement, I hoped she wasn't going to kill me. Fortunately, she was a real trouper and took it all in stride. I hope my disclosure didn't burst any beauty bubbles.)

Depending on your point of view, you can see this as either a light-eyes-and-light-mouth face or an (ever so slightly) dark-eyes-and-light-mouth look. Which goes to show you that the interpretation from one individual to another is very personal.

chameleon

A most versatile creature, a chameleon can take on the visual characteristics of its surroundings, normally as a way to protect itself from predators. If it's sitting on a tree trunk, its skin will turn mottled browns; set it on a rock bed and its colorations will become slate grays. Isn't that a cool trick? I read recently that clothes and makeup of the future will also have the ability to change characteristics and composition, to mirror the needs of the person's surroundings—as a way to protect the wearer from predators, as well as harsh climatic conditions, and as a matter of pure convenience. We already have sunscreens, self-tanners, and wrinkle removers, but soon you may soon be able to purchase a lip color that will change automatically to match your outfit. Clothes that you wear on a day that starts out chilly will keep you warm, but change instantly to cool and breathable fabrics should the temperature rise. Now how are those for really cool tricks?!

To be a good model, you have to allow yourself a certain amount of flexibility from job to job; you can't be too rigid. To be a great model, you must not only be flexible, but you must also bring a level of excellence to every job you undertake. If it is a sportswear shoot, you become the best sportswear model; if the day requires wearing couture clothes, you are the epitome of couture grace. Christy Turlington is a beloved figure in the modeling world. She has a chameleon-like understanding of the needs of her surroundings and the ability to take on the characteristics of whatever is expected of her. It has been a constant joy to have worked for so many years with such a pro.

For our chameleon portrait, Christy's makeup is low-key except for her wash of "patent leather" red eyeshadow. The color, coupled with that of her camouflage tulle netting, like the skin of a chameleon, helps her to "blend in" with the background. Christy always "blends in" when it comes to getting along with everyone. But no amount of camouflage can hide the extraordinary warmth and inner beauty so evident in those soulful eyes.

Christy Turlington as Chameleon

1 Prep skin with **moisturizer**.

2 Use **concealer** on red spots or any areas of discoloration. Blend well.

3 Smooth on a very light application of **liquid foundation** to enhance the dewy look.

4 Groom and tweeze brows to bring out natural shape and arch. Use a **basic brown eyebrow pencil.**

5 With a **red lipliner pencil**, lightly draw in desired eye shape.

6 With a *small shadow brush*, fill in area with a **true red creme eyeshadow**.

7 With the fingertips, dot on **rose liquid blush** and smooth into the cheeks.

8 Line lips with a **light flesh lip pencil** and fill in.

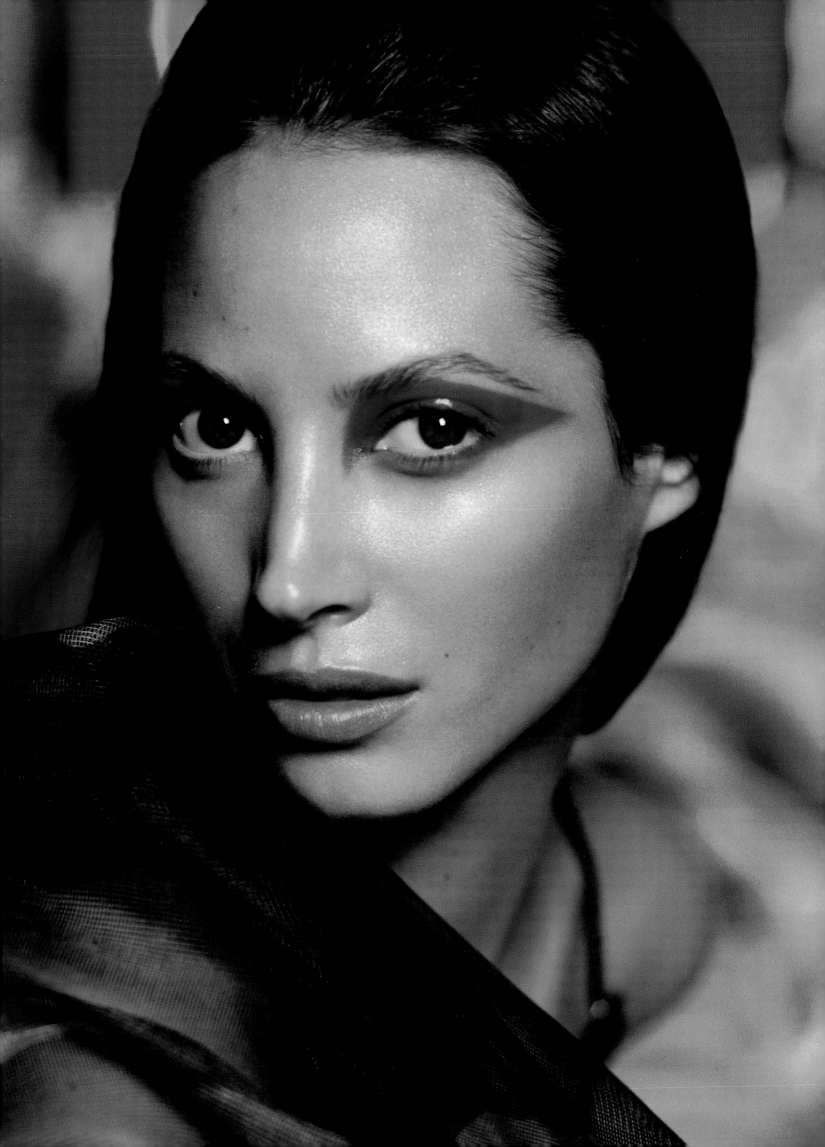

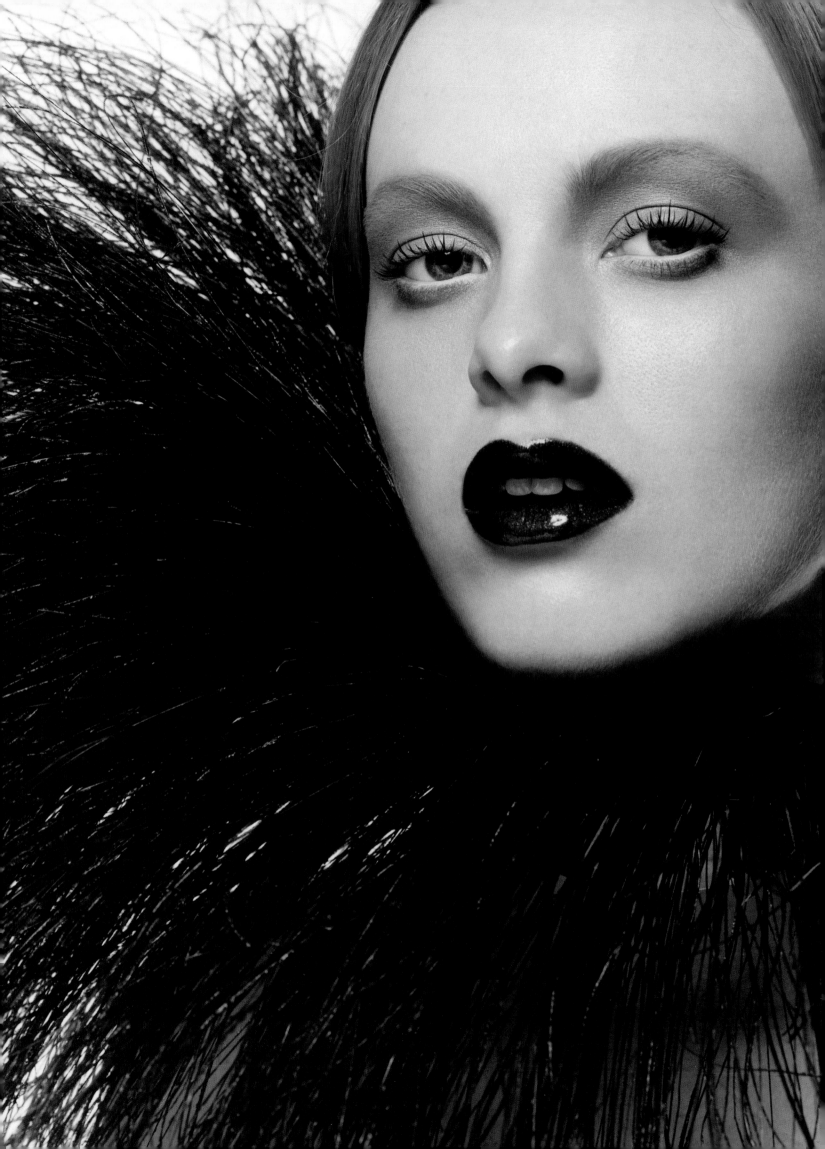

bird of paradise

Karen Elson as Bird of Paradise

1 Prep skin with **moisturizer** and blot any excess with a *tissue*.

2 Lightly groom the brows.

3 Dot **concealer** on any red spots, blemishes, or under the eyes where skin may appear darker, and blend well.

4 Using a **light creme matte foundation**, smooth with the fingers or a *sponge* over the face, starting in the center and blending outward. Set foundation and concealer with a light dusting of **loose translucent face powder**, using a *circualr* sponge.

5 Using a trio of eyeshadows and a *medium shadow brush*, begin by taking a **shimmery light aqua powder eyeshadow** and washing the eyelid, over the crease and just under the browbone. Blend very well.

6 Next, Take a **warm olive-green shimmery powder eyeshadow** and the same brush and lightly sweep under the eye. Also blend well.

7 To finish, take a **warm golden-brown shimmery powder eyeshadow** and stroke over the eyebrows in a broad arc, going from the bridge of the nose outward to the temples. Again, blend well. (Note: All three shadows should softly blend into each other. There should be no distinct lines between them.)

8 Curl the lashes and apply a light coat of **black mascara** to the top lashes only.

9 Lightly dust the cheeks with a **soft pink powder blush**, using a *large blush brush*.

10 Line the lips with a **navy blue lip pencil** and fill in.

11 Cover mouth with a **iridescent indigo creme lip color** using a *lip brush* to get an exact shape.

12 Over the top of the lip color, generously coat with **translucent metallic blue lip gloss.**

We've all heard that the ability to reason is one thing that sets us apart from other forms of life. Another is our ability to create things and, in turn, appreciate what we have created. As far as I know, no other species on this planet has the ability to do these things (although I once read something about a species of bird that actually constructed its nest in an aesthetically pleasing manner). Speaking of our feathered friends, they also use elaborate plumage and colors—the way we take time with hair, makeup, and clothes—to attract mates. But humans can take that one step further—if we don't like what we have to offer, we have the power to change it. In fact, throughout time we have used our appearance as a way to attract and excite others (and ourselves)—and I do not mean that solely in a sensual sense. It's human nature to want to belong and fit in. Yet we need to be careful about exactly what we agree to sacrifice in order to be "like everyone else." The more we are told to "just be normal" the more the occasions to visually stand out take on even greater significance. I truly hope that in this new millennium all of us will find the courage to exhibit and live as the unique creatures we were meant to be. With our infinite resources for originality, who knows what ideas we may conjure. I'll always be drawn to the feathery freaks over the cloaked conventional types—they're a helluva lot more fun. Fitting in is just a cop out. As the wonderful Auntie Mame said, "Life is a banquet, but most poor suckers are starving to death. You should live, live, live!" Amen to that.

With her quirky, off-beat personality and beauty, Karen Elson is a bird of paradise. Taking colors directly from the feathers of a peacock—gold, green, and indigo blue—I used them in unexpected places. However, I don't feel that there is anything unwearable about this unexpected face. Time to fly!

feles-femina

The Island of Dr. Moreau by H. G. Wells was a famous novel of the late nineteenth century (1896 to be exact) that told the once-incomprehensible story of a scientist who learned how to interbreed humans with animals. Beyond its fanciful science-fiction aspects, the tale was actually an exploration into the self-imposed limits (and freedoms) of science and technology that posed the question: How far should any of us go in the name of enlightenment and understanding? Today, the continual interrelation of races is creating complex ethnicities. We know it is possible to clone lower forms of mammals, and that the replication of humans is not far off. We are fast learning how to forestall the aging process—the fountain of youth is within our grasp. But with every advance forward, we find ourselves in even newer, less familiar territory. Furthermore, the evolution of our species and planet will likely keep changing and never be finished. But the mystery of what lies ahead is part of the beauty of life.

In real life, Monica looks nothing like a cat, but I knew that with the extension of an eyeline, a touch of golden foundation, a sharp black wig, and a downturn of the head, we could transform her into something fabulously feline. *Grrrr!* The makeup effects were even doubled when it was discovered that the sweep of eyeliner and angle of the face revealed an Asiatic quality in her features.

If we've come this far, I'm guessing that many of your would say this is an eye and brow shape picture. (Some of you may have said that this was also a texture face—and you'd be right on the money too.) But remember, just because the focus is on the eyes, it is still important to "finish" the rest of the face.

Monica as Feles-Femina

1 Prep skin with **moisturizer**.

2 Use **concealer** in spots where needed and blend well.

3 Smooth on **golden-sparkle liquid foundation** all over the face with your fingers and blend outward.

4 Groom and shape the brow by exaggerating the upward slant. Using a **basic black eyebrow pencil** and your own brow as a guide, at the point where it naturally turns (arches) downward, continue the line upward, above the temple. (It may be necessary to partially cover over the tail end of the brow with *sealer, spirit gum,* and *brow wax.*) Brush hairs up and fill in sparse spots with pencil or **black liquid eye pencil**. (The extended part of the brow should be drawn in with short slanted strokes of the pencil.)

5 Next, take **basic black powder eyeshadow** and a *sponge-tip applicator* to soften and enhance the brow.

6 Using a *medium shadow brush*, wash **gold metallic powder eyeshadow** all over the lid, crease, and up to the browbone of the eye. Blend away any noticeable edges.

6 With a **black liquid eyeliner**, define the upper lashline. Begin the line at the inside corner of the eye and end it well up into the temple area. The line is noticeably thicker along the middle—across the eyelid—and tapers to a very fine point.

7 Curl lashes and apply a heavy coat (or two) of **black mascara** to top lashes only.

8 With a *large blush brush*, very lightly dust **hot pink powder blush** onto the cheeks.

9 Line the lips with a **light flesh lip pencil** and fill in. Use a *cotton swab* to soften the edges. Over top, smooth on a **clear pearlized-glitter lip gloss**.

Christina Ricci as Youth Eternal

1 If necessary, moisturize the skin.

2 Brows are covered over with the use of *spirit gum*, *brow wax*, and *sealer*, then covered using **creme foundation** (to match skin tone) and set with **loose face powder**.

3 On the rest of the face, use **concealer** (to match) in spots where needed to cover redness and discoloration. Then, all over the face, use the same foundation as above to give the skin a consistent texture. Set with powder.

4 **Powder blue creme eyeshadow** is blended onto the entire upper eyelid from corner to corner, using the fingertips or a *medium shadow brush*.

5 Line the upper lashline with **navy (or indigo) blue eye pencil**. Smudge into lashes.

6 **Hot pink powder blush** was applied high on the cheekbones and up to the outer corner of the bottom lashline with a *large powder brush*.

7 The lips were softly defined using a *lip brush* and a **sheer red liquid lip color** and kept to the inside of the mouth and away from the corners to appear pouty. (Note: concealer was applied to the outer corners of the mouth so that the shape of the actual lips could be made smaller.)

8 Finally, the brows were drawn in as short diagonal slashes high above the actual browline with a **basic brown eyebrow pencil**.

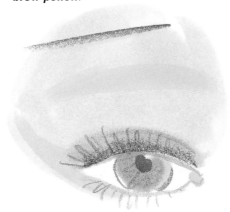

At the beginning of the 1900s, children not yet ten were often engaged in what amounted to slave labor and were expected to carry their share of the burden of a poor, working-class society. Considered an expendable commodity, to be exploited for the benefit of others without question, they were made ragpickers, human canaries and human moles; their prisons were mines, fields, and factories. Lives so truly bleak, even the rhetoric of a Dickens novel seems trite. Thank God for women. If it weren't for them, where would our children be today? After realizing the great injustice that not only they but their children were suffering, our heroic foremothers struggled valiantly (and successfully) to give their young a true childhood away from the shackles of industry and power.

The youth of the twenty-first-century developed world are inheriting a different place from that of the youth at the turn of the last century. However, that is hardly the case around the rest of the globe, where poverty, illiteracy, and hunger still harness children to a work plow. While the benefits of a more enlightened society may be in place in some parts of the planet, let's never forget that we are still the guardians, protectors, and teachers of children no matter where they dwell.

Christina Ricci is twenty, yet her timeless beauty allows her to play the part of this haunting doll-child. Quite a jump back in age from the last time we saw her, as Edith Piaf. Here you just want to make sure this little waif gets home safely and has something to eat. (Another note: the little doll Christina holds in her lap is a treasure from the eccentric 1960s; fittingly, though bizarrely, her name is "Little Miss No-name.")

damsel primitif

Remember what I said in the beginning of the book about helping women take over the world? Well, it looks like this female of the future will need no assistance from me. (She certainly looks like she can take care of herself!)

Scientists are telling us that in the not-too-distant future, women and men will take on more characteristics of each other—women will become physically stronger, men will become more vulnerable—and the lines between the two genders will blur. Hip-Hip-Hooray! If that does happen, it will be quite interesting to see how it affects the way society functions. With all of us rendered more or less alike and no longer easily distinguishable purely on the way we look, then who we are on the inside, not the outside, will determine our worth. But honestly, I do not know how I feel about this prediction. Obviously, I like the physical differences between people. I would rather inhabit a world where we all look different but are nonetheless still treated equally. And we don't have to wait for future generations to bring that about, it's something we can work on right now.

Anyone who has followed Julianne Moore's prolific career will not be surprised at her ability to shed one skin for another. After all, in reality it is just makeup altering and exposing different aspects of her own personality. The same is true for everyone open to all of life's possibilities, male or female.

In terms of shape and balance, the "eyes" have it. (Although up this close the mouth comes in a very close second.)

Photograph by Warwick Saint

Julianne Moore as Damsel Primitif

1 Prep skin with ***moisturizer***.

2 Apply spot ***concealer*** (to match) where needed and blend well.

3 Lightly groom the brows and fill in with a ***golden-brown brow pencil***. (Note: this is a very "natural"-looking eyebrow shape.)

4 Taking a ***basic black eye pencil***, with a smooth softened tip, line the inner rim of the eye, top and bottom, and smudge into lashline.

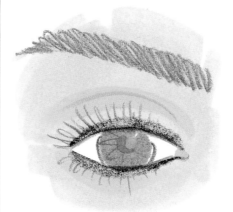

5 With a *medium shadow brush* and ***basic black powder eyeshadow***, encircle the entire eye area, top and botttom. Start small and enlarge the circle as you go—blending and smoothing out from the center—which will make the shape easier to control.

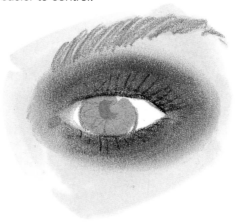

6 Using a *small shadow brush* and a ***black creme eyeshadow*** (or ***black liquid liner***), deepen the blackness of the very center of the already darkened eye. (This will give the eye more dimension.) Be sure to soften the edges with the powder shadow, which will aslo "seal" the creme or liquid liner.)

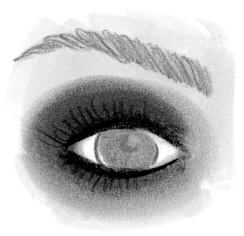

7 Curl lashes and apply a heavy coat of ***black mascara*** to top and bottom lashes.

8 With your fingertips, smooth on a touch of ***soft pink creme blush*** on the cheeks.

9 Line the lips with a ***light flesh pencil*** and fill in. Top off with a lick of ***sheer red lip gloss***.

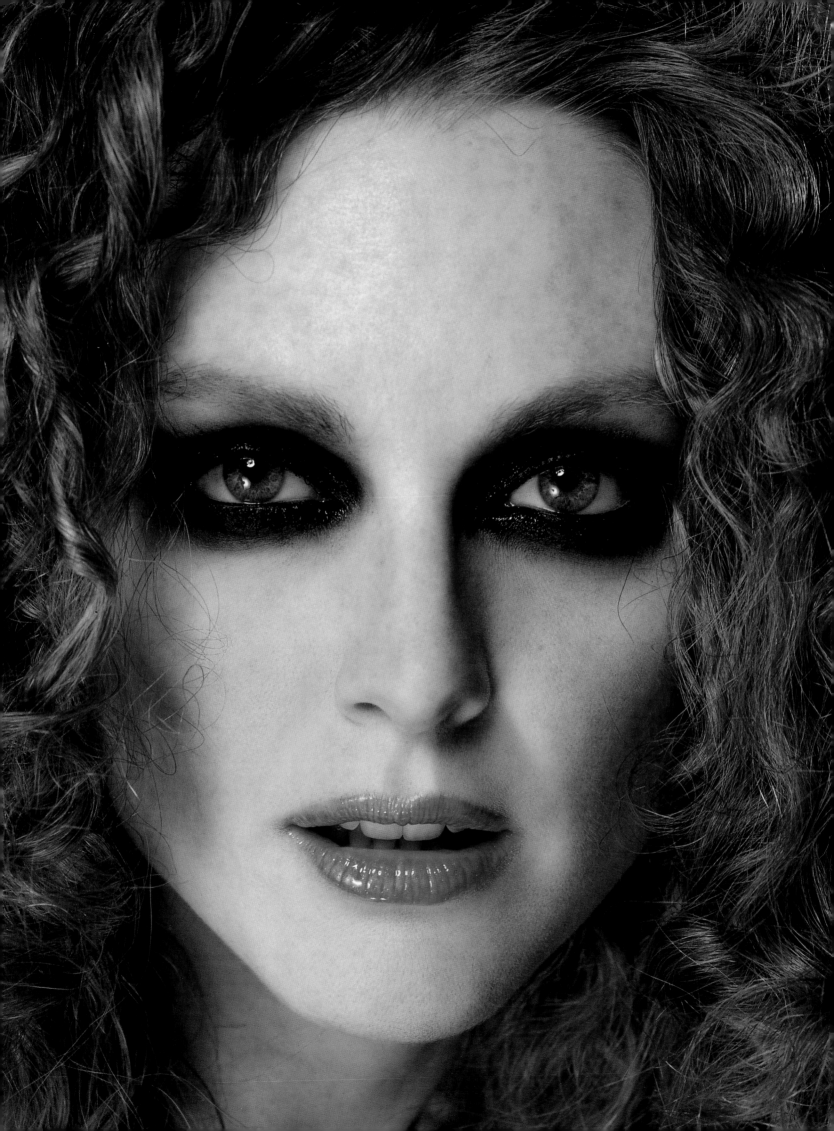

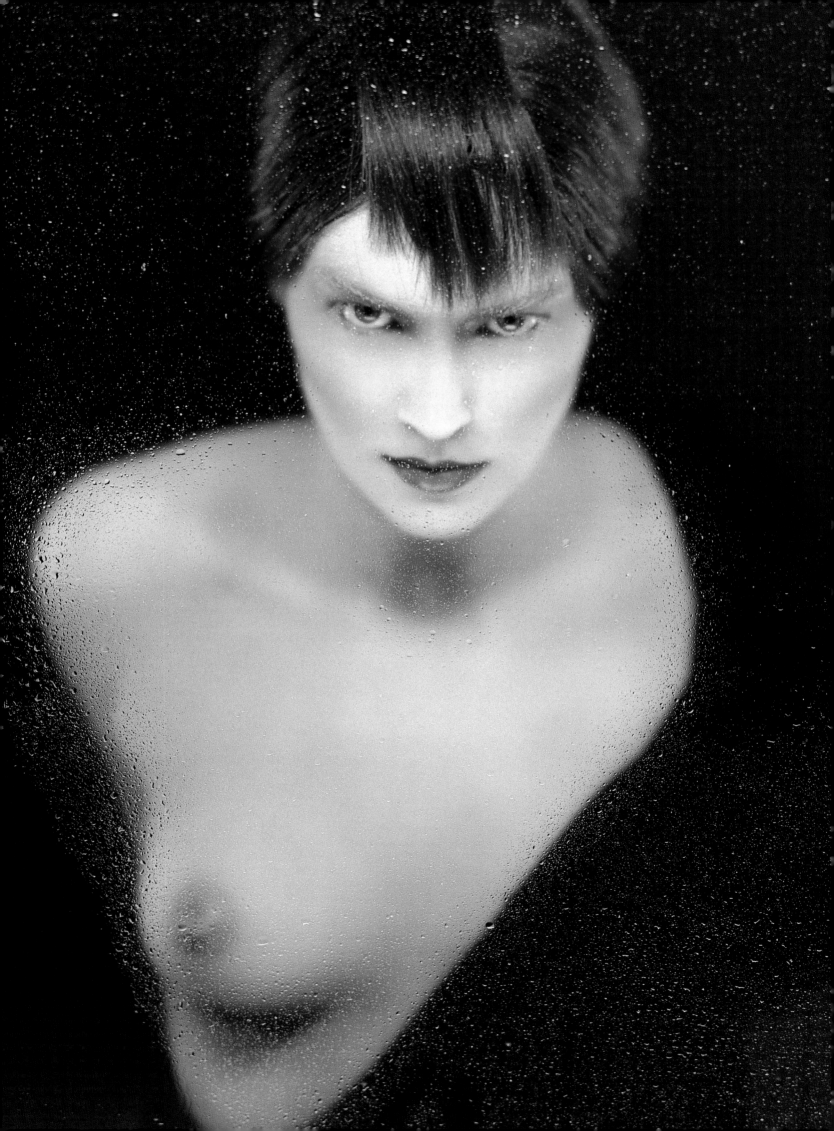

Sharon Stone as Venusian de Milo

1 Prep skin with **moisturizer**. Be sure to blot any excess with a *tissue*.

2 With a water-based pure white pigment, spray onto the skin with an airbrush. (Special companies make airbrushing equipment for makeup use.) Spray evenly all over the face and exposed parts of the body to give yourself a pure white canvas. (Note: this technique is best for film and photography and might be easier to do on someone else, and not yourself. Either way, it takes quite some time to learn, but it is worth it. By the way, the Steven Klein photograph of Karen Elson on page 3 was created through this process.)

3 Switching to a bronze paint, spray lightly across the eyes to create a Zorro-like mask effect.

4 Very lightly spray bronze on the cheek area. (Note: airbrushing can be used to create so many effects and cover especially large areas much quicker than a brush.)

5 Line and fill in the mouth with a **light flesh lip pencil**. With the airbrush, spray a "hot spot" of bronze paint right to the center of the mouth, fading outward.

6 Lightly spray bronze along the collarbones and in the hollow of the neck, and, if you plan on duplicating this look exactly, completely encircle the nipple.

Danger, Will Robinson! Maybe somewhere along our journey into the future we will encounter creatures from other planets not too dissimilar from ourselves. There is a chance their bodies and faces will remind us of our own—like the resemblence we see with this hypnotic beauty. However, the odds are that they will not. And if not, how will we react? What would you do if you met up with a one-eyed Cyclops, a snake-headed Medusa, or a sensual Venusian? Upon seeing someone or *something* that is unfamiliar to us, how have we reacted in the past? Were we wary of this newcomer's presence or did we welcome them with open arms and open minds? Obviously, recreating this other-worldly femme fatale's alluring yet somewhat intimidating presence is not for the faint of heart—it involves bluish-white body makeup, copper-tinged hair wefts, and a bronze airbrushed chest—though it is by far one of my favorite looks in the book. But feel free to take elements that interest you and leave the rest behind. You'll find that once you get over the initial shock of something, its essence can become an abundant source of new ideas and inspiration.

With this last of my three portraits of her, Sharon Stone has taken a journey through the entire spectrum of beauty's past, present, and future. In any one of the trio, she is no more or less beautiful (or provocative) then in the other two. Certainly, some aspects of the makeup applications are more conventional, while others are less so. Regardless, inspiration can be found in all three—and in what we expect and what we do not.

Because her skin tone is so light, this is a (soft) dark-eyes-and-dark-mouth balance combination. Color is an important factor, too. So is shape, especially because the metallic paint widens the eye area as it extends across the breadth of the face.

muse

● ● ● ● ● ● ● ● ● ● ● ● ● ● ●

Okay, I admit it, I deliberately chose to close this section with a face not painted in a surreal manner. Why? Because the true future face of beauty may look like this: the simple representation of the subject, unadulterated and unencumbered. I also elected to end my gathering of tomorrow's beauty subjects with Muse. Since the beginning of civilization, the muse has served as our inspiration to create and occupy a more beautiful world. From the lilt of an enchanted melody to the measured cadence of a beautiful poem, the muse has taken us by the hand and heart out of the darkness and into the light. She is the past, present, and future. In this book, I call my mother and some of my friends muses, and that's the truth. But to be totally honest, at one point or another, every woman in *Face Forward* and every woman I have ever worked with has inspired and taught me for the very reason that this simple Grecian deity was first created: to help us bring joy to ourselves by first bringing joy to others.

Madonna is the perfect subject to play the Muse, because she has inspired so much creativity and thought. Further, her commitment to ignore all of the unjust criticism thrown her way and forge ahead is admirable, and at the same time what we have come to expect from this heavenly hellraiser. All I have to say to her critics is this: a rose-toned base will help to counteract your green-hued skin. Fan or not, you must respect her. She has paved unlimited venues for people of all backgrounds to feel free to explore and understand themselves. By challenging oppressive and puritanical views, she has liberated and enlightened countless individuals. The political undertones in her work have influenced a broader spectrum of humanity and continue to do so. This is the true future of beauty. The right shade of lipstick can never equal social consciousness. Never.

Madonna as Muse

1 Prep skin with *moisturizer*.

2 Use *concealer* in spots where needed and blend well.

3 Lightly dust face with a *loose translucent face powder* with a *sponge*.

4 Lightly groom the brows and fill in with a *basic brown eyebrow pencil*.

5 With a *small shadow brush* or *sponge-tip applicator*, define the crease of the eyelid with a *basic brown powder eyeshadow*. Also run a light line of shadow along the top and bottom lashline.

6 Lightly wash the eyelid with a very sheer, *off-white shimmery powder eyeshadow*. This is a soft, undefined look that works best when done with the fingertips.

7 Curl the lashes and apply a coat of *dark brown mascara*, top and bottom. (Dark brown will give you a softer, less defined look than black mascara.)

8 With a *large blush brush*, lightly dust *soft pink powder blush* onto the cheeks, temple, and chin.

9 Cover the mouth with a *sheer red lip gloss*. Top off with a sweep of *caramel lip gloss*.

Photograph by Dah Len

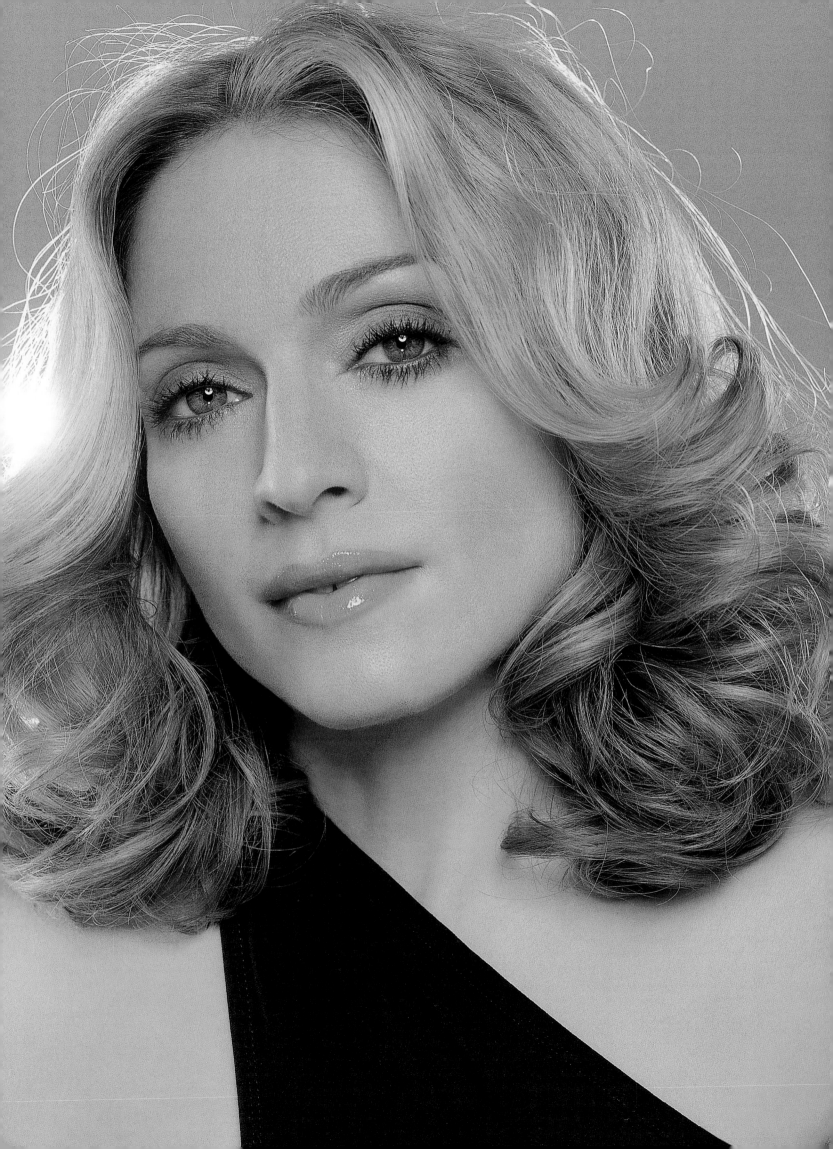

acknowledgments

First, I would like to say that my muse, my rock of Gibraltar, the man who never let me down, and an angel in human form has appeared in the guise of Donald Reuter. Throughout this and our last two projects, he has proved himself to be not only invaluable, but a generous soul. Donald is a teacher and an out-and-out genius. I'd be lost without him.

Words alone cannot express the dedication, loyalty, and pure beauty of my soulmate and best friend, Eric Sakas. His unerring faith and belief in me are the most significant factors in my ability to endure and thrive. No gentler spirit has walked this earth.

To my family and friends, which of course includes everyone in this book, I am forever indebted to you for your love and support. You are my greatest source of inspiration.

Special thanks to the magnificent Suzanne Gluck, Karen Gerwin-Stoopack, and Caroline Sparrow @ ICM. Not only are they the best at what they do, they have become dear friends. To Jennifer Josephy, my errant editor, for her love, support, and creative vision—this book would not be possible without you.

To everyone at Little, Brown for their continual support and enthusiasm, including Sarah Crichton, Judy Clain, Holly Wilkinson, Beth Davies, Linda Biagi, Matthew Ballast, Melanie Okadigwe, Jean Griffin, Amanda Murray, and Dylan Hoke.

To my amazing team of assistants: Craig Paulson, Alex Beauchesne, Stephen Snowder, Andreas Hesse, David Malykont, Stuart Tyson, Jennifer Smith, Robert Fimmano, James Munoz, and D. Tyler Huff . . . thank you dearly for your loyalty, dedication, and, most of all, sense of humor.

Thank you to all the hairstylists, fashion stylists, and prop stylists who helped to create this book. A special thanks to Freddie Leiba for all his guidance and support.

Much gratitude to Marcy Engelman for this our third project together. Thank you for your consistently brilliant work.

I cannot express how invaluable my daily team of support has been, especially Sandra Rubalcava, my valiant agent and friend. To Troy Surratt, whose devotion is unsurpassed. And much gratitude to Dimitri Elfes and Ann Gorga.

A very special thank-you to Mazdack Rassi and everyone at Milk Studios, Glenn Ban and everyone at Pier 59 Studios, Timothy White and everyone at Whitespace, Bruce Kramer and everyone at 5th & Sunset Studios.

Endless thanks to Rebecca Arnold, Markus Klinko, Manny Riggi, Indrami Pal Chaudhuri, Jaspal Rai, Peter Possenti, Elizabeth Royden, Kai Wong, Jason Elliott and Katie Murphy, Roger and Sloan Barnett, Michelle Williams, Karen Young, Sandra Singer, Michael Goff, Silke Steinberg, Adam Smith, Patrice Luanay, Charlie Duff, John Witherspoon, Natalie Caplan, Rene Angelil, Kim Jakwerth at Marleah Leslie & Associates, Robert Forrest, Steve Huvane at Huvane, Baum & Hall, Natalie Stevenson, Deana Bolton, Phil Bronstein, Terry Simms, Lydia Sarno, Michele Schweitzer, Jeff Ayeroff, Tim Robbins, Brian Pines, Chad Lowe, Troy Nankin at BWR, Carol Brodie, Karyn Gatt, Desiree Gruber, Larry Beck, Amy Swift, Louie Chaban at Elite Model Management, Susan Magrino, Samantha Shable, Kevin Sharkey, Annie Armstrong, Lisa Zay, Ken Bach, Jim Caruso, Wade Binder, Gena Avery, Mark Robertson, Peggy Pelino at Ford Models, Victor Alfaro, Cassi Caeser at Elite Special Services, Carlton Gardner, Lori Berk at MCA, Melinda Dancil, Ivan Bart at IMG Models, Bari Mattes, Liz Rosenberg, Johanna Wietsma, Jennifer Ruiz, Lily Moussa, Ellie Aitken, Roger Davies, Lindsey Scott, Jaime Mendoza, Terry Harris, Shawnette Heard, Rhonda Graam, Giraffe, Patrick Prendergast, Oprah Winfrey, Dianne Hudson, Kandi Amelon, Katie Couric, Matt Lauer, Diane Sawyer, Rosie O'Donnell, Barbara Walters, Lisa Ling, Meredith Viera, Iman and David Bowie, Tom Woolley, Benny Medina, Jane Siberry, Bart Freundlich and Caleb, Christina Smith, Vivian Walker, Michael Costa, Adam Bell, Tom Ford, Lisa Schiek, Keri Albright, Charlotte Sprintis, Marleen Everett and everyone at Gucci, Donatella Versace, Carineh Martin, Ola Alya Itani, Yoki Ono and everyone at Prada, Billy Daley and everyone at Dolce & Gabbana, John Bartlett, Vivienne Westwood, Tommy Hilfiger, Stephen Cirona, Annette Wolf at Wolf-Kasteler, Liz Smith, Denis Ferrara, Lori Goldstein, Blaine Trump, Dr. Mathilde Krim, Vernon Jolly, Carol Morris, Kristian Hanif, Dolly Sakas, Lindsey Simmen, Estelle Gardner, Elaine Goldsmith, Edward Norton, Jr., Salma Hayek, Sarah Jessica Parker and Matthew Broderick, Ben Affleck, Matt Damon, Courtney Love, Dr. Carmen Caggiano, Dr. Gregg Lituchy, Jason Kim, Dr. Patricia Wexler, Dr. Daniel Baker and Nina Griscom, Dr. Karin Lyngstad, Ed Limato, Julien D'Ys, Serge Normant, Laura Mercier, Karen Binns, Sandra Bernhard, David Sims, Bette Midler, Fern Mallis and Stan Herman at the CFDA, Fabien Baron, Queen Noor of Jordan, Carlos Avalle, Jani Bhagvat, Orlando Pita and George Casson, Warren Leight, Maureen Porter, Judith Guieuillemot, Jennifer Dynof, Erin O'Donnell, Roseanne Shelnutt, Karin Smith, Wendell Maruyama, Lina Bey, Jessica Sares, Keith Coleman, Vincent Mallardi, Ilaria Alber, Marnie Prather, Susan Duffy, Robert Sammons, Allison Haas, Marie Barrett, Dianne Vavra, Alison Mazzola, Lis Guiney, Liz Pender, Susan Hagamann, Deborah Morton, Ricky Kenig, Sandra Gabriele, Christian Mitchell, Maura Quinn, Susan Maurizio, Johanna DeKanna, Laura Lee, Guido, Barry Gothelf, Joe Calvo, Lois Varall at Calvo, Gothelf & Co., Stephen and Eric Raphael at Bear Sterns, Patti Conte, Linda Ferrando and Donna Jaffe at Atlantic Records, Cindi Berger, Lois Smith, Carri McClure and Melissa Kates at PMK, Maraq Buxbaum, Joe Libonati and Carrie Byalick at ID Public Relations, the entire cast of *Strangers with Candy*, Jami and Klaus Von Heidegger, Cammie Burns, Jason Schell and Kimberly Trask at Kiehl's, Lev Glazman, Alina Roytberg, Kelly Brown and Laurie Griffin, Casey Patterson, John Sykes and Wayne Isaak at VH1, Linda Wells, Paul Cavaco, Andrew Wilkes, Kate Waters and Margaret Feldstein, Kate Betts, Christine Lennon Shea and Michael Botbol, Anna Wintour, Amy Astley and Charlie Churchward, Martha Nelson and Kim Van Dang, Glenda Bailey and Alexandra Parnass, Elizabeth Salttzman and Graydon Carter, Tina Brown, Gabe Doppelt and Beth Butts, and Patrick McCarthy.

And last, but not least, to everyone who has patiently stood in line at book signings or written me what are some of the most beautiful letters in the world. Thank you for caring and sharing your creativity and love with me.

On the right, Victoire Charles is the phoenix rising from the ashes. Metaphorically speaking, Victoire was reborn over and over again in *Face Forward* a total of four times (but never to the point where she was actually in flames!). That day, when she sat for her first portrait (see page 32), she had no idea where her makeup journey would lead. Yet, when you look at the quartet together, she seems to have traveled back and forth through time and in and out of fantasy and reality. For one person, the resulting images were amazing—and any one of us can take the same trip whenever we choose with a makeup kit and an open mind.

Here is my mom, Thelma, now as the legendary fashion designer Gabrielle "Coco" Chanel (which also doubles as a tribute to the legendary photographer Horst). Beyond being a great designer (possibly the greatest in the twentieth century), Chanel was also a great leader of women. She almost singlehandedly took women out of nineteenth-century clothes and placed them in modern attire. Obviously, I champion women like that, who dare to stand up against the majority for what they believe is valid. In this case, something as relatively simple as women wearing pants. If I had the time, I would have done another hundred photographs of women just like her.

last page: the sublime Diana Ross. When I said earlier in the book that I tried to have at least two photographs of every person, I allowed myself to have a little fun with that concept. Ms. Ross is in *Face Forward* twice—once in real life, and another in tribute. (photograph by Albert Watson)

endpapers: starting from top, left to right: That's me with Jewel; my godniece Samantha and my dog Alex; Tina Turner; Sheryl Crow; Tori Amos, Eric Sakas and me; Jeremy with my niece Falon; Mom and Dad, way back when; my birth father Jerry Burch; me with Eric Hyrman, Hilary Swank, and Herb Ritts; a duo with Thomas Efaw; Falon; with Catherine Deneuve; Isidore and Thelma; with my niece Katarina; Sibi and Christian Bale; Jeremy, Eric, Gwyneth, Orlando, and George; Julianne Moore as Bette Davis; great friend Glenn Neely; Madonna; niece Tatijana; me with Antonios; a young me with sister and brother Carla and Keith; a very colorful Winona Ryder; with Courtney Love; Stevie Nicks; with Lisa Kudrow; Liza; with Shalom Harlow; Linda Evangelista; with Casey Patterson; Sharon Stone; with Winona, Tori, and Jeremy; my nephew Ian; sisters Kim and Carla, from long ago; me with Amy Sedaris; kooky Cheri Oteri; with Mom and Dad; a deep blue Angela Lindval; curly Teresa Stewart; me with Winona; a rather green Karen Elson; me with Thomas; with Maria Thayer; with Meg Ryan; with President Clinton and the First Lady; sister Kim and her husband Doug; me with Jeremy; Gwyneth; Eric and Katrina; me with Lisa Marie Presley and John O.; Janet Jackson; Jeremy with Jennifer Lopez; my brother Kieth; Mom; Samantha; Carolyn Murphy and I; Celine Dion; Jenna and Kristy; with Julianne Moore; Samantha and Gwyneth; Carla, Katrina, and Samantha; me with Michelle Fontneaux and Glenn; with Julianne Moore; Tori; Snow White and Snow White (Falon); with Rubin; Samantha, Ian, Tatijana, and Falon; Dana Hamill and her spouse; Keith and Tatijana; me with Janet; Mom, Gena Rowlands, and Eveline Lange; Ian, Falon, and Kim; me with Katarina; Julien; Christy Turlington; Robert Montgomery and Cheri Oteri; Mom and Dad; Caroline Rhea and I; Jeremy, me, Mom, Ian, and Falon; with Brian Erb; Ian; T-Boz and Julie Mijares; my creative director Don Reuter; Caroline, Jeremy, me, Liza, Tracey Ullman, and Eric; Julianne and Eric; me and Hilary Swank; and with Gwyneth.

credits

page 1: photographer: Albert Watson; hair stylist: Janet Zeitoun; clothing stylist: David Bradshaw; clothing credits: Dolce & Gabbana and Harvie Hudson. *pages 2-3:* photographer: Steven Klein; hair stylist: Jimmy Paul @ Susan Price; fashion stylist: Karl Templer @ Streeters London; clothing credits: Gattinoni Couture. *page 4:* photographer: Steven Meisel; hair stylist: Garren; fashion stylist: Paul Cavaco; clothing credits: Chanel; jewelry credits: Fred Leighton; prop stylist: Stefan Beckman @ Exposure NY. *pages 6-7:* photographer: Herb Ritts; hair stylist: Sally Herschberger; fashion stylist: L'Wren Scott @ Vernon Jolly; clothing credits: DKNY, Donna Karan Collection; prop stylist: Pedro Zalba. *pages 8-9:* photographer: Patrick Demarchelier; hair stylist: Oribe; fashion stylist: Freddie Leiba (conceived by Simon Doonan); prop stylist: Bradley Garlock @ Judy Casey. *page 10:* from the video "Power of Goodbye" directed by Matthew Rolston; video photograph by Frank Micelotta; hair stylist: Luigi Mureno; fashion stylist: Arianne Phillips. *page 13:* photographer: Dah Len; hair stylist: Orlando Pita; fashion stylist: Arianne Phillips; prop stylist: M.A.K. @ DeFacto. *pages 16-17:* hair stylist: Orlando Pita; fashion stylist: Anne Christensen @ Art & Commerce. *page 19:* hair stylist: Mel McKinney; fashion stylist: Lisa Von Weise @ Filomeno; clothing credit: J. Crew. *pages 22-23:* hair stylist: Mel McKinney; fashion stylist: Lisa Von Weise @ Filomeno; clothing credit: D&G. *pages 24-25:* hair stylist: Mel McKinney; fashion stylist: Lisa Von Weise @ Filomeno; clothing credit: D&G. *pages 26-27:* hair stylist: Colleen Callaghan; fashion stylist: Lisa Von Weise @ Filomeno; clothing credit: Giorgio Armani. *pages 28-29:* hair stylist: Lisa Mitchell; fashion stylist: Lisa Von Weise @ Filomeno; clothing credit: DKNY. *page 30:* hair stylist: Lisa Mitchell; fashion stylist: Rachel Haas @ Filomeno; clothing credit: Fendi. *page 31:* hair stylist: Lisa Mitchell; fashion stylist: Rachel Haas @ Filomeno; clothing credit: Yves Saint Laurent/Rive Gauche. *page 32:* hair stylist: Karina Castaneda @ Lavar Hair Designs; fashion stylist: Kithe Brewster @ Creative Exchange; prop stylist: Vincent Mazeau @ Smashbox NY. *pages 34-35:* hair stylist: Colleen Callaghan; fashion stylist: L'Wren Scott @ Vernon Jolly; prop stylist: Chris Gaskill @ Smashbox LA. *page 36:* photographer: Walter Chin; hair stylist: Jonathan Antin; fashion stylist: Nicole Fritton; clothing credit: tse surface. *page 37:* video still from "Down So Long" directed by Lawrence Carroll; hair stylist: John Sahag. *pages 38-39:* hair stylist: Dale Brownell; fashion stylist: Kithe Brewster @ Creative Exchange; prop stylist: Vincent Mazeau @ Smashbox NY. *page 40:* hair stylist: Dale Brownell; fashion stylist: Kithe Brewster @ Creative Exchange; prop stylist: Vincent Mazeau @ Smashbox NY. *pages 42-43:* hair stylist: Dale Brownell; fashion stylist: Kithe Brewster @ Creative Exchange. *pages 44-45:* hair stylist: Dale Brownell; fashion stylist: Kithe Brewster @ Creative Exchange. *page 46:* hair stylist: Tony Lucha; fashion stylist: Kithe Brewster @ Creative Exchange. *page 49:* hair stylist: Roberto DiCuia; fashion stylist: Kithe Brewster @ Creative Exchange. *page 50:* hair stylist: Colleen Callaghan; fashion stylist: L'Wren Scott @ Vernon Jolly. *page 53:* hair stylist: Mel McKinney; fashion stylist: Lisa Von Weise @ Filomeno; clothing credit: Armani Exchange. *page 54:* hair stylist: Lisa Mitchell; fashion stylist: Lisa Von Weise @ Filomeno. *page 57:* hair stylist: Mel McKinney; fashion stylist: Lisa Von Weise @ Filomeno; clothing credit: Armani. *page 58:* hair stylist: Colleen Callaghan; fashion stylist: Lisa Von Weise @ Filomeno; clothing credit: Vivienne Westwood. *page 61:* hair stylist: Lisa Mitchell @ Lisa Mitchell Salon; fashion stylist: Rachel Haas @ Filomeno; clothing credit: Roberto Cavalli. *page 62:* hair stylist: Mel McKinney; fashion stylist: Lisa Von Weise @ Filomeno. *page 65:* hair stylist: Tony Lucha; fashion stylist: Kithe Brewster @ Creative Exchange. *page 66:* hair stylist: Dale Brownell; fashion stylist: Joey Falcone @ Creative Exchange. *page 69:* hair stylist: Ricky Pannell; fashion stylist: Lisa Von Weise @ Filomeno; clothing credit: D&G. *page 70:* hair stylist: Colleen Callaghan; fashion stylist: L'Wren Scott @ Vernon Jolly. *page 74:* hair stylist: Colleen Callaghan; fashion stylist: L'Wren Scott @ Vernon Jolly. *page 79:* hair stylist: Roberto DiCuia; fashion stylist: Kithe Brewster @ Creative Exchange; prop stylist: Marla Weinhoff @ Creative Exchange. *page 80:* hair stylist: Lee Crawford; prop stylist: Chris Gaskill @ Smashbox LA. *page 83:* hair stylist: Dale Brownell; fashion stylist: Joey Falcone @ Creative Exchange; prop stylist: Jared Lawton. *page 84:* hair stylist: Dale Brownell; fashion stylist: Kithe Brewster @ Creative Exchange; prop stylist: Vincent Mazeau @ Smashbox NY. *page 87:* hair stylist: Mel McKinney; fashion stylist: Lisa Von Weise @ Filomeno; clothing credit: D&G; jewelry credit: Early Halloween. *page 88:* hair stylist: Dale Brownell; fashion stylist: Kithe Brewster @ Creative Exchange; prop stylist: Vincent Mazeau @ Smashbox NY. *page 90:* video still from "Dové L'Amore" directed by Marcus Nispel. *page 92:* hair stylist: Mel McKinney; fashion stylist: Lisa Von Weise @ Filomeno; clothing credit: Source III. *page 95:* hair stylist: Colleen Callaghan; fashion stylist: Lisa Von Weise @ Filomeno; clothing credit: Early Halloween; jewelry credit: Chanel; prop stylist: Jared Lawton. *pages 96-97:* hair stylist: Mel McKinney; fashion stylist: Lisa Von Weise @ Filomeno; clothing credit: Early Halloween; prop stylist: Jared Lawton. *page 99:* hair stylist: Karina Castaneda @ Lavar Hair Designs; fashion stylist: Kithe Brewster @ Creative Exchange; prop stylist: Vincent Mazeau @ Smashbox NY. *page 100:* hair stylist: Colleen Callaghan; fashion stylist: L'Wren Scott @ Vernon Jolly; prop stylist: Chris Gaskill @ Smashbox LA. *page 103:* hair stylist: Mel McKinney; fashion stylist: Lisa Von Weise @ Filomeno; clothing credit: Source III; prop stylist: Jared Lawton. *page 104:* hair stylist: Dale Brownell; fashion stylist: Kithe Brewster @ Creative Exchange; prop stylist: Vincent Mazeau @ Smashbox NY. *page 107:* hair stylist: Dale Brownell; fashion stylist: Joey Falcone @ Creative Exchange; prop stylist: Jared Lawton. *page 108:* hair stylist: Colleen Callaghan; fashion stylist: L'Wren Scott @ Vernon Jolly; prop stylist: Chris Gaskill @ Smashbox NY. *page 111:* hair stylist: Dale Brownell; fashion stylist: Kithe Brewster @ Creative Exchange; prop stylist: Vincent Mazeau @ Smashbox NY. *page 112:* hair stylist: Roberto DiCuia. *page 114:* hair stylist: Colleen Callaghan; fashion stylist: L'Wren Scott @ Vernon Jolly; prop stylist: Chris Gaskill @ Smashbox LA. *pages 116-117:* hair stylist: Dale Brownell; fashion stylist: Kithe Brewster @ Creative Exchange; prop stylist: Vincent Mazeau @ Smashbox NY. *pages 118-119:* hair stylist: Colleen Callaghan; fashion stylist: L'Wren Scott @ Vernon Jolly; prop stylist: Chris Gaskill @ Smashbox LA. *page 121:* hair stylist: Mel McKinney; fashion stylist: Lisa Von Weise @ Filomeno; clothing credit: Joan Vass; prop stylist: Jared Lawton. *page 123:* hair stylist: Dale Brownell; fashion stylist: Kithe Brewster @ Creative Exchange; prop stylist: Vincent Mazeau @ Smashbox NY. *page 126:* hair stylist: Colleen Callaghan; fashion stylist: L'Wren Scott @ Vernon Jolly; prop stylist: Chris Gaskill @ Smashbox LA. *page 129:* hair stylist: Ricky Pannell; fashion stylist: Lisa Von Weise @ Filomeno; flowers: ZeZe Flowers. *page 131:* hair stylist: Colleen Callaghan; fashion stylist: L'Wren Scott @ Vernon Jolly; prop stylist: Chris Gaskill @ Smashbox LA. *page 132:* hair stylist: Dale Brownell; fashion stylist: Kithe Brewster @ Creative Exchange; prop stylist: Vincent Mazeau @ Smashbox NY. *page 134:* hair stylist: Tony Lucha; fashion stylist: Kithe Brewster @ Creative Exchange; clothing credit: Halston; prop stylist: Vincent Mazeau @ Smashbox NY. *page 137:* hair stylist: Lisa Mitchell; fashion stylist: Rachel Haas @ Filomeno; clothing credit: Darlene De Andrade. *page 139:* hair stylist: Tony Lucha; fashion stylist: Kithe Brewster @ Creative Exchange; prop stylist: Vincent Mazeau @ Smashbox NY. *page 140:* hair stylist: Dale Brownell; fashion stylist: Joey Falcone @ Creative Exchange; prop stylist: Jared Lawton. *page 143:* photographer: Warwick Saint; hair stylist: Ward; fashion stylist: Kithe Brewster @ Creative Exchange. *page 144:* hair stylist: Ricky Pannell. *page 147:* hair stylist: Tony Lucha; fashion stylist: Kithe Brewster @ Creative Exchange; prop stylist: Vincent Mazeau @ Smashbox NY. *page 148:* hair stylist: Dale Brownell; fashion stylist: Kithe Brewster @ Creative Exchange; prop stylist: Vincent Mazeau @ Smashbox NY. *page 151:* hair stylist: Lisa Mitchell; fashion stylist: Rachel Haas @ Filomeno. *page 152:* hair stylist: Dale Brownell; fashion stylist: Kithe Brewster @ Creative Exchange; clothing credit: Dolce & Gabbana. *page 154:* hair stylist: Lisa Mitchell; fashion stylist: Rachel Haas @ Filomeno; jewelry credit: Lara Bohine 107; prop stylist: Jared Lawton. *page 156:* hair stylist: Colleen Callaghan; fashion stylist: L'Wren Scott @ Vernon Jolly; prop stylist: Chris Gaskill @ Smashbox LA. *pages 158-159:* hair stylist: Ricky Pannell; fashion stylist: Lisa Von Wesie @ Filomeno; clothing credit: Claude Sabbah. *page 160:* hair stylist: Mel McKinney; fashion stylist: Lisa Von Weise @ Filomeno; jewelry credit: Sara Samoiloff. *page 163:* hair stylist: Lisa Mitchell; fashion stylist: Rachel Haas @ Filomeno; clothing credit: Roberto Cavalli; prop stylist: Ryan King. *page 164:* hair stylist: Colleen Callaghan; fashion stylist: L'Wren Scott @ Vernon Jolly; prop stylist: Chris Gaskill @ Smashbox LA. *page 167:* photographer: Warwick Saint; hair stylist: Ward; fashion stylist: Kithe Brewster @ Creative Exchange. *page 168:* hair stylist: Roberto DiCuia; fashion stylist: Kithe Brewster @ Creative Exchange; prop stylist: Marla Weinhoff @ Creative Exchange. *page 171:* photographer: Dah Len; hair stylist: Orlando Pita; fashion stylist: Arianne Phillips. *page 173:* hair stylist: Karina Castaneda @ Lavar Hair Designs; fashion stylist: Kithe Brewster @ Creative Exchange; prop stylist: Vincent Mazeau @ Smashbox NY. *page 174:* hair stylist: Dale Brownell; fashion stylist: Kithe Brewster @ Creative Exchange; prop stylist: Vincent Mazeau @ Smashbox NY. *page 176:* photographer: Albert Watson; hair stylist: Kevin Woon; fashion stylist: George Bloodwell.

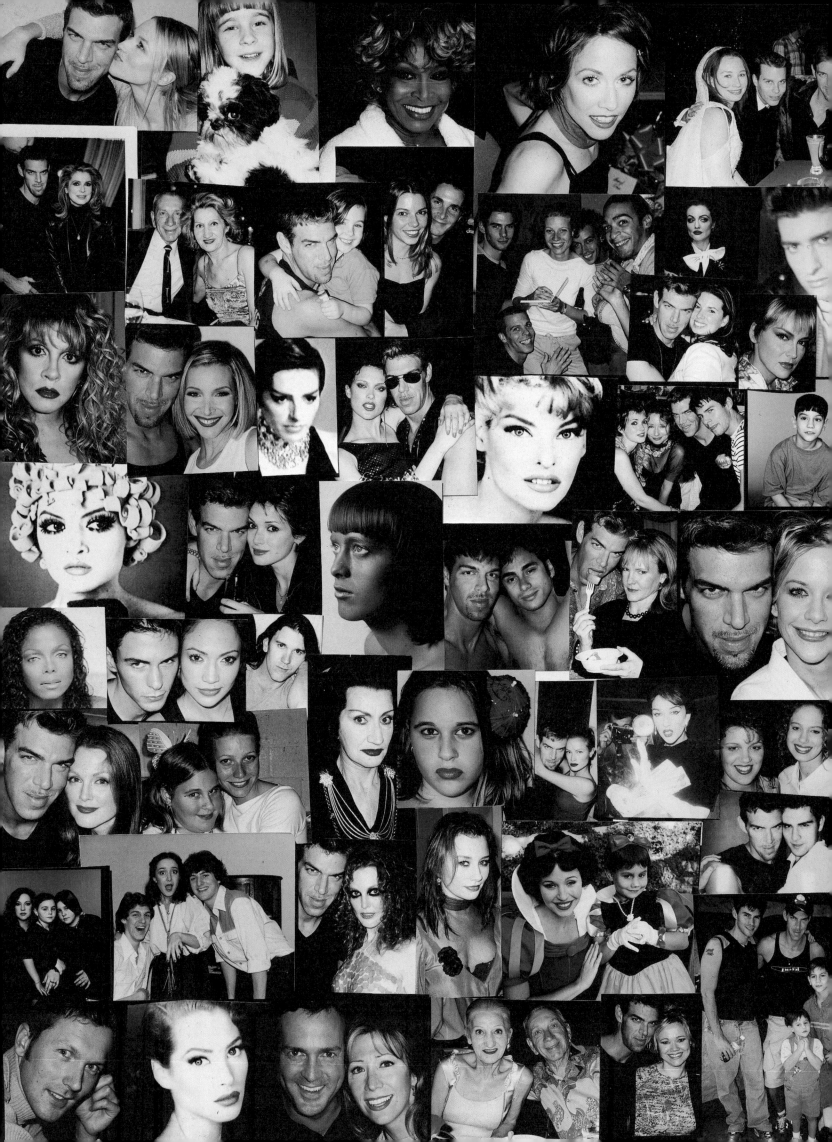